THE PROFESSIONAL PHOTOGRAPHER

THE PROFESSIONAL PHOTOGRAPHER

Developing a Successful Career

LARRY GOLDMAN

1983
A DOLPHIN BOOK
Doubleday & Company, Inc., Garden City, New York

Photo credits and acknowledgments appear on page 235. Any rights information found to be erroneous or missing will be corrected in future editions.

BOOK DESIGNED BY SYLVIA DEMONTE-BAYARD

Library of Congress Cataloging in Publication Data

Goldman, Larry.
 The professional photographer.

 "A Dolphin book."
 1. Photography—Vocational guidance. I. Title.
TR154.G63 770'.23'2
ISBN 0-385-15753-3
AACR2
Library of Congress Catalog Card Number 81–43582

TO MY WIFE, LESLIE, AND MY DAUGHTER, RACHEL.

CONTENTS

INTRODUCTION ix

1 BREAKING INTO THE BUSINESS 1
 The Experts Give Their Advice

2 THE TRADITIONAL APPROACH 27
 Working as an Assistant

3 OUT OF SCHOOL AND INTO THE MARKET 37
 The Portfolio

4 MAKING IT WORK 53
 Reps and Business

5 LIGHTS, ACTION, CAMERA 71
 Assignment and Shooting

6 FOCUSING YOUR APPROACH 99
 Markets

7 INTO THE BIG TIME 147
 Career Strategies

APPENDIX 153
 Where to Find . . .
 Photographers' Representatives 153
 Stock Photo Agencies 166
 Photographic Research 172
 Trade Publications 174
 Directories 174
 Magazines 174
 Photo Galleries 178
 Models and Talent 190
 Stylists 201
 Hair 208
 Makeup 210
 Hair and Makeup 214
 Costumes 216
 Locations 219
 Sets 223
 Props 225

PHOTO CREDITS AND ACKNOWLEDGMENTS 235

INTRODUCTION

THE PROFESSIONAL PHOTOGRAPHER is intended to give a practical view of the realities of earning a living as a professional photographer. It is directed toward those who want either to begin to earn a living by photography or to work with greater efficiency within the field.

The book offers the essential information for any talented and technically competent photographer to break into the world of advertising, editorial, corporate, or stock photography, or any of the dozens of related areas. It provides information on how to put together a successful portfolio; where the potential markets for your work are and how to gain access to them; what a novice needs to know to get a job as an assistant, often the first rung on the ladder to becoming a successful professional; what constitutes a salable photograph; and how you could land a major assignment where you live, with the skills you already possess.

This book is written for the photographer who is serious about photography as a profession, not as a hobby. Photography has been accepted as an art form, and its applications in galleries, books, posters, and so on, are endless. There are more commercial uses for photographs than ever before because photography is accepted as the quickest, most direct means of calling attention to products. Print, more than any other medium, can merchandise products. Print sits there, and can be looked at again and again. Television is less effective because its movement can be distracting; it can sell *mood* better, but print sells the merchandise. Magazines are now flourishing after languishing for more than a decade. With the death of *Look* and the original weekly *Life*, we lost magazines with major national visual impact. Pictures, however, are once again becoming more a part of our daily lives, and the origin of all visual media is the camera, the use of light, and the photographer's ability to frame an event.

Throughout the book, photographs have been used to help illustrate various approaches to the problems that confront professionals and to show how these problems are resolved. The illustrations will detail the process of receiving and executing major assignments, giving concrete ex-

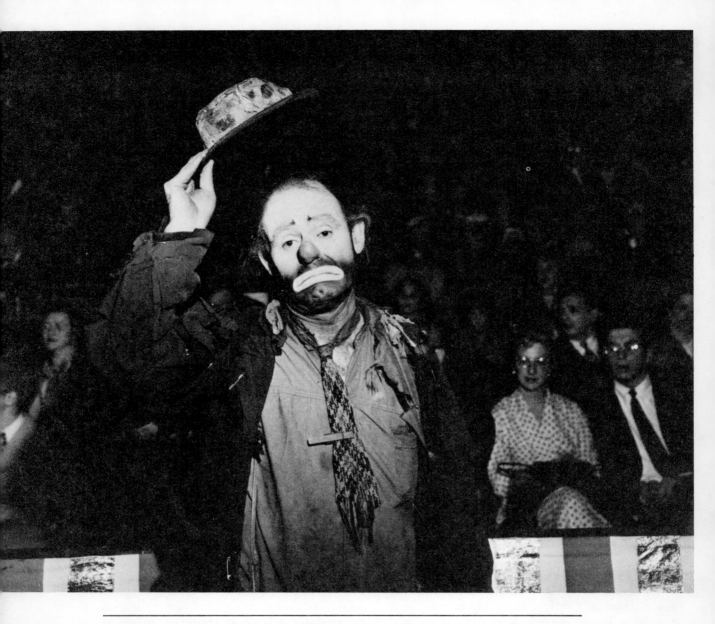

Weegee, the ultimate photojournalist, earned his signature—Weegee the famous—
by always being the first to the scene of a crime. This picture of Emmett Kelly,
world-renowned clown, was sold for promotional use by Photo-Representatives,
his stock house, as the circus criss-crossed the country.

Photographers must be acutely aware of time and space. Deborah Turbeville's famous bathhouse series, anticipating the punk look, had an immediate impact on store windows, magazines, and fashion. Not only a beautiful example of fashion photography, it represents a unique solution to photographing bathing suits during the cold winter in the Northeast.

Seminal art director William Golden, the creator of the corporate visual image for Columbia Broadcasting, started a remarkable photographic tradition by hiring the best talent available. This picture for Columbia's radio broadcasting network captures a worker in his milieu, giving the suggestion of a wide variety of CBS listeners. Paul Strand, the photographer, was a student of Lewis Hine's. Although this 1942 photograph was used as an ad, it could have just as easily have been included in one of Mr. Strand's many gallery shows.

amples of the experience of several established photographers.

The professionals who take pictures for the media are taste-makers; they set the visual standards, trends, and ideas of the time. Photographers are, and must be, in sync with what is going on around them; they must have a distinct sense of the contemporary. The current mood, the overriding values, concerns, and interests, are the essence of their focus. Photographers must immerse themselves in their time. It is their responsibility to capture, through irony or through documentation, what is going on around them. Photography is a meditative form, and at its best a transcriber of events, places, and

people. Photography is being used more and more in every field; ours is a culture that absorbs information visually, whether from advertising, art, technology, or news.

Four qualities constitute being a professional. First, professionals are people who earn more than half their income from taking pictures. Second, while a lot of pictures that professionals sell may be similar to pictures that many amateur photographers have taken, it is the *selling* of the pictures that distinguishes the professional. Third, professionals shoot the same picture in more than one way; professionals must cover themselves on any assignment because they have

The mentor to generations of American photographers, and also one of photography's most inspiring innovators, Edward Steichen photographed for many commercial clients while at the same time establishing his reputation as a classic American artist. The secret to his success was in keeping his clients for years and years. One of these was Welch's Grape Juice, for whom he consistently created a distinctive atmosphere. Here he transforms mundane drink to the level of a work of art. One of Steichen's democratic aphorisms was that the best work done in advertising was of the same level as the best work in photography of any kind.

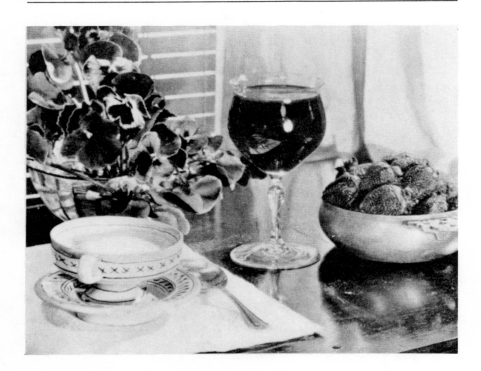

to leave as little as possible to chance. What makes them professional is their ability to deliver; fulfilling the requirements of a specific assignment successfully, reliably, and imaginatively distinguishes them from amateurs.

The fourth and most important distinction between amateur and professional is the fact that professionals collaborate with those who know the most about photography. Those who see the greatest number of photographers and seek out the best among them are the art directors. The art director serves the photographer as a sounding board and a security blanket. He can sense what a photographer will produce next, sometimes even before the photographer knows, and can gear him toward it and advise him in what direction he should move. There is a trust that develops between the two, both psychologically and visually. The novice should not underestimate the importance of the art director, for he will be undermining his own possibilities.

Curiosity is essential to good photography. Being aware of what is going on around you is a basic requirement, no matter what field of photography you are interested in. You must also know what has been done in the past to know what you can contribute. It is a serious mistake to think that once you are out of school you don't have anything else to learn. Photography is as much personality as ability; if you believe in what you are doing, you have a better chance to succeed.

THE PROFESSIONAL PHOTOGRAPHER

1

BREAKING INTO THE BUSINESS

The Experts Give Their Advice

However remote and unattainable the goal of success as a professional photographer may seem, the requirements for becoming a professional are relatively simple: basic technical proficiency, an awareness of the field you wish to enter, and the dedication and persistence to follow through on your ambitions. That is it in a nutshell. If you are reading this book, you probably already have these qualifications to some degree. Your basic problem, then, is discovering and taking the next practical step toward a career in professional photography. Before outlining the various routes you can investigate, I want to detail the requirements outlined above and clarify what they involve.

Familiarity with your equipment and facility in operating it are elementary technical requirements. But technology should never intrude on your work. The ability to produce sharp, well-lit, well-composed pictures is obviously going to be an asset in any field of professional photography, although you would be surprised at the number of very successful photographers who started out knowing the minimum about the camera, less about light meters, and nothing at all about the darkroom. The reason for this is simply that in photography subject matter and interpretation take precedence over any technical knowledge. Robert Maplethorpe, a well-known portrait photographer, said in an interview with Lord Snowdon, "The less time I have to spend working with technology the more time I have to do other things. You can't do everything." Photography magazines have made a fetish out of gadgets and techniques, and many amateur photographers suffer from an addiction to attachments and gimmickry that have little bearing on how good or bad a photograph may be. One of the telltale signs of amateurism in any photograph is when effects dominate image.

This early CBS ad by Ben Rose, based on a famous painting by Fantin-Latour, exhibits an admirable technical virtuosity in the use of dual lighting (strobe plus the light from the television screen). The image given to television by early ads was calculated to give a wholesome impression; the family togetherness that this photograph seems to promise provided television with the benign image that it sorely needed.

Technology should be as unobtrusive as possible in your finished work. As Duane Michals, an internationally exhibited photographer, paradoxically put it, "I would take better pictures if the camera weren't in the way."

Peter Beard, the acclaimed documentor of African wildlife, states:

Even if you're a grammar school dropout, the camera can still do incredible things. Particularly now with strobe lights, everybody can take the same "professional" pictures. One just hauls around all this equipment, hundreds of pounds of it, aluminum boxes on the backs of assistants, so that every single picture—sunrise and sunset, night and day—turns out exactly the same.

In her memoirs, *Allure*, Diana Vreeland, former editor in chief of *Vogue*, remembers Cecil Beaton:

Cecil was affected by everything and everything was affected by him. But he was always a snapshot photographer. "I'd like to snap a few, darling," he'd always say, "I'd just like to snap a few."

He was never technique-riddled. He al-

ways worked as an *amateur*—in the French sense of the word—which is the only way I know how to work. I can remember one of the first times I met him, in London in the early thirties. I was sitting in Cecil's studio with quite an important man he was photographing—I can't remember who—when Condé Nast walked in. Cecil sort of went *this* way and the camera made so much noise the poor man thought he was being *shot.* . . .

Then . . . *another* shot went off and the man almost fell off his chair. So Condé said, "Cecil, I'm sure we have a great picture. But *may* I make you a present of a proper camera?" . . .

The punch line is this: Cecil didn't want to part with his old Brownie. He felt it was what his *success* had come from. It was like an actor with his dirty old dressing gown— he never gives it up!

This is how one of the great photographers of fashion and portraits (who was also a major stage and set designer) got his effects—through the simplest methods possible. Peter Beard corroborates this point:

I think that most of the world has misinterpreted what photography is about. It is about *economy.* Doing it with the least amount of effort, quickly, brilliantly, lyrically, whatever, but not getting caught up in all the Madison Avenue absurdity. That is the art of photography—staying away from the plastic claustrophobia—steering clear of the greasy cliché and the schoolroom dogma. One of the greatest fashion photographers will always be Cecil Beaton, as he was one of the few lensmen who could go into the special light of a bathroom or open up the windows and take superbly creative pictures right there and then—fifty years ago! What is this gigantic need of assistants, aluminum boxes of equipment, reflectors, tripods, gimmicks of all kinds? None of this is evident in the work of Julia Margaret Cameron or Lartigue or even Henri Cartier-Bresson.

In the 1860s Julia Margaret Cameron taught photography. Lewis Carroll was one of her students, and his works of one hundred years ago stand up to those of any of the pros today. As Cocteau once said:

Writers have too many words and artists too many colors. Too many photographers have too many cameras, too much overhead, take too many pictures and focus their talents on convincing people to take it seriously.

Today cameras are so sophisticated that almost no technical expertise is required to use them effectively. The same could be said about custom darkrooms, where professional printers can produce excellent prints in any way you instruct them. It is, however, an advantage to know as much as possible about the medium you are working in. Knowing the limitations and options allows more flexibility and more possibilities. If you feel insecure about your mechanical ability in any aspect of photography, this is easily remedied by taking a technical course, say, a class in lighting. I don't want to recommend technical virtuosity for its own sake, but if you do know photography technology, you can more readily achieve the results you want. It is a well-known secret that many of the great innovations in photography, whether aesthetic or technical, had their origin in accidents that the photographers were able to capitalize on because they were in control of the process.

It is equally important for you to be aware of what is being done in the field. Magazines are an invaluable resource regardless of the type of photography you are interested in. If your ambition is to have your prints exhibited, you should be aware of the kind of work being shown and which galleries deal with the different genres of photography. There is a profusion of photography classes, books, and exhibitions that you can use to familiarize yourself with what is being done. Exposing yourself to many different sources is essential for the development of a style that separates you from the crowd. Alexey Brodovitch, who was art director of *Harper's Bazaar* from 1934 to 1959, and who was the first to establish the relationship between the art director and the photographer, speaks of the initial requirements for this learning process in "Aphorisms," a collection of his observations on the field:

Develop a statement of your own. Shout, don't whisper. Look for inspiration in nature, in all sources of culture and art, in the theater, films, museums, exhibitions, news, the perpetual movement of events.

Harie von Wijnberge, a hair and makeup stylist, also speaks of the importance of looking:

If you want to be a fine artist you should look at fine pictures. You can do something identical to someone else's work, but it doesn't mean you can't stop experimenting with it because you might go further with it. One should know what other people are doing, but if you are an art student or an amateur and want to be a working photographer, you must inform yourself as much as possible about the trade. Read all the publications. If you see a magazine ad that intrigues you, try to find out whose work it is through the agency handling the account or who the art director was. Find out as much as you can. There are magazines, such as *Art Direction, Advertising Age, Adweek, Women's Wear Daily* for fashion, that point out certain ads and give you quite a bit of information.

This is not to say that you should adapt yourself to what is currently being shown. Rigid copying of trends, in fact, is the last thing I would recommend. To paraphrase Edison, if it's successful, it's obsolete. To make any impression in any field, your contribution must be ahead of what is being shown, but you can hope to achieve a niche for yourself only by knowing what the trends are and evaluating them in terms of your own direction.

While this is true of the work shown in galleries and photographic magazines, it is especially true of editorial and advertising photography. Magazines and agencies are always looking for new ideas. Their business is to get people's attention. You cannot help but benefit from analyzing what is currently being done and recognizing how each photographer solved the specific problem presented by the assignment. A careful examination of any current publication will convince you that a successful solution depends on a new answer to conventional problems, although the case could also be made that

advertising demands conventional answers to new problems.

Whether it be technical, stylistic, or conceptual, problem solving will be your main challenge. To develop your ability to meet the standards of the industry, the best thing you can do is give yourself assignments, putting yourself in the position of an actual shooting.

The combination of working in a 49¢ portrait studio and studying photography through self-assignments allowed Arnold Newman, who trained to be a painter in the thirties, to develop both his techniques and his style. In *One Mind's Eye* he remembers those years:

During lunch hours and weekends I carried my borrowed camera (a 2¼ × 2¼ Contessa Nettle that belonged to my uncle) and tripod into the streets of Philadelphia, mostly around the area of the Lit Brothers Department Store, where I worked. At nights, having been granted special permission, I would work on my own photographs in the studio darkroom until midnight or later.

I began to experiment in photographic abstractions as well as social realism. I became fascinated with the control of the camera and the ability to make it see as I saw. The examination of one pack of film was enough to make me realize that I had to stop looking as a painter and try to examine in terms of the camera's eye. I read and looked up everything I could find on photography, going back to its beginnings as well as studying the work of contemporary photographers. My friends produced material from their libraries and gave freely of their advice and time. I went to museums and bought and clipped (used) magazines like *Vanity Fair*, a strong influence on me. However, the biggest impression was made by the photographs of the Farm Security Administration, principally those of Walker Evans, whose book was my most constant reference source during this period.

Now we come to another condition for success in the field of professional photography, and in my opinion by far the most important: dedication and persistence. Without these I would advise you to stick to photography as a hobby.

In this 1929 ad for CBS, photographer Erich Kastan makes a witty comment on the mind-boggling proliferation of printed media. While the point CBS wished to make was the economy of information sources provided by radio, this picture has quite another message for the novice photographer: nothing better illustrates the almost endless possible markets for photography than a close look at your local newsstand.

The field is so highly competitive that only the most talented and tenacious have any hope of succeeding.

Success in photography, except in special cases, is determined by commitment. Professional photography is a vocation, not an avocation. Unlike the traditional professions or almost any type of business, photography does not necessarily require a long apprenticeship or years of schooling. The rewards are limitless for those who single-mindedly pursue their goals. The problem is never that there are too many photographers. Overcrowding may present obstacles, but it does not mean there is an overabundance of *great* photographers. When a market is saturated, it generally means there is an excess of mediocrity. In photography, the gifted amateur has every opportunity of converting his talent into a successful career.

In setting out on your career as a professional photographer, you should know something about the markets toward which you are directing your work. However, you will be starting off on the wrong track if you set out trying to cater to the market. As soon as you try to anticipate your market, you are diluting your chances. By merely accommodating yourself to the market, you debase your potential. You do not "sell out," for you can do this only if you have already established a standard and then work far below it. Obviously no one just entering the field of photography has attained that standard. To become successful, you must know what you want to do and what your talent equips you to do well.

If you set out with only monetary attractions in mind, you are saddling yourself with a negative attitude that will, at best, undermine your chances of succeeding. You can subsidize yourself, however, by tapping into the demand for sunsets, vacation snaps, grandma getting on the train, and so on. Surprisingly enough, there is a constant income from just this kind of picture, when it is professionally shot. Such photos are the backbone of stock photography.

The stock photography houses are a ready-made market for good-quality photographs of just about anything, from exotic places to human-interest shots to photographs used to illustrate ideas or words. Such photographs are used in ads and as illustrations for magazines, book jackets, posters, album covers, and greeting

Almost any good photograph—whether it is your mother or dog, flowers, sunsets, or exotic vacation background—can find an application either in editorial or advertising. Here is a tongue-in-cheek use of a stock picture bought for Mother Klein's Kosher Style Dog Food.

cards. Simply put, a stock house is the supplier to anyone who wants a picture of anything.

If you have a large stock of excellent photographs of everyday situations, of exotic people in exotic places, of commonplace people in commonplace situations, of commonplace people in exotic situations—I think you get the idea—if you have the pictures, stock houses are the place to take them.

ALTERNATE ROUTES

No matter where you live, you are the local talent. Many photographers starting out burden themselves with an almost impossible task: trying to break into the biggest market in the world in one optimistic leap. A far better idea is to work on your style and put together an impressive portfolio by getting assignments in your hometown.

New York City, Los Angeles, and Chicago are not good places to learn. You are very likely to

get discouraged before you have even begun. Work is hard to come by, and in any case you need to establish a degree of professionalism before you begin showing your work to professionals. You are better off trying out "out of town," as they say on Broadway. Relatively, you have a better chance in Paris or Milan than you do in New York. Even if you do have the capital to sustain yourself in New York over a long period, you cannot help getting discouraged by the almost daily rejection of your work. If you avoid falling into the trap of the lure of the Big Apple, you will give yourself an extra advantage over the legions of beginning photographers who, quite unprepared, head like lemmings into the big time.

Arnold Newman was one of *Life* magazine's renowned photographers and is an acclaimed portrait photographer who has had many one-man shows. He offers this advice:

There was a survey that disclosed that there are twice as many students as there are people in the whole industry, which means that, to say the least, the field is overcrowded. The problem is that everybody wants to be a general and not a foot soldier. There is opportunity in other areas. You don't have to be a top photographer in New York City, and I wonder if that's so important after all. I think that novices should get a good education and have a wide background in art, since photography stems from art. The average student knows nothing about his field. Students don't go study other people's work enough. Art students are constantly going to museums, but you can't drag a photography student to a museum. You mention key people in the history of photography, and they don't know who they are. The students imitate the imitators without knowing their origins. This is very common and is the fault of their education.

On the other hand, Professor Phil Perkis, an instructor at Pratt Institute, believes that if you have a distinct sense of what you want to do, you should follow it through—in New York:

If you get into something special and are really interested in it and have a passion for it,

the most important thing is to be in New York City and stick it out long enough to see what is going on. You can't think you're going to be a success within six months after you get out of school. The competition is so amazing. If you know what you want, you shouldn't go to school, you should just go and do that. If you want to do still life, for instance, you should look for a job in that. The problem is that students don't know what they want. They just want to learn about art. I have many students who were painters and became photographers, or vice versa. I don't ever remember an art director asking if someone had a degree.

Ruth Ansel, former art director of the New York *Times Magazine* and now editorial design director at *House and Garden*, talks about what young photographers face today and what they should be seeking to prepare themselves for a career:

I really believe someone starting out today has a more difficult time because there's a much shorter nurturing period than there used to be. In the past, if you had talent and a passion to photograph fashion, you were encouraged to realize your dreams, to experiment, to fail. There was time to develop and emerge with a totally different, but just as valid, vision of fashion as that of your colleagues. In the golden age of the great magazines there were editors like Carmel Snow and Diana Vreeland, who, together with the brilliant Alexey Brodovitch, created a climate of excellence and caring. They were innovators, teachers, skilled opinion makers. Their attitude and the environment they created eventually coaxed the extraordinary talents and unique vision out of young photographers like Richard Avedon and Hiro back in the late forties and early fifties. Before them, visionary talents like Munkacsi and Hoyningen-Huene transformed their daring views of women from European high society into thoroughly American archetypes, modern goddesses influencing generations of women who aspired to be like them.

In return there developed an aesthetic grace that was reflected in the gloriously

varied pages of certain magazines like *Life, Look, Fortune, Bazaar, Vogue, Esquire,* and the new *Rolling Stone.* From the thirties through the sixties, what was so exciting was to see these wonderful collaborations often triumph over the growing conservative tastes of many of the editors. The strength of the photographer–art director team was clearly felt. The readers who looked toward those magazines for a cultural high not only began to see themselves in a more idealized state, but began to understand, beyond their own narrow experience, the world in which they lived. They came to know other ways of life, they were encouraged to discover splendors in unfamiliar places and contradictions about the way they lived. Editors were aware of their responsibilities to their readers. They *were* the readers.

Now more than ever we seem to be witnessing the opposite phenomenon—culture being brought down to the masses, readers being patronized, the media print trying to compete with television for its enormous audience yet misunderstanding the electronic message completely. It is therefore vital, it seems to me, for the photographer just starting out to seek a relationship with an art director that can help him or her grow. This is essential to the development of any young talent who wishes to work commercially and rise above the competition.

Today there's another even more corrupting influence that has crept into the world of the working photographer, and that is the deification of the "photographer-as-artist." Everyone seems more interested in Making It than in really taking pictures. More and more professionals who've only been out there a couple of years are consumed with the idea of publishing a book of their latest shoot, or being feted in some gallery show. Both they and their museum counterparts are hungry to exploit the public's insatiable interest in the photographic image. Some of this is due, of course, to the sad fact that the day of the great magazines is over, and there is really no place left to publish a body of work as it

develops. The joy of *Life* magazine in the forties and fifties was to be able to bear witness weekly to the extraordinary development of their superb stable of photojournalists. People like Eugene Smith, Alfred Eisenstaedt, David Douglas Duncan, Margaret Bourke-White. Where are the Smiths and Bourke-Whites of today? Not in the pages of any American magazine since the seventies.

Instead we are left with a sterile preference to be seen on a museum wall, fulfilling some precious "idea" of what a photograph is. These photographers have forgotten about the magnificent value their particular form of witnessing life experience once served—and still can serve. The photograph is, it has been said, one of the single most extraordinary records of history yet devised. I agree. Everything we see, and some things we can't, can be known by it—every human event defined, revealed, and celebrated. If you agree that this moment will never again exist, that no two moments are ever quite alike, no two faces, no two trees, no two mountains, or sunsets, then you begin to appreciate the sense of urgency one can feel about capturing all of it before it disappears. This unique ability to see, select, pursue, and define a subject that deeply moves you or troubles you, to try to uncover some secrets that reveal a deeper truth than what appears to be, is, I feel, finally at the heart of what distinguishes a good photographer from all the rest. Let others worry about whether your work is art or not. If it is true, it will eventually be transformed into a work of lasting value. Whether it originated as a fashion photograph or a photojournalism assignment, time will solemnize it soon enough.

So you must try to find a way, however difficult, to work with a person who encourages your particular vision. Maybe you'll find that person in a photographer whose work you particularly admire, or in an art director. Or you might find that person in someone who has nothing to do with taking photographs, but they and their work fascinate you. It might mean you'll have to relocate. What could be better? We all love to travel and confront new truths in

new places. First, though, find out what you really like, what excites you, who is doing this, and how you can begin to be a part of it. Don't be afraid to look up the addresses of people you admire. Make an appointment to show your work. Know as much as you can about that person, and show them only the work that you're most proud of. Or write to the person. Send a letter that tells them something about the kind of person you are, and what it is about their work that inspires you. I understand that Hiro started that way. When he was still in China, he wrote a long letter to Avedon, and whatever that letter contained so impressed Dick Avedon that he invited Hiro to come to America as his assistant. Surround yourself with people who expect amazing things from themselves and others. Surprise yourself, discover what your own feelings about the world really are. There are no quick methods. No shortcuts. No rules. But if you really have something to say and are willing to work hard, I believe that in time you will be heard.

Good experience could be gained on your local newspaper or college paper, as John Dominis, picture editor of *Sports Illustrated*, suggests:

A novice can get pictures published in college papers, high school papers, or can sell them to the local newspaper. They don't send staff photographers to high school events. That's what I did. I took boxing pictures to the L.A. *Times*. Sports photography is probably easier to get into, although it's hard to get the big-time assignments. You have to work your way up. The novice has to practice a lot with whatever telephoto he has. You're not allowed to get close to a sport, so you need the longest lens you can afford. It's essential to practice in color, although not for the newspapers. You go to an ice skating rink and shoot until you get a cramp in your arm. You have to go to events and learn from your mistakes.

Sometimes on a self-assignment, covering a local event or a human-interest story, a photographer can come up with a great single shot or a series of pictures that will be bought by a major newspaper or national magazine. Such self-assignments are actively encouraged by news and picture magazines, which rely heavily on free-lance photographers to submit ideas and even entire stories. Bob Ciano, art director of *Life* magazine, says that this is often how *Life* comes to use new photographers:

If an unknown photographer was presenting his portfolio, I think a self-assignment would be a terrific idea. I don't expect it. It is more than we can ask people to do. But we have run stories that photographers did for themselves. Two issues ago, we ran a story on the Walla Walla State Prison in Washington. It was a story that came in complete. The photographer walked in one day with his photos. He was a newspaper photographer for a Seattle paper, and he worked on this, taking time off to do it. He came to us because the Seattle paper wouldn't run it.

This is the way Hans Namuth, one of the greatest reportage photographers of all time, began:

I started off doing free-lance photography in Europe before getting involved with the Spanish Civil War. There were few photographers, and by sheer accident I happened to be on the spot, so I was in demand, being in Barcelona July 18, 1936. Georg Reisner and I, working as a team, would shoot pictures, then develop the films. After they passed the censors, they were sent to Paris. There an agent would sell them to various magazines the world over. We never saw the pictures until they came out.

Citing the necessity for self-assignments, Hans Namuth continues:

A self-imposed assignment is very important. One must not wait for an art director to call. Try to do things yourself by inventing and developing stories. One of the axioms of Alexey Brodovitch, a great art director and a great teacher, was: "You cannot be a photographer from nine to five and then stop; you *are* one, twenty-four hours a

day." The routes to becoming a professional photographer are either that you become somebody's assistant or that you work for a magazine. A third avenue would be taking pictures on your own. There is a point in being inspired by someone else's work, like, say, Cartier-Bresson's. A photographer should learn from the masters. By looking at various people's styles you will be able to define your own vision. I think it was Hemingway who said, "Imitation is often a sign of genius." Being under the guidance of a great photographer helps to find your direction. Submit yourself to a powerful influence in the beginning! In my own case it was the German photographer August Sander.

One should expose oneself to experience, without any particular market or motive in mind. You have to remember when you are photographing artists, for instance, that your photograph may not have an immediate market but it may be quite valuable in the future. To go out and shoot and immediately hope to sell the picture is a mistake. Even if these artists' work is considered unimportant now, hold on to your photograph; it may become valuable.

Annie Leibovitz, long-time photographer for *Rolling Stone* and one of today's best portrait photographers, points out that there are opportunities everywhere if you look for them. In her case she found a way to use her fine-arts background in a new kind of commercial outlet, the rock newspaper:

I got involved with *Rolling Stone* in 1969, just out of art school. I had gone to an art institute as a painter and had been to Japan between semesters and got a camera. I was in San Francisco, and when I came out of art school everyone's approach was very puritanical—if they could take a picture they wouldn't sell it. The whole commercial area is such an open space, a vast land. It is asking, begging, to be used.

Rolling Stone was just starting when I got out of school; it was very editorial. You always think everything is sewn up and they can't possibly use you. It's just the opposite. I never took what I had for granted

or underestimated it. I work very hard—it's my life. It's turned into a big responsibility.

For beginning people, if they see something in a magazine that they really like and if they want to do something for that publication, they should go after it. Magazines really need people. They love to have you walk in the door with a great portfolio. But you must have the sincerity of heart to really want to do it. There are very few people who express that sincerity. Granted, it's hard to get things rolling. I walked in the door of *Rolling Stone* and saw a big hole. They wanted me to start right away. A newspaper is a great place to start. It is really through photojournalism that I got into portrait photography and into doing the covers for *Rolling Stone*. I don't think of them as covers but as posters. You get split down the middle; sometimes you need the attraction of a poster cover. I think my art background helped me in making a photograph express a concept very graphically so that it grabs your attention immediately on the newsstand.

Even if you are not interested in pursuing reportage as a career, working for a local newspaper is excellent training for any field of photography. It teaches you to adapt quickly to any situation, to work with people who are strangers, and to make the narrative element in your story speak for itself.

Outside of photojournalism—news events and sports—there are numerous other areas where photographs are needed: community events for local papers, store displays, brochures for business, as well as the less obvious fields of aerial photography (usually for real estate), police photography, insurance photography for accident liability and appraisal of possessions, and the more exacting field of architectural photography, in which many professional photographers are interested. You should not reject these nominally mundane subjects. They will give you an opportunity to exercise your talent. The content of a photograph may be 75 percent subject matter, but the crucial 25 percent comes from how you interpret it. Many of the greatest photographers have achieved their fame by shedding a unique perspective on subjects, events, and people. The portraits of William

Rolling Stone

JAMES TAYLOR

The Rolling Stone
Interview
By Peter Herbst

REGGIE JACKSON CLOSE UP

Baseball's
Most Volatile Player
By Roy Blount Jr.

Annie Leibovitz's portrait of James Taylor for the cover of Rolling Stone *maga-zine* illustrates the use of a cover photograph as an attention-getting poster. The skills you learn shooting portraits of friends and relatives will eventually be indispensible to you in whatever field of photography you choose to enter.

Van Der Zee taken in his studio in Harlem and hanging in New York's Metropolitan Museum of Art, August Sander's portraits of German workers, Irving Penn's book *Worlds in a Small Room*, as well as the work of Diane Arbus, have all given us important interpretive documentary views. Other examples are Edward Curtis's studies of American Indians, Mathew Brady's Civil War photojournalism, and Leni Riefenstahl's documentation of the Nuba. Alexey Brodovitch speaks of the importance of this aspect of photography:

> The subject matter is important. Arts should reflect the time, events, surroundings. We must be up to date and feel the tempo of life, for all works of art are impressions, conscious or unconscious.

Barbara Schapiro, director of publicity at the International Center of Photography when Peter Beard had his 1977 show there, talks about the impressions it made:

> The show was larger than life—the scale and the full development of the environment with sound, pictures that could be walked through and on, a dead-elephant room where the large blowups were framed in brown burlap and placed on knee-high display modules. Up until that time all the shows had been the same and very conservative. This show had a newspaper, a book, buttons, posters, movies. It was an experience in mixed media, ranging from the diaries that Peter had kept for twenty years, in the downstairs gallery, where the movies were also screened, to large boxes of mementos, memorabilia, stuffed animals, to natural foliage from Africa. It was the first time that a museum of that size, specializing in photography, had ever given over its entire space to one man for a show of this type. The critical reaction was sensational—Bob Hughes of *Time* magazine, Hilton Kramer of the New York *Times*, and Owen Edwards from *Saturday Review* seemed to legitimize the show. It attracted so much attention that TV stations, radio, and newspaper interviews made it into a media blitz. Peter's "The End of the Game" had the largest audience to that date at the Interna-

tional Center of Photography. It seemed to appeal to the more general and broader museum-going audience—the regular patrons of the Museum of Modern Art and the American Museum of Natural History. It also attracted people who are usually intimidated by photography shows. We received huge quantities of letters that showed just how strong the impact had been.

Peter relates how he conceived the show:

> The ICP show was not meant to be commercial—it was just like a collection of different little messes. I liked it, don't worry. I didn't think it was art, I just thought it was a show that represented a certain amount of experience, twenty years in Africa, diaries and documentations. It was like exploring, and I mean that figuratively as well as literally, trying to find a niche for oneself.
>
> A recent "earth" show at the Victoria and Albert Museum in London exhibited photographs taken from weather balloons, bomber planes, ranger towers, by scientists, weather experts, air force personnel, researchers, oceanographers, astronauts, etc. This was hardly "art photography." It was so much better—more direct, honest, purposeful, technical, yet magical—a series of snapshots of a volcano taken by a local native would be hard to beat.

By developing your area of interest, you can begin to refine the content of your photos. But you also need general experience. For a beginner, any experience in any area of photography is going to be better than simply carrying your portfolio from one magazine to the next. Even if it's printing in a darkroom or photographing confirmations, graduations, and weddings, all that is contributing to your education. Phil Perkis of Pratt comments:

> When they get out of school at twenty-one, twenty-two, they really don't know what to do. I tell them to work in photography in any way so that they are continually working in the field. When I check back with them they have figured out what they are interested in and are meeting people. They end up doing what they want.

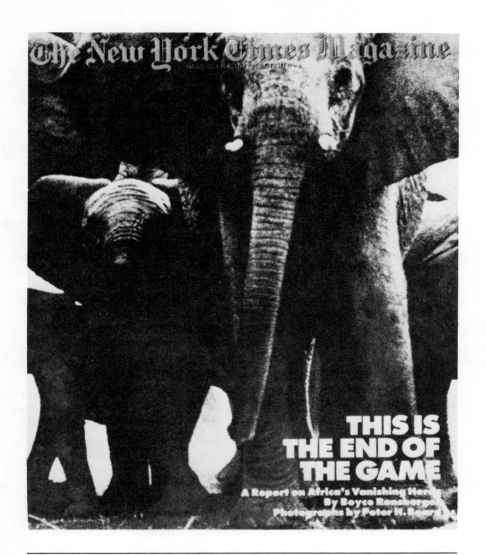

Peter Beard's abiding interest in the diminishing elephant population of East Africa led him to record the virtual extinction of these animals in that area. This in turn created the basis of his photography career. Above is Peter Beard's cover story photograph from the New York Times Magazine, 1977.

The practical place to start is with your own interests. You will have a natural familiarity with your own subject, whether it be sports, fashion, wildlife, or architecture; you probably know many of the people active in your area of interest; and you already have a genuine involvement in it. These are three prerequisites you will need in any field you enter. There are many photographers who have developed highly successful careers from specific interests: Herbert Migdoll and Martha Swope in dance; Kate Simon and Lynn Goldsmith in music; Jill Krementz in photographs of authors, and Andy Warhol in photos of celebrities.

Horst, one of the masters of twentieth-century photography, began his career studying in the Bauhaus and surrealist movements:

I grew up in Weimar, Germany. As a child I started to know the people of Bauhaus, and naturally I was influenced. I studied under the architect Walter Gropius and in 1930 left Germany for good, becoming an assistant at American *Vogue* for Dr. M. F. Agha, then art director for Condé Nast publications. However, I never had fashion as an ambition. Actually, I knew nothing about it. My goal had been to learn everything about art and the artists who made it. I studied with two of the greatest architects of the twentieth century, Gropius and Le Corbusier, and from them I got an eye for structural forms, which I later used in French *Vogue*. I had a fascination as a novice photographer with what made classical art work. I went to the Louvre, I went all over to find out why an Ingres drawing is so good: the proportion, the movement. I incorporated into my photography the unadorned planes of face and body and the sinuous modeling of sculpture. From surrealism—I was a friend of Man Ray and Cocteau—I borrowed the enigmatic mood, created by shadows, and a mysterious focus on details that is in all my work.

From his interest in American artists of the 1950s, Hans Namuth, through friendships with Jackson Pollock, Willem de Kooning, Robert Rauschenberg, and others, established a second reputation as a portrait photographer whose work is an important document of a great period in American painting and sculpture, which led to work on documentaries such as the classic film collaboration with Jackson Pollock.

I had always been interested in photographing artists. I met Jackson Pollock and worked on a variety of projects with him; the pictures were eventually made into two books. I also made two films of him, a collaboration between two friends. Through Pollock I met many others, including Barnett Newman and Clyfford Still. In 1957 George Staempfli, then working for the State Department, was looking for somebody to document seventeen artists for the World's Fair in Brussels. He assigned me to photograph them. Ad Reinhardt, Robert Motherwell, and Richard Diebenkorn were among them.

It is not always easy to establish a rapport with people you confront with a camera. Clyfford Still, for instance, was very difficult at first, but one must learn to deal with the hostility of someone who doesn't want to be photographed. I noticed that he had turned all his canvases toward the wall, so there was a problem photographing him with his work. Fortunately, I was with Barnett Newman. He asked Still to please turn the paintings around for me, which he finally did—begrudgingly. It so happened that there was something wrong with the shutter of my camera, an old Primar Reflex; the lower part of the image remained in total darkness. The resulting portrait looked as if a flame were bursting out of darkness; this flame relates very much to all his work. The whole thing had happened quite by accident. Photographing Saul Steinberg was equally difficult. The sessions with him reminded me of the Indians in Guatemala who think when you take their picture you are capturing their souls. But he needed a photograph for a book jacket. After fifteen minutes, which is just about the time it takes me to warm up, he said he just couldn't stand it any longer. I was upset and left. In my favorite picture of him he is holding a toy pistol, aimed at the viewer like a real gun, perhaps in imitation of me photographing him. When I'm taking portraits of artists or anyone else, for that mat-

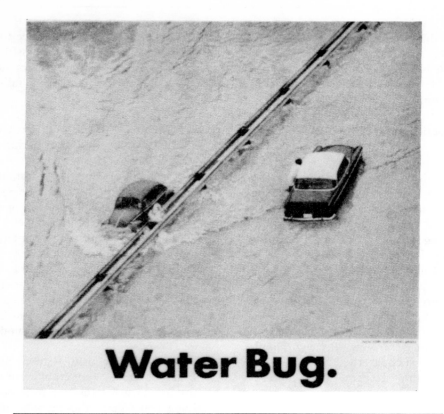

Water Bug.

In David Kennerly's autobiography Shooter, *he says that at the age of eleven all he wanted to do was watch fires. After seeing a local news photographer at the scene of a fire, he picked up a camera and his career began. Above, a* Daily News *photograph (not by Mr. Kennerly) of a flooded highway that was later featured as the illustration for a Volkswagen of America ad.*

ter, I try to catch a revealing quality in that person.

As Arnold Newman pointed out, most of the classic American photographers actually worked outside the main commercial areas. Since photography is to a large extent subject matter, you have a better chance of producing original work simply by concentrating on subjects not available to the majority of photographers who live in large urban areas. This is especially true if you want to concentrate on getting your pictures exhibited or getting your work published. A brief look at photography magazines, *Life, National Geographic,* or even *People,* where a good half of the stories originate from local

human-interest stories, will convince you that your best subjects can be right at hand.

MAKING CONNECTIONS

Another excellent route that beginning photographers should take advantage of is to take a course with an acknowledged expert in the field you are interested in, whether this be a well-known photographer, an art director, or an established gallery director. Not only will you acquire useful and informative experience, you are likely to get excellent advice on what you can do with your specific talent. Many of the best

photographers working today got their first chance from this student/teacher relationship. Good teachers are always interested in new talent and will be far more encouraging in the context of a class than they will ever be in a business situation.

Such an association can lead to excellent contacts. The experience of Hans Namuth is again instructive:

I had a great deal of trouble trying to make a living when I first arrived in the U.S. in 1941. I came over as a refugee and, for a while, worked for a group of chemical engineers trying to invent a waterproofing substance for kraft paper. When the company went bankrupt I started to go back into photography and took a course with Alexey Brodovitch. He was a legendary art director and teacher at the New School for Social Research. Subsequently, I began photographing for *Harper's Bazaar*, simple things at first, such as the "Shopping Bazaar," a monthly feature with postage-stamp-size photos.

Seek out the photographers you most admire. Nearly every major photographer or art director teaches a course. Find out where these courses are being held and what requirements are needed for them—usually a sample of your work or an interview.

Another way of meeting people who work in your field is simply to contact them directly, as Ruth Ansel mentioned. However busy photographers are, they will always be receptive to someone interested in their work. Making contact by phone is probably not the best way to go about this. Write a letter, communicate your admiration for their work, tell them you would like to meet with them briefly and ask their advice. Preferably include some examples of your work. If you don't get a reply, call up and refer to your letter. It is surprising how many photographers have made their first contact this way. In any creative area, enthusiasm is irresistible, and most established photographers are not only flattered to be recognized and complimented on their contributions, they are pleased to be helpful to beginners seeking them out. The worst that can happen is that they will put you off. If you don't even make the effort to approach

them, you are not giving yourself a chance, and you are not giving them a chance to help you.

Kourken Pakchanian, a successful fashion and advertising photographer, relates how he went about planning his career in fashion photography:

When I first started I only went by inspiration and by looking at American *Bazaar*. I thought that if I could work for *Bazaar* I could consider myself a fashion photographer. A lot of work was being done, but I didn't have a specific idea in mind of what I wanted women to look like. I did know that I didn't want to be contaminated by other photographers' styles at the beginning stage. I could recognize who I liked in the magazine, and they were fascinating, creative, innovative, and challenging. But I felt I had to do it the hard way and find out my own style, without knowing models, agents, or clients.

Before I got into fashion photography I did portraits, and architecture, which is my love. I was interested in photoreportage, but when I made the decision to be a commercial photographer I didn't know anything about Madison Avenue. That was a big challenge. I decided I needed a studio to start testing and an agent to represent my work. That's how I started—by testing every night I could. Testing and printing, making blowups, making the rounds, seeing people and getting recommendations, following through and getting other people's reactions.

I remember about three months after I started I had the chance to meet Irving Penn. Somebody asked me if I'd like to meet him, and I said I'd love to. I met him, he looked at my work and asked me why I had decided to go into fashion photography. I said of all the commercial aspects of photography, I wanted to do fashion because it is the most creative way to photograph, plus I had worked in portraits and I like photographing women. He said he didn't think that I was quite clear in my mind about fashion photography and that I had a lot of experimenting and research to do. I asked him if I could come back and show him my work periodically. He said

not before a year because I needed a year just to clear my mind. I asked him what his outlook on fashion photography was and what it represented to him. He said that all he could say was he thought the models were just accessories to the fashion. For me, the model was more important than the clothes. It was good meeting him. It confirmed what I had to do, and then it was back to testing, meeting people, etc.

My first fashion job was for Vogue Patterns. It was a whole thirty-page book. I had had nothing published. The editor saw my work, loved it, and said that the job was open. She also said many others were up for the assignment, and she asked me if I would bring a model and shoot a roll or two in the park, in front of an art director. At that time I didn't think about ego. I just put it in my pocket. It was an opportunity and I took it. I realized later that since I had no printed matter someone might have thought that I could have just found a portfolio on the street and bluffed my way in. So I shot two rolls, and when the art director saw the prints the next day, I had the assignment.

Other Connections: From the Business Itself

Any part of the business is a good place to make contacts. Many photographers started out as art directors or fashion editors who felt they could shoot the pictures they were assigning better than the people they gave the assignments to. For instance, Art Kane was Alexey Brodovitch's assistant at *Harper's Bazaar* and went on to art-direct *Viva* and *Seventeen* magazines before becoming a photographer. Henry Wolf also worked at *Bazaar* before moving into photography. He continues to wear two hats, working as both a designer and a photographer, sometimes on the same project, such as Saks Fifth Avenue's "Portfolio" catalog. But the most dramatic example is Bert Stern, possibly one of the most influential among advertising photographers. Starting as a mailroom clerk at *Look* in the early 1950s, he learned about design from Hershel Bramson, who was art director of *Look's* promotion department, and went on to

shoot his own pictures, revolutionizing advertising photography by creating the first conceptual ads.

Expertise in the field of graphic art is applicable to photography, as Jean Pagliuso, a gifted photographer, explains:

Once in New York, I got a job with Vogue Patterns as an assistant art director, and I thought eventually I would be able to illustrate. But it really didn't matter because I was very interested in layout too. Eventually this led to doing layouts for Vogue Patterns for the United Kingdom edition, and they gave me all that to do. They brought the material over from England, and I would just sit back and work on layouts. At that point I had to use pickup photography, that is, I had to use the European photography they did for the collections and reposition it and lay out a new form for it.

Then I decided I wanted to work for *Mademoiselle*. I went there and they said nothing had opened up in six years, but by a fluke something opened up two weeks later, and I started working there. I was doing the same thing, but I was working directly with photographers. *Mademoiselle* was good because you handle everything first. It's a great way to work.

I started working with people who were into the geometric form of girls in Sassoon haircuts and go-go boots. There were three main photographers that I worked with, and I just kept looking at their work. You get millions of stats and blowups for layout so you can see how it will look on the page. You can cut them any way you like. You turn in three or four layouts, and somebody will say what they like best. In a way it's like photographing without a camera. You look at the object and you change it to the way you want. I also liked the way the stats looked, more than the photographs, because they abstract everything.

I left *Mademoiselle* after a couple of months, mainly because there wasn't enough work, and opened a dress store in California. Then I went to Mexico after a couple of years and borrowed someone's camera and I kept taking pictures. I came back to Los Angeles and enrolled in a photography course for $2.50 at L.A. Technical College.

Henry Wolf's dramatic grouping of pencils is the product of many years of working in graphic design. He was initially well known as an art director for Harper's Bazaar *and* Esquire *before focusing his attentions behind the camera. The above poster for Cornell University demonstrates his application of design to photography.*

AVENUE

DECEMBER-JANUARY, 1979 / TWO DOLLARS

In this Ernst Haas photograph of New York's Rockefeller Center, we see skaters on the ice in front of the annual Christmas tree. Taken for Avenue *magazine and designed by Bob Ciano, the picture was shot from above to capture the spirit of New York while maintaining a cohesive form.*

I kept doing all my Mexico pictures, and they said I had to do the assigned work. They wanted you to do all these formulas— still lifes, portraits, Rembrandt lighting. Actually I should have listened to them.

After that I went to Nina Blanchard's modeling agency to do tests for models. This was about 1968–69. I don't even remember wanting to be a fashion photographer, it was just all I knew. Blanchard gave me this girl to work with. We did a lot of photos, and she put them in her book. I was then working as an interior decorator and designer of office spaces. It was a funny transition. I just started getting calls from art directors saying they had seen my work and wanted to see my portfolio. Well, I didn't have a portfolio, but I got one together. After starting at $150 a week, I was offered $750 to work for Catalina sportswear and places like that. It's not a great way to start because I was just plodding along, not really knowing what I was doing. You can do that in California because there's no competition.

Deborah Turbeville worked for Claire McCardell, one of America's foremost sportswear designers, as a mannequin before moving on to magazines. Her first job was as an assistant fashion editor, which led her to a position as the special features editor at *Harper's Bazaar*. Then on to *Mademoiselle* as the photography editor, where she worked closely with such inspiring photographers as Guy Bourdin, Gusta Petersen, and Bob Richardson. She was *Mademoiselle*'s photographic correspondent in Paris, where she first photographed for *Dépêche Mode* and *Nova* in Paris and London respectively. On returning to New York she worked as a free-lance photographer for *Mademoiselle*, *Men's Wear*, and fashion clients like Betsey Johnson and Charles Jourdan before doing an extensive magazine campaign for Saks Fifth Avenue's fiftieth anniversary. The success of the campaign contributed to her start as a photographer for *Vogue*.

Experience in some area of your specialty, outside of photography, is good training and gives you an idea of what to expect. Tamarra Schneider, art director of *Seventeen* magazine, explains:

I've known some professional photographers who came to the profession in unusual ways. One was an art director, some female photographers were fashion editors, and one I knew was a beauty assistant. You can't know all the ins and outs and nuances of fashion and beauty photography if you don't work for another photographer or work in some other aspect of the business itself. It is important to get a feeling of what is going on outside of school because you are in such a vacuum; school has no relationship to the business at all. If you come out of art school, you can't know what jobs are available unless your teachers have been experienced in the field. I have often thought of proposing a course on how to prepare yourself and the kinds of experiences you will encounter when you get out of school. But so much of it is intangible. It is important to develop some kind of eye, to see what looks good in clothes, but there are extremes. Some people I've worked with think their job includes being a fashion editor. It doesn't. But a good photographer should be able to deal with details that are being seen through the lens, like makeup. You are not shooting statues, you are photographing a woman wearing clothes, and every part of her must look right or else your photograph is not going to work. When all else fails, you as a photographer must be able to know what's wrong and what it takes to fix it.

Ara Gallant, a leading fashion photographer, learned his impeccable sense of fashion by working as a stylist:

I began working as a hair stylist for photographers. I also did cosmetics, designed jewelry, anything that went into setting up a commercial photograph. I did everything really except click the shutter. I was lucky to have the photographic training I got. There are very few people on the planet who have had the opportunity of working as closely as I did with every gifted photographer there is, and you have to believe me when I say *everybody*.

Whatever you finally decide to specialize in, experience in many other areas of photography can only help you. Also, it is an illusion that a photographer does only one thing. Most of those who have succeeded, as Arnold Newman points out, have done so because they could be good in any area.

What is so exciting about commercial photography is that there are many fields—advertising, industrial, lots of others. I happen to have a foot in almost everything. For me it is satisfying to do annual reports and work directly with corporations. There are almost no creative photographers who can earn a living selling photographs to galleries. Only two or three can. Either photographers teach, or they do industrial work or photojournalism, which is bouncing back. If students could understand that, they could choose an area where they could be comfortable. The areas are expanding, and photography is being used more and more in many different ways. The greatest danger is getting swept up in the romantic bull about photography. Novices are not aware of the hard work involved.

In the field of professional photography it is not just one road that leads to Rome; all roads lead to Rome.

ADVICE TO THE OUT-OF-TOWNER

Arnold Newman:

I think novices should stay at home and open a studio and promote their work in places other than New York City. In your hometown you may be the best around. I gave this advice to someone. He returned to Pennsylvania and is very successful and is probably making more money than I am. He takes great pride in what he is doing. In New York he would have been lost. If I had to do it all over again, I might live in a small town and come to New York later. I don't advocate this advice for everybody . . . but it's amazing how many advertising agencies in Denver have money. I've worked with

them. I had a fellow working with me who got an offer in Dallas. He bought into the firm and is now the sole owner and very big in the Dallas area. It would be a huge operation even in New York. The creative photographers, like Ansel Adams, show in New York, but their life and work are based outside of it.

Jean Pagliuso on starting out at the bottom:

They were small companies, but by the time I got to New York, I already had work published there through these companies. I never could have done anything here as a beginner. They would have been too hard on me. How many art directors do you know who can afford the risk of jeopardizing their jobs in order to hire an inexperienced person? I do think you have to start outside of the big time.

There are tens of thousands of photographers in New York right now who are trying to do the exact same thing that you want to do. When you come to New York from a smaller market you have to have all your guns loaded. Arriving in New York cold, you probably won't even have a chance to get your gun cocked. In a market like Boston there are much better opportunities to assemble an impressive portfolio without being under pressure. Besides, the types of assignment you are likely to get in Boston if you are good are going to be a lot more prestigious than the work you will get as a novice in New York.

Before coming to New York, get ten to twenty tear sheets of the kind of work you want to do. It is essential to have good samples before you make a move. It is much easier to get quality assignments in a local area first, and if you arrive in New York with quality work you will be one step ahead. Every time you go up for an ad in New York, the competition is ten times greater than in a local market. You are also going to be putting your work up against the best there is: Hiro, Bourdin, Penn, among others.

In two years you can assemble, in your local area at your own pace, the same portfolio it would take five years to put together in New

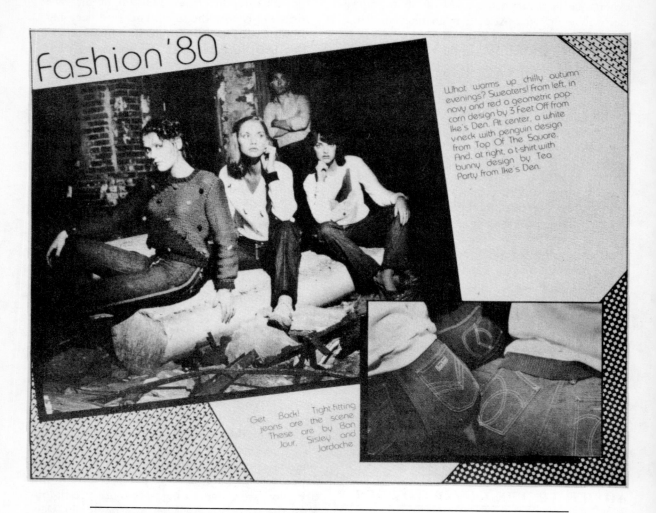

fashion '80

What warms up chilly autumn evenings? Sweaters! From left, in navy and red a geometric popcorn design by 3 Feet Off from Ike's Den. At center, a white v-neck with penguin design from Top Of The Square. And, at right, a t-shirt with bunny design by Tea Party from Ike's Den.

Get Back! Tight-fitting jeans are the scene. These are by Bon Jour, Sisley and Jordache.

Here is a perfect example of a photographer creating his own marketplace. I advised David Melhado, who was then working in the Boston area, to explore the possibilities there before tackling New York. Above is one innovative idea: the cover from a series of fashion layouts for a local newspaper featuring David's work in Worcester, Massachusetts.

York. If you come to New York without a strong portfolio and reputation, you will probably have to do catalog work. You won't be able to do the creative shots that might take you to the next level, so you'll find yourself in just another version of a rut.

There are prestigious department store catalogs, brochures, mailers, inserts, circulars. This area is becoming more editorial, but, again, in the very best catalogs you are competing with the best.

There are, however, disadvantages to working in a local area. The market is limited, not sophisticated, thereby restricting your expression. And the market is often product-oriented and heavily industrial. It may be difficult to find choice high-fashion assignments in a local area, and by local area I mean a medium-sized city or even larger ones such as Atlanta, Boston, Minneapolis, Denver, or Seattle. Smaller cities will naturally offer even fewer opportunities for good fashion and advertising assignments. Even in the larger cities, you could be hampered by a small selection of styles, for instance, in shoes, clothing, or accessories. Many local assignments will in fact resemble direct-to-the-client shootings where the client (advertiser, store, or magazine) will choose the model, the background, the accessory, and even the lighting, often to show every detail at the expense of the photograph. Shooting a shoe under these circumstances may not be very rewarding, challenging, or different from shooting a computer component, but since New York and Paris are the major fashion centers there will not be as many assignments elsewhere. The majority of available assignments in local areas will be for trade ads or pictures used by salesmen in place of samples. In these photographs the client usually wants the pictures lit so that you can see all the teeth on a gear, for instance. Not a very inspiring challenge, but don't abandon hope. There is a solution—or a few solutions.

Exploit all the resources and markets in your local area. A simple and immediate way to make a start is by approaching local merchants and department stores with ideas for point-of-purchase ads, for which tests can be shot. If you are in a metropolitan area like Boston, explore the ad

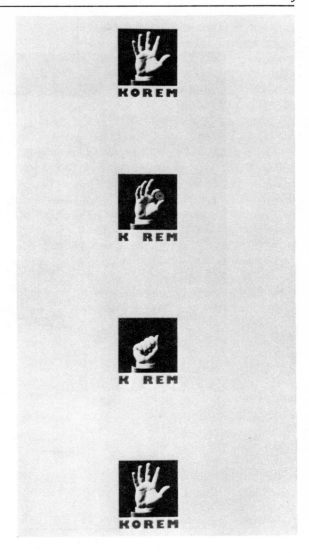

David Edmonson devised this eye-catching visual sequence for a magician's letterhead. This is yet another way that photography can be used in an unexpected form. Without moving from his locale, Edmonson found a way to incorporate his pictures with the Richards Design Group in Dallas, Texas.

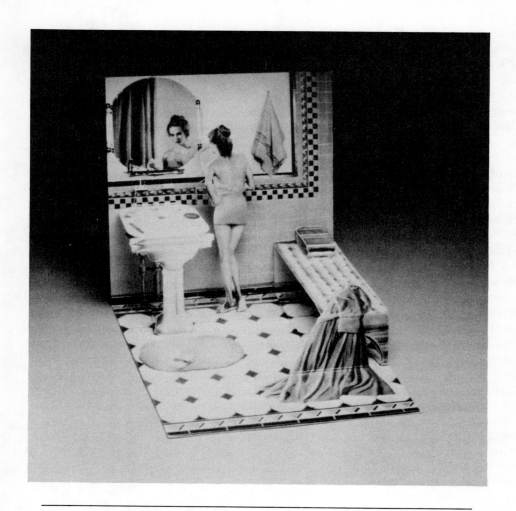

Richard Shaefer and Paul Zalon came up with an imaginative solution to creating assignments for themselves. The above is a greeting card that folds out and pops up. It is created from many different photographs and is actually a collage.

agencies in the outlying areas. As a Boston photographer you will have some clout with them. They will probably also allow you more flexibility. In addition, you will build up your own clientele.

Come up with an innovative idea for a newspaper, flyer, magazine, or your own column about fashion news and merchandise that is available locally. Think up a catchy title for your column. Photograph local celebrities wearing merchandise; these photos could be sold to the local paper's style page or used in a department store flyer, a country club newsletter, or for a religious institution. Come up with an idea for publicity for local stores; a seasonal newspaper for a large department store, local industry, or beauty center; a flyer using editorial techniques, which is advertising and publicity disguised as a magazine (for example, Christmas magazines or sales magazines). A small brochure or newspaper is simple to put together, cheap to print, and less expensive for the clients than local advertising, while, because you are publisher, advertising agent, art director, and photographer, you have an opportunity to create and display your best pictures. Although this may seem like a lot of effort, it will create more work for you in the future because you are acquiring clients, you are creating an excellent showcase for your work, and you have control over style, presentation, and the final product. This is a microcosm of what you will have to do for your own promotional mailings in New York or any other center of photography.

Find out from a local printer the cost of 5,000 to 10,000 copies of a 16- or 32-page newspaper or a small, coated-paper color brochure. Go to local merchants for ad assignments, perhaps specializing in, say, shoes, back-to-school clothes, food markets, or liquor stores. You can key the publication to local news items, personality profiles, television shows, a local fair, tourist handouts, a shopping guide, and so on.

When shooting, always use the best stylist and the best models you can find. Take the garments or products to the closest area where there is a good selection of models and stylists. Take the best assignments available in your local area, even if the remuneration is not great. Even if you make only several hundred dollars or less on the shooting, it will be worth it if you get good-quality tear sheets for your portfolio. Choice assignments and testing are the way to build a great portfolio.

If fashion work is scarce, start with shoes and accessories. Bert Stern, Hiro, and many others broke into fashion through photographing shoes. You can exercise your fashion sense by shooting shoes and accessories that allow you some latitude, rather than shooting second-rate fashion assignments where your input is limited. To make it in New York, you have to be obsessed with your style and with the look you want to create.

2

THE TRADITIONAL APPROACH

Working as an Assistant

The system of photographer and assistant is similar to the medieval guild system—a master of his craft and his apprentices. It has its own genealogy, practices, and prospects. As in any profession, you start at the bottom in order to gain the perspective that school does not—and need not—give you. Theoretically your school has provided the fundamental technical experience, and you have begun to refine your interests. Learning how to apply what you have learned to a business setting is the reason for working as an assistant. It is also the point at which you begin to explore your interests more intensively. You are providing assistance to a master who is simultaneously passing his experience on to you. Once you have absorbed all that he can contribute to your understanding, you should acknowledge that and move on, either to another photographer or to begin your own business. The relationship between a master

photographer and his assistant can be quiet. Richard Avedon remembers in *Camera* magazine when Hiro became his assistant and the relationship that followed:

> He came to New York, to my studio, a silent, honest man, became the most meticulous assistant I had ever experienced, and soon began to create his first photographs. The mystery, the alchemy, the discipline of what makes a fine photographer had begun in him. Hiro and I rarely speak, although we have shared the same walls for nine years; being photographers we have watched each other.

While serving as an assistant to an established photographer is not without its drawbacks, working day by day beside a seasoned professional offers tremendous advantages, many of

which are essential to functioning in the business but have little to do with the technique or aesthetics of photography.

With each new stage in your career, whatever your previous experience, technical virtuosity, or creative qualities, you will be starting from scratch. But as Ted Wachs, an experienced photographer's assistant, points out, your technical background will have provided you with a basic photographic vocabulary with which you can function in the studio:

> The first year in school I only studied black and white, 4×5 large-format camera photography—the function of that kind of camera, the swings, the tilts, how you can distort or correct for distortion. I learned how film responds to varying amounts of light and amounts of development, temperature, grades of contrast, and how to print properly. The assignments ranged from people to architectural and industrial subjects. I was in the illustration department, which is basically advertising. We had a teacher tell us on the first day of class that when we graduated from school we would finally reach point zero. When I got to New York I found out he was right. But what school did give me was that when I walked into any studio in New York and was told to do something, I knew what to do—how to process film properly, how to make a good print—and I could do the types of developing or printing they wanted. So I was working pretty regularly within a month. I was making $35 a day to start out.

Phil Perkis of Pratt Institute advises one to work as an assistant:

> I am convinced that this is the best training possible. I did it for four or five years, and so did most of my friends. You learn and make a living at the same time. You get the perspective and the business. You develop a portfolio. When you get out of school you don't have a commercial portfolio, you have a fine arts portfolio. Some are excellent, but you can't walk into an agency with it.

How to Get a Job as an Assistant

You are unlikely to be hired the first week you start looking for an assistant's post. If you come to a major city like New York, you should plan on having a substantial amount of money to live on so you don't have to take a job just because you need it. Make up a list of who you want to work for and start seeing these people—and be persistent. Don't get in their hair, but you want them to know that you are there to work. When you go see them you should look presentable. Most important of all, don't get discouraged, because you'll get put off by people time and time again.

A portfolio containing work that shows you are technically proficient at developing and especially at printing is a good idea, but it's not essential. Bear in mind when selecting prints that while photographers may be interested in your own work, they are much more interested in how you can help them.

Pat Luciano, a full-time assistant, recalls his earliest experience in the business:

> The first job I had as an assistant was in a catalog house. I came out of photography school, and I had a portfolio. I never showed it to a photographer to get a job. You don't have to have a portfolio to get a job as an assistant. I looked at what kind of work was going on, and I looked at my portfolio and was embarrassed. So I decided not to show it at interviews. I was sort of chagrined when I thought about the time and money I had spent going to photography school. But it's almost necessary to do, if only for technical reasons.

Mike O'Neill, one of the top still-life advertising photographers, explains that your ability to perform in a studio situation is the determining factor in getting hired. He told me that he did not even have a portfolio. He had already created a track record and needed to get a job as a full-time assistant. "By doing free-lance assisting with other people I got to the level of going for an interview with Avedon's studio manager. I found out that Hiro was looking for a studio manager and we talked." Hiro hired Mike free-lance for a few days and then gave him the job.

Having accepted the job with Hiro, two weeks later he had to turn down Penn because he had committed himself to Hiro for at least a year or two.

Since many studios now send films to labs for processing and use professional printers, your technical skills are not always the most important criterion in getting hired. Photographers are often looking for an assistant whom they feel would be compatible to work with.

Pat Luciano continues:

I met Bert [Stern] through a friend. I walked into a shoot and told him he was my idol. Bert knows exactly what to do. The best thing I can do is to take some of the pressure away from him so he doesn't have to worry about the lights, the exposure, the props, etc. Your job as an assistant is to take care of everything but the picture itself. The only thing the photographer should have to do is take the picture. You bring the shooting to a point where he makes the final decision. When you are ready to leave photography school, the first thing to do is to look at the school bulletin board. I looked up catalog houses in the Yellow Pages because I figured there would be a bigger market and more demand there. You go to some place for the interview, your name gets filed, and if you make some kind of impression you will get a position.

Often in looking for a job as an assistant the most important thing is your compatibility with the photographer. If he thinks he can work with you easily and that you're not the kind of person who's going to cause him a lot of problems, he'll consider you. He's hiring you to take some of the weight off of him. You've got to remember that although assisting may be a great education, that's not a photographer's primary concern when hiring. In most cases the photographer doesn't even ask to see your portfolio. He isn't hiring you as a photographer. He wants someone, most of all, who is less temperamental than he is, who will not overreact to situations. If the photographer you are working with screams at you in the middle of a shooting, you know he's trying to teach you something. Whatever you are told to do, you do it the best you can.

Aside from learning the nuts and bolts of professional photography, you should be seeking a challenge from the photographer for whom you work. Your first choices should be photographers you admire. Make a list of preferred people to see, and write to them with your résumé and qualifications. There are many excellent directories of photographers, such as the *Madison Avenue Handbook*, *Black Book*, American Society of Magazine Photographers (ASMP), and *American Showcase* in New York. Ted Wachs tells how he got his first job:

I just started calling. I got a lot of rejections, but you have to keep calling back. You finally happen to be in the neighborhood and stop in, which is what I did; they get a chance to see you. Photographers are too busy to talk over the phone. I had a friend who moved from California to New York. Two days before he got here he sent résumés, so that the day he arrived he started calling all these people, and since they had just received his résumé they remembered his name. It's promotion—you have to promote yourself. I had one contact in New York, a friend from school who was working for Mike O'Neill. I called the studio and was invited in and I showed my pictures. That's how I got my first job. Then I worked for Bert Glenn for two weeks, and then I was made Mike O'Neill's permanent assistant.

Assistants are always needed in the catalog houses, where there is a large turnover and almost always some work available. Pat Luciano amplifies:

I got a job in a catalog house because somebody said it was listed in the paper. I called up, and they said they needed an assistant. But generally you have to go out and look. I took the industry source books and went through the magazines and wrote down names of photographers who were being published more and more. The catalog places are probably the best places to start, though. It's a business where you are not getting paid much. Your responsibilities are not that great either. The place where I worked had four or five photographers

doing different shooting sections. It's almost like a factory, but the constant exposure to what's going on and being with the photographer are very educational. Fortunately, the person I worked with was a really great guy. I spent eight hours a day with him, and that's a long time.

Function of an Assistant

Many photographers have only one assistant, but the larger studios generally have more. If you are the only assistant your function is to help with everything from booking models on the phone to "spec-ing" (specification and research of) locations, securing props, building sets, and schlepping equipment—which even models do. "On trips or locations, you all have to pitch in and carry things," says Cheryl Tiegs. "Even the photographer has to schlepp, but that is what is expected. Everyone plays an equal part in making the sitting come out." Of course, the assistant also assists with the shooting itself, acts as a gofer, takes film to the lab, cleans up, and answers the phone. If you do a lot of production work, you must be a resourceful problem solver —figuring out, say, how and where to get two hundred oil cans. Equipment often has to be especially rented for advertising jobs. The production work is really all-encompassing. Large sets are made by set builders who know exactly what to do. Sometimes an assistant will build simple things like two cabinet doors made of plywood with painted-on knobs. Photographers are constantly improving their studios, putting up walls, adding doors, and installing camera carts, and the assistant helps with it all. No matter what the tasks, weigh the experience in terms of the learning process. Store the knowledge for when you will need to apply it in your own studio.

There are some full-time assistants who do the bookkeeping after a while. But generally there are too many other things that demand your attention, so most photographers try to get a person who does that sort of thing exclusively. Unless you are the only assistant, you are rarely required to attend to things such as lunch.

The hierarchy is that there is a studio manager who is usually the top assistant and works directly with the photographer—takes the photographer's ideas and orders and turns them into action. This person is usually called the first assistant. Then there is a second assistant, or "gofer." You work your way up.

Ted Wachs continues on the printing tasks:

The assistant does a lot of darkroom work. I now have my own darkroom and I can take things home. You can make good money doing it when you work full time for somebody because they ask you to do a lot of printing. I process the film, sometimes I do a clip test, make sure the exposure is right, make contact sheets, sometimes proof prints. Some art directors can't see a small picture, so you have to give them a big one before the final print. Still-life photographers usually have their own labs in their studios and their own assistants to process the film, black and white, because their volume is great enough.

Now I've become good enough so that I can make a final print out of three sheets of paper where before I was using eight or ten sheets to get a print. You just know what's going on well enough to make a little test, and by looking at it you know the contrast and exposure. You make another test, and by then you just know. That's for a commercial print. For portfolio prints you have to take more care in order for them to be perfect. If the prints are not going to be reproduced, you concentrate on the detail and texture that would be lost in a newspaper.

My function as a free-lance assistant is to be there just in case anything goes wrong. Or to set up and do all the preparation for the shooting of the picture. There are times everything is done and the photographer will walk in at the last minute. The composition, lens, angle of the camera, lights are set, and all the photographer has to do is take the picture. That doesn't happen too often.

In the specialized field of underwater photography, an assistant sometimes has a crucial function, as Peter Gimbel explains:

Photographers usually dive with a partner. However, when you dive for the purpose

of taking pictures it is advisable to have a diver with you who understands what you are trying to accomplish. Shortly after I began to take underwater photographs I went to Montauk to take pictures at Cox's Ledge, a moraine just off the coast of Long Island deposited by a glacier thousands of years ago. The colossal boulders and clear water make for a dramatic underwater location. The area is a favorite fishing ground for boats out of Montauk. During the photography session I got hooked by a fisherman angling from a boat 130 feet above. Inexorably, he began to reel me in! My assistant luckily noticed that I was slowly being lifted toward the surface, and undid the hook from my wet suit.

The most important lesson you can learn as an assistant in a field that deals with such intangibles as mood, client expectations, and market trends is how to work under pressure. Mike O'Neill reiterates:

One of the amazing things about commercial photography is the tension level. It is usually so thick you could cut it. It is something you could never simulate in a school. Nobody could ever be taught what it is like to work under that kind of pressure. How do you instruct a student in the politics of who's really paying the bills and who has the power? All the technical training seems of little consequence compared to attitude, talent, drive, and the ability to assert yourself. I studied psychology in school as well as English and economics. But I learned photography through experience—assisting and managing various studios. I worked for Hiro when he was shooting for *Bazaar*, when Avedon and Hiro were in one studio. My moves were very calculated. You get in the door of your first job, learn everything you can, then move to a different aspect that is more fascinating and powerful.

An assistant's main business is to take some of the weight off the photographer and keep the psychological atmosphere as cool as possible. Here is Mike O'Neill again:

The men I worked for taught me how to

think in a crisis. That is the most important part of your function as an assistant. You are paid the least, and you have quite a bit of responsibility. The atmosphere is very intense, because so much is wasted if a mistake is made. If something happens to the film, say, the whole shooting is blown. When accidents happen they happen royally. I made all the mistakes I ever want to make in my first years as an assistant. You can't keep making mistakes—it is absolutely necessary not to make them twice because there are thousands of people who want jobs as assistants.

The advantage of being an assistant to a number of photographers is that you get to see how various photographers do things, the mistakes they make and how they correct them, how they tackle and solve problems. Get your feet wet and see what is going on. An assistant can build up a reputation for being competent, for having traveled all over the world successfully, and for knowing what needs to be done. Get your foot in the door of photography any way you can. Once you make the switch from assistant to photographer you will have to prove yourself on your own merit and based on the experience you have.

It is part of your function as an assistant to bolster the shooting. You must make it possible for everybody to do their best. Often your job has a lot to do with personal relations and learning to deal with situations tactfully; the ego can play as big a role as the camera. This is the time to get used to photography as a business. You can very easily say the wrong thing and offend somebody. Ted Wachs relates his personal experiences as an assistant and lessons to be learned from them:

A small example of one of the first things I had to do for a photographer was to cast men's hands. He had been using someone who was one of the top hand models in the business for years and years, but the hands were starting to show age. I was told to get someone younger. While I was testing someone I told him we were testing because we wanted someone with younger hands. It turned out he was the best friend of the other model, and when the older man found

out he was very upset. So I learned not to say anything.

Another thing I've learned is that photography is actually 90 percent business and 10 percent art. There are many successful photographers who are not artists, but they can deliver a job. That means as much to many clients as anything else. To deliver a job on time and under a certain amount of money is something I'm still learning day to day—so that I can run my own business.

Having been an assistant, I can't imagine not assisting for the education you get, unless you have a lot of money to set yourself up. The best thing about it is that you get to play studio at someone else's expense. If I screwed up I'd get yelled at, but ultimately the client would blame the photographer. An assistant can learn without losing a client or his reputation.

Working as an assistant is a valuable time in which you are mastering basic skills as well as beginning to experiment in your free time, rounding out your interests and defining your influences. Arnold Newman elaborates:

My job was a blessing in disguise. I had to make forty-nine-cent portraits, but before I was allowed behind the camera I had to know every phase of the darkroom and know the use of every chemical that lined its shelves. A chemical mixture did not merely do something—I had to understand why and how.

I worked for over a year for a commercial chain in Philadelphia, in Baltimore, and for a while in Allentown, Pennsylvania, exploring the cities and photographing on my own as I traveled.

Make the most of your situation to· do as much work on your own as possible. You have access to a fully equipped studio and to models who, like you, may be starting out in the business and need good photographs for their portfolios.

Testing professional models under the simulated conditions of an actual assignment is a valuable experience with practical results. It is also key in putting together a strong portfolio. You can afford to test two or three days a week and build up an impressive portfolio.

Rookie models who have signed with agencies are anxious to do pictures. That is the way they get their experience and build up their portfolios. If an agency happens to see your pictures and likes them, it will send you more experienced models to work with. One of the biggest problems for a beginner is often not finding the model but finding good hair and makeup people. If styling and beauty are not good, the photograph is not likely to look good. If a model is really professional, she can usually do her hair and makeup herself.

Most of the first commercial work you will get will be a by-product of working for a photographer: catalog shots, shopping columns, head shots. You should avoid including such pictures in your portfolio unless they are of exceptional quality. They show your novice standing, and art directors generally do not consider assistants serious candidates for major assignments.

Bev Don, an art buyer at Young & Rubicam, confirms this:

I don't need to see novices' tear sheets. If their chromes look good, I don't need to see catalog shots. It does take a lot of perseverance to get your foot in the door. A good rep is important. I assume that the person is coming from a very good studio. I would say that you have to apprentice to somebody. I don't think there's any other way unless you are a genius. Assisting is very classical in nature. When people come in with something they've done on their own, it usually doesn't work.

It is clear that when you test with professional models in good clothes, the results should be indistinguishable from the norms of the business, not look like something you've done on your own.

Sylvia Dudock, an art buyer for Dancer Fitzgerald Sample, concurs:

The good novices come from really big studios and have been assistants to top people, so they're more in line with what is required. Others have no conception of what commercial photography is like and bring

in pretty pictures. I hate to be faced with that. This business is one place you have to pay dues. You can't walk in and expect that you will get work.

Strategy

As valuable as your apprenticeship is, there are serious drawbacks. Unless you are content to be a professional assistant, you will have to be thinking about your next move almost as soon as you have settled into your first job. The main problem is that the symbiotic nature of working with a professional photographer may be as harmful as it is helpful.

As an assistant, you are exposed to the actual working conditions in a professional studio. But in many ways you are still in a protected environment, comparable to that of a student. As an apprentice you have numerous responsibilities, but it is the photographer who has to deal with the realities of the marketplace. Unless you also further your own career while working as an assistant, your experience will not be directed toward your own goals. You must know what you can learn as an assistant, what you *can't* learn, and the right time to leave, as Rob Erdman, an assistant art director for Condé Nast in Europe, makes clear:

It is very important whom you learn from and where you are learning. It is as easy to absorb bad information as it is to absorb good information, and at the beginning it is awfully hard to distinguish between them. You are very impressionable. It all comes down to whom you assist and what art directors you have listened to. When I was in New York my range of responsibilities included lighting, location, checking out the clothes, often constructing the picture. The photographer would ask, "How do I make this more cheerful?" and I'd put white sheets on the ground to reflect light. Or there may have been a question of cropping. I was in a sense involved in the creation of the image itself.

Being an assistant works to your advantage, although it doesn't necessarily make you a good photographer. Generally, the function of a good assistant is to make sure that everything gets accomplished smoothly. It's a very impersonal way of working with photography. The point in good commercial photography is to develop a style. You work with the photographer's style. You generally pick up everything you could possibly learn from one person in the first few months and at the most in five months. However, most assistants end up spending a year or a year and a half as an assistant.

The most important thing in the business is meeting clients, but when you work as an assistant, you're perceived as just that. If you are working for a photographer who is technically efficient by nature of what he or she knows, you're apt to be excluded. I began doing free-lance work on my own. There came a point where I felt that I had learned everything I could possibly learn from the photographers I had assisted. At that point being an assistant was dead. I think it is very important to know at what point you should stop being an assistant.

When people ask me about being an assistant, I always say it is best to work free-lance for a number of professional photographers and don't worry if you're not working for the best. Some say that the best way to develop your own style is to imitate someone else's, and that if you have any creative talent you will naturally evolve from these experiments. I don't believe that. There are things in people's work that you may like, but your own ideas are the most important. In college I majored in art history. I didn't know what I wanted to do, but I was always interested in fashion. So I thought I would be an assistant. The first person I talked to about it was Duane Michals, and he said never be someone's assistant. It's a very bad idea because you learn the photographer's bad habits. You learn more working on your own. If you assist someone who is really good, you can become overwhelmed by their style.

Ted Wachs confirms this. His solution, once he had established a track record as a good assistant and had made enough contacts, was to free-lance as an assistant.

It's dangerous because when you are working with a photographer you can begin aping his style. But if you get away from that influence for six months, you begin to see things your way, although you'll still be influenced. You should leave yourself as flexible as possible. While you are getting yourself established you should try and work for as many people as possible.

Is There Life After Assisting?

When is it time to stop assisting and go out on your own? Mike O'Neill suggests a simple rule of thumb:

When assistants think they can do it better than the photographers they are working for. It is part of the thinking process that goes beyond the terror of going into business for yourself. If you don't have that, you can't do it. It is the key. If the student thinks he can do it as well as the master or better, and disagrees with his attitudes or principles, it's time to leave.

Crucial considerations when setting yourself up are strategy, direction, and overhead. First, a photographer has to learn to distinguish between trends and fads, especially in editorial fashion photography. It is important to be able to know which styles are going to be valid and which will never make it.

Next, to do magazine work, you have to start with tear sheets. Ted Wachs exclaimed: "It's one of those things—which comes first, the chicken or the egg? You can't get a job without the tear sheets, and you can't get the tear sheets without getting an assignment. From having done this over and over again I have come to the conclusion that editorial exposure is the quickest and most efficient way to subsidize yourself."

Setting yourself up as a still-life photographer is considerably more expensive, because you are using an 8×10 view camera, so all film for tests is more expensive to buy and process. The advantage you have in working with still life, however, is that the subject doesn't get up and run away, and when you get the pictures back and you don't like them, reshooting is no problem. Polaroid film has helped alleviate the problem of waiting around before reshooting. It has eliminated the five- or six-hour wait for the pictures to get back from the lab, with you wondering how far the lights and framing were off.

If the traditional approach of going from school to assistant, from assistant to professional, seems like a frustrating series of learning and unlearning processes, remember that sticking with it is always half the battle. The main thing is not to get discouraged. Ted Wachs recalls:

When I was in school I was in the top of my class. It's been four years since I came to New York. It takes that long for you to accumulate the practical information to be able to go out on your own. It took me two years to establish myself as a competent assistant and accumulate enough money to take time off to shoot my own tests and put together a portfolio. Then it was another year before I started to see the pictures I was shooting and know what I was doing. In any kind of professional photography, the mental aspect is really important.

If school didn't give you a perspective on how things are, working as an assistant also creates a distorted picture. You can only know what it's like to work on your own by doing it. Now, after four years of working at it, I think I am better than the average guy and am very encouraged by it. There are not many jobs where you can reach that financial, professional level in three or four years.

The average fashion photographer who is making it is thirty-five or better. It seems to take that long. There are always exceptions. There are many nuances in the fashion world that you have to learn to recognize, so it takes a long time. The only way you can train your eye is to photograph, then look at the photograph, and go back and do it again, until you get to the point when you don't feel the camera between you and your subject. You just know what the photograph is going to look like as you are seeing it.

The European Connection

Even with the contacts you have established as an assistant, you may find that you still cannot survive on the jobs you are getting or that the

jobs you do get are simply not challenging enough. The ideal situation would be to work on a challenging assignment in a sophisticated market where you can upgrade your portfolio, amass an impressive collection of tear sheets, and develop a reputation and the prestige needed to boost your career into its next phase. If this sounds like a fantasy, it isn't. One of the best things you can do when you feel you've reached a certain plateau in the United States and can't go any further is to go and work in Europe for a year or so.

Rob Erdman, after a period in New York as a free-lance assistant, worked for various European magazines, both as an editor and as an art director. He gives excellent reasons for taking the European route, where to go, what your strategy should be, what the advantages and disadvantages are, and what to expect:

I would advise a beginning photographer to go to Europe as an assistant or as a free-lance photographer. You will learn more about fashion in one year in Europe than in five years in New York. Americans are not brought up with fashion; it doesn't have the everyday influence here that it does in Europe, where it is a more dominant part of the society. Also, European magazines are more inclined to hire the new and unknown. As a new photographer, go over and show your work to various European art directors and come back here so you won't get depressed waiting for answers. Do the rounds there, come back to New York, and then return in a month or so and hit them again.

I would advise working for Italian magazines to begin with. Paris is hard to break into, and London has its own strange sense of style. If I were in London, though, I would go to see English *Vogue, Harper's & Queen,* and the London *Sunday Times.* In Paris, the magazines to see are *Elle, Marie-France,* and *Marie-Claire,* which is one of the most advanced of the French magazines right now. In Italy, see *Grazia* and *Lei,* which are equivalent to *Glamour* and *Mademoiselle* here. There are also *Vogue* and *L'Uomo Vogue* in Rome. In fact, Italy has twelve monthly fashion publications and numerous weekly publications, and they are equal to or better than their United States counterparts. Even if you go over there and are not working on the top magazines, at least you'll be working.

In Germany there is no fashion really, but there is a lot of money. If you want to work for a German magazine, you have to set yourself up in Paris and they will come to you. Germany is expensive, fashion is terrible, and makeup is horrible—but you get paid well. You won't get much material as far as tear sheets go, but you will come away with money to finance your stay in Europe. Europe, especially Italy, pays very little compared to United States rates. So you really just break even.

European magazines are the best-looking in the world. If you get your pictures in them, there is not only the prestige of being in the magazine: when you pull that tear sheet out, it can be one of the best tear sheets you've got.

To sum up, here are a few pieces of good advice from some established art directors.

Alan Septoff, creative director of CBS Records, counsels:

My advice to a novice is that it is important for a young photographer to get tear sheets, like a young designer getting printed pieces. So if and when the opportunity arises, although you may not make much money or may just break even, do the piece. It's very important, because people have this idea that you make a lot of money in photography, but they want to see that return right away. The expectations seem so astronomical because of the amounts of money you hear of people making—$2,000, $3,000, $4,000 a day.

Frazier Purdy, a vice-president of Young & Rubicam, says:

A novice photographer must have technical ability, be able to handle a studio situation, a stylist, the lighting; he must become familiar with all of these elements and be capable of delivering. Managing a print shot is not simple. He has to be able to work with people, be flexible, but at the same time protect

the integrity of his thinking and work. That is an art in itself. It is not often that he will be asked to roam around for three days and come back and edit a lot of pictures. He will have to shoot something specific and do it professionally. You are always looking for those special things that make his work different—still life, for instance. There are some who will shoot a certain thing because of his/her distinct character, and you will buy him/her because of that.

Gene Grief, an art director at CBS Records, adds:

My advice to a novice is to do what you really want to do. I realize this in my own profession. I work for an extremely conservative company, but I've received enough reaction to stuff I've done in the past six months or so that people are calling me to do free-lance work and asking me to art-direct, without any interference. I seem to spy a space within the industry for people to do exactly what they want if they are just brave enough to do it. I'm a great deal more avant-garde than my work is at the moment.

Art Kugelman, vice-president and associate creative director of Wells Rich Greene, concludes:

To do photographic illustration you look around to see what other people do. If you want to be a photographer, you go to school for the technical knowledge that is essential. The type of photographer I look for is one who is sure that this is the profession he wants and sure of what makes him most comfortable, what pleases him most.

3

OUT OF SCHOOL
AND INTO THE MARKET

The

Portfolio

WHAT MAKES A PORTFOLIO LOOK PROFESSIONAL

For you to be accepted as a professional, your book (as portfolios are called in the business) must look as if it is the work of a professional, even if you haven't had any of your photographs published. Remember that while many photographers do include examples of their printed work in their portfolios, they often include only the original chromes from which printed ads were reproduced. This is because original chromes are always of better quality than magazine reproduction. This gives the amateur an equal footing with the professional because, except for the reputation of a professional known to an art director, whoever opens your book has no way of knowing whether the work has been used in an ad or fashion plate or not. It is crucial to look professional. This is achieved in several ways. All your prints must be of technically professional quality. Do not include rough prints. If you do not have access to a darkroom, send your negatives to a good custom darkroom with specific instructions.

It goes without saying that if your book is to have a professional impact, you must be careful to remove all traces of amateurism from it. Often this means unlearning many of the hackneyed things you have picked up in art school or photography courses. The interests of most instructors are naturally in aesthetics rather than in the business of selling photographs. As Mike O'Neill points out, "Often the hardest adjustment after finishing school is learning to deal with the harsh realities of the business world." The needs of commercial photography are generated by a market; markets fluctuate, and all those entering the field of commercial photography must adjust themselves to its demands.

You should scrupulously avoid any hint of the class assignment in your book. Photography schools and classes generally give out the same assignment to a number of students. This is a dead giveaway, as Tamarra Schneider, art director of *Seventeen* magazine, explains:

> The portfolios of recent graduates usually have the same material they had in school. Students know what will please the teacher and what they need to pass. After graduation, twenty portfolios will come in with the same basic look. Why? Because they were all shot on the same day in the Central Park Zoo on the same assignment. Students should use their spare time to make their portfolios special. They could do something extra, something to separate them from the rest of their class, but they rarely bother. It's a pity, because this is the one thing that will give them an edge.

The earmarks of a class assignment can easily be spotted by most art directors—they were in school, too—and such signs become painfully obvious when a dozen graduates turn up at an art department with shots of identical models, backgrounds, and situations. When this happens, an art director will be inclined to dismiss an entire portfolio without giving it the benefit of a doubt. This is not because art directors are ruthless; it is because the novices have not thought out their strategy. To put it in simple economic terms, you must appear to be an independent supplier who is sensitive to the needs of the market, not a talented amateur looking for a break. The only history a buyer is interested in is your commercial track record and how well suited you are or could be to the buyer's needs. In the absence of tear sheets, you have to create self-assignments that approximate the needs of the market you are aiming at. Above all, avoid repetitiveness. As seasoned representative Bob Fischer says, "One of the marks of an amateur is fifteen shots of the same model."

Even if your style is not fully realized, your portfolio must telegraph that you are a dedicated photographer. Art directors have little patience with dilettantes, students, or chronic amateurs because that sort of dabbling attitude does not lead to anything useful. Victor Schrager, former director of Light Gallery, says, "The

whole discussion of building a portfolio proceeds from the idea that you are already a serious working artist and that you have ideas of your own about the kind of photography you want to make."

HOW TO MAKE YOUR WORK LOOK USABLE

Avoid experiments that cannot reasonably be applied to commercial, professional photography. Bev Don calls this avoiding the "Sneaker Floating in Space":

> I would rather look at someone's personal vision or someone who is attempting to duplicate an ad-type situation than the Sneaker Floating in Space! I would want to see that sneaker have the possibility of developing some sort of potential; you have to see that it's usable. There are obvious things I look for in a portfolio, such as lighting in a still life, design sense, and consistency in quality. You have to show the best that you have done and show that you can do it again.

Do not include examples of techniques you have not perfected. Be extremely critical of each piece of work you select, subjecting it to a number of acid tests. Is it relevant to whatever market you are addressing? (That is, don't include studies of wildlife, sunsets, or abstractions, if you're after fashion work.) Is the style you present in your portfolio applicable to mass-market advertising? Would a photograph have the same effect on a total stranger as it does on you? Advertising photography is in many ways more demanding than any other kind because it must fulfill more conditions within a restrictive framework. The most important of these is that a photograph, to be a successful ad, must meet the demands of the marketplace—it must sell something. An advertising photograph, unlike an editorial picture, reportage, a portrait, or gallery work, never exists in a void. It always appears within the context of its market. Keep in mind that someone, art directors and audience alike, has to *want* your work.

If you are interested in going into advertising photography, this point, as Mike O'Neill bears out, should be utmost in your mind: "For my

original portfolio I photographed things I wanted to, *but in the context of the graphic qualities of advertising at the time*. Some of these images are just as, if not more, powerful today."

Just reproducing an ad shows only that you are technically capable of producing it. You can study ads and define your own likes and dislikes, but copying them teaches you little and will not convince an art director that you can interpret the full scope of the assignment. Develop your own style and maintain it.

Bob Fischer stresses that whatever adaptation to a commercial portfolio you make, you must maintain an individual point of view:

Novices have to have intellectual motivation. They have to get their own artistic emotions clear first. Most young photographers are former assistants, and they have their own samples, have met some clients, managed to pick up some stray work here and there, and have the rudiments of a book. When I interview a young photographer I ask him what he wants to do. If he says (in effect), "I want to do what you can sell," I'd think less of his chances. If he had some idea of what he wanted to say, then I'd respect him. He should really have a point of view and stick to it and not try and anticipate or imitate the market. The art director makes the ad. A novice has to develop a style from within himself. A young photographer has to know his place in the machinery of the advertising, editorial, and fine-arts market. With knowledge of the plumbing the pipes work better.

You must stand out to compete with other photographers. Remember, however, that the more "far-out" your work is, the better you must be at realizing your ideas. There is nothing more amateurish than an idea that almost makes it. The best rule to follow, therefore, is to include in your portfolio only your strongest stylistic technique and one that is possible given the demands of the advertising market. General eccentricity in a book will certainly limit the commercial application of your work.

Projecting a bland image with a conservative portfolio will diminish the necessary dramatic impact. Tamarra Schneider of *Seventeen* makes this point:

Each portfolio has something. I try to see if a photographer has something young in his portfolio. If they're too sophisticated we can't use it. Generally I look for an easy look, more realistic than posed. We have enough people to get the straight pictures. It changes with different editors, though. I have to consider whom I'm going to use with whom. Once I see a book I like, I send it down to fashion or to the pattern people. Then I call a photographer in and talk to them and find out how they feel about shooting, what they like, and what they prefer to do.

A good part of the professionalism of a photograph comes from the people you work with. They must be as professional as the way you shoot the picture, for the people you choose to work with are a statement of style. In the case of fashion advertising and illustration, these people include the model you choose; the stylist who coordinates the clothes, location, and so forth; and the beauty artist who does the model's hair and makeup.

When selecting pictures for your portfolio, avoid situations that are unnatural unless you are trying for a surrealistic effect, in which case you should exaggerate these effects. Choose photographs that are realistic in respect to your subject, location, and style. If it's illustration, think about what your model is wearing in relation to what she's doing; put your subjects in places appropriate to them and their clothes. Ask yourself, no matter how arresting the image, "Does this make sense? Would she be wearing this outfit in this situation? What is she doing, and why?"

Rob Erdman brings up a typical case of misplaced effects:

In almost every current young photographer's book that I've seen there is a photograph of somebody on roller skates in a disco outfit with a sequined wraparound top. It's almost something you can predict in a beginner's book. When you see this kind of flashy, gimmicky, and unfashionable shot in somebody's portfolio, you know that they have not worked very much. As if this isn't enough surrealism for one picture, the photographer has the girl falling in a

very stylized manner, and has shot the picture indoors with tungsten light against no-seam paper. This sort of thing doesn't happen in life, and there's no reason it should be in a portfolio, either.

If every photograph is worth a thousand words, make sure your portfolio is not inadvertently telegraphing a distorted image of you and your ability. Every picture tells a story, and an art director who looks at hundreds of books a week can read a number of things about you as a photographer from even a brief look through your portfolio. Here's what Stan Freeman, creative director of Allied Graphic Arts, Inc., a catalog house, keeps an eye out for when he is examining portfolios:

Depending on the classification, we look to see exactly what the photographer is doing. We look for his style, his understanding of graphics, lighting, composition, and mostly how he seems to relate to his subject or object. Also, the atmosphere and the mood are part of both the fashion photograph and the still life. However, I am amused at the exaggerated stories told in photographs: someone jumping off a bridge, or listening at the wall to the next room. Every good picture tells a story without that exaggeration.

The following example illustrates, in simple terms, crucial information about how a photograph can express an idea in purely visual terms. In his campaign for Smirnoff, Bert Stern used the desert as a visual motif to communicate the dryness of a dry martini, as well as subliminally suggesting thirst. Although only the very best examples of this technique should go into your portfolio, the ability to conceptualize is essential in landing a professional account, be it advertising or editorial. Often at the beginning of campaigns, art directors will call in the books of a number of photographers to get ideas before they present their ad concepts to clients. In this way, an ad may indirectly arise from the style of a well-known photographer. It is mainly your skill in communicating ideas visually that will open the door to advertising photography. Before attempting to set up a photograph to express a concept of your own, practice by illustrating copy lines from existing ads. Remember,

the photograph does not duplicate the copy, it works off it, or often against it.

The ability to communicate visual ideas, as Frazier Purdy, vice-president of Young & Rubicam, makes clear, is, especially in advertising, often the deciding factor in the choice of photographer:

I look at ideas first and technique second. If the person is not technically competent, then he can't produce anything anyway. The thing that interests most art directors is interpretive ability and someone who brings some thinking to it, rather than just a record of what he had been asked to do. A lot of assignments are just that, but the better art directors will go to a certain photographer to get the benefit of his thinking. I would rather look at the portfolio of someone who had done experiments on his own. It gives me an idea of how he would approach a communication problem, how he wants to make his statement, and it shows that he is creative. A portfolio should have an identity of its own. There is also the fact that you have to work with other people. Most art directors are artists in their own right. They have a point of view, and at the same time they are asking the photographer to put some added value in there.

Even if your work has never been reproduced, it should look as if it has. Every photograph must appear to be salable and usable. In other words, each photograph should stand by itself without explanation or context supplied by you or anyone else to make it "readable." Do not try to duplicate the effect of an ad by attaching advertising copy or dummy type to create the impression that your photograph is part of a real ad or feature. Include only the photograph itself. Your work should never need props of any kind to sustain it. Keep in mind that almost all great advertising photographs work without copy. A look at any successful ad will bear this out.

In the beginning, your portfolio will have to perform all these functions without either the aid of your established reputation or the assistance of a rep. It has to contain all the necessary information so that whoever looks at it can know about you as a photographer: your style,

competency, and reliability. In essence, it must project your photographic personality. Not only must it represent you, it must *be* you.

HOW TO MAKE YOUR PORTFOLIO INTO A VISUAL SALESPERSON

The demands of the advertising business are very stringent. You will find it easier to assemble a strong professional portfolio if you remember, while selecting photographs, that professional photography is first and foremost a business, a medium that must reach out to its largest possible audience. For your work to be bought, it must be able to sell not only itself but the merchandise it depicts; it must be a visual salesperson. Within the frame of your photograph you must create enough emotional response in viewers to sell the product to them. Often with only a few lines of copy to back up its selling power, your picture has to be able to talk anybody interested in that particular product into buying it. A successful professional photograph never presents a personal vision exclusively. The photograph itself is a commodity, a powerful medium of persuasion, and therefore must communicate.

What Should I Put in a Portfolio?

If you know the area you want to work in, include only the best examples of your photography in that area. If your strongest skill, for example, is in still life or portraiture, show only that. Obviously, your portfolio will cover a wide range of subjects. If you haven't decided yet which kind of photography to specialize in and need to round out your portfolio, you can include examples from several areas. Remember, however, that what you are trying to project is a consistent photographic personality. That personality in your work will be effective only if it is focused.

Bev Don elaborates:

When I go through books and think that things need to be weeded, I will tell the photographers. Many times, because they haven't produced enough, they will show an enormous amount of information. Some-

times I have to spend time looking all the way through somebody's portfolio, and maybe the best print is on the bottom. Then there are the people who are all over the place. They're in fashion, food, still life, and I will tell them that they have to be specialized if they're going to work in New York. When you become a *star* you can have three different portfolios. For now, I urge them to stick to the one area that interests them most.

Patricia Trainor, a fashion publicist who has looked through many portfolios in her years of assembling press kits, likes to see character and a personal statement reflected in a portfolio. "I look for an awareness and an individual perspective, an ability to translate one's own fantasy into photography."

What to Leave Out

The essential quality every good portfolio contains is consistency of style. You can include work from different areas, but not from different styles. Your portfolio should have a unified impact. What you omit can be as influential in getting you work as what you put in. This does not preclude your having more than one portfolio, but as a general rule you should include one *type* of photography in any portfolio. And only established professionals can present more than one portfolio to any given art director on the same day.

Diversity of styles, as Sylvia Dudock, an art buyer for Dancer Fitzgerald Sample explains, is not an advantage in commercial photography:

When you look at a book and somebody has a range of styles, you tend to think of that person as less capable of fulfilling an assignment. I know most of the great photographers can produce it all, but you really identify most of those names with one thing. The precision of someone who loves still life is very different from someone who likes shooting people and motion. When new photographers come and see an art director or art buyer, the best thing to tell them is to find yourself, experiment as much as you can, but select an idiom of the business. Ultimately you have to make up

your mind and specialize because, if you want to be successful in the market, people are going to select you for having had a lot of experience in one area. Too many ideas in a book or a book that does not show a point of view leaves me unimpressed. Direction is important. Try and look for a style of your own, although I do hesitate to say go in a specific direction; sometimes you need that period of experimentation.

Your work must leave a strong impression on art directors. While a wide range of skillful photographs, such as still lifes, fashion, beauty, portraits, and reportage, will imply versatility, the type of work art directors see in your portfolio is the type of work they are going to assign you. Strategy can be the decisive factor in a career, as it was for Mike O'Neill:

When I started out I made a decision to specialize. Rather than attempting fashion, reportage, portraits, etc., I concentrated on still life. I chose 8×10 chromes for my portfolio. Part of the thinking was that if one was a beginner and trying to get a job, there is a lot less risk in giving a photographer a still life to shoot, without models. At that time there was a 35mm peak in the industry, and the ability to use an 8×10 was considered a special craft. Not many did it well. I felt that there was something special about it, and this worked.

What you don't want to project is anything that will dilute or obscure the consistent, unified impression you are trying to create. However proficient you are, if you are working in several different photographic idioms resist the temptation to include more than one dominant style. Even if you think you are equally skilled in a reportage style of fashion photography, like Arthur Elgort's, and a stylized studio approach, like Irving Penn's, consider the consequences. You are presenting your potential employer with two contradictory faces. If you think about the personality you want your portfolio to have, this will make the desired effect easier to understand. Offering two contradictory styles or even parallel ones will only give the appearance of indecision. This is fatal to your first impression. Select one style and stick to it.

Emphasize it. Never present more than one photographic personality in any one portfolio. To do so only leads to confusion over who you are, what you do best, and how you are likely to perform on an assignment.

David Leddick, worldwide creative director for Revlon at Grey Advertising:

Many of the portfolios that come in could be put next to one another, and no one would be able to tell the difference. They are exactly alike. The photographers have not seen things themselves. A great photographer, like any great artist, must be able to see things no one else can see and then make them visible. Even a very good professional photographer will have an individual style you can pick out immediately. It's style that sells cosmetics, and it's photographic style that we buy when we hire photographers for our campaigns.

Visibility

The most important quality any photographer can possess—and express through a portfolio—is to be identifiable. Every successful photographer has a style that is easily identifiable, at least within the advertising community. This means that incorporated into every picture is a great photographer's own trademark. While this stylistic signature should never be so idiosyncratic that it interferes with the effectiveness of the ad, it is the presence of this very quality in each picture that grabs the viewer's attention and gets the photographer work. Because advertising is essentially a conservative medium in the business of finding new and visually arresting images to attract the public's attention, visibility is the photographer's greatest asset. The trick is to find an original, personal style that also communicates to a mass public the message of the client's product. Do not be too conservative, therefore, in developing a style. While advertising itself may be conservative in adopting new styles, a conservative attitude on the part of the photographer who is starting out can only limit him.

Gene Grief reiterates:

I made the mistake of trying to make things look like the status quo when I got out of

school, and that is worthless. What you should be making is what hasn't been made before, unless you want to be a real rich imitator. I am not really interested in something new unless I'm forced to react to something I haven't seen before. For me, most people's books are so alike and so ordinary that I would prefer a sense of humor. A nice strange attitude would also be fine— I think most people should allow their strangeness into their work. It's the only thing that separates them from other people. But I have had enough of perverse sado-masochistic or pseudohomosexual fashion pictures. What I mean by strangeness is a way of seeing things that is different, rather than a different subject matter. I would prefer to see work by someone who sees the world totally differently from anyone whose work I had seen before. That may seem incredibly presumptuous, but a certain arrogance is important to me—somebody who believes that people can fly and that is evident in his work. That's what's exciting about looking at people's books. You're going to open a book one day, and there's going to be this one thing that jumps out. It may be a combination of everything that has existed before.

Whatever field you are interested in, your work must be appropriate to its market, even when you are dealing with galleries, where an original print is considered on the same level as any other fine art. As Victor Schrager says, originality is considered within the context of the gallery's format:

As a gallery curator, I look for someone who is making a contribution to what we already have, not merely duplicating a style of people we have already shown or who were readily recognized. We are looking for someone interested in adding something to general public knowledge through their work. Originality is not quite the word; it gets used for novelty for its own sake, and there is something more fundamental than that. At the gallery, we look for people with a serious lifelong career. Originality is important in a photographer, but he must have the possibility of growing.

A Portfolio Is Not a Collection of Photographs

Your book should never look like a mere assemblage or collection. The pictures must work together, have a consistency of technical quality and visual continuity. As a unit, your book must add up to something. Its effect must, therefore, be cumulative. The complete impression is created by arranging your photographs so that your very best work occurs toward the end of your book, thereby leaving the most lasting impact. Arlene McDonald, an art director at J. C. Penney, points out, however, that the first pages of your portfolio are also very important:

If there is a soft focus in the front of the book, that could make an art director nervous, and therefore he or she wouldn't even look any further in the book for fear that the photographer would give them a look that is too soft-focused.

Art Kugelman of Wells Rich Greene concurs:

You have to think of me like the client. Bring me a book that doesn't necessarily have the kind of work I am looking for but with something that turns me on or excites me. Then I might think about it, consider it. There is an area of specialization. If you want to make a living you have to be specialized. This is the way of the world. There are guys out there who can put an orange on a milk glass and make a beautiful picture. If you change the scale or have something dramatic that happens when you look at it or it's a trick, then it has something extra. Even if the photo was an accident that worked, then that person was smart enough to put it in his portfolio. The judgment itself is a talent.

Art directors are going to remember your portfolio as a whole. And in order to get them to turn the page it is vital to make your pictures work for one another. Avoid complicated layouts or combinations of pictures that fight. As a rule of thumb, avoid busyness when combining pictures on facing pages. Look out for distracting elements, such as too many hands, that predominate in the facing pictures. This

On the facing page and the following pages are examples of what I would consider successful solutions to putting together an effective portfolio by a beginning photographer. Below, Rob Erdman wisely opens this mini-portfolio with a tear sheet, a published picture. This shows him to be a working photographer capable of carrying out an assignment professionally. This is important. *However good your unpublished work may be, the art director is concerned about how you will function in a working situation.*

The four pictures that follow were all shot as tests for Rob's portfolio. They are technically proficient as well as being well composed and interesting to look at. They fulfill the requirements a real assignment would demand: they display the merchandise; the subjects look contemporary; the people are set in a real context and are well groomed. When photographing people you do not have to use subjects who are models. Good-looking photogenic friends can certainly fill the bill. By starting with male subjects, the photographer avoids the very real complications involved with female models in the area of hair, makeup, styling, and accessorizing. With a man, a watch can be enough. A woman, however, needs the proper jewelry and accessories. Her hair and makeup must be impeccable, and everything from her shoes to her hair clasp must be coordinated.

How your portfolio looks is often as important as what is in it. The style here is consistent, which shows Rob knows what he is doing and that he is secure in his approach. The style may not be right for every client, but those that it is right for will know he is capable of giving them what they want.

All of the pictures that face each other in the portfolio complement each other. The first two present an interesting idea—back shots rather than full front shots. The next two present a pleasing juxtaposition of poses. It helps the flow if all the figures are of relatively equal proportion, or at least do not jump from big to small and then back again to big. These first five pictures show enough grasp of a particular area—men's fashion—that Rob can now move on to new subject matter. (Later on by adding a female to the pictures he can show his ability to handle women as well.)

Rob here makes a good transition from male fashion to photographs of children. This presents less of an abrupt transition than going from men's fashion to food or a product shot. It is important to stick to the same photographic genre (i.e., fashion) at least for the first part of your book. The pictures below also provide a nice contrast to the preceding shots, since they were taken against a no-seam background. This indicates that Rob is as proficient in the studio as he is on location. Children may seem ideal subjects for test shots, but they are notoriously unpredictable to work with. A great deal of patience is required when working with children, and this series of pictures shows that Rob was successfully able to control children in a fashion context without stifling their natural ebullience. This group of tests was shot as if part of an assignment to do a portfolio of pictures for a series of editorial fashion spreads on children. Rob intentionally gave these photos an inner continuity by creating a theme: each child, assuming a similar pose, is carrying a musical instrument, which is seen first wrapped and then unwrapped, just as the child is first seen in a coat, then without it.

The final point to make in your book is versatility within your own established style. Examples of your work, and tests in various fields such as advertising, newspaper, magazine, and editorial, packaging, promotion, and posters will help get you work in different markets. The picture of the two boys holding Coke bottles is an excellent example of a self-assignment using a national product. This could as easily be done using sporting equipment or an ice cream truck as a background. Self-created ads are effective advertising for your own talent. One should, of course, readily admit, if asked, that these were not done for the nationally known company (in this case, Coca-Cola), but the point is made that the shot is good enough to be mistaken for a legitimate ad. The picture of the infant shows that Rob can manage any aspect of the area of photography that he has taken on.

Self-assignments and tear sheets must be indicative of your work and style. No shot should look as if it comes from left field. Each should be a statement about your work. Ending with another tear sheet reinforces to the buyer that you are professional. (All photographs in this portfolio are used by permission of Rob Erdman.)

sort of thing undermines your layout, taking the eye away from your images. In short, check to see that each double-page spread works harmoniously.

Finally, don't repeat yourself. Don't overload your book with too many similar poses or shots from the same sitting. If you can't make up your mind which of two almost identical pictures to include, ask someone whose judgment you trust, and eliminate the other.

MAKE YOUR BOOK FLOW: Continuity is to the order of your presentation what consistency is to its style. In the most general terms, this means the images must flow in and out of one another. Edit or rearrange pictures that interrupt that continuity. Each page the art director turns should reinforce what went before and confirm the initial reaction. Your portfolio must work as a unit, building to your most dramatic shots. On the whole, avoid abrupt changes in direction unless, of course, you wish to draw attention to a particular page. Your portfolio should look sleek, dynamic, and in control of its photographic vocabulary. Consider your portfolio as a book. You should be able to read it intelligibly from the first image to the last.

Because of the number of different images in a good photograph, your contribution may be in the way you select and combine the various elements. A new look in photography need not involve a revolutionary approach. More often it is simply a new juxtaposition of familiar elements.

What Kind of Portfolio Should I Buy?

The truth of the matter is that this is the least important part of your presentation. Contrary to popular superstition among photographers, a portfolio can be any size (within limits), any color, and made of any material, including wood. Art directors see so many portfolios every day they rarely even notice the case. From years of looking at portfolios I can assure you that it is highly unlikely your presentation will be affected by the kind of container you choose for your work. Gene Grief remembers:

When I got out of school I thought I should have a really slick portfolio with beautifully mounted prints, a great package

with a cohesive idea, something that was really going to impress art directors. For me, when I'm looking at people's books, I could care less if someone brings me a bunch of stuff wrapped in a paper bag and dumps it on my desk—if it's good. When stuff is bad it's really a shame that people are going to all the trouble to make pretty mats and a nice sleeve—it's a crime.

Victor Schrager explains that even for a gallery an elaborate preparation can work against you:

I always regretted when a photographer went to extreme lengths to deliver a beautifully framed, extensively prepared series of pictures. We like to think that you can tell a good picture on its own merits. Whether they are loose prints in a box or not, it doesn't matter. They should be sequenced or presented in a way that they are legible, but I don't think anyone should go to drastic lengths to make a slick production. Sometimes it confuses the issue. It can be a liability to have an elaborate production.

By suggesting that you avoid excess in the packaging of your work, I do not, of course, mean to imply that sloppiness is an asset! Far from it. Remember that your photographic personality represents you, so make it worthy of you. "The presentation is important," stresses Sylvia Dudock:

I like to see a book that is neat, not just tear sheets cataloged. I feel that if the photographers and the reps think enough of their work, they will show it in a very good form. You can tell a lot about how organized they are in how they present themselves.

For your own sake, whatever type of portfolio you decide on, make it manageable; for the time being, you're the only one who is going to have to carry it around. Black and white 8×10 or 11×14 photographs are generally presented on double-weight paper. Color must be presented on chromes or as color prints. The only "don't" here is slide trays. It may seem like a

convenient and compact way to show your work, but it will only antagonize the person who is looking at them. No art director wants to view work on slide carrousels. It presents too much of a distraction in a busy art department, even on projectors equipped with display screens. If you give an art director no choice but to set up a projector to look at your slides, he is going to be less receptive to your work than if you presented it in a more accessible manner. The other drawback is that such presentations involve the art director in looking at and commenting on the work in your presence; they create unnecessary confrontations and force snap judgments. This cannot help but put you at a disadvantage that you don't need.

A professional constantly upgrades his portfolio. It is an axiom that even a novice can follow. It is ongoing—each new print and tear sheet must be considered in relation to the whole. Over a period of time, the attention will be apparent and a source of satisfaction.

TALKING TO THE ART DIRECTOR

When you go to pick up your portfolio, you should try to find out from the art director what he or she thought of your book. What were, in his opinion, the weak and the strong points of your book? Make it very clear you want a frank opinion of your work. And you should be ready to accept and welcome any criticism. It may be that this is just not the agency or magazine best suited to your work. On the other hand, there is a lot to gain from an open discussion. You cannot expect an art director to take on the role of the instructor, but most art directors, if they see promise in a portfolio, will have constructive things to say about it.

There is another advantage in asking for the art director's opinion: you are beginning a dialogue with him and letting him know you are open to an honest exchange of ideas. This is important to any art director who is going to work with you. He must feel at ease with you personally and feel that he is dealing with a professional, since this will be the next step in your relationship: your ability to carry out an assignment and your ease in dealing with the people involved in the shooting. It is your responsibility in this situation to let the art director know you want and are willing to accept honest criticism. As Alexey Brodovitch put it:

> Don't be a snob; don't live in an ivory tower. Expose yourself to criticism and opinion.

Because of the large volume of work coming through an art department, most art directors will not volunteer opinions. You must elicit them, as Gene Grief says:

> When I'm looking through someone's portfolio and it's really bad, I'm thinking, "What am I going to say when I get to the end of this?" I don't know if it's my job to straighten people out, tell them to get out or go back to school. So mostly I try and say something encouraging unless I know that they want and can handle honest criticism. More often than not I patronize just so they'll go away and not bother me. It would be nice if people were more prepared than they usually are.

Although your portfolio may be good, persistence is a major part of getting work. Even with the right portfolio at the right agency, you may still encounter obstacle after obstacle over which you have little control. Arlene McDonald observes that even if you have a nice book it doesn't always mean you are going to get work. "A lot of it is timing. Send your cards out constantly. Eventually they will try you."

In graphic design there is a fast and constant turnover. This is advantageous especially to people moving up the ladder of commercial photography; it provides more opportunities for the novice. It means you could submit your portfolio to the same magazine or account several times a year as art directors change. If an art director has liked your work but couldn't use you and then moves on to another magazine or agency, contact him again because in his new position your work could be reconsidered. You should not become discouraged if your portfolio does not get immediate recognition. The best you can hope for is to elicit a reaction. As Art Kugelman points out, the reasons for hiring a photographer may have little to do with him or his book:

It's a bit of a crap shoot. A photographer can put together a terrific portfolio and see a buyer who says, "I don't handle these kinds of accounts." That may be a lack of imagination on the part of the buyer, or he may actually have a narrow clientele.

However, creativity is always at a premium in any field of professional photography. There is a very simple reason for any kind of innovation in photography: competition. Bev Don elaborates:

Every day I see one portfolio. I see so many young people coming in who are just starting off, and they are competing with established people. If they are really good I try to see if I have an opening for a test or a product, something that is not a major campaign. I try to use these people. Their frustration is the competition.

Toby Aurelia, art director of J. C. Penney, speaks of how photographers get their start in retail departments:

We will try a new photographer on a small job, in order to test his skills and capabilities. If his work is acceptable he will be assigned to other jobs.

It might be encouraging here to give you some insight into the way art directors look at portfolios of photographers who have not yet established themselves. Bob Ciano, art director of *Life* magazine, explains:

In a portfolio my responses are usually intuitive, gut reactions. Most of the photographers we have used are new, meaning we were not aware that they were around. Most of the stories we do come in through the photographer. They want to cover something they think is worthwhile for us to do.

However good your work is, any assignment and shooting involves a lot of personal interaction. Art directors must feel confident that they can work with you and that you will be compatible. Patricia Trainor makes this point:

I look for someone with a terrific personality. It is good to meet the photographer himself to see whether he is a prima donna who is going to have a temper tantrum—or if he is someone who is pleasant and will not harass you. Instead of their calling eight thousand times a week, I'd rather they send me something that they had done that was memorable.

Sylvia Dudock affirms this:

I won't give out any work unless I know that the person is solid, and my job is to make sure they can have a working relationship with my people. Once that is developed, you can get good work with people.

The only way to start on your own is through your most effective weapon: your portfolio. Take sufficient time and thought in developing it. No matter how talented you are or how technically proficient your work may be, getting your first assignment will be a matter of your portfolio being in the right shape at the right time. It must convey that you are prepared for the opportunity and that you are professional with a memorable photographic personality.

MAKING IT WORK

Reps and Business

The photographer's rep meets the needs of both picture buyers—whether they are advertising agencies, magazines, or galleries—and photographers. The photographer-rep relationship can be a traditional business partnership like that of the agent/manager and artist. Some photographers operate better without a rep, no matter how effective reps may be for others. If a photographer has become established without a rep, there may be little reason to ever get one. The function of a rep is to secure assignments. The rep handles the daily business affairs, much as a personal manager does.

Most free-lance photographers starting out feel the need for someone who will represent them in the marketplace. The question is whether reps can secure sufficient business to justify the large compensation they earn. Reps can open new markets to photographers because they know when campaigns are coming up and who is looking at portfolios. From previous working relationships with the rep, an art director can tell him or her about future assignments before a specific photographer has been chosen. An advertising agency or even the client may have confidence in a rep's ability to supply the right photographer for a campaign. This can be particularly valuable to a new photographer, but it is also helpful for established photographers. A rep can direct the portfolio to the appropriate markets, eliminating wasted effort and time. A rep is a constant sounding board and useful critic for a photographer's work, technically as well as stylistically. A rep can tell the photographer which areas it would be profitable to experiment in, where to take newer approaches, and the like. A rep's understanding of a photographer's sensibility and temperament can help stimulate a photographer into developing new career ideas. A rep is the liaison to the creative marketplace, which therefore puts him in a position to know of changes and how to adapt to them.

A rep is a businessman who keeps abreast of the movements within the market—where the power bases are and where clients are headed to and from. It is his business to interpret these shifts in supply and demand to the photographer, and it is the rep who must also explain the photographer's work to the art director. A rep knows how the photographer's work will fit into the market and the direction that should be

taken to realize his potential. Drumming up new markets is a specialty that must be pursued by someone with experience. The same is true of switching from one area to another, for example, from editorial to advertising or from corporate work to editorial. In many cases success is understanding how much work in each market maximizes profits, and how heavily to pursue various areas to achieve a healthy mix of work.

As the market has grown tremendously in the past decade, the business of selling the services of a photographer has become increasingly sophisticated. The demands of clients have grown over the years, and much of the preproduction work formerly done by the client is falling to the photographer and the rep. As a campaign extends over months or years, the client becomes increasingly dependent on the rep and photographer for the contribution of new perspectives on the theme of the campaign. Obviously, working arrangements vary from client to client; some give the photographer complete responsibility while others provide no leeway.

The marketplace is constantly evolving, and therefore a photographer with a rep who accurately follows the changes stands to benefit greatly from the relationship. A rep's duties and priorities vary according to the unique strengths and weaknesses of the photographer. It's always better, as a rule, for each to do what they do best. They are working as a team.

There are also pitfalls in this partnership, such as not communicating with each other about the marketplace and not keeping abreast of the changes. There has to be a constant exchange of information, ideas, and perceptions in order to make decisions together and apart; this exchange must be done freely and comfortably. Both are overseers of all the minute details that must be looked after to ensure a smoothly executed job. Both hold the production checklists to make certain that everything is attended to and can then be followed up.

A very good rep should be able to recognize the strong and weak points in a photographer and be able to bring out the best in his or her creativity. The rep has to match personalities between two artists—the photographer being the constant and the art director the variable. A rep is responsible for making the environment suitable for seeing a problem through to its solution.

The rep should be able to market a photog-

rapher's work for special projects. Museum and gallery shows and published books are appearing more frequently today as part of a photographer's oeuvre. This results in overall promotion and public relations for the photographer as well as for business in general.

A rep's specialty should match that of the photographer. A rep should have the ability to interpret the photographer's style and should know where to market it. He should be familiar with the politics of the advertising business and have a sense of timing, and be able to apply these to the best advantage. He should be able to fill voids in a photographer's career by strategically planning an individual career methodically and promptly. He must be aware of the trade publications, using them not only for promotion through advertising but also to stay informed of the activity in the business.

In talking about a novice photographer looking for a rep, Bob Fischer, one of New York's best and most successful reps, says:

An agent might very well handle someone without a reputation. I started with Phil Marco when all he had was a box of editorial-type 2¼s and was living in and working from a one-room apartment. I believed in the solutions he found for commercial problems. What a rep needs to communicate is his photographer's ability to solve the given problem. I further believe that a photographer is his own best rep. The rep is merely the face of the photographer. He must project the photographer's real image and feel confident that the photographer will come through. The whole thing is a strong rapport between all of the parties.

Bob also bases his decisions on specific criteria:

One of the flattering things that happens to me is that art directors ask me to suggest photographers I know but do not represent. This gives me an overview of the entire market at a given time. That part does not take a great talent. A reputation is important, but so is being aware. It is all cumulative. Piece by piece you establish relationships within the business. I do question

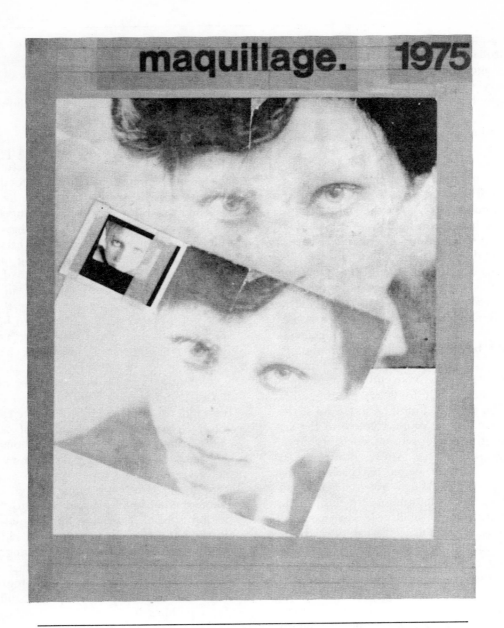

maquillage. 1975

One way for anyone breaking into the field to attract attention to his or her work is to create a dramatic and attractive showpiece for it. Above is the cover of a 40-page magazine created by Deborah Turbeville as a promotion piece. It is made up of reworked pictures from assignments.

the professionalism of many agents. There are probably no more than fifteen or twenty agents who understand all the pieces necessary in producing even the simplest photograph.

Debra Simon explains the functions of a good rep:

A rep must totally understand the sensitivity, potential, style, needs, and priorities of a photographer within the framework of his work habits. To be able to sell photographers, you must make a commitment to them, to their egos and temperaments. You have to be there for them, not just from nine to five, but ready to put in the care that is needed. To handle a photographer at his maximum and at a maximized gross billing, the details and plans—the arrangements—should be kept away from the photographer except when his specific input is needed. After the conceptual, preproduction meeting, ideally the photographer should be protected until he shows up at the given place at the proper time with the art director, the perfect setup, models, studio or location, stylists, etc. An art director does not want his time wasted with an inappropriate portfolio. When given a job, you should act with the utmost care and assume the creative responsibility for as many of the details as possible. This has two advantages. You will have more control over the servicing of the photographer's needs, and the art director is grateful for having the burden lifted off his shoulders. It's smart for a rep to keep in touch with art directors, without being a pest, by simply calling to say hello or stopping in while passing by; a casual social meeting is often a welcomed break. A good rep will keep a continual flow of new work or tear sheets that may interest clients; it is important to be responsive and to cater to their needs, and to make their jobs as easy as possible by getting portfolios to them for client meetings as soon as possible and supplying them with good, accurate, and detailed budgets and estimates. You should make yourself available for meetings on budgets, layouts, casting, or any other details. Finally, you should ideally

go to the shootings to be sure that everything runs smoothly and that any last-minute problems can be taken care of.

Gene Grief relates a story that shows whom *not* to have representing your work:

I had a rep bring in a book of a photographer whose work I had seen before and liked and wanted to use. It was a good thing it wasn't the first time I was seeing his work because this rep was so surly, giving monosyllabic answers, I never would have used the photographer. I was seeing his work, and the rep acted like I was giving him the third degree. He was making it so difficult that I called the photographer up and said, "I really like your book, you have the job, but you have to get rid of the rep because he will ruin you. You'll never get a job if someone has not seen your book before." And he did get rid of him.

I think reps think that they can make a lot of money taking a percentage of a photographer's salary and all they have to do is carry around this black piece of leather. That is not what it is about. It's about making friends and making people happy. You should not pick up reps recklessly at all. A rep should know the book as well as the photographer knows it, and relate to the situation at hand. I want to know how things in the book happened, what kind of film it is. I want to know about the photography. I want to be asked questions that don't waste time. The rep can get a photographer work when the rep is competent and professional himself.

The close relationship, built on trust and instinct, of a rep and an art director can ensure a continual flow of jobs for a photographer. Louis Hernandez, an art director at Dancer Fitzgerald Sample, expects very specific things from a rep:

After I have given a rep a job there are certain things I expect him to do: (1) First, if I like the photographer's work, I try to meet him. (2) The rep should also get involved in the expected work—not just hard sell the photographer and then not contribute to the general atmosphere of the working rela-

This promotional mailer has every chance of winding up on an art director's bulletin board, where it will serve as a constant reminder of the photographer, Larry Keenan, Jr. A self-promotion mailer is a tried-and-true method for the novice to get his work seen by the art-buying community.

tionship. (3) Coordinate some kind of time-table with the studio and photographers—depending on the assignment, this can be simple or complex. (4) Take care of the client, because it is really important to have the PR. And that is what the rep is all about. He is not a door-to-door salesman. He has to be an intelligent and subtle salesman.

Being a subtle and intelligent salesman requires a sense that comes through experience. What one art director insists on, another may consider irrelevant. Experience gives a rep an idea of what he has to know, what the individual needs are going to be, and then he can set out to fulfill whatever they are.

Adrian Kliros, a rep, elaborates on what makes a good rep:

I think being honest, sincere, and able to clearly understand and articulate the thoughts, concepts, and information that are being discussed is absolutely necessary. It is essential to have an overview of the business in general and any assignment given to you specifically. There are limitations and boundaries surrounding a problem given to a photographer by an art director. A rep is expected to be useful when need be and offer different alternatives to a shooting. It helps to have a knowledge of the contemporary and to be sensitive to human nature and to have a personal sense of organization to help meet production and delivery needs. As in any business, it helps to be eager, well rounded, and literate, with a sense of the advertising business and the way it operates as an industry. You must be open to receiving information, and you must be able to apply it. You are meeting new people all the time.

In representing a photographer, you don't have to sell him like a car because his work will sell itself, but you do have to be careful of presentation at all times. Your presence at the initial meeting is important, and your job is to provide information and background to place the photographer in the right light to the art director. This means pointing out the photographer's attitudes and beliefs toward photography.

When you find a rep who can do this for you,

the specific terms of an agreement should be worked out. It is important to discuss regularly financial and creative directions and goals, to know that assignments, fees, and markets are being properly pursued. The best results seem to come from mutual respect and hard work. The relationship should be set along strict guidelines so that neither person feels that there is no recourse when an unsatisfactory situation arises. A rep should not fear being discarded whenever there is sufficient business, nor should a photographer be tied to an unproductive rep.

There are the logistics of office space, telephone, and organization needed by a rep that must be worked out up front. Applied basic business practices and personal preference will enable the rep to come up with the best solutions. Some reps work with a number of photographers, while some photographers need and demand a one-to-one relationship. These as well as other considerations govern the working environment. The commissions are generally based on the fee only, and expenses are billed separately. If the job is not on a cost-plus basis, expenses are deducted in computing the commissions. A 25 percent commission is common, if not standard, in the business. The amount is based on the cost of the studio, and whether or not the overhead is the responsibility of the photographer. Some photographers hire a rep on a salary plus bonus, and I imagine every conceivable method of representation has been tried and could work. It is up to each rep and photographer to negotiate commissions according to circumstances.

The particular markets or specialties that a rep will cover should be spelled out specifically. This is important as far as geographical area and specialties are concerned—for example, to cover the East Coast or not to cover catalogs. Promotion and advertising of clients, which are two of the most important aspects of the rep's duties, can be complicated by the question of who pays for how much. A 25/75 split (25 percent to be paid by the rep, 75 percent by the photographer) seems appropriate in most circumstances. This, along with the commissions, is negotiated at the time of the signing of an agreement.

There is also the problematic matter of house accounts—those that came to a photographer before the rep, and those which the rep brings in

but which will remain the photographer's after the rep is gone. One solution is that on all work billed while the rep is responsible for the output of a photographer commission is paid, and then, in turn, commissions are not maintained on accounts that continue after the rep-photographer relationship has ended. If the photographer feels that a rep does not deserve moneys on work not directly brought in by the rep, he should question getting into the relationship at all. And conversely, for a rep to try to keep track of moneys from his former accounts after a relationship has terminated is nearly impossible and is unbecoming at best. One last point: make a fair contractual arrangement and then follow it to the letter.

The invoicing and collection of accounts receivable should be done by the one most qualified to handle it. That person should also be in charge of the corporate books. Each part of the process must be carefully watched, and access to the books by either party should be mandatory, along with both having copies of all invoicing to ensure there are no mistakes or misunderstandings.

It is the rep who negotiates the details of a purchase order before any photography assignment is started. The details of all aspects of the assignment should then be cleared between the photographer and rep. If you do not have a rep to interpret the details or know the markings of the industry, you will need to reckon with the important aspects of business yourself. If you find yourself in this situation, be sure to consult all printed material and acquaint yourself with the finer details. As a novice, you will most likely have to be your own rep for a while. This can be a neat and simple process, or it can become very byzantine. It is not only an advantage but a necessity for you to understand the intricacies so you can work independently.

As to the exact compensation, most markets have well-established guidelines that are very easy to follow. Rates are based on the premise that services are being obtained on a free-lance basis, and the fee structure reflects this rather than permanent employment. Once a job is assigned, you can quickly find out the rates. For example, editorial work usually has a set price, calculated on either a page rate or a day rate. The figure will be rigid and nonnegotiable, so don't think a rep could have done any better. In editorial work, circumstances occasionally dic-

tate that compensation will be awarded depending on the photographer, but there is never negotiation except when exclusive contracts are sought, which is only at the height of a career. You will have to keep in mind that part of your compensation is the gaining of a professional credit. Therefore, always make sure that the policy of the newspaper, magazine, or supplement is to include a credit line.

Most assignments for catalogs, annual reports, publicity, or record covers are awarded on a day rate, a page rate, or a per-shot basis that is established within ranges depending on the photographer's status. Usually these rates will vary within hundreds of dollars on a day or page rate or no more than one thousand dollars on a per-shot basis.

Stock pictures are directly tied to kinds of usage, with rarer images commanding higher fees. The usages are geographic area (national versus regional); trade or consumer; type of reproduction (black-and-white versus color); circulation; and number of times used. Stock rates are basically cut-and-dried, but they are also a function of supply and demand. Stock usage will be clearly stated when photographs are purchased.

For an advertising assignment, the rep's objective is to get the maximum from the budget for the photographer without the loss of other parameters (highly qualified stylists, hair and makeup artists, models, and the other requisite elements of the picture). The variables are time, day rate, ad rate, and bonus fees for billboard, poster art, packaging, point of purchase, or the "buy out"—the purchase of all rights to the pictures. It is the juggling of the proportions within the financial constraints, which must always fall within the limits of the budget, that through negotiation leads to an ideal photographic fee. In advertising photography, whether it is spec testing—a photographer taking test photographs for a job—or shooting for an assigned layout, the day rate should at least entitle the client to one advertisement per shooting day without additional payment. Each advertisement created beyond the payment for one shooting day will involve additional compensation equal to the agreed per-day fee. This is a highly sophisticated negotiable point. Compensation is provided in corporate work if a picture is used beyond the original agreement—if a photograph for an an-

Stock Picture Delivery/Invoice

FROM:

TO:

Date:
Subject:
Purchase Order No:
Client:
A.D./Editor:
Shooting Date(s):
Our Job No:
☐ Assignment Confirmation
☐ Job Estimate
☐ Invoice

RIGHTS GRANTED

One-time, non-exclusive reproduction rights to the photographs listed below, solely for the uses and specifications indicated, and limited to the individual edition, volume series, show, event or the like contemplated for this specific transaction (unless otherwise indicated in writing).

SPECIFICATIONS (if applicable)

PLACEMENT (cover, inside etc.) _____
SIZE (½ pg. 1 pg., double pg., etc.) _____
TIME LIMIT ON USE _____
USE OUTSIDE U.S. (specify, if any) _____
COPYRIGHT CREDIT: © 19_____ _____
(name)

MEDIA USAGE

ADVERTISING
Animatic ☐
Billboard ☐
Brochure ☐
Catalog ☐
Consumer Magazine ☐
Newspaper ☐
Packaging ☐
Point of purchase ☐
Television ☐
Trade Magazine ☐
Other ☐

EDITORIAL/JOURNALISM
Book Jacket ☐
Consumer Magazine ☐
Encyclopedia ☐
Film Strip ☐
Newspaper ☐
Sunday Supplement ☐
Television ☐
Text Book ☐
Trade Book ☐
Trade Magazine ☐
Other ☐

CORPORATE/INDUSTRIAL
Album Cover ☐
Annual Report ☐
Brochure ☐
Film Strip ☐
House Organ ☐
Trade Slide Show ☐
Other ☐

PROMOTION & MISC.
Booklet ☐
Brochure ☐
Calendar ☐
Card ☐
Poster ☐
Press Kit ☐
Other ☐

DESCRIPTION OF PHOTOGRAPHS	Format:	2¼	4×5	5×7	8×10	11×14	Other	USE FEES ($)
Total Black & White Total Color								

If this is a delivery kindly check count and acknowledge by signing and returning one copy. Count shall be considered accurate and quality deemed satisfactory for reproduction if said copy is not immediately received by return mail with all exceptions duly noted.

TOTAL USE FEES: _____
MISCELLANEOUS: _____
Service Fee: _____
Research Fee: _____
Other: _____
TOTAL: _____
DEPOSIT: _____
BALANCE DUE: _____

SUBJECT TO TERMS ON REVERSE SIDE PURSUANT TO ARTICLE 2, UNIFORM COMMERCIAL CODE
ACKNOWLEDGED AND ACCEPTED

Stock picture delivery memos and invoices must be very explicit. (All business forms in this chapter have been reproduced through the courtesy of the American Society of Magazine Photographers.)

(a) "Photographer" hereafter refers to (Insert name). Except where outright purchase is specified, all photographs and rights not expressly granted remain the exclusive property of Photographer without limitation; user (or recipient) acquires only the rights specified and agrees to return all photographs by the sooner of 30 days after publication or 4 months after invoice date, or pay thereafter $5.00 per week per transparency and $1.00 per week per print.

(b) Submission and use rights granted are specifically based on the condition that user (or recipient) assumes insurers liability to (1) indemnify photographer for loss, damage or misuse of any photograph(s) and (2) return all photographs prepaid and fully insured, safe and undamaged by bonded messenger, air freight or registered mail. User (or recipient) assumes full liability for its employees, agents, assigns, messengers and freelance researchers for any loss, damage or misuse of the photographs.

(c) Reimbursement for loss or damage shall be determined by a photograph's reasonable value which shall be no less than $1,500.00 per transparency or $_____ per print.

(d) Adjacent credit line for photographer must accompany editorial use, or invoiced fee shall be doubled. User will provide copyright protection on any use and assign same to Photographer immediately upon request, without charge (assuming no outright purchase).

(e) User will indemnify Photographer against all claims and expenses arising out of the use of any photograph(s) unless a model or other release was specified to exist, in writing, by Photographer. Unless so specified no release exists. Photographer's liability for all claims shall not exceed, in any event, the amount paid under this invoice.

(f) Time is of the essence for receipt of payment and return of photographs. No rights are granted until payment is made. Payment required within 30 days of invoice; 1½% per month service charge on unpaid balance is applied thereafter. Adjustment of amount or terms must be requested within 10 days of invoice receipt.

(g) User shall provide two free copies of uses appearing in print and a semi-annual statement of sales and subsidiary uses for photographs appearing in books.

(h) User may not assign or transfer this agreement. Holding or use of the photographs constitutes acceptance of the above terms, hereby incorporating Article 2 of the Uniform Commercial Code. No waiver is binding unless set forth in writing.

(i) Any dispute regarding this invoice, including its validity, interpretation, performance or breach shall be arbitrated in (Photographer's City & State) under rules of the American Arbitration Association and the laws of (State of Arbitration) Judgement on the Arbitration Award may be entered in the highest Federal or State Court having jurisdiction. Any dispute involving $1000 or less may be submitted, without arbitration, to any court having jurisdicition thereof. User shall pay all arbitration and Court costs, reasonable Attorneys' fees plus legal interest on any award or judgement.

(j) User agrees that the above terms are made pursuant to Article 2 of the Uniform Commercial Code and agrees to be bound by same, including specifically clause (i) above to arbitrate disputes.

Terms and conditions of the agreement are spelled out on the back of the form.

nual report gets used as an advertisement, for instance.

When you are dealing directly with a client, rather than through an advertising agency, rates will not be established in the same way. Clients usually have a rough idea (sometimes even a more defined one) of what they can spend, and the figure is often negotiable. Advertising agencies have a budget previously established and approved by the client. As a rule, before any creative work is begun, the costs are agreed on. What is offered to the photographer can still be negotiated, however, because the fee is dependent on the factors of usage, deadlines, number of ads to be used, and any other circumstances that could affect the scope of the job.

Every situation is slightly different. If you have an ongoing relationship with a client, it entails a larger focus and a longer view. It takes practice and experience to make sure that things go smoothly and effectively so that you keep the account. One tool that facilitates this is the purchase order form. All the contingencies of the purchase order must be understood. The purchase order is a written agreement detailing the services to be rendered, the work to be done,

and the money to be paid. All this should be in writing before a job is started or before the photographer incurs any expenses for a job. Without long experience in the field, you should *never* attempt to work without a written agreement. It is the only legal backup you have.

Either a purchase order is issued by the client or an assignment confirmation is issued by the photographer or rep; they are binding agreements between the photographer/rep and the client. They should be issued and signed, if at all possible, before any preproduction work begins. It is very easy to determine if a client will issue a purchase order: ask the art director who is giving you the job. If you issue a job confirmation, it will be the record of the financial agreement for the assignment, and it is meant to protect you. Among the items listed should be the nature and requirements of the job: single-page or double-page, black-and-white or color, and how the picture will be used, including a time frame—for example, a one-year campaign. Any other factor that may limit or expand the agreement is also to be included.

As a rule of thumb, it is always easier to receive a purchase order than to issue a job

Assignment Confirmation/
Estimate/Invoice Form

FROM: **TO:**

Date:
Subject:
Purchase Order No:
Client:
A.D./Editor:
Shooting Date(s):
Our Job No:
☐ Assignment Confirmation
☐ Job Estimate
☐ Invoice

Expenses

ASSISTANTS	
CASTING	
Fee/Labor	_____
Film	_____
Transportation	_____
FILM & PROCESSING	
Black & White	
Color	_____
Polaroid	
Prints	_____
GROUND TRANSPORTATION	
Cabs	
Car Rentals &/or Mileage	_____
Other	_____
INSURANCE	
Liability	
Other	_____
LOCATION SEARCH	
Fee	_____
Labor	_____
Film	_____
Transportation	_____
LOCATION/STUDIO RENTAL	
MESENGERS & TRUCKING	
Local	
Long Distance	_____
SETS/PROPS/WARDROBE	
Set Design Fee	_____
Food	
Materials	_____
Props	
Set Construction	_____
Set Strike	
Surfaces	_____
Wardrobe	
Other	_____
SPECIAL EQUIPMENT	
SPECIALIST ASSISTANCE	
Electrician	
Hairdresser	_____
Home Economist	
Make-up Artist	_____
Stylist	
Other	_____
TALENT	
Adults	
Children	_____
Extras	
Animals	_____
TRAVEL	
Air Fares	
Meals	_____
Hotels	
Overweight Baggage	_____
MISCELLANEOUS	
Gratuities	
Shoot Meals	_____
Toll Telephone	
Other	_____
EXPENSE TOTAL	_____

Photography Fee(s) & Totals

$

PRINCIPLE PHOTOGRAPHY (BASIC FEE) _____
($_____ per day or photograph, if applicable)

DESCRIPTION

SPACE &/OR USE RATE (IF HIGHER)
($_____ per page: $_____ per cover: $_____ per photo)
TRAVEL &/OR PREP DAYS (at $_____ per day) _____
PRODUCT OR SUBSIDIARY PHOTOGRAPHY
($_____ per photograph)
POSTPONEMENT/CANCELLATION/RESHOOT _____
(_____ % of orig. fee)
WEATHER DAYS (at $_____ per day) _____

TOTAL FEE(S)
TOTAL EXPENSES (see 1st column)
FEE PLUS EXPENSES _____

SALES TAX (if applicable)

TOTAL _____

ADVANCE

BALANCE DUE _____

MEDIA USAGE

ADVERTISING		EDITORIAL/JOURNALISM	
Animatic	☐	Book Jacket	☐
Billboard	☐	Consumer Magazine	☐
Brochure	☐	Encyclopedia	☐
Catalog	☐	Film Strip	☐
Consumer Magazine	☐	Newspaper	☐
Newspaper	☐	Sunday Supplement	☐
Packaging	☐	Television	☐
Point of purchase	☐	Text Book	☐
Television	☐	Trade Book	☐
Trade Magazine	☐	Trade Magazine	☐
Other	☐	Other	☐

CORPORATE/INDUSTRIAL		PROMOTION & MISC.	
Album Cover	☐	Booklet	☐
Annual Report	☐	Brochure	☐
Brochure	☐	Calendar	☐
Film Strip	☐	Card	☐
House Organ	☐	Poster	☐
Trade Slide Show	☐	Press Kit	☐
Other	☐	Other	☐

Subject to all Terms on Reverse Side — Which Apply in All Cases Unless Objected to in Writing by the Sooner of the First Shooting Day or Ten Calendar Days. Usage Limited to Reproduction Rights Specified

Client Signature: _____

Terms and Conditions

(a) "Photographer" hereafter refers to (insert name). Except where outright purchase is specified, all photographs and rights not expressly granted on reverse side remain the exclusive property of Photographer. All editorial use limited to one time in the edition and volume contemplated for this assignment. In all cases additional usage by client requires additional compensation and permission for use to be negotiated with Photographer.

(b) Absent outright purchase, client assumes insurer's liability to (1) indemnify Photographer for loss, damage, or misuse of any photograph(s)and (2) return all photographs prepaid and fully insured, safe and undamaged by bonded messenger, air freight or registered mail, within 30 days of publication. In any event, client agrees to return all unpublished material to Photographer in the above manner, and supply Photographer with two free copies of uses appearing in print.

(c) Reimbursement for loss or damage shall be determined by a photograph's market value or, in the absence of that due to lack of prior use, then its intrinsic value.

(d) Adjacent credit line for Photographer must accompany editorial use, or invoice fee shall be doubled. Absent outright purchase, client will provide copyright protection on any use and assign same to Photographer immediately upon request, without charge.

(e) Photographer has supplied or will supply specifically requested releases on photographs requiring same for use. Client will indemnify Photographer against all claims and expenses due to uses for which no release was requested in writing. Photographer's liability for all claims shall not, in any event, exceed the fee paid under this invoice.

(f) Time is of the essence for receipt of payment and return of photographs. Grant of right of usage is conditioned on payment. Payment required within 30 days of invoice; 1½% per month service charge on unpaid balance is applied thereafter. Adjustment of amount, or terms, must be requested within 10 days of invoice receipt. All expense estimates subject to normal trade variance of 10%.

(g) Client may not assign or transfer this agreement. Only the specified terms, hereby incorporating Article 2 of the Uniform Commercial Code, are binding. No waiver is binding unless set forth in writing. Nonetheless, invoice may reflect, and client is bounded by, oral authorizations for fees or expenses which could not be confirmed in writing due to immediate proximity of shooting.

(h) Any dispute regarding this agreement, including its validity, interpretation, performance, or breach, shall be arbitrated in (Photographer's City and State) under rules of the American Arbitration Association and the laws of (State of Arbitration). Judgment on the Arbitration award may be entered in the highest Federal or State Court having jurisdiction. Any dispute involving $1000 or less may be submitted, without arbitration, to any Court having jurisdiction thereof. Client shall pay all arbitration and court costs, reasonable Attorneys' fees plus legal interest on any award or judgement.

(i) Additional Specifications: (to be filled in as applicable)
Placement (cover, inside, etc. _____).
Size (½ page, 1 page double page, etc. _____).
Time limit on use _____ Use outside U.S. (if any) _____ .
Copyright Credit Line is required in the following form: © 19___ (insert photographer's name).

(j) Client agrees that the above terms are made pursuant to Article 2 of the Uniform Commercial Code and agrees to be bound by same, including specifically clause (h) above to arbitrate disputes.

(k) Weather postponements and cancellations 48 hours prior to shooting, will be billed at ½ fee. Thereafter, full fee will be charged. All expenses, costs and charges shall be paid in full by the agency.

(l) Days put on hold at client or agency request and not cancelled within 24 hours will be billed at full fee. All expenses, costs and charges shall be paid in full by the agency.

(m) All cancellations after confirmation and/or booking a shooting date will be billed at ½ fee if cancellation is prior to 48 hours before shooting date, and full fee if cancelled less than 48 hours before shooting date. All expenses, costs and charges shall be paid in full by the agency.

(n) If same photograph that is cancelled is rescheduled for a later date, full fee will be charged for the actual shooting.

(o) The cost of all charges or deviations from the original layout or job description must be approved by the art director, art buyer or agency representative.

(p) The agency is responsible for sending an authorized representative to the shooting. If no representative is present, the agency must accept the photographers judgement as to the execution of the photograph.

(q) When shootings are booked on a day basis, the day rate shall apply to any consecutive 8 hour period. Any further time will be paid for on a pro-rated basis. All additional expenses (rentals, talent assistants, etc.) due to extended time shall be paid in full by the agency.

The assignment confirmation and its terms and conditions must be equally explicit.

confirmation—you avoid the paper work. However, there is an advantage to being the one to draft a binding agreement. In such cases you can include riders specifying your requirements, copyright, the credit that should be used, loss or damage as the responsibility of the client and your reimbursement for these occurrences, responsibility for release, and so on.

Billable expenses are arranged between the photographer or the rep and the client. Many of the expenses are reimbursable according to the arrangements set down on the purchase order or job confirmation. Reimbursement is standard for film and processing of black-and-white, color, and Polaroids. All location fees, transportation, and travel time (billed at 50 to 100 percent of the normal day rate), as well as lodging, food (including lunches if applicable), scouting ex-

penses, location, search, tips, and overweight baggage, are also paid by the client. Any special technical requirements for a job, such as helicopter rentals, a special lens for photographing insects, or unusual studio needs, will also be billable, as will any rented or leased equipment that a normal job would not require, such as generators or kitchen equipment. Fees for additional professional assistance, such as casting agents, stylists, hairstyling, and makeup—in fact, anyone except the first assistant or studio manager, who has traditionally been part of the photographer's overhead—will also be billable to the client. In cases of time-consuming travel or when additional assistants are needed, the client pays. Overtime for crew members is another billable expense. Any additional insurance for liabilities that may be part of a job, such as insuring jewelry and fur coats, is taken out by the photographer for the period of the shooting and billed to the client. Petty-cash outlays for messengers, postage, miscellaneous trucking, cables, or long-distance telephone calls should be recorded and billed.

As media changes (billboard, packaging, and so on) occur after negotiations have been completed, the budget should reflect these changes, and it is advisable to obtain a new purchase order. Any shifts in the job concept should be carefully considered in terms of a major shift in the requirements of the job or the degree of difficulty of the work. Subtle changes can cause dangerous expense changes, and unless they are billed to the client they will become an expense to you. Time must also be considered an expense, if it is not paid for by the client. By being sensitive to the nature of the changes and what they mean to expenses as well as your fee, you can control the profit on any given job.

Payment terms should be stated on the purchase order, and if payment is not received in thirty days there is usually a 1½ percent service charge per month. Payment for expenses is usually the client's responsibility, but because suppliers bill photographers, the photographer accommodates the client by advancing the payment. The expenses are then documented and billed with the fee. When expenses will exceed 25 percent of the fee, an advance from the client is often provided for on the purchase order. Because of rising expense bills, advances have become more common.

The only circumstances that will affect the fee, besides additional usages, are reshoots, postponements, or cancellations.

RESHOOT: A photographer reserves the right to reshoot, without an additional fee, if he is dissatisfied with the quality of the photographs. If a reshoot is required because of his own negligence or through equipment malfunction, then the client is not charged. Any other reshoot is fully billable according to any previously approved guidelines or through renegotiation. A new purchase order should be furnished before the reshoot.

POSTPONEMENT: A variety of reasons can cause a postponement: weather, lack of delivery of merchandise, a change in concept. The assignment should be moved to a mutually convenient date that falls within thirty days. If the job is not reassigned within the month, then a cancellation fee should be submitted.

CANCELLATION: When time and effort have been spent in organizing a job and the client informs the photographer of a cancellation after preparations are well under way, a cancellation fee is paid. If a signed purchase order has been obtained, the rate fluctuates between 25 and 100 percent of the fee, depending on the circumstances and the photographer's relationship with the client. The amount depends on the loss sustained, since the photographer may not be able to arrange another booking on short notice.

The last point about purchase orders or job confirmations is that for each step of the process a separate form should be used: an estimate, a confirmation, an invoice. It may seem easier to use a form that covers everything, but this can be highly confusing, and the whole point of being organized is to give yourself peace of mind.

When a job is completed and delivered and the selection of photographs has been made, the invoice is sent to the art director; it should cover all aspects of the job, including the intended usage of the photographer's work and fees and expenses. It is important always to double-check an invoice—an overlooked omission could cost you money.

At times the client will want to review a written estimate, including all the projected costs and fees, before a job begins. You are expected to keep within 10 percent of your estimate. For

each job a separate file should be maintained with copies of the three different forms—the estimate, the purchase order or job confirmation, and the invoice.

A delivery memo can be used to ensure that the materials sent to a client or art director are recorded and returned in the same condition. And if there are any questions about the location of a portfolio or stock pictures, answers can be traced. Many times during the course of an upcoming campaign the art director will duplicate a piece of work from a tear sheet or a chrome to use as reference art. This is a widely practiced method of obtaining "swipe," which art directors use in putting together comps (rough artwork) for campaigns. It is assumed that the photographer whose swipe is used will be asked to photograph the campaign, although this is not always the case.

USAGE: Any use beyond that which has been granted in the purchase order requires additional compensation, to be negotiated with the rep or photographer. The negotiation will depend on the usage established for the photographs during the initial negotiation between the rep or the photographer and the client. In order to avoid uncertainty and misunderstandings, it is wise to state the specifics in any written agreement, especially that payment for extensive reproduction does not include purchase of the copyright. Each area has its own idiosyncratic practice, but usage always figures in the pricing. Editorial is based on one-time publication. Advertising is based on space and type of use—national ads, trade ads, or use in a brochure.

COPYRIGHTS: The copyright question is complex. Here are some specific things to be careful of. A free-lance photographer when on assignment—or anytime—is the owner of his work unless he agrees to waive that right. ("Work made for hire" is an expression used in transferring or waiving the copyright of assignment pictures.) The new copyright law of 1978 gives the copyright to the photographer throughout his lifetime plus fifty years. There are two ways to secure a copyright: proper notice on each photograph, and registration at the Library of Congress, which is for both an individual picture or bulk pictures. Damages for infringement of a copyrighted photograph can be sued for in court under specified legal precedents, for example, breach of contract, unfair enrichment, or improper conversion of a photographer's property. There is a "fair use" doctrine that allows for some uses of a copyrighted photograph. Copyright guidelines should be carefully reviewed and applied to your work as warranted.

RELEASES: The release is a document stating that a person has consented to being photographed and to the photograph's being used.

A release from the subject should be obtained at the shooting. You should also date both the release and the photograph so that no questions arise later as to what release applies to what photo.

A release protects a photographer from an invasion-of-privacy lawsuit, which can be brought when a photograph is used without authorization for "trade or advertising," or a libel suit, which alleges that the person in the photograph has been subjected to some form of unfair embarrassment or loss of status and/or income by virtue of a published photograph.

When a photographer is taking a photograph, he often does not know what uses will ultimately be made of it. If you don't have a release and the picture might tend, however remotely, to embarrass the subject, then the possible publication should be reviewed by an expert. The photographer should discuss insurance against these kinds of risk with an insurance adviser. It is called advertiser's liability insurance. A photographer should never specify that a release is available when in fact it cannot be found.

The use of "trade or advertising" does not include the editorial contents of most news and informational media. The U. S. Constitution's First Amendment provides protection of the photographer without a release for nonadvertising or nonpromotional photographs appearing in any media on any subject of public interest about any person shown and the subject in question. The primary issue is usually whether or not the person in the photograph was properly associated with the subject matter in question and the amount of harm caused by any improper publication.

A release should be obtained for both people and places: a building has no right of privacy, but it does come under unfair competition infringement. Public buildings or places that charge admission are usually not included. If any doubt about the legality of a background is involved, consult the local authority in the area.

Delivery Memo

FROM: **TO:**

Date:

Subject:

Purchase Order No:

Client:

A.D. Editor

Our Job No:

Enclosed please find:

Set No. & Subject:	Format:	35	2¼	4×5	5×7	8×10	11×14	Contracts
Total Black & White	Total Color							

Kindly check count and acknowledge by signing and returning one copy. Count shall be considered accurate and quality deemed satisfactory for reproduction if said copy is not immediately received by return mail with all exceptions duly noted.

Terms of delivery:

1. After 14 days the following holding fees are charged until return: $5.00 per week per color transparency and $1.00 per week per print.

2. Submission is for examination only. Photographs may not be reproduced, copied, projected, or used in any way without (a) express written permission on our invoice stating the rights granted and the terms thereof, and (b) payment of said invoice. The reasonable and stipulated fee for any other usage shall be two times our normal fee for such usage.

3. Submission is conditioned on return of all delivered items safely, undamaged and in the condition delivered. Recipient assumes insurer's liability, not bailee's, for such return prepaid and fully insured by bonded messenger, air freight or registered mail. Recipient assumes full liability for its employees, agents, assigns, messengers and freelance researchers for any loss, damage or misuse of the photographs.

4. Reimbursement for loss or damage shall be determined by photograph's value which recipient agrees shall be not less than a reasonable minimum of $1,500.00 for each transparency and $ for each print.

5. Objection to above terms must be made in writing within ten (10) days of this Memo's receipt. Holding materials constitutes acceptance of above terms which incorporate hereby Article 2 of the Uniform Commercial Code.

6. Any dispute in connection with this Memo including its validity, interpretation, performance or breach shall be arbitrated in **(photographer's City and State)** pursuant to rules of the American Arbitration Association and the laws of **(State of Arbitration)** Judgment on the Arbitration award may be entered in the highest Federal or State Court having jurisdiction. Any dispute involving $1000 or less may be submitted, without arbitration, to any Court having jurisdiction thereof. Recipient shall pay all arbitration and Court costs, reasonable Attorneys' fees plus legal interest on any award or judgement.

7. Recipient agrees that the above terms are made pursuant to Article 2 of the Uniform Commercial Code and agrees to be bound by same, including specifically the above clause 6 to arbitrate disputes.

Acknowledged and accepted: _____

Delivery memos help to keep track of materials sent to art directors and clients.

Adult Release

In consideration of my engagement as a model, and for other good and valuable consideration herein acknowledged as received, upon the terms hereinafter stated, I hereby grant _____, his legal representatives and assigns, those for whom _____ is acting, and those acting with his authority and permission, the absolute right and permission to copyright and use, re-use and publish, and republish photographic portraits or pictures of me or in which I may be included, in whole or in part, or composite or distorted in character or form, without restriction as to changes or alterations, from time to time, in conjunction with my own or a fictitious name, or reproductions thereof in color or otherwise made through any media at his studios or elsewhere for art, advertising, trade, or any other purpose whatsoever.

I also consent to the use of any printed matter in conjunction therewith.

I hereby waive any right that I may have to inspect or approve the finished product or products or the advertising copy or printed matter that may be used in connection therewith or the use to which it may be applied.

I hereby release, discharge and agree to save harmless _____, his legal representatives or assigns, and all persons acting under his permission or authority or those for whom he is acting, from any liability by virtue of any blurring, distortion, alteration, optical illusion, or use in composite form, whether intentional or otherwise, that may occur or be produced in the taking of said picture or in any subsequent processing thereof, as well as any publication thereof even though it may subject me to ridicule, scandal, reproach, scorn and indignity.

I hereby warrant that I am of full age and have every right to contract in my own name in the above regard. I state further that I have read the above authorization, release and agreement, prior to its execution, and that I am fully familiar with the contents thereof.

Dated: _____

(Address)

(Witness)

Simplified Adult Release

Dated:

For valuable consideration received, I hereby give _____ the absolute and irrevocable right and permission, with respect to the photographs that he has taken of me or in which I may be included with others:

 (a) To copyright the same in his own name or any other name that he may choose.

 (b) To use, re-use, publish and re-publish the same in whole or in part, individually or in conjunction with other photographs, in any medium and for any purpose whatsoever, including (but not by way of limitation) illustration, promotion and advertising and trade, and

 (c) To use my name in connection therewith if he so chooses.

I hereby release and discharge _____ from any and all claims and demands arising out of or in connection with the use of the photographs, including any and all claims for libel.

This authorization and release shall also enure to the benefit of the legal representatives, licensees and assigns of _____ as well as, the person(s) for whom he took the photographs.

I am over the age of twenty-one. I have read the foregoing and fully understand the contents thereof.

Witnessed by:

Minor Release

In consideration of the engagement as a model of the minor named below, and for other good and valuable consideration herein acknowledged as received, upon the terms hereinafter stated, I hereby grant _____, his legal representatives and assigns, those for whom _____ is acting, and those acting with his authority and permission, the absolute right and permisssion to copyright and use, re-use and publish, and republish photographic portraits or pictures of the minor or in which the minor may be included, in whole or in part, or composite or distorted in character or form, without restriction as to changes or alterations from time to time, in conjunction with the minor's own or a fictitious name, or reproductions thereof in color or otherwise made through any media at his studios or elsewhere for art, advertising, trade, or any other purpose whatsoever.

I also consent to the use of any printed matter in conjunction therewith.

I hereby waive any right that I or the minor may have to inspect or approve the finished product or products or the advertising copy or printed matter that may be used in connection therewith or the use to which it may be applied.

I hereby release, discharge and agree to save harmless _____, his legal representatives or assigns, and all persons acting under his permission or authority or those for whom he is acting, from any liability by virtue of any blurring, distortion, alteration, optical illusion, or use in composite form, whether intentional or otherwise, that may occur or be produced in the taking of said picture or in any subsequent processing thereof, as well as any publication thereof even though it may subject the minor to ridicule, scandal, reproach, scorn and indignity.

I hereby warrant that I am of full age and have every right to contract for the minor in the above regard. I state further that I have read the above authorization, release and agreement, prior to its execution, and that I am fully familiar with the contents thereof.

Dated: _____

_____ _____
(Minor's Name) (Father) (Mother) (Guardian)

_____ _____

(Minor's Address) (Address)

(Witness)

Property Release

For good and valuable consideration herein acknowledged as received, the undersigned being the legal owner of, or having the right to permit the taking and use of photographs of certain property designated as _____ does grant to _____, his agents or assigns, the full rights to use such photographs and copyright same, in advertising, trade or for any purpose.

I also consent to the use of any printed matter in conjunction therewith.

I hereby waive any right that I may have to inspect or approve the finished product or products or the advertising copy or printed matter that may be used in connection therewith or the use to which it may be applied.

I hereby release, discharge and agree to save harmless, _____ his legal representatives or assigns, and all persons acting under his permission or authority or those for whom he is acting, from any liability by virtue of any blurring, distortion, alteration, optical illusion, or use in composite form, whether intentional or otherwise, that may occur or be produced in the taking of said picture or in any subsequent processing thereof, as well as any publication thereof even though it may subject me to ridicule, scandal, reproach, scorn and indignity.

I hereby warrant that I am of full age and have every right to contract in my own name in the above regard. I state further that I have read the above authorization, release and agreement, prior to its execution, and that I am fully familiar with the contents thereof.

Dated: _____

Witness

(Address)

5

LIGHTS, ACTION, CAMERA

*Assignment
and Shooting*

THE ASSIGNMENT

Once you have your assignment, preproduction for the shooting begins. This is the start of translating the concept into its final visual form. In addition, preproduction involves strategy and coordination, because in any commercial shooting a large number of people are always involved.

First, meetings between the photographer, the art director, and the rep are arranged to discuss the layout, the concept, and the general production details, including locations, the budget, and which professionals will be required at the shooting. Discussions are also held to decide on props, wardrobe, sets, and any special effects. Such thorough planning is essential to the suc-

cess of the shooting. If the shooting is for an ad, the idea that the ad is to get across will be discussed, including the mood the photograph must convey if the ad is to communicate successfully the underlying intention of the campaign and sell the product. This is tied to the "attitude" of the account.

In most advertising campaigns, market research results will have established the approach that should be used, and the function of the photographer will be to solve the technical problems outlined in the layout and bring to it his own nuances of style. The concept may either have been thoroughly developed by the art director or have been minimally sketched out. If only sketched out, contributions from the photographer and the rep will be necessary to flesh out the basic idea.

In trying to recapture your youth, are you losing your dignity?

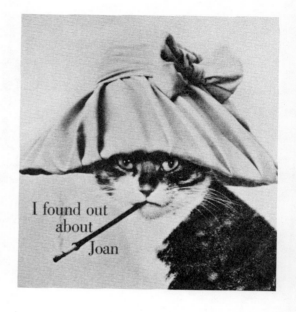

I found out about Joan

These ads were part of a now classic campaign designed by Robert Gage of Doyle Dane Bernbach for Ohrbach's department store in New York City. As in the ad for the Sanforized process, these are examples of a visual joke that is eye-catching because of the juxtaposition of the elements; they are effective illustrations of the use of concept in advertising. Even without copy, the images boldly communicate an underlying message. The photographer's role is especially important in the execution of graphic puns that rely on pictorial impact alone.

Models, Stylists, and the Support Staff

Once preproduction is under way, model selection begins. The selection process can include any number of models, depending on the demands of the layout. The models' physical types, ages, and styles should obviously be compatible with the clothes they are going to wear, but the models should also be able to capture the look wanted and project a flexible range of expression. The right model is often the crucial element in a shooting. Not only must a model be the appropriate physical type, he or she must also be selected by the photographer for less obvious psychological qualities. Photographer Kourken Pakchanian points out the subtle factors involved in such a choice:

> The success of the shoot has a lot to do with the model. When we cast for a model I look for someone who is not only appropriate to either the shoes or the lipstick, but who is intelligent as well. I look for a model who I know can interpret direction and will be able to visualize herself in the situation, rather than someone who has the right figure and simply fits well in the clothes, who may be beautiful but who cannot relax or pick up good direction. You always get better pictures with a secure, intelligent person who accepts herself. If I don't know the model or haven't followed her changes in recent times, I need to evaluate her. If she hasn't changed too much, then I don't have to see her. If the model is very busy but will come in on her lunch hour or late in the day, at that time I will talk to her so that she can prepare herself. I like the models to be a little psyched for the shooting.

Once models have been chosen, they are booked through their agencies. There are usually alternates chosen in a rated order of preference. A fee must be paid if the photographer cancels definite bookings, so great care must be exercised in placing bookings with a modeling agency. Advertising agencies may also have a casting department, which can free the photographer and the art director from the process of choosing

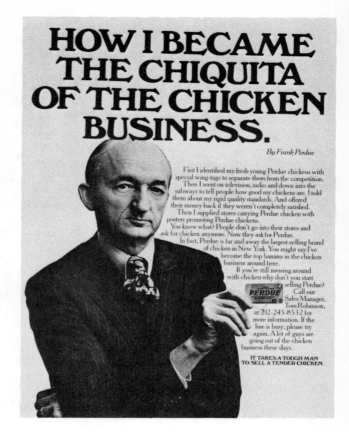

Model selection for this ad was no problem, for the ad's effectiveness lies as much in the brand identification of Mr. Perdue with his chickens as with the one-liners used as copy. This, therefore, might just as well be a portrait of Mr. Perdue set in the context of a visual gag.

and booking models. The selection, however, usually stays in the hands of the photographer.

Any shooting in which models are required involves a number of production people. If the assignment is for a magazine, the fashion editor will be at the shooting to see that the clothes are coordinated and the accessories appropriate, and to oversee the beauty artists who are in charge of makeup and hair. Her main contribution is her taste, for she must make sure that all the elements in the picture work together to create the desired effect, and that the pictures are within the range of what is usable by the publication.

In advertising, the fashion editor's functions are carried out by a stylist. The stylist is chosen

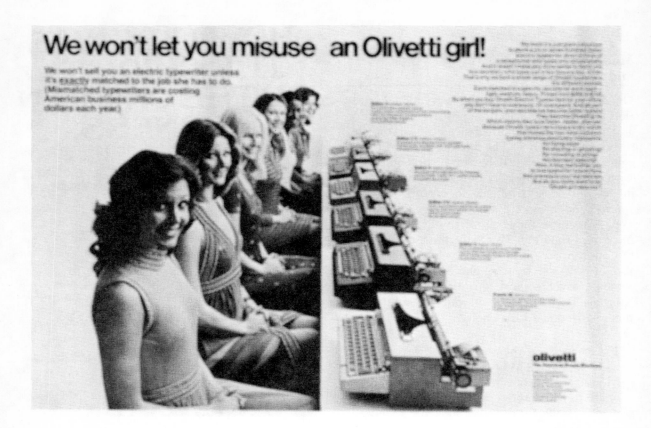

We won't let you misuse an Olivetti girl!

We won't sell you an electric typewriter unless it's *exactly* matched to the job she has to do. (Mismatched typewriters are costing American business millions of dollars each year.)

This is one in a series of ads for Olivetti designed by one of the great innovative art directors, George Lois, and photographed by a master of the product shot, Carl Fisher. It may come as a surprise to novices that the secretaries featured in the ad are the result of careful model selection. These women did not happen to be found in a typing pool, but are the deliberate choices of the agency, photographer, and stylist. The point of all of this was to bring a distinct personality to a piece of hardware and the variety of Olivettis available, by pairing different models of typewriters with different women. Although it appears to be spontaneous, it actually was a complicated production that took several days to set up, test, and shoot. The selection of the model for the Cotton Guild ad from the 1950s (left) is equally crucial, if for no other reason than she is repeated seven times. The two ads each pose difficult styling and composition problems to be solved within the context of a good photograph and a good advertisement.

by mutual agreement between the photographer and the advertising agency. But since it is the photographer who must work with the stylist, it is important that they be compatible. Stylists are generally chosen for their ability to provide not only the props, clothes, and accessories, but also the hair and makeup artists. Because stylists are usually well versed in all these areas, they can provide the elements for a shooting while keeping within the limits of the budget. The stylist must be able to fit into the photographer's working habits; for example, knowing if the photographer will need a large selection of clothes and props or will have a very definite idea of what is wanted. The stylist will be chosen because of a knowledge of the way that photographer operates, the pace, specific lighting requirements, or maybe hair and makeup preferences.

The stylist chooses appropriate clothing and accessories for the ad and is also responsible for organizing appropriate props. Access to a wide variety of designer lines and an ability to provide different looks is an invaluable asset. Like anyone else in professional photography, stylists are chosen by reputation and prior work; they build a career in the same way a photographer does, and they may similarly be represented by an agent or may work independently. A stylist must be efficient, organized, and responsible in order to work successfully with photographers. Only with these established working habits will the stylist then be free to be creative, adding color and design to the layout. Like the photographer, a stylist must be sensitive to the intent of the layout. Tina Fagin, one of the very top commercial sylists in New York, speaks about her profession:

You have to be very diverse as a stylist, and give the models many different looks. Since the agencies are paying you a lot, they expect to be given many choices. I sometimes spend two or three thousand dollars on one high-fashion outfit or a period costume. The clothes often have to be aged to look realistic. In order to accomplish that I bleach, dye, or sometimes use coffee or tea. New shoes are often ruined. I scuff them with sandpaper to make them look used. I choose the clothes by what will fit—basically, what will work in that particular situation.

For costumes—fashion or illustration—every photographer has a list of stylists from which they choose. They pick someone who will be the best for the particular situation. A good stylist can make anything look beautiful. Some photographers hire stylists to work exclusively in their studios, as their personal stylist.

A stylist puts everything together except taking the photograph. She creates the look the photographer has envisioned. Some agencies have specific ideas; I might be called in with the photographer to discuss what it will be. In men's fashion you may be given a suit fabric swatch to work with.

What I do in photography concerns more than just what the models are wearing and the accessories. I will help decide on the beauty artists, the location, the props, the set—the creative look of the picture. I can start with a thumbnail sketch or samples or a conversation about concept. Originally when I started I did everything involved in a shooting. Now I just do costumes for television commercials and film. I'm a specialist in that one area. The wardrobe is a production in itself. I have several assistants who are exclusively hired to find whatever is necessary. I oversee the production end on the set.

A stylist has to listen to the photographer for direction. It's a very political situation because you also have to listen to the art director, but a stylist has her own opinions. At most shootings, someone will take the reins, but a stylist is in the middle when a decision can't be reached. That is the time a stylist should speak up and diplomatically present a solution.

Hair and makeup artists are chosen for their ability to represent specified looks and their strengths in specific areas. The stylist and the hair and makeup artist must be open to direction, flexible in working with the models, and able to participate in a shooting as part of a "family" unit. Model Cheryl Tiegs talks about the importance of the hair and makeup artists:

If everybody makes you feel good, then you feel good and *look* good. In England, they were wonderful—somebody would

**When you really believe in Iowa,
it shows.**

Brenton Banks

After the lovin', platinum is just another fact of life.

Here are examples of three different ways in which the stylist's contribution is a very specific one. In the ad for Brenton Banks, her function would involve not only the selection of the shirt and suit, making sure that they fit the model impeccably, but also—believe it or not—selecting the ideal corn cob to complement the ensemble and then to make sure it stays there. In the top right picture for Polaroid, it is the job of the stylist to create the total ambiance from scratch. This includes the making of the clothes to look appropriately old and used, the gathering of the props, and even the splattering of the paint. In the ad below, the stylist has been given the reverse problem of creating an atmosphere of flawless and effortless glamour for use as an Epic Records ad. The stylists' solutions demonstrate their invaluable talent for ingenuity in creating a mood, whether funky, chic, straightforward, or surreal.

take your coat, then let you sit down and have a cup of tea. Or they would have champagne for lunch. All the little things contribute to the end picture. The makeup and beauty people are really important. The model spends so much time with them, and if they have personalities that allow you to relax and feel good, then the picture comes out that much more beautiful. Beauty comes from feeling good, and it will come out if you're relaxed. The personalities of the hair and makeup artists are very important in extracting that from you. You can't just walk into a cold studio and work all day and expect the pictures to come out well.

Harie von Wijnberge, a world-renowned hair stylist and makeup artist, speaks of the importance of being professional:

Since I deal with makeup more than anything else, I can make the models feel comfortable that I will do the job well. I do the job very professionally, and if there is a technical problem during the shooting, I can deal with it better than the model because it is my profession. The whole purpose of makeup artists being there is to make the model feel very, very special, which will show in the photograph. It's the star treatment—just like the movies.

The Communal Effort

The most important thing in a shooting is the people who will be supporting you. The shooting has to be a mutual, communal effort aimed toward a rhythm that allows the photographer and model to work together, resulting in a successful session. This solid unit, working with the photographer and model, is important to creating the right atmosphere. Timing is also of the essence in order to preserve the energies of the model and the photographer and to keep within the budget. Professionalism is forged under the intense pressure of maintaining a smooth shooting. Ruth Ansel elaborates:

I think part of the skill of a good fashion photographer is to be able to work with certain people who are as temperamental as he

is, to be able to merge with them for the purpose of a shooting. A successful shooting is when the model and fashion editor create their own excitement and offer it to the photographer. It is a mysterious process. The things you think might be important are often irrelevant or secondary to the intuitive grasp of the creation.

Tamarra Schneider, art director at *Seventeen* magazine, won't book a photographer unless the editor says she will work with him. "I may love somebody's work," she explains, "but I won't send them out if they will not be easy for us to work with." In this business it is all close contact, and the chemistry is very important.

This kind of cooperative effort ideally exists through the entire assignment, starting at the top of the decision-making hierarchy, where it is initiated with the art director and the client, through to the final picture.

Art director Louis Hernandez talks about his role in the process:

First I have the layout approved by the client. I show the client the idea we come up with and then describe the essence of what we are trying to do. In the initial layout I cover the basic idea established by the client, but then I suggest that we step on the gas and expand the idea. They will see if the idea fits their strategy, and then they will consider its visual effect. In developing the concept, the relationship between the copywriter and the art director is like that of brother and sister. The next good working relationship is in three parts: the rep, the photographer, and the art director. In working with the photographer, I present the layouts to him, show him what the client is expecting. I believe once the layouts have gone through the client, you should give them exactly what they want. But then I give the photographer poetic license to do something much better. The next thing is choosing models, and you should let the client be as much involved in this process and decision as possible.

You have to work with many people around you. The people I work with are my colors, my palette. I get ideas and inspiration from the people I work with. My

philosophy is to work together like a team. I try to put a series of energy levels together. If you work really hard you can be really creative, but you have to be very businesslike. You have to be very verbal; communication is of the essence. Ultimately, though, if you are going to grow, the important thing is your relationship with your client.

It is essential to have an integrated sense of photography and layout, a strong graphic sense that allows you to contribute to the art director's concept, amplify it, and bring your own perceptions to it. Peter Strongwater, a photographer, emphasizes this point:

I like to work with an art director on concept, from the inception if possible. I work best when a certain atmosphere is needed, when it is "this is the feeling we want," so the agency or the magazine can get what they want but I can help shape it, too. I don't like to take a layout and execute it literally. If you want that, you can hire a mechanic. I think a shooting always turns out better if I am part of the progress.

HOW THE COMMUNAL EFFORT WORKS: An example can show how the communal effort works, how collaboration between a client (Max Factor), an art director (Art Kugelman), a photographer (Kourken Pakchanian), and his rep (Adrian Kliros) created a successful campaign for Max Factor cosmetics.

Adrian Kliros approached Max Factor, hoping to land the Max Factor account for Kourken Pakchanian. At the first meeting, Adrian was shown a series of layouts from a previous campaign. He was asked to comment on what had been done with the concept of the campaign. Adrian said he felt the campaign had been rather flat, sterile, and lacking in energy, and as an alternative he suggested ways it could be improved. To start with, he recommended Kourken, whose style could bring something fresh to the campaign. The client liked the approach and the interpretation of the concept Adrian and Kourken had come up with. After a series of discussions covering the attitude of the account, they awarded the Max Factor campaign to Kourken.

Production

The client wanted to select a new face that wasn't established or known. Through exhaustive casting over a period of four days, they decided on a model named Katrinka. The ad called for a woman with a fresh as well as beautiful appearance, someone who would be able to project both sophistication and playfulness. Once the model had been selected, careful consideration was given to finding a hair and makeup artist who could enhance the qualities for which Katrinka had been chosen. Christine de Lassus was picked as stylist because of her knowledge of the top designer lines.

After the successful production and completion of the first ad, a second set of ads was developed and completed in much the same manner. In the third set the client needed four spreads completed within four days. The process that had previously taken a week to ten days—getting another new face, new stylists—now had to be done in half that time. The consistent quality of photographs and the ability of the rep to service specific needs enabled a successful working relationship to develop. The photographer's dependability, ability to work under pressure, and cooperation in pursuing alternatives resulted in a successful advertising campaign.

Location

Location is, of course, determined by the demands of the layout, the type of product, the preferences of the client, and the budget. Many people may be involved in scouting a location. There are a number of books available that can tell you where to find exotic, unusual, or specific types of locations.

The importance of spec-ing a location cannot be underestimated. There are so many things that can go wrong at a shooting that you should never add to your problems by being unsure of your location. For example, Elizabeth Heyert, an interiors photographer, and her assistants once spent six hours, starting at 5:30 P.M., setting up a table shot—a champagne dinner with candlelight—in a Manhattan apartment overlooking the East River, with a dramatic view of the Fifty-ninth Street Queensboro Bridge. It took until 11:30 P.M. to solve the technical problems of balancing the candlelight in the apart-

In ads requiring location work as well as a sizable cast of models, props, and crew, the coordination between the photographer, the stylist, the agency, the hair and makeup people, and the models demand the kind of teamwork found in a Broadway play. If you think of all the details to be considered in setting up a complex shot like the above, you will realize that the photographer's function is at times close to that of a movie director.

ment and the lights of the bridge outside. After taking some final Polaroids, just to make sure everything was set to shoot, she looked into the viewfinder only to discover that the bridge had disappeared—the bridge lights are turned off at midnight. The entire setup had to be done all over again the next evening.

Another vanishing location happened when Deborah Turbeville found a beach with a group of rocks that beautifully complemented the clothing for a fashion assignment she was going to shoot. Five models, assistants—about thirteen people in all—and equipment were loaded into a van. They were unexpectedly stuck in a traffic jam, and by the time the crew reached the location the tide had come in, and the rocks, along with the rest of the beach, were completely underwater. The shooting had to be done on the steps leading to the beach with Deborah in a rowboat bobbing about ten yards offshore.

In other fields of photography, spec-ing is not only advisable but essential. Without careful preparations there may be no picture at all. Peter Gimbel, director of *Blue Water, White Death* and a renowned underwater photographer, illustrates:

It is crucial in underwater photography to do a proper location search to ascertain both the predictability of the wildlife subject and the conditions. During the scouting for *Blue Water, White Death*, we established and checked out each of the locations one year prior to the shooting so that there would not be any seasonal distortion in terms of the prevalence of sharks or the meteorological conditions. The conditions to be considered were water clarity (which is an important consideration in lens selection), currents, water temperature, wind and waves, as well as the atmospheric variables for brightness. Even when careful scouting has been done, you must make sure man has not tampered with the area after your reconnaissance was completed, e.g., dynamiting, long-line fishing, chemical contamination, and other insults to the ecosystem.

In getting a location, you have to make sure that you have secured permission if it is owned by a municipality. Permits are easily obtainable. There are also fees paid for private locations, whether residential or commercial. In some locations, such as hotels, restaurants, and theaters, unions will have to be dealt with. Backstage in a theater can be a very difficult place to work because of restrictive union practices. When shooting in any place covered by unions, you must negotiate permission, and you must abide by the rules that govern union members.

Formerly it was quite fashionable for photographers to have their own studios, but this practice has decreased in popularity. Now it is essential only for still-life photographers to have studios. Some photographers maintain a shooting space that is oriented to their favorite light, usually northern, or know of a variety of available spaces, which they use as jobs require. It is becoming more common for a photographer to rent a fully equipped studio when needed. Temporary spaces used as locations or rentable facilities are alternatives to the traditional concept of a studio as an integral part of commercial photography. There are positive advantages to not having a studio. Deborah Turbeville, for example, is known for her imaginative environments, which have become part of her trademark. Because Deborah is not tied down to a studio, she allows herself to come up with creative solutions for assignments. The nature of ads is also changing. The image of a natural life-style has become an important part of current selling techniques, because advertisements respond to changes in public mood; hence the general broadening of attitudes in commercial photography. As a rule I advise photographers against taking on the huge responsibilities of a studio; they thereby gain a freedom and latitude that the studio can limit. In some cases a fully equipped studio may actually become a liability. Because business tends to fluctuate unpredictably in commercial photography, you may invest too heavily in a studio, anticipating continual assignments, only to be stuck with a huge overhead if business falls off, bringing you and your studio down together. Here are two photographers who solved the problem by weighing what their requirements were. For a still-life photographer, such as Mike O'Neill, a permanent studio, however expensive, is essential. He borrowed, and through "financial machinations" was able to buy good equipment

and set himself up. For Annie Leibovitz, a long-time photographer for *Rolling Stone*, mobility is far more important:

> Having a portable studio is part of my whole philosophy of going to the subject in order to have them relaxed and themselves. Most people think of a sitting as something that has to be got over with. I can make the whole experience less horrible if I bring my lights to their home, where they can sit in a chair they sit in all the time, and if they like where they are, then they can relax better.

Each Assignment Is a Different Story

Since the conditions for editorial and advertising assignments differ at a number of specific points, here are examples of various types of assignment.

An assignment begins in the offices of an art director. Tamarra Schneider of *Seventeen* describes the editorial assignment:

> We decide how the story is to be shot in the office after we select the clothes. We talk with the fashion editor about where we're going to shoot, how we're going to handle it, and the general mood we want. Then we get together with the photographer and discuss the story. If he is going to shoot back-to-school clothes, for instance, we try to get on the street and see where it would relate—places that would add a realistic quality to the clothes worn. If a model is sitting in a studio or on the stairs holding a book, we will bring other models into the shot so they can interact and aren't just staring into space or into the camera.
>
> I don't go on the shooting. My assistant is there. But I will talk to the photographer beforehand, and we will discuss the models, layout, and budget.

However precisely the assignment is described and however specific the layout, it is the photographer who must fill out the idea and who must remember that photography is *about* its subject;

for example, fashion photography is *about* fashion, a garment, and a photograph must sell that garment. In editorial work, with the exception of still life, the layout, if there is one at all, will be very sketchy. Here a photographer must bring into play one of his most important assets: the ability to visualize. What kind of situation do you want to create? You must be able to contribute to the original idea, not simply carry it out mechanically. The idea for the story is only the starting point. Arlene McDonald of J. C. Penney points out the attitude of retail photography:

> I appreciate people who contribute to my designs. I am not a photographer. My *design* is my undertaking, and I like to work with someone who will take me one step further. I do the sketches and the artwork, but when it comes to the shooting I am eager to have the photographer add his touches. There are some people who don't work that way—they draw very tight. I think it has to be up to the photographer in the end. I can design my type and my area, but I don't take the pictures.

An example of how this process can operate at its best is the story Bert Stern tells about an assignment, the cover and collateral advertisements for *The Collector-Investor* magazine's premiere issue:

> Larry Brown Associates, the agency in charge of the account, had developed a hand-down layout sketch and had especially wanted to work with me. The sketch was of a Wall Street sign with a sunset in the background. At a preproduction meeting, the layouts were being discussed as they existed, even to methods of stripping in the sign and the sunset. It occurred spontaneously to me that the picture should be of a man walking out of a Wall Street building in a pin-striped suit, carrying a Picasso—the perfect image for *The Collector-Investor* magazine. The meeting adjourned, and Larry Brown subsequently discussed it with the client, who loved the idea and wanted to do it. The photograph appeared on the cover of the premier issue and was used as

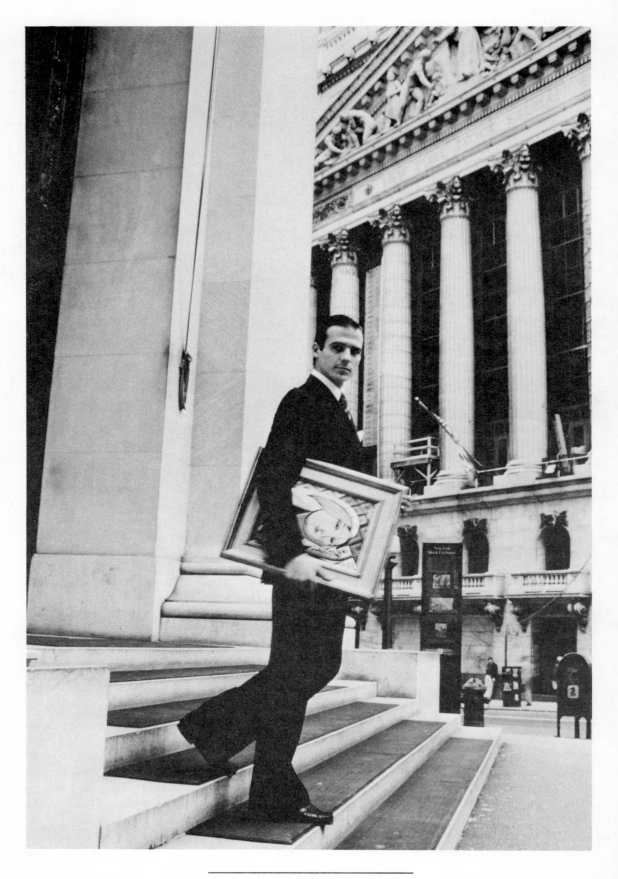

The Collector-Investor, *Bert Stern*.

the collateral advertising. The real success of this picture was that everybody involved actively participated—the art director timed the sun on some stairs near Wall Street so the changes in the light were known, and he changed the direction (north to south) to be photographed so my idea could be realized when I came to the shooting. I tried a new lens I had been testing. There was room for experimentation and innovation in a project that evolved from the initial sketch. A photographer can be *the* imaginative force behind an entire advertising campaign.

If it is a story, what is the narrative line? You do not have to be a scriptwriter to plan a shooting, but it may help to see your pictures as stills from a movie. Most editorial assignments consist of a series of double-page spreads, and they should relate when seen as a sequence. This, not surprisingly, is why editorial assignments are referred to as "stories." Thinking in terms of a movie and your photographs being stills from it, a process of abstraction, is how you conceive a story. Your concept of how it will read sequentially as a story on the double-page spread of the magazine is what will hold your shooting together on the printed page. There is a tendency among inexperienced photographers to overcompensate for style and technique with props from grand opera and sets from *The Ten Commandments*. No amount of inappropriately conceived background will make up for a basic lack of conceptual intent in your photographs.

One witty story of this is told by Horst about himself in his early years, with characteristically wry humor:

My first pictures were loaded with background. I was constantly dismantling palaces, hurling in small forests and entire hothouses meant to enhance but really crushing the little women posing in their midst. Finally I realized the incongruous effect and began a series of strong black compositions that made a big inky splash on the magazine page, blotting out everything else. This went so far that one day a *Vogue* editor produced during a sitting a little flashlight—"just for the dress, please." This absurdity made me laugh and taught me that I was

still avoiding the issue. In fact, the story going around Paris was that I was being paid by the dressmakers to make their dresses impossible to copy. So, by elimination, I arrived at a clarity and a simplification—which, believe me, is harder to accomplish than the murky romanticism of yesteryear.

A successful professional photographer must find the equilibrium between compromises: between fantasy and function, between a personal vision and the client's product, between cliché and innovation, between formula and originality. Although it is a photographer's style and interpretation that makes him sought after for a particular job, Harie von Wijnberge cautions that "you must remove yourself from being an artist when doing a job. What you have to consider when you want to make your living being an artist is that you are not going to be an artist making money doing what you want. Your problem must always be to translate the idea or concept of another artist, such as an art director. You are catering to a client's needs. You make art for yourself and you can make money for them. Photography is a very commercial business. Make the shoes look good."

The limitations of commercial work can also be a springboard by providing challenges and problems you will not encounter in your own work. The important thing to remember is balance. Just as there is no such thing as "pure photography," there is no commercial photography that does not depend on interpretation. *You should never deliberately try to efface your style for any reason.* Your style is the principal reason you have been hired. Tamarra Schneider says:

To me the most important thing about being a successful professional photographer is having your pictures say something about you, no matter what you are shooting. Shoot any type of clothes and still have a personal enough approach to have them be your photos. Different photographers react to different models. Given the same clothes and the same models, one set of photos can look great, and in any other set you can see that the interaction between photographer and model did not exist.

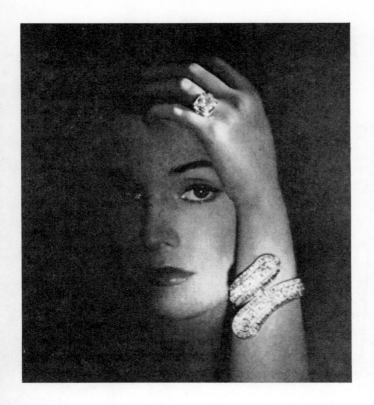

Here are two different approaches to photographing jewelry, both of which make the product seem alluring and the model sensual. The shot on the left by Irwin Blumenfeld for Van Cleef & Arpels was taken in the forties. It makes the woman look mysterious, provocative in a different way. It is both erotic, and abstract. It is also about jewelry. The more contemporary photograph below was taken by O. Paccione for Harry Winston, Inc. By placing the necklace on an unexpected part of the body, the photographer both highlights it and makes a statement. The moods produced here by the photographers are very personal interpretations brought to the sitting.

Above are two ads using cars from different eras and differing photographic points of view. The Lincoln ad at the top, from 1940, focuses on the car as an art object set against a neutral patterned background. The recent ad for the Porsche-Audi Fox uses a visual metaphor to sell its product. The photographer's role is to adapt to the design requirements and the visual vocabulary of his own time, while still bringing his unique interpretation to each layout. Note that background clutter is unnecessary when the conceptual intent is clear.

Frazier Purdy of Young & Rubicam emphasizes the "personality of the work":

The photographer must be able to listen and understand what the assignment is and still bring his own thing into it. It's very, very important. Someone who does not listen and goes out and does it his own way will not be working very long. On the other hand, we want something different from him, so there is a delicate balance. He must be able to address himself to the work and still find solutions. I'd be more impressed with a photographer who shows how he views the world or how he wished to express a metaphor or a different attitude toward the traditional, presenting it in a new light; I'm interested in the personality being represented. The better ones always bring a personal point of view to the job. They make those extra contributions, whether it is lighting, casting, or the visual idea itself. It is very hard to define. It is an attitude that the photographer brings to an assignment. Like Avedon—you look at his work and you can say, "That is an Avedon," because his attitude shows. This is one of the things you are buying, or hope to buy—his sense of personal manner, not just looking through the lens. There are picture makers and picture finders. But even the picture finders must have something unique. Picture makers stage the photos, conceptualize them. We are interested in creativity. That is something that has been missing in the last decade or so.

Art Kugelman of Wells Rich Greene discusses the factors that determine how he chooses a photographer for an assignment:

I have my choice of maybe twenty photographers who will do a good job. There is an instinct, a chemistry, certain intangibles, that come into play. One thing that is important is the ability to make a decision. I don't care if there are ten people collaborating or twenty—the photographer has to make the crucial decisions. Otherwise after everyone goes home I have to look at all those pictures and choose one out of five hundred. Second is the photographer's creativity in cropping. I don't want to exalt this

to a primary art form, but it is creative. It's important for a photographer to be able to make creative decisions because once a job is given out I'm in for the money.

The assignment is realized in the shooting and at this crucial point everything must be coordinated. Timing becomes essential in more senses than one. Not only must you orchestrate every element so that the rhythm of the shoot never lags or goes stale, but you must also anticipate and seize that indefinable moment and crystallize it.

THE SHOOTING

However much planning and preparation have preceded it, when the day of the shooting comes you must rely not only on your own wits but on the experience of the crew you have assembled. You will all have to deal imaginatively with solving both the requirements of the layout and the inevitable problem of there never being enough time. Kourken Pakchanian explains:

Unavoidable pressure comes from not having enough time, like when a shooting should take a full day and it is scheduled to be done in four hours. And then they want to do an extra shot you didn't know about and you say yes to please them. At the end it is passable but not as good as you would like. Time is important, and crew is one of the most important things in overcoming problems created by rushed situations.

A shooting is a timed event during which all the preplanning and organization come together with the photographer's particular ability to focus all these energies and extract a marketable and salable photograph. In fashion and editorial, it is a framed event, with a short time span; it is immediately set into production and quickly seen in the media. It is instantly a finished project. Diana Vreeland points out the immediacy of fashion:

A new fashion can be photographed and published the next morning. The whole world is able to see it immediately. It is the time-eliminating factor of fashion photography that makes it so important.

She stole the shirt off his back. Took the pants off his legs. Now, she's walked off with his closet full of suits.

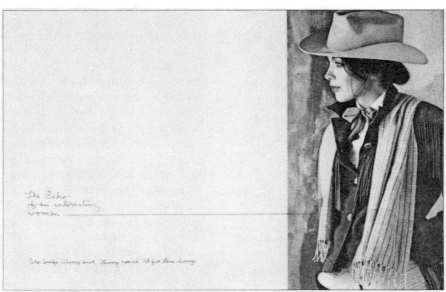

The Echo
of an interesting
woman

Of all forms of photography, fashion photography is most keyed into the trends, styles, and concerns of its own day. In these two recent fashion ads by Hal Davis for Happy Legs/Jazzie and Saul Leiter for Echo Scarfs, the models reflect contemporary attitudes of sexual provocativeness, casual dress, and confidence as well as beauty. Note that both models are wearing men's clothes made for women, but that the looks are quite different. Because fashion photography is such an ephemeral medium, the photographer must be very much in tune with his time to be able to interpret it.

David Leddick, worldwide creative director for Revlon at Grey Advertising, talks about the timing of a shooting:

There are some photographers I really like to work with. They can zero in, and in half an hour they have done their most inspired work. I may as well go home because they've had it. Genius only operates for short intervals. Photographers are very restrained by whom they are working with. It is the people in the studio who create the atmosphere that limits or enhances the photographer's work. It's hard because you have to guide the photographer; you must deliver a certain result, but you try not to hold them down to a point where they don't care and just start clicking away.

On the other hand, procrastination, indecision, and avoidable delays can seriously erode a shooting. Since the peak in an illustration shooting is short-lived and very perishable, it is important to be able to work fast and capture the high-energy moments before they dissipate. Susan Kernit, fashion editor of *Seventeen*, expounds:

I like the work to be done quickly. When you sit around waiting for shots to be taken, the makeup has to be reapplied a thousand times. The energy is lost and it shows in the pictures. You're always trying to keep that energy up, and if you do you get the best pictures. I have worked with guys who take three quarters of the day finding the locations, and when they get around to the shot it isn't worth two cents because everyone gets so dragged out.

Cheryl Tiegs talks about reaching the moment when everything pulls together:

I like it when a photographer gets into a rhythm and keeps taking photographs, even if some of them are bad. I'm not talking about just shooting endless rolls and hoping one will be all right. You have to have the highs and lows, and not every picture can be perfect. One of the only times I cried on a set was when I was working with this photographer who couldn't take a picture no matter what I did. I was twirling around doing everything I could possibly think of,

and he just would not take a picture. He really should have taken a few, allowed me to get a little rhythm into what I was doing, even if he didn't like it. You find that there are photographers who have the kind of personalities you can work with, and then there are some you just aren't in sync with. I have worked with some photographers and it wasn't right somehow, we just didn't have a good rapport.

If a photograph is predominantly subject matter mediated through the ego of the photographer, then the model is the most important ingredient. A mediocre picture of a great model is a good photograph; a great photo of a mediocre model can never be. The creation of a great fashion photograph, as Kourken Pakchanian describes it, is an intuitive, symbiotic process:

A woman is beautiful if, number one, she shows intelligence in the photograph. Now, intelligence doesn't mean that she has to look like an educated person but that she can interpret and transcend the moment that has been caught by the camera, and not even be aware of it. She has interpreted the moment and relaxed. If she is intelligent, regardless of whether she has a certain side which is better, she relaxes, and her beauty will come out of her eyes. If she does not understand her beauty and is insecure and cannot do it even after direction, then she is limited. She may be a beautiful girl in a limited way, but only a new situation will bring out her intelligence. She will be caught in that fleeting moment. It is not only one frame, there are several frames. There is a surprise, and I will say, "This one's for me." I pull that frame where she transcends herself. That is my challenge, and I will always try to find it if I can. Beauty is inner self and inner mind, not just a beauty of body. The model must relate to sadness or mystery or beauty at any moment. A beautiful woman who comes across as worldly, without panic, who has traveled enough and has suffered in relationships, is in control. For example, if there is a scene where I want someone to look frightened because there is an accident in the background and the woman has a look of pain

on her face, then she has become what she was brought up to be—pretty face, nice hair—but she also looks like she suffers. She can be a non-model, but she is more beautiful than the most beautiful model who cannot express those qualities. There is acting that goes into interpreting beauty. I help them relate to the action and then wait for the surprises.

Capturing a mood is a very delicate operation. Just as the model has her peak, the photographer has his high point. The two should overlap. Kourken continues:

It has been said that a photographer's creative peak lasts for twenty minutes at the time of a shooting, and that is right if the photographer is aiming for one concept and one specific photograph. If you have to do two different things, that twenty minutes is only ten. Sometimes the photographer can stretch it out. It comes to a level of how to keep the model interested and keep her going. It all depends on everybody's stamina. If the photographer and the model have stamina, then it can go on, but understand that there is a high point that you reach.

Anticipation is the key to capturing high-intensity moments on film. You cannot wait until after that moment because it will have faded before you've clicked the shutter. Few photographers have understood this area of precognition as well as Bert Stern, and fewer still have been able to use it as effectively. Bert Stern elaborates:

When I shoot I am synchronizing my reflexes with my instincts. I am dealing with 1/1000 of a second for a specific picture. So it becomes an instantaneous delving into a feeling as I shoot toward that person's center. At the most intense moment of involvement the concept of talent is irrelevant.
There are certain things I do that are most natural to me. So when I do what is natural for me it works, whatever that is. I never think of that as being talented. I think of that as being me, and the purer the me is, the more I like it and the better it is. People tend to associate that sort of telepathy with

the picture, whereas it is really a process, something that is functioning successfully.

This is backhanded modesty at its most ingenuous. It would be a serious mistake, however, to think of Bert as naïve about the zone of precognition in which a photographer must work. He has to see that split millisecond with his mind's eye, especially when he uses a single-lens reflex camera, where the mirror obscures the image at the instant the shutter clicks. Bert has an uncanny sense for the projection of that frozen moment which makes still photography somehow spookier than the continuum of film:

The camera itself has to be one of the most important inventions of all, especially in its relation to consciousness. Its appearance parallels our psychic development. The camera is such a fascinating medium because you can project your idea and then suck it in and it crystallizes on film. There's a certain magic in photography. It is different levels of consciousness at work, which is one of the things that has really kept my interest. A picture is full of facts, graphic information on a nonverbal level. Pictures are not limited to what is known.

It must be stressed that there is no one way to approach a shooting. Reportage styles, especially with the perfection of the 35mm camera, have become very popular, but many of the classic fashion photographers such as Irving Penn, Hiro, and Horst created their great pictures through well-planned, deliberate, and highly stylized approaches. In *Photographs of a Decade*, Dr. M. F. Agha, creative director at Condé Nast during its early years, describes Horst's Pygmalion-like method of working with models:

He takes the inert clay of human flesh and molds it into decorative shapes of his own devising. There is nothing accidental in his work; not for him the strange incongruity of arrested artificial motion, the candid awkwardness caught on the wing of a fast lens. Every gesture of his models is planned, every line controlled and coordinated to the whole of the picture. Some gestures look natural and careless because they are care-

These two ads demonstrate the gradual democratization of advertising between the two world wars. Baron de Meyer was a member of Europe's social elite and his photographs were sought after as much for the opulent life-style they reflected as for their technical virtuosity. In this still life for Louis Sherry chocolates, the elegance and the style of the beau monde of the twenties is self-evident. Snobbery was an inherent appeal in early advertising, and this photograph deliberately exudes the precious life-style of the carriage trade. Herbert Matter, on the other hand, emphasizes the practicality of the chinaware in his photograph by showing a housewife doing her own dishes. Along with this new realism came bravura effects which would take the reader's mind off what could otherwise look like plain domestic drudgery. Matter here captures the reader's attention through a technical gimmick. This is only one of an endless number of virtuoso tabletop techniques that can be used to give a product the desired effect. All of the elements in this kind of production must be precisely coordinated to capture the moment.

fully rehearsed; the others, like Voltaire's god, were invented by the artist because they did not exist.

This may seem like a highly idiosyncratic and artificial approach, but any "reality" created in the studio is quite literally artificial by definition. While spontaneity may be desired during a shooting, you should take advantage of the theatrics of a shooting. In any case, careful planning never preempts playfulness.

Ara Gallant, who has produced some of the most provocative images in recent years, describes how he sets up his unique effects:

I like to put people in contexts where you don't expect to see them: it makes your models stand out. Like taking chic people into sleaze, street life, S&M bars. But in my work it's never violent or destructive, and I don't like to poke fun at people either. I just like juxtapositions in life. Even if it's just a picture of a face, I like to have it provocative, not necessarily in a sexual way. You can look at somebody in a photograph and imagine or care about what they're thinking. If you don't care what a photograph is thinking, if it is just a beautiful face, then it's not a photograph to me. It is a frozen frame. You can afford to go dead on a screen for a few moments but not in a photograph.

Whatever effects you are trying to achieve, they must first of all be believable to you. It is an intimacy that involves the viewer because it involves the photographer. Bert Stern recalls contributing to a portfolio in *Life* on photographic interpretations of love. Bert's picture was the only one where the girl is looking out of the page. "I had used my own hand reaching into the frame to touch her face. All the other pictures were of two people looking at each other. The other photographers' interpretation of love was more what they see than what they feel."

An assignment for a magazine that relies heavily on pictures, such as *Life*, *People*, or *Rolling Stone*, presents a completely different set of conditions. Bob Ciano, art director for *Life*, explains:

In most instances the idea for the story originates among the editors and the picture staff. We decide what we want to cover, and the discussion moves on from there to who would be the best photographer to cover that assignment. In general you try to find someone who has a portfolio that is distinctive, who is available, and who can understand direction. One of the problems is that we find not every photographer can do this. For an assignment covering a war zone, we would probably employ two photographers and a reporter with each. We rarely send a photographer out by himself. There is usually a reporter along to help set things up and make sure that the editorial point of view doesn't get obscured. When you are trying to do stories in pictures without relying on text, that is, basically pictures with captions, it is very important to remember you are putting a story together. Not having had a magazine like *Life* around for a while, very few photographers, it seems, think in terms of story.

We have been trying to develop *Life* photographers, for want of a better term, the way the old *Life* did. The photographers who became famous were unknown when the magazine started. So we have given a few assignments to unknowns, and the ones who worked out or showed promise we continue to work with. We have been looking more along the lines of newspaper photographers than advertising photographers.

Hans Namuth, who covered the Spanish Civil War for a number of European and American magazines through an agency that became known as "Pix," describes the conditions under which a reportage photographer works:

Photographing under combat conditions sharpens your reflexes. You become terrified, or perhaps you get used to the noise and danger of the situation and keep taking pictures. In documentary photography there is often an element of directing people, which is necessary to create an air of naturalness. The photographer's presence has to be invisible, although people

Here are two ads that unmistakably reflect their own era. Note, for instance, that the model above is set against a background of the Washington Monument, expressing the patriotic spirit of the postwar times. Below is a photograph by Margaret Bourke-White, who, like Steichen, de Meyer, Berenice Abbott, and Paul Strand, did not make a distinction between the work that she did for clients and the work she did for herself. Here Bourke-White consciously imitates a painting by Degas in an advertisement for the Beck Engraving Company of Philadelphia. In the forties photography still aspired to emulate painting as the superior art form. Today, of course, photographers no longer feel the need to consciously imitate the great masters.

Green.

Shooting photo-illustration could be compared to directing mini-movies, except that in print ads you only get one frame to tell the whole story. The face of this new recruit is a map of apprehension. What might at first seem a negative message is actually an ingenious use of reverse psychology: the Army provides the challenge that will make a boy into a man.

react as strongly to the presence of a cam-
era as they would to a gun. The first thing I
learned to say when I was photographing
the Civil War in Spain was *"No mira la
machina,"* Spanish for: "Don't look at the
camera." This, or a similar phrase in my
atrocious Spanish, would immediately iden-
tify me as a friendly foreigner and as a pro-
fessional.

Shooting corporate annual portraits demands
another skill that defies even the most ingenious
design sense. Here, Hans Namuth suggests, you
may have to rely on shock tactics:

At times you must go to extremes to get
any expression out of corporate executives.
You have to talk to them, joke with them,
insult them if there is a desperate lull in the
proceedings. You must learn to "loosen
them up," and in a way they like to be
shaken up. They are often terrified of the
camera, and always say that five minutes of
their time is all they can give you. I think, if
a photographer gets tough to them, they re-
spond to him, which is the only way to get
a good photograph. In other words, don't
be timid. Assert yourself. They'll respect
you, especially if your picture of them
looks good in the annual report.

Whether you are dealing with a group of ex-
ecutives or a group of artists and poets, the
problem becomes more complicated as more
people are involved. Hans Namuth describes an
interesting solution to a group portrait of the
New York avant-garde when two members
were absent:

I remember once in the sixties solving a
problem of a group photo of John Cage and
the people around him for *Harper's Bazaar*
in which the two most significant members
of the group, Robert Rauschenberg and
Jasper Johns, could not show up for some
reason. However, there happened to be two
other people present, my son, Peter, and the
boy friend of the art director, an Italian
painter. I shot a few photographs of the
group adding these extra bodies. From pho-
tographs taken earlier of Rauschenberg and
Johns I chose some head shots and stuck

them on Peter's and the Italian's bodies.
Whereupon a friend, the photographer
David Attie, said, "Why not switch every-
body's head around?" John Cage's head
went on David Tudor's body, Jackson Mac-
Low's head on John Cage's body, etc; in the
end the completed collage looked as if it
had been planned that way from the begin-
ning. It was a great success.

One of the problems a photographer faces in
shooting individual portraits is making his sitter,
through his background, express himself symbol-
ically. As Arnold Newman points out, most
people's environments are naturally expressive
whether they are writers, engineers, or artists,
and the most basic intuition allows you to capi-
talize on this:

When you go to photograph someone in
their own environment, you have a ready-
made context. This is especially true in the
case of an artist. You must be able to take
advantage of a unique opportunity. When I
was shooting Edward Hopper, everything
in his house looked like his paintings. In
fact, so much of what I saw had been in his
paintings, wherever I looked it resembled
his paintings. That's why my portrait of
him looked so much like his canvases; he
was in his own context.

This suggests an important point to remember
when taking portraits. Unlike fashion or adver-
tising, where having a concept of what you are
going to do at the shooting is almost essential, in
portrait photography you should set out with as
few preconceptions as possible.
Annie Leibovitz, who has shot nearly all the
celebrities who have appeared on the covers of
Rolling Stone over the past ten years, explains:

I think it's important for a beginner to al-
ways maintain an open mind. Once I am
with the person, it's what happens between
me and the subject. If you have a precon-
ceived notion before you go, you are stuck
with it, end up putting yourself in a hole,
and you may miss what is actually going on.
I may discuss graphics or ideas with the edi-
tor, but when I walk into a subject's place, I
know there is no formula to it. You spend

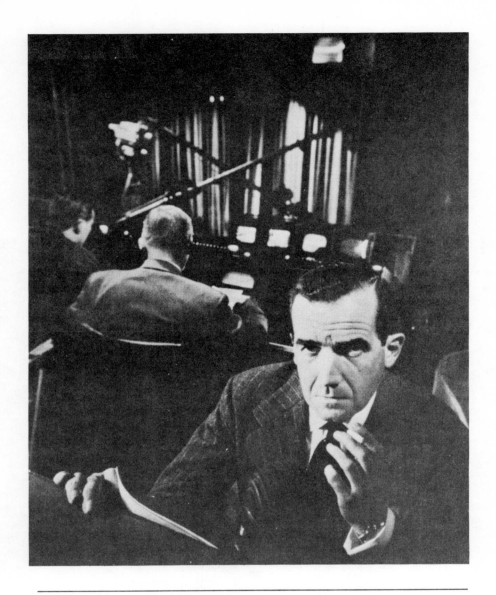

Here Arnold Newman shows Edward R. Murrow, the familiar war correspondent and radio reporter in his studio setting, one which the public would not know. The setting helped to make him recognizable as he was being swept onto the crest of the new wave of television personalities. He is portrayed as he is always remembered—with an intense furrowed brow and the proverbial cigarette in his hand. Mr. Newman has created an indelible image of an American hero.

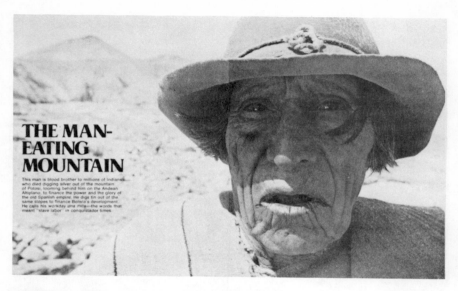

THE MAN-EATING MOUNTAIN

This man is blood brother to millions of Indians who died digging silver out of the mountain of Potosi, looming behind him on the Andean Altiplano, to finance the power and the glory of the old Spanish empire. He digs tin out of the same slopes to finance Bolivia's development. He calls his workday una mita—the words that meant "slave labor" in conquistador times.

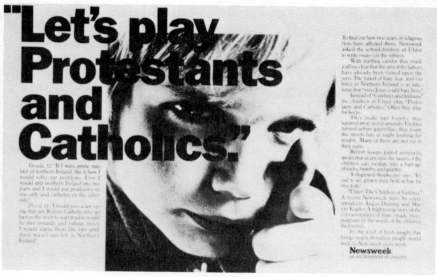

"Let's play Protestants and Catholics."

Gerald, 12: "If I were prime minister of northern Ireland, this is how I would solve our problems. First I would split northern Ireland into two parts and I would put professors on one side and Catholics on the other side."

David, 12: "I would pass a law saying that any Roman Catholic who set foot on the street to start trouble would be shot instantly, and without mercy. I would starve them like rats until there wasn't one left in Northern Ireland."

To find out how two years of religious riots have affected them, Newsweek asked the schoolchildren of Ulster to write essays on the subject.

With startling candor, they made it all too clear that the sins of the fathers have already been visited upon the sons. The mood of hate, fear, and violence in Northern Ireland is so intense that "even Jesus could hate here."

Instead of "Cowboys and Indians," the children of Ulster play "Protestants and Catholics." Often they play for keeps.

They make nail bombs, they squirrel away secret arsenals. Urchins turned urban guerrillas, they roam the streets late at night looking for trouble. Many of them are not yet in their teens.

British troops patrol nervously, aware that at any time the taunts of the children can escalate into a barrage of rocks, bombs, and gunfire.

A depressed shopkeeper says, "It's sad to see grown men hold at bay by wee kids."

"Ulster: The Children of Violence." A recent Newsweek story by correspondents Angus Deming and Marvin Kupfer. A frightening story of the contamination of hate, made more poignant by the words of the children themselves.

It's the kind of fresh insight that brings nearly 18 million people worldwide to Newsweek every week.

Newsweek
an environment of concern.

In a sense, all photographs involving people are portraits. While fashion models often tend to be eclipsed by the clothes they are wearing, in the two pictures above the portraits are the essences of their images—whether used for a double-page spread in Geo magazine (top) or for an arresting ad by Alen MacWeeney for Newsweek above.

time with people, and when you go in to photograph them you really give your whole self to them. I really believe in that theory—that when you go in to photograph them you identify with them, like them a little bit, want to photograph them. When you do portraits you're looking straight into their eyes, and they are looking straight into yours—there is a trust. Sometimes it takes days, sometimes three minutes. You have to be prepared to more or less let them direct it. That's how I get my pictures. I let them pretty much direct it, but only to a point. You take over once you have let them relax. But it's their show. There is no way to make someone look good or bad. You can be understanding, but they reveal themselves. People will always show on film exactly what they are.

It interests me when someone knows what they want to look like. Since it's their photograph, their best ones are usually the ones they did. Recently, for a cover I did for *Rolling Stone*, I spent three days with James Taylor. I was looking for the cover, the ultimate picture, and I was spending time with him to build trust, letting him know I wasn't going to hurt him. It finally came to the point of the last shooting, and everything was being packed up, the lighting and everything, and he said, "Wait, I'd like to try one more thing." It was his idea and it was the best picture. He finally gave himself up and looked directly into the camera. He took the picture. Since photography is in fashion, you would be surprised at how many of these so-called rock-and-rollers know about it. They are all aware of image, and they are all desperately trying to find ways to deal with it. Although some people prefer to work with someone who just gets it done.

My theory is that the covers of *Rolling Stone* are posters. Whether as blowups on the large display carts or as they appear on the cover of the magazine, they should work as effectively as posters do in getting your attention. There is no formula. Bea Feitler [a design consultant to *Rolling Stone*] was the one who instigated the idea for a poster-type cover. Very simple—the kind of typefaces she chose began to make it a real poster, and that is when I began to think of the cover as a poster, not so much as a photograph. I like that presentation. It has impact.

Elizabeth Heyert, who specializes in interior photography, speaks about her approach to her field:

My photographs concentrate on the atmospheric qualities of interiors. This is achieved by careful balancing of the lights, which is technically very complicated. In shooting interiors there are photographers who light and those who don't. I do.

There is a lot of preparation involved in shooting interiors. You have to constantly balance the lights, change light bulbs to keep the color constant. It may take up to four hours just to set up the lights. Even when you're doing catalog work, when the subject matter is not inherently interesting, if you light it gorgeously then you can make it beautiful.

My work is essentially illustrative. Seeing how people live, especially personalities, is very interesting to most people. They are interested in different approaches to interiors—how young people do their apartments, how Joan Fontaine does her house. People want to see how other people function in their spaces. In the case of photographing celebrities' homes, it is really putting glamour on top of glamour. The Dewar's ads where they have profiles of people are a good example because now they are photographing celebrities' homes, instead of just close-up portraits.

Getting an assignment and successfully completing the shooting are the hallmarks of a professional photographer. This comes from an instinctive feel for synchronizing that every photographer must develop. No less important is the ability to anticipate the unexpected and to work with the accidents that inevitably crop up on location. You are the director of a moment, who must take advantage of all the resources at hand and capture the essence.

In this 1963 ad for Lightolier fixtures, Ben Rose has ingeniously transformed what might have been a stark still life into a witty group portrait by paralleling the life-styles expressed by the chairs with the complementary styles of the chandeliers. This in itself is a considerable job of studio lighting by Rose.

Along with changing values in America come changing life-styles. In this 1929 photograph for the Oak Flooring Bureau, we see the standards of that time. The setting is a bedroom simply appointed to show off the merchandise—the floor. William Shewell Ellis, a popular commercial photographer of the time, worked with the pieces to create a warm, inviting atmosphere. The same requirements would be asked of an interior assignment today.

6

FOCUSING YOUR APPROACH

Markets

STOCK

A photographer can augment his income by having his work licensed and repeatedly sold by a stock agency. While some photographers may make a living exclusively out of servicing a stock agency's needs, most are primarily involved in other fields of photography and simply find extra outlets for their photographs through stock agencies. Stock agencies fill a need for pictures that are either too inconvenient or too uneconomical to be assigned. Art directors use stock pictures when they are limited by time, cost, or risk factors on a given job. Usually individual shots are purchased, rather than full stories. A stock agency is a good place to approach if you need a substantial addition to your income or a means of supporting yourself in other pursuits. It is a shoot-first, sell-later field with areas of specialization: agriculture, urban landscapes, sunsets, policemen around the world directing traffic, etc. The fees that are paid for a

photograph are for one-time use at a standardized rate that varies with the purpose, which can range from a billboard to a matchbook cover. If the photographer does not own the picture outright, he must secure permission from the copyright holder.

Photographers can consult a stock agency for self-assignments. For example, one photographer took a few models and went on a schooner cruise. He provided pictures for the owner of the schooner as well as for the company that built it, and they paid his expenses. He worked ten days shooting all over the Caribbean, and that self-assignment will earn him about $20,000 to $30,000 in the next five years. But you can do a self-assignment without great expense. Just one city block will give you many interesting photographs—but as far as commercial resale, that is not reasonable. The majority of photographs submitted to stock agencies come from the residuals of an assignment—shots not used. Before pictures are submitted, check with an agency to

This spectacular aerial shot, used here as an ad, is actually a stock photograph bought from the International News Photo Service. The provocative and nationalistic juxtaposition of USAF bombers against Mount Fuji makes the image dramatic and eye-catching—but the shot also happens to be a sharp, clear picture of the product: Boeing aircraft.

see if it's interested in your shots. When you do submit, accompany the pictures with an itemized transmittal form.

Larry Fried, executive vice-president of Image Bank, a stock picture agency, speaks about the stock market:

It is important for a young photographer to show a lot of pictures. If he is young, he'd better be prolific. Young photographers should be learning their craft, developing quality and style. This frequently comes from professional assignments, although they can shoot a lot on their own. Novices should not be concerned with old-age security at this point. Just out of school, it's unreasonable. You have to develop and learn, and it can't be done with books. I hate to use a trite expression, but you have to pay your dues. The average age of the photographers we use is usually in the late thirties, although we have a few younger ones.

One of our prerequisites is that you have a large file, which takes time to amass, so you have to have been around for a while. The perfect profile of an Image Bank photographer is someone about forty who has had about twenty years of photographic experience and is a highly graphic illustrator. Young photographers can get there, but it takes a while. Image Bank photography is heavily used in the advertising industry but the client could be anyone, and photo researchers from magazines, corporate publications, audiovisual companies, and book publishers also come to us.

New photographers are now learning about the variety of rights they own. We have always been involved in this area. Every photographer should retain his copyright. I personally have photographed about one hundred *Newsweek* covers, and I own all the rights to them, so I can resell them to anyone. I have a huge file of these residuals. A file to a photographer is his old-age insurance, his security, just as an actor may live on television reruns. There is a significant income to be made this way.

We have an agreement with the photographer up front: we take the photograph on consignment. No picture agency that I am aware of actually buys the photograph. If we like his work, we sign a contract with him for a five-year period. He brings us work he wants to put into our library. If we approve his submission we file it. We know what our needs are and what sells for us. It is not hit-or-miss anymore because we know what our clients want. For instance, they might want a classic shot, which might be of a sunset with palm trees. They may say they want a tropical or a California sun, they may say it doesn't matter. We will send them what they request.

We file under categories, not under the photographer's name. If a photographer is going to China or somewhere, we might ask them to try and get certain pictures, but only if they are under our contract. We don't ask anyone outside the agency because it wouldn't be fair to our contract people. We work with about 250 photographers throughout the world. This is a small, very elite group when compared with some other

agencies, which can have from two thousand to five thousand contributors.

The sale price could range from one hundred dollars for audiovisual usage to fifteen thousand, which is rare, but sales can run to these extremes. Fifteen thousand dollars could be for a large budget with all usages given. The photo could be used for years in advertisements, magazines, and newspapers. The picture in the ad for the movie *Close Encounters of the Third Kind*, the one with the road disappearing into the sky, was done by one of our photographers, Pete Turner. This picture earned the photographer a price well into five figures, and all that sold was unlimited use for eighteen months.

The ways in which to use pictures from your own personal stock file are numerous. Every professional photographer is constantly selecting and organizing his work toward specific projects, as well as rounding out or expanding the scope of his stock library. This is an important aspect of photography as a *profession*, and the care and diligence that is exercised with the photographs will be rewarded financially and meritoriously by stock agencies, potential clients, and perhaps even museums, galleries, and publishers.

PUBLISHING AND GALLERIES

Pictures that have already been taken and filed constitute one's stock library, and these can then be extended for two other uses: exhibitions and books. One young gallery owner told me that in speaking to professional photographers for a show he was creating, each photographer was preparing a book; indeed the gallery exhibition can be held either in conjunction with a book or by itself. There are photographic galleries all over the country. And public interest and attention are continually increasing, which will lead to more galleries, more sales and higher prices.

Books can be organized under a monograph, by subject, period, or any other way that works. Publication involves expensive production costs and rarely earns large royalties for the photographer, but it does offer an artistic outlet and a path toward recognition.

A mistaken idea that young photographers have is that publishing a book will immediately entitle them to join the pantheon and be like Avedon or Penn. That is not the case. But publishing a book is something a photographer can do without worrying about whether he is making money or not. He could even put up his own money. It is a superb piece of promotion for himself and puts him into a "serious" category. Any photographer who can afford to do it is very wise to do so, because you are immediately looked at as someone who has a body of work that is worth being published. That is a tremendously different thing from walking around with a portfolio.

It is difficult to know when to publish. There are photographers who run to have books published prematurely. When you publish, it is like exhibiting—that work is then in the past and you go forward. Your career is accelerated. If you have a body of work that you want to put behind you, then it is good to publish it. For example, Eve Simon published a book of her black-and-white photographs when she wanted to move into color work. That was an important move because once she was working in color it would have been very difficult for her to have gone back and published her earlier works in black-and-white. Artists need to step back and see their work in another dimension. It produces a great sense of objectivity.

Avedon's and Penn's careers in publishing are interesting—they began doing books before anybody else was interested in it. They published works that were completed—adventures—so they could then continue on. Books provide tremendous self-gratification. One of the problems with magazines today is that a photographer can't feel that satisfaction.

Every photographer can involve himself in design (outside of the composition of his photographs). If you want to publish your work you should be making dummy books, not just portfolios, which are misleading and do not give you a true sense of your work. Take your work and play, experiment with it as a book to begin to understand something about design. The experience teaches how one photograph affects another photograph, negatively or positively, and it teaches rhythm and pacing. Books are seeing photographs in time and space. You are moving in time and that tempo is like music—learn to build tempo and rhythms. In a good book you

can create all sorts of different movements inside. And things you may have never thought of when you were taking the photographs come out in the book. So the book reveals to the photographer what may not have been in his conscious mind but what was deeply rooted in his perceptions.

It was only after his career in fashion and advertising photography was well established that Irving Penn began to publish books in 1960. Each of his three books typifies a genre. His first book, *Moments Preserved*, was culled from his collection of portraits and fashion photographs for *Vogue*, as well as from his commercial still-life work. *Worlds in a Small Room*, published in 1974, is comprised of photographs taken during his years of travel, usually with a canvas tent that he set up as a studio in order to take his exotic portraits. The fourteen-year period between his first and second books shows that there was a selective, slow accumulation of material. Book publishing is not a quick process with quick rewards; the decisions made about a book require a detailed approach to one's work. A recent Penn book (1977), with text by Diana Vreeland, *Inventive Paris Clothes, 1909–1939*, makes use of his talent as a fashion photographer in quite a novel way: in the photographs of dresses by Poiret and Vionnet, subject and form complement each other. These pictures were taken specifically for a book.

Penn's exhibitions, "Street Material," shown at New York's Metropolitan Museum of Art in 1974, and "Recent Works," shown at the Museum of Modern Art in 1975, gave credence to the argument that current commercial photography can be considered as art. Peter Beard said of his show at the International Center of Photography in 1977 that there were "a few nibbles"; his audience was a wide cross section of people. This show used photography to present "a certain amount of experience," leading us to consider the attitudes toward photography and its state as an art. Penn's exhibition of cigarette butts at the Modern and then again at the Metropolitan Museum also engendered discussion on this issue. While this controversy rages on, photographers are being presented all over the country in galleries, leading us to believe that at last there is a more appreciative audience for photography. Certainly, with more 35mm cameras being bought every year, one would think so.

Victor Schrager, former director of Light Gallery, describes the ever-expanding gallery market:

The younger photographer doesn't really support himself from gallery shows. The economics of it just won't work right now. In many cases, the sales get progressively better each year, so maybe in a few years' time it will be possible to make a living at it. Then, in terms of the intangibles, getting your work into a gallery is very important for getting other sources of income. The way the gallery can handle the photographer's work and get exposure for him may make him more likely to get grants or other subsidies, better teaching offers, and better commissions. Increasingly, the galleries are getting involved in trying to broker investment plans, tax shelter proposals, and investment syndicates for their artists. So much of a reality for the potential of an artist's work lies in that area.

All the galleries have different approaches to letting a photographer show with them. Sometimes they will make an appointment with the photographer. Or on certain days they will see you at any time. At Light Gallery the volume of portfolios that I had to see was over one hundred a month. That prohibited any individual appointments with people, so we would ask them to leave their portfolios for a couple of days. If there were things to discuss, if their work was under consideration, then we would see them. The first step would be to check the policy of the gallery you are approaching.

The kind of photography exhibited at the Light Gallery was contemporary, and we exhibited young, up-and-coming talent. During the time I was there, Grant Mudford appeared through that process. He is still with the gallery and recently had a show. There was a guy from San Francisco and one from Washington State, and they all were getting favorable reaction through first-submission work. It was extremely rare for someone to be taken on absolutely instantaneously. Usually you want to see a second body of work to see if they are consistently good and haven't just made some clever pictures once.

This Berenice Abbott photograph from 1945 and the six following photographs were all commissioned for commercial use. They are now, needless to say, quite valuable, and hang in galleries and museums because of their intrinsic qualities. This goes to show that the best work done in commercial photography will always be on a par with the state of the art in general. (Interestingly enough, the photograph above was actually commissioned by the New York Dress Institute.)

Edward Steichen was one of the pioneers of commercial photography who brought the same standards of excellence to his work in advertising as he did to his exhibitions. All three of these ads were shot by Steichen for Jergens Lotion, and despite the pedestrian nature of the subject matter he manages to endow the photographs with a dynamic sense of design through his use of form.

In New York City there are a lot of galleries that are comparable to Light Gallery—for instance, Daniel Wolf Gallery and Witkin Gallery, which show as many old-master nineteenth-century photographs as they do contemporary, and Sonnabend Gallery, Castelli Graphics, O. K. Harris, and Robert Freidus Gallery, which show contemporary photographs as well as graphics, painting, and sculpture. There are plenty of galleries that operate on either a full-time or an occasional basis, and there are galleries that handle exclusively nineteenth-century material.

There are also galleries outside New York. In the past three or four years almost every major city has had several galleries pop up. In Houston there is the Cronin Gallery, in Boston there is Vision Gallery, in Washington there is the Sander Gallery, and in Chicago there are several galleries that show photography either exclusively or with general fine arts too. In Los Angeles there are about eight galleries, and they are proliferating in San Francisco and Seattle as well. In spite of this growth, there are still only a limited number of galleries with a limited number of openings a year—and there are thousands and thousands of people wanting to exhibit, whether they are coming from a commercial area or straight out of art schools. It *is* tough to get your first gallery exposure.

"Anything that increases your general exposure is looked at kindly by a gallery," advises Mr. Shrager, "whether it's *Camera* magazine, *Forum,* or *Popular Photography*. Some people think that *Popular Photography* is too amateur or hobbyist, but the fact that it has a large circulation is something you can't ignore." He continues:

This Lewis Hine photograph evokes the force of the dignity of labor. Hine is working in a classic tradition—portraits of workers with the symbolic apparatus of their trade—that goes back to the beginning of photography itself.

These two fashion ads were shot by Herbert Matter (top) and George Platt Lynes (bottom) whose work has recently shown up in the Sonnabend and Marlboro galleries in New York. Some of America's largest and best-known corporations, such as du Pont and Cannon Mills (who commissioned these photographs) have given assignments to photographers who are now considered masters. Both are typical of the mannequin-like style favored by photographers until the arrival of the reportage fashion photographs in the early fifties.

A lot of really good photographers overtly or covertly do commercial work. That never worked against anyone, and in some cases it really helped. A crossover between areas is always good. Helmut Newton, for instance, is starting to cross over into the art area by virtue of his achievements in editorial and advertising photography. Arnold Newman, Irving Penn, and Richard Avedon also did commercial photography.

Then there are totally separate areas. A lot of photographers are eager to do whatever commercial photography they can, although it bears very little resemblance to their art work, Lee Friedlander and Duane Michals are examples. Even Ansel Adams did product shots in the thirties. I think it can help and it certainly can't hurt.

Increasingly, galleries are becoming more sensitive to the fact that people involved in commercial work have tapped into a special cultural power that the art photographs, in their most isolated sense, do not avail themselves of. I think the galleries are getting more and more interested instead of less and less interested in this. You can think of the kind of photography they show, in the most narrow sense, as artistic exploration or, in the broadest sense, as the exploration of the cultural power of photographic images. I think that is where Sonnabend Gallery has been all along, and Light Gallery is becoming more sensitive to it. Galleries would be ill advised to draw a line in their policies.

Gene Thornton, New York *Times* photography critic, comments on the power of mass media photography in *Graphis:*

Its ability to set standards of taste is beyond the wildest dreams of a museum director. For this reason, mass media photography deserves attention. Precisely because it *is* commercial art, it must appeal to the public, giving pictorial expression to the dreams and ideals of its time and place.

EDITORIAL

The editorial market considered here is magazines, newspapers, and supplements. On an editorial page the photography does not directly sell any specific product, as is the intention of advertising photography, although the pictures may *promote* the products shown. Because editorial photographs tell a story themselves or promote the telling of a written one, the editorial market relies heavily on the principles of page layout and the significance of the photograph within the editorial context.

As editorial photography exists today, it still owes much to the contributions of Alexey Brodovitch (1898–1971) and M. F. Agha (1896–1978), and the students and colleagues guided by their original insights continue to apply these principles to their work. Brodovitch and Agha were contemporary rivals as the art directors of *Harper's Bazaar* and *Vanity Fair* in the 1930s. Both were Russian-born and both revolutionized editorial standards; page layout, photography, and illustration were no longer mechanical, mundane elements to support the text but were integrated with the editorial point of view. The two men were bold and experimental. Brodovitch applied elements of Constructivist design—the bold graphic style of revolutionary Russia. He painted sets for the Ballets Russes in Paris and seems to have picked up the unique abilities of an impressario from watching Diaghilev work. Agha was appointed art director of *Vogue* in 1929 by Condé Nast, who had discovered him working in the Berlin office. He transformed the role of the art director by insisting that he have control of the design and direction of the photographic content to a much larger degree; he achieved this on the premise that not only was the editorial content dependent on its visual impact but the visual impact was a magazine's organic function. He introduced sans serif typography, hitherto seen only in Europe, and experimented with methods of color reproduction. He introduced the pictorial feature as a standard part of the magazine.

Both Agha and Brodovitch were impresarios. They had a vision of what could be done and sought out the talent to realize it. The role of the art director became one closely associated with the activity of the photographer. The interpretation the photographer gives on the job of the decisions that have been made jointly in an art department by him and the art director is a reflection of the working style developed by Brodovitch. In the catalog of an exhibition in honor of Brodovitch at the Philadelphia College of Art in 1972, Marvin Israel wrote:

I think one of the most moving times I ever spent with him was when I got my job at the *Bazaar*. I went to him and said I'd like to ask his opinion (after all, he really was the Winston Churchill of the magazines). He took down these books, volumes, fifteen years of *Harper's Bazaar*. He was suddenly very paternal, like a father showing the family scrapbook to let me see what the family looked like and what they had done so that I could look like that and do the same. And I did.

The nature of magazine life is that you're in advance of the present; working with Brodovitch you were ahead of the advance. You were trying to create a thing that had never happened before, well before it was ever going to happen. Once you did, it was a fact. The evidence was that everybody around town began to do it. He was obsessed with change. Each issue had to be unique in some way. And before it was even out, there was another one going. I think he was in a perpetual state of optimism.

Bea Feitler, a great art director and graphic designer, said about fashion photography:

The challenging thing about being an art director is working with photographers and developing them. That is becoming harder, almost impossible. As far as photographing fashion goes, it is the outside influences brought into their pictures that change the approach. How can photographers change when they photograph shoes, suits, and dresses every month? It can be different all the time if they are receptive to influences. You must be able to publish photographers so they can see what they have done. Then you can help direct them. The problem is that they don't have a place to publish,

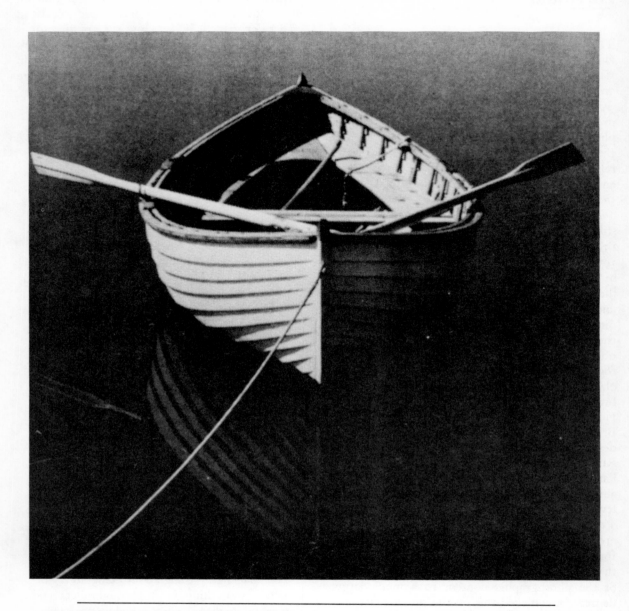

This editorial shot stands up with the best work that can be seen in galleries and photographic books. Through its use of simple lines, this Nautical Quarterly *cover evokes a tranquil serenity and images of a lazy summer day.*

which is why it's so hard for them to change and grow.

As Gene Thornton pointed out in *Fashion Photography: Six Decades*, fashion has become the great equalizer. Through mass production, people are able to dress in the current styles, regardless of their economic status. The styles penetrate the stores that sell even the least expensive clothes, so that on the street nearly everyone can affect a common economic level. Clothes used to distinguish classes; mass production has more or less leveled that distinction. The fashion industry, then, is a relatively democratic industry; style is within the reach of almost anyone who is interested in it.

Diana Vreeland, in a *Rolling Stone* interview, capsulizes this thought and takes it to another level:

Fashion is always taking place. It's the one thing that pestilence, death, economic crises won't affect. Fashion goes right on. Women will always ornament themselves; and there's always a ways and means of making money out of arranging things for women to wear. It's history. It's history through the world.

Fashion photography is a development of this century. Beginning with the photographs of Baron de Meyer in 1913, it has come to supersede fashion illustration as the sole mode of presenting fashion to the public. Succeeding De Meyer at *Vogue*, Edward Steichen introduced the high-contrast, black-and-white, dramatically lit fashion photographs that remain even today as part of the fashion photography vocabulary. Martin Munkacsi at *Harper's Bazaar* in the 1930s took fashion out of the studio into the streets—the reportage style became a staple and is dominating magazine pages more and more.

Since the peacock revolution of the early seventies, the men's fashion photography market has been increasingly active. It still remains open to newcomers; the competition is not as intense as it is in women's fashion photography. There are financial and creative outlets in men's fashion centers, including Chicago, Milan, Paris, and Los Angeles. Ken Fleck, an experienced men's fashion editor, speaks of the peculiarities of the men's wear market:

Men's wear is a strange category, and I think it's a difficult category to take the right approach with. Basically, men don't like to see other men in print. The latest psychological studies have proved that men look at other men in print and think of them as competition. It's actually very territorial. It's interesting to note it and to watch it take place.

For years, men have been buying clothes with their wives, and they would buy things that really looked like quality. There's a company that had slacks out that were so fitted that no one I knew could get into them. I happened to be in a retail store, and what was horrible was a guy with a thirty-eight waist came in with his wife and his wife wanted a fit like in the ads. Now, there is a certain amount of realism and a certain amount of relaxed standards.

Other things are still quite important, like the fit of ties and collars. Sleeve length and cuffs coming outside of sleeves are also very important. When you see men wearing suits, you almost always see a cuff sticking outside his sleeve. The reason for that is that no one trusts someone when they don't know what they've got up their sleeve. Consequently, if you see an arm with just a suit sleeve and no shirt, a subliminal negative image is conjured up.

When you start getting into print, you have to think in terms of somebody who looks clean and manicured to a certain degree but not completely overdone. If a photographer is working for a magazine, he must consider the content of the magazine —who is the audience, and what kind of image is to be portrayed? A lot has to do with motivation, but there are a lot of dollars and cents involved as well. With an ad agency, I have to be concerned not only with what is popular today but with projecting what will sell my product to the broadest section of the market.

The photographer has to look at his male model and be able to relate him to a situation sympathetically. He has to let the model know he believes in the attitude. The good men's photographers I have worked with have always had this factor of "I've got to believe in it" or "I've got to look at it

and say it's real." That's when I think you get the best editorial work, and certainly when you get the best ad work. It's the believability factor. The male animal is not fooled very easily. An esoteric fantasy that works in women's wear does not work in men's wear. The male as viewer is the consuming audience, and the male photographer has got to see it, believe it, feel it, and understand it. More times than not, a stylist on a job will get a guy dressed up and give him a briefcase, a newspaper, sunglasses, cigarettes, a cigarette holder, and a lighter—all the paraphernalia—and then I or the photographer will take it all away from the model because it's not believable. Who is this guy? He obviously doesn't work. If you're shooting men in clothing, meaning suits and sportcoats, etc., there are certain things you have to do. You have a tie, a shirt, a suit, a hankie, socks, belts, all coming from different manufacturers. You've got twenty-two parts that go into that guy's wardrobe. The way men dress, the clothing has to fit perfectly, it must be pinned, the sleeves must be taped the right length, there should be no threads on the buttons.

From Ruth Ansel's point of view, the nature of editorial will see changes in the eighties; it will move on to the new technologies at hand. Video images will come into use and may bring a whole new set of editorial possibilities:

There has been such upheaval. There has been less quality in magazines. I look back at the old *Esquires*, the sheer beauty of the product of the pages; today I don't see wonderful things happening in print. Image making will change, as the nature of the media is changing. In the sixties, when money was more plentiful, money backed editorial photography. Consumerism took over in the seventies, and the advertisers could take more risks, allowing advertising to take over areas where editorial photography used to be allowed to dictate the vanguard. It should be very interesting in the next five years for the young people coming into photography in the eighties— the magazines could become videocassettes. A photographer can create a new book

every three years using images that were only in magazines in the past. Maybe videotape images will replace magazines, maybe they will free the image makers.

I think it is interesting that at the point when photography has been accepted as an art it has ceased to be provocative and challenging even commercially. I think photography will become a more meditative form. But that bothers me, too. I hope not all photography does. I hope some is still there essentially to document. Photography at its best is a documentation of events and people and is a record keeper. I think it is the new uses of visual recording that can be put to exciting uses.

A photographer can approach the magazine industry in several ways. He (or she) can develop his craft in terms of an interest, so that he could work for a specific magazine—as in children's photography for *Parents* magazine. He could also approach the magazine in a general way and attempt to get pictures published that show his attitude, thus securing wide exposure in a magazine such as *American Photographer* or *Zoom*. Or he may wish to approach a magazine such as *Life,* where he can do photojournalism. Getting published in any national magazine can only help one's career. The immediacy of the printed page can focus a photographer's attention on his strengths and weaknesses and teach him a great deal about his own work. Alan Septoff emphasizes the point:

My advice to a novice is that it is important for a young photographer to get tear sheets, like a young art director getting his ideas printed. So if and when the opportunity arises—even if you may not make much money or may just break even—do the piece. People have this idea that you can make a lot of money in photography, but they want to see that return right away. The expectations are so astronomical because of the amounts some people are making—one, two, and three thousand a day.

Andy Grundberg, picture editor of *Modern Photography,* cautions:

Very few photographers can earn a decent living solely from editorial reproduction fees, but traditionally there's been quite a bit of prestige attached to magazine publication. This was especially true in the era of the photo essay—when *Life* and *Look* were in flower. Today there's not so much prestige, but it's still true that art directors at ad agencies and big commercial accounts look through *Modern* and other photo magazines for ideas and names of photographers. At least, that's what I'm told.

Modern reaches well over half a million people every month, which by most standards is a big audience. For most photographers that kind of exposure is unusual, and occasionally valuable as well. We publish all sorts of photographs from all sorts of sources and all sorts of photographers. For "Currents: American Photography Today," a series I'm doing with Julia Scully on contemporary art photography, the pictures might come from a gallery or museum. For more down-to-earth articles, showing pictures taken with telephoto lenses or difficult metering situations or the like, the photos probably would come from the stock of photographers who have shown us their work, or from picture agencies, or from mailed-in submissions. For the cover we might use a commercial photographer who has a studio in New York. Many of the photographers we use live far from our offices—in California, or Colorado, or even in Europe. Many manage to make it financially by getting assignments from *Smithsonian, Natural History, National Geographic,* or *Audubon*—magazines with a need for pictures that show the wilderness, or the Rockies, or whatever. I find it easier to work directly with these photographers even though I have to track them down, because stock agencies and picture agencies don't file things in a way that is usable for us. We need "backlighting" and they've only got a file that says "Colorado River Raft Trip."

Basically, in our picture stories we try to serve the interests of people who are taking pictures. Some photographers are interested in technique and some are not; some just want to know what camera was used. It's a broad spectrum, which is why we publish everything from gorgeous scenic shots to Xerox self-portraits. The only depressing thing about all this is that nobody earns a living working for *Modern* except the staff.

Reflecting on photojournalism and what qualities effective photojournalists seem to share, Bob Ciano says:

If you want to do something for *Life,* newspaper work would be a good way to get into that kind of thinking, where you get past doing a single picture and think in terms of a story.

Most of the stories are not really that accessible. You've got to be quick, and you have to ingratiate yourself with the local people. You are an alien coming there wanting to take pictures, which always causes problems. It is important to be able to do that—fit in. Look at the 1960s pictures that Bruce Davidson did in the South, England, and Paris—they are marvelous. That was because he was able to establish some rapport with the people he was working with. What I find in most of the work I see is a lack of passion, a lack of emotion. Photography has become very introspective and, in so doing, is being shot to hang on the wall. I think that is a valid approach, but it's narrow. Too many photographers are oriented to galleries now. They are fine artists. I'm not negating the art aspect of photography. But there is an emotional quality to photography that too many times is overlooked for the cerebral approach, and that is a mistake. Too often, photographers don't have enough fanaticism about their own photos, or passion. There is a distance that doesn't produce pictures that are moving. The picture may sort of tease someone, but doesn't really deliver emotionally. I see a lot of pretty pictures and designs. I'm interested in people under stress or some emotional situation, not necessarily violent or tragic.

In violent situations the photographers who seem to get the best pictures are the ones who do not care about the danger. They can operate that way because, whether they had fear or not, it never got

in the way of their taking pictures. Taking the pictures, getting it on film, is an obsession. I think that good photographers, whether they are photojournalists or advertising photographers, all share that.

Annie Leibovitz speaks about the photograph within the context of the magazine and the value of seeing your work printed there:

You have to remember when you are working for a magazine that magazines are packages and your work is seen within the context of that package. A photograph of yours does not appear in isolation in a magazine. In the forties and fifties creative photographers worked for *Life* with the idea that they were bringing art to the masses. What they did not realize was that they had become *Life* magazine photographers because that's where their work was seen and that's how people thought of them.

Today the problem with photography is that photographers have been pushed into galleries. I'm not saying that great photographs aren't art, but I think photography's first obligation is to document, to make visible, and it does that best in magazines and books, not as a framed, isolated object or artifact. As an artifact, a photograph loses its informative ability and becomes object-like, another "thing" about which we now need information to understand it. The best photographs have a subjective value, a quality that involves the person who looks at them. Magazines are great catalysts, they release photographic information into the world. When I first saw my pictures in print it was spellbinding. There's a real need to reach out. That is the major function of photography, to reach people, to touch an audience visually and leave an imprint.

My advice to people coming to New York is to just take pictures the way they always did, the way they see things themselves. They should not preconceive a style to fit a magazine. Remember that most of the great New York photographers began somewhere else and that they were accepted and in demand because their style was different, it came from a different place, psychologically as well as geographically.

Your work should be reflective. The value of appearing in magazines is that you can see your work. I didn't know what I had done until I saw the tenth anniversary issue of *Rolling Stone*. Magazines put your work in perspective. If you never see your work in print it will be harder for you to know what you are achieving. When you see it out there you have a better idea of how to change, to expand, to continue.

Mary Shanahan, art director of *Rolling Stone* magazine, describes the nature of personality photography in the music business:

I avoid the idea of rock-and-roll photography. I think it's an unfair judgment of anyone's work. We strive to publish good work by a wide variety of photographers. Since most of our stories are about personalities, there is a strong emphasis on portrait photography, or what you might call personality photography. These subjects can be approached from almost any point of view: reportage, formal studio work, or location pictures. Even a still life of a subject's works or composition could be used. Oftentimes a fashion point of view is appropriate; for example, we used Scavullo for the covers of Linda Ronstadt and Gilda Radner. In other words, it's not necessary for someone to be a rock-and-roll photographer in order to take pictures for our magazine. An unexpected pairing of photographer and subject often produces the most interesting results.

The most difficult aspect of our work is that the subjects are personalities, not models or friends, and probably don't behave in any predictable manner. A subject may be at his best at two in the morning, or arrive at a studio only to announce he doesn't feel like being photographed that day. The trick is to work with these people and be flexible enough so the subject trusts the photographer and makes a good picture, reveals some information about himself.

I think the hardest picture to take is a concert photograph. Photographers aren't always allowed the mobility they need to move around the stage, and you certainly need a lot of guts to push through the

crowds. These situations are usually badly lit, too. It's tough to take more than the standard shot of a small figure with a microphone in front of his face against a black background. It takes a great amount of ingenuity to come up with something new and exciting. We try to assign new photographers for all our stories, but there are instances where we buy unassigned work. I find it important to work with young photographers as well as the more established ones. Because of time limitations, we can't see everyone who calls for an appointment. We've set up a drop-off policy to review portfolios.

John Dominis of *Sports Illustrated*, himself a sports photographer, describes good sports photography and the qualities a novice needs in order to enter this field:

The people I use have generally specialized in sports photography on their own. They have been interested in sports all their lives, and they want to be this type of photographer. I think that is the first essential point, because it is very difficult for any professional to be an excellent sports photographer. It takes a lot of practice. It is almost the same as being an athlete. You have to know sports well, have the reaction time of an athlete, and train like an athlete in the sense of shooting constantly. You should shoot every week, as much as possible, so that you are tuned like the athlete is. That will produce a good sports photographer. The proper equipment is essential. Many young people fail because they don't have the gear. Beyond that they must develop an artistic ability, know composition, lighting, background. The first element is content, the intent. That's the main thing. The exceptional photographer has the special ability to focus faster and follow runners. Also, he uses the telephoto better than other people, as well as having the anticipation it takes to capture sports. I figure that people who are really good at this actually see things in slow motion. They look through the lens and have plenty of time, where someone else would be frantic.

Sports photographers almost always use motor-driven cameras. First you have to focus the lens on the athlete. In football, if it's a pass play and you don't know it, you have to get the camera on the guy that gets passed to and focus. The last thing is to push the button. If you don't care about film you can leave the motor running. But in some sports it's not good to use a motor unless you have a high-speed camera. Most cameras don't run fast enough to catch people at a peak moment. What regular motor-driven cameras are good for is a fall or victory-raised arms or javelin throws. It needs to be a single frame. The photographer's reaction to the breaking of the tape in a run or the javelin throw is more important than the motor. Motor is good for following things like a football play.

If a photographer comes in with two or three football pictures and nothing else, I won't use him. You have to have a selection of sports as well as good pictures that are close in and tight so you can see faces. Ordinary pictures will not do. I get 90 percent ordinary photographers. I don't have the time to develop people in black-and-white photography. I use people from all around the country. Some of them are very good, but I give them a color assignment and they can't handle it. We use some younger people. There is one now who was new a year ago, and now he is one of the regular photographers. He took it seriously and equipped himself, spent lots of money on lenses. Except for working in a studio, sports training is the best training for a young person because you develop focus, composition, and light. If you can shoot sports well you can do everything else better than anyone else. Even if it's a portrait you can do it better because you will be faster in catching the expression. I don't believe anyone should carry a camera around professionally without going through sports training first.

I once worked for a magazine where the people couldn't shoot anything that moved —someone walking down the street or roller-skating. Everything is moving. If you are doing tabletops, that's one thing. In advertising, people move. You should shoot sports with an 8×10 camera so you can

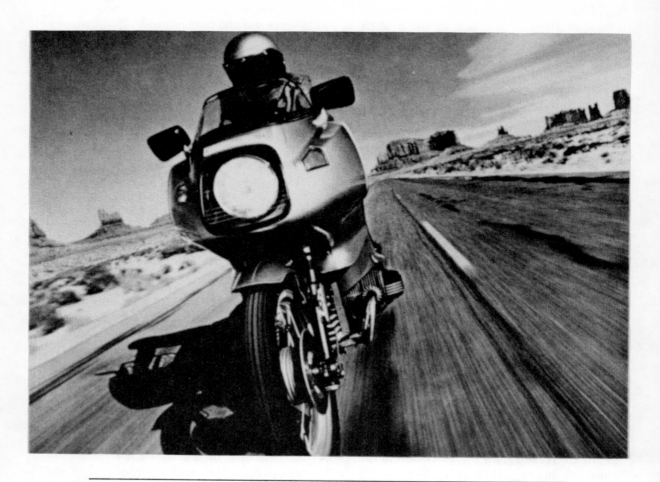

Sports photography is perhaps the most technically demanding form of professional photography. In Rudy Tesa's ad for BMW of North America, a moment of action is caught through a careful calculation of speed, distance, light, and framing. All of these elements must be taken into account and coordinated with split-second timing. In many cases the sports photographer must himself be physically and emotionally attuned to the sport he or she is recording.

study the composition. You get movement and focus with sports photography. Cartier-Bresson can shoot candidly, and everything he has printed is composed beautifully. It was all action, and he didn't set it up. That's composition. You have to shoot like an artist, working in slow motion.

The structure of the editorial market does not change with each specialty, but the photographic approach may have its own idiosyncrasies, as it does in architectural and interiors photography. Hans Namuth describes architectural photography, which he has done for *Artforum, House Beautiful,* and *House and Garden:*

In photographing architecture you have to develop a sense of scale and design to find an equivalent for the building since you can't describe the whole building in a single photo. A number of good photographers have begun by studying architecture. I really got into photographing buildings by taking the portraits of architects. Then they would ask me to take pictures of their buildings. In this business of finding a photographic equivalent, I was once having lunch with Marcel Breuer and he said, "How is it that when a photographer takes a picture of a building he always redesigns the building in the photograph?" I think I became proficient at portraits and architecture because I was bored to death photographing liquor bottles and cars. I stuck to what I was interested in, and this comes through in my photographs. It is the interest between the photographer and his subject.

Elizabeth Heyert, a noted interiors photographer, describes how she approached the market:

I went the editorial route, which is not what most photographers for interiors have done. What most novices decide is that they want to work directly with the designer, documenting their showrooms. There will be one designer, and the photographer will do all of her photographs. I was more interested in interpretative photography. At magazines I usually work with a writer. We talk about the idea and discuss the photographic possibilities. The text is usually written from the photographs. This way the assignment is more interpretive, not just a documentation series.

For the New York *Times,* for instance, I shot table settings and enclosed terraces. The concept of the shots was discussed with the editor; we talked about furniture used in the locations, what was possible in the given section, and what was to be included in the shot. Once the basic conceptual decisions have been made, I go ahead of time to the location and look at the space, walk through it, make decisions about how I'm going to shoot it. I choose the shots, I'll make a sketch or write it down. You also have to scout the locations so you know what will be required technically at the shooting.

Your work is directed toward a specific group or a general audience. In either case, one of the basic intentions of editorial is to display and move products being presented to the market: this is merchandising. Ken Fleck, a former editor of *Gentlemen's Quarterly,* talks about this concept:

The prime motivation of publications such as *Esquire* and *Gentlemen's Quarterly* is to try to stretch their viewers and give them something that is unattainable. Unattainable not only from the standpoint of dollars and cents but also from the standpoint of being able to walk into their local store and find it immediately. The rhyme and reason for that, the job they perform, is to help bring about a greater awareness of style changes. A man may see a lavender fur coat in a magazine this month and it's not in the store, but a year later he sees a standard brown fur coat and says to himself, "That's not too bad"—that's promoting the fur industry. With general-audience magazines we are talking about the industry of communicating to the world at large, making products available to the world at large that are no different than those in *Architectural Digest,* with the availability you would find in *Better Homes and Gardens.* The job of

every present-day publication is to be a merchandiser and to move goods from point A to point B. If it's a trade publication, it moves goods from the manufacturer to the retailer; if it's a consumer publication, it's moving goods from the retailer to the consumer. The job of magazines is to educate the eyes. This is the way we live. So when I go into a store in Illinois and I see a certain turntable, I will have seen it in *Esquire* and already be looking for it.

Magazine photography, with its depth and breadth, stems from the innovative steps taken by Brodovitch and Agha. It was their efforts that integrated design with content, necessitating photographers' originality, vision, and contributions. It is because these attributes are sought after in the editorial world that a novice, and even accomplished professionals, should enter or periodically return to working for publications.

Doing so will keep your eye fresh by continually challenging you.

FREE-LANCE PHOTOGRAPHY

The many different areas in which photographers are employed as staff or "full-time free-lancers" —movie stills, food, fashion, beauty, interiors, underwater, and so on—reflect the depth and breadth of the market for free-lance photographs. Perhaps most essential for the novice to realize is that there really is a market for every interest or subject. One need not focus on advertising; any interest can sustain a career in professional photography. The glamour and glitter of fashion is truly only skin deep, and it requires that you be obsessed with the products and their world.

Free-lance fashion photography is epitomized during the collection weeks that run several

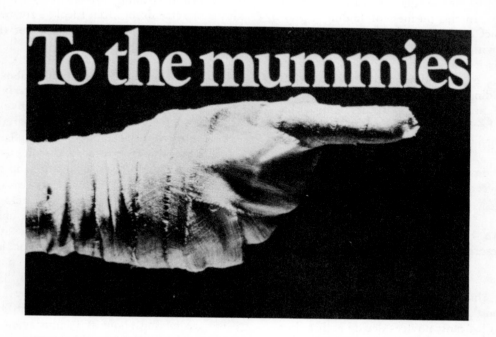

Phil Porcella's arresting poster for the Boston Museum of Fine Arts plays on a visual as well as verbal pun to attract and direct our attention. It is important to remember that the ways in which photographs can be used are virtually endless, and therefore the opportunities available to the free-lance photographer are also virtually unlimited. Many times, the not-so-obvious uses are the most worthwhile to explore.

times a year in New York, Milan, and Paris. To cover these events is the highlight of the year for fashion photographers, and those who photograph the collections are at the height of the profession. Diana Vreeland continues:

The collections are absolutely delightful, full of glamour and magic. It is easy to recognize that people have poured all their heart and talent into making the collections. You can *feel* the heart that went into them, and that is what makes them so exciting and beautiful.

Jean Pagliuso began working as a *special unit still photographer* for Robert Altman, the movie director. She describes her unique position in the industry:

In 1971 I had to get away from Los Angeles, so I went to Europe for six months. I met Bob Altman at a dinner and he told me to get in touch with Joan Tewkesbury, a writer he was interested in working with, when I got back to L.A. At the time that I looked her up, I was printing on Kodalith paper, which gives you sepia tones. She showed some of these to Bob and said, "Why don't you ask her on the set?" I went to Jackson, Mississippi, for six weeks on location with Altman's film *Thieves Like Us* and shot all around the streets and sets. Bob gave me free rein to use wardrobe and hair stylists. Two or three months later I took them to Bob. They really came out fantastic, and every time Bob worked on a movie after that, he called me and asked me to work on it. For *Three Women* I went and bought a Widelux, which is a little panorama camera. You have to be careful with it because the lens takes in more than you can see. I just worked on *Coal Miner's Daughter*. As a special unit still photographer you are low man on the totem pole on the set, and you are always in somebody's way. But everyone is happy to see the photographs when they're printed.

For *A Wedding* Bob would show me the dailies, and I would formulate from his point of view and mine what I was going to shoot to illustrate what the movie was about. I never shoot on the set. I use the set, but I don't use his scenes. For *Buffalo Bill and the Indians* I would use old walls from the sets and furniture from the film. It's more rewarding than fashion, that's for sure.

On every film there's a unit photographer who shoots exactly what the cameraman is shooting. There is a blimp on their camera so there isn't any sound when they click the picture. But they're not hiring me to do that because there is someone right in front of the camera recording every scene. As long as they have a unit still photographer on the set, they give me an excuse for doing the other photos.

To be a unit still photographer you have to apply to the union. A special unit still photographer does not need to be a union member. Joining the union is one of those Catch-22 situations: you have to have recommendations and a certain number of hours to your credit, but you can't get the hours or the recommendations without being in the union. So the best way is to get work on assignment as a special unit still photographer and try to make connections. Being a special unit still photographer, I'm not a union member. I have the qualifications, but to me it would be too confining. They own all of your photographs—negatives, contacts—and you never get to see anything. I own my own photographs. Once you get a good reputation—maybe the cameraman will say that you were good, got good pictures and stayed out of the way—your name gets passed on.

Melinda Wickman is a *unit still photographer* based in Texas. She describes how she got into the field and what it entails:

I worked as a free-lance photographer for five or six years, and then I discovered the movie set. There was a still photographer as part of the permanent crew. So I started to investigate because it seemed to be something that would interest me—traveling, being on a different job every time—as well as a little more steady employment.

The objective on the set is to shoot for advertising and publicity. The guidelines are that I have to tell the same story in the stills

This stock picture taken by the unit still photographer on "Barney Miller" (Columbia Pictures Television) is both an animated group portrait that brings out the personalities of the characters from the show, and a visual expression of the effervescent mood of the series. Initially shot for publicity purposes, it was later used in a series of ads.

that they do in the motion picture. More than anything else, that necessitates the same camera position as the movie camera. However, sometimes I must re-create the scene on my own after they finish. The job requires that you cover everything. In addition, you are required to shoot production shots, which means behind the scenes, the actual making of the picture, every person at work. The other required areas are to take photos for continuity for wardrobe, makeup, hairstyle, and props. You are keeping a record of the total look of the scene. I will shoot a full-length wardrobe shot of each actor in a new scene, maybe head and

shoulders for makeup and one for hairstyles, and if there is something special, like props or bloodstains, I shoot that. The script supervisor may need Polaroids of the scene—where the furniture is, what is on the table, or the way an actor pushed a chair back. Since it may be two or three days before they do a continuation of the scene, they need the Polaroids for continuity.

Unit still photography jobs are controlled by the unions, so when I entered the field I went about the business of getting into the union, which took about two years. At that time a big problem was getting information about it. All movie work is dominated by the International Alliance of Theatrical Stage Employees—I.A. for short. It is the parent union under which is separated each talent or craft with its own local. There are only three camera locals: Chicago, New York, and Los Angeles.

There were only a handful of people who knew anything about getting into the union. So I tracked them down. When I got the necessary information, I wrote for an application and went about finding out about the politics of the situation. It was very political right up to the screening board. There were no guidelines to qualify. It was a matter of whether they wanted to let me in. I have heard stories of women in New York who have spent seventeen years trying to get into the local. I think at this point the Chicago local, which covers the entire Midwest and South, was happy to find qualified women. They let me and one other woman in on the first vote. In 1976, when I applied, I needed recommendations and letters of support, more than what was written on the application. I think it has changed and expanded since I have been in. Now there is also a technical test you must pass, and I think an examination and a personal interview by the board. The exam covers all areas of photography—35mm and large-format. It was initiated about a year ago, and it covers everything: repair, strobe, cameras, processing. It has been described to me that still photography on the set is the stepchild of the industry. It is not actually involved in the making of the picture. But after it is over and people are saying, "Where is the

picture of this and that?" or "Did you get that?" it's necessary to have had it all documented. There is a general attitude while you are there that you are not needed. That creates a problem on the set, and you have to fight for your job. The still photographer is pushed around some because people don't think about or understand your job. You are the *only* person who is responsible for stills; it's surprising how many people working on a film do not know that. I think the work is 40 percent technical knowledge and 60 percent getting along with people. You are the last one on the list. If you are rude or unable to get along with other people, then it could be very difficult to get your job done, no matter how good you are.

If a director kicks you off the set and the producer sends you back in, you stay away from the integral part of the set for a few minutes, but you work your way back in. You have to. Even the director really can't send you away. It does happen often, for example, that the director will say one thing and the producer will say something else. They are both your bosses and can override each other. You are subject to much limitation by the people around you.

Since the motion picture camera is so specialized, they don't regularly attach a still camera to it. If there is a dangerous stunt they may have a lock shot, without an operator. I am expected to get the same shots, so I set up a tripod and a remote activator. If they are shooting in a small interior room and if I'm on good terms with the director, I will ask him to hold a scene after he is finished so I can set up and shoot stills of the scene. They do begrudgingly allow that. It takes me less than a minute to shoot three rolls of film with a motor-driven camera. It takes on the average six weeks or longer to shoot a motion picture. I might shoot from 300 rolls upward. For one scene I might shoot three different approaches. For each scene I usually need one whole roll of color and one whole roll of black-and-white. They need color transparencies for the magazines and then I shoot black-and-white for newspapers. Motorized cameras are essential because I need as many pictures of a scene as quickly as I can get. I do none of the processing or printing—it's all sent back to the studio lab.

I am a free-lancer—almost everyone in the motion picture business is, from show to show. In the case of the still photographer, it is always free-lance. If the people like you, they will have you back. Universal has had me on three films this year. I started out with a portfolio that reflected a documentary or journalistic approach. I had done political campaigns and entertainment, but I hadn't done much studio work. I did have work in my portfolio, though, and that is what they wanted to see, even though I didn't have any film work except a few statewide television shows. I went to each studio and introduced myself, letting them know I was available. I was in the union and I left a résumé and showed my portfolio. Then everyone tried me at least once. If they are pleased they will call back. I have been fortunate. I have worked hard at it, and I have a good reputation. I was very determined, and I actively pursued feature film work.

In the last two years, I have done a lot of television series work—"Dallas" and "Dukes of Hazard," as well as movies of the week, *One in a Million, Word of Honor, The Pride of Jesse Hallam.* The features I've done have been *Outlaw Blues, Pretty Baby,* Robert Altman's film *Health, Coal Miner's Daughter, Blues Brothers, Somewhere in Time,* and *Popeye.*

An average rate for a movie still photographer is now about $200 a day. But you work hard—fourteen hours a day many times. We do have benefits, and the union gets you more money for overtime. A commercial photographer would demand much more money for the hours and the conditions. There are people who have developed a certain style and reputation, who are called special still photographers, and they are sometimes brought along with a still photographer for a particular movie.

What is called for is basically a journalistic style, as opposed to heavy studio work. Knowing studio wouldn't hurt you, but I rarely use that. I am doing documentary work on a motion picture. Newspaper work

Almost every area of the arts and entertainment industry needs bold graphic images to get the public's attention. These ads represent three very different photographic styles, each effective in its own way. While Warren Lynch's poster for the Kentucky Arts Commission is essentially a still life wittily used, it could easily have been done as an ad or a shot for the photographer's personal portfolio, and then wound up on a gallery wall. Jean-Marie Guyaux's dramatic poster for a production of the New York Shakespeare Festival is a highly animated full-length portrait of Estelle Parsons, who starred in Miss Margarida's Way. Phil Marco's sight gag (using a horned helmet from Wagner's Ring as a collection box) is a dramatic fund-raising promotion piece for the Metropolitan Opera.

and free-lance work background in a journalistic style are good to have had. You follow the action, but you don't have control of the lights. That approach and background are necessary for this kind of work. You must also have that sense to illustrate the behind-the-scenes shots. Magazine work, political campaigns, or shooting concerts give you that sense.

Peter Gimbel speaks of the particulars of an *underwater unit still photographer:*

After the setup for the scene, the unit photographer poses the actors on the underwater set or location to reestablish the action of the scene. It is done much like its counterpart on land. A good example is the very famous shot from *The Deep* of Jacqueline Bisset in a T-shirt. That shot was taken by David Doubilet, who is as good as they come. The unit photographer on documentaries, where the conditions are not as controlled, has less opportunities of getting shots quite like that, but he follows the crew and documents the action as it happens. He is an integral part of the diving crew.

Jeff Albert, an expert in *aerial photography,* describes its uses:

Real estate is one of the main businesses in which aerial photography is utilized. It is a great way to see a home and the property itself. The government uses it for agriculture, and for the past thirty years they have been plotting land to see how farmers have been using the land. Depending on what they want to use this for, they can discover anything with an infrared camera—certain types of gases coming through the soils, what kinds of things are underground, and more.

For aerial photography it helps to have a general background in film and cameras,

Aerial photography is another quite specialized area. Once you have gained proficiency in a specific technical field, the chances that you will get work are quite good. The shot above is from a regional advertising campaign stressing the local natural recreational areas. The headline for the ad reads: "Sometimes, you get the feeling that the beaches here are as endless as the ocean"—a perfect articulation of the image shown.

lenses and filters. The only thing that is different is that you are shooting from the air and the light angles are off. You have to plan a flight pattern for the plane so you get the best series of shots. For stills I use a hand-held camera. For shooting commercials I use a specially mounted camera to cut the vibrations. It works on a gyral principle. You must also know what angle of light will give you a blue haze, and you have to correct for that. I use a normal-format 35mm camera with a long lens or a 2¼ Hasselblad for a bigger format.

It is tough to get into this field. The market is small, so the competition is very steep. If you are interested in doing commercial aerial photography, you start by contacting architects.

You charter a plane for half an hour for about $90. You can go up any time of day you like and pick an angle that you like best and fly around and shoot what you see. One of the critical things is to get your pilot in tune with what kind of photographs you are taking. You also have to be aware that there are certain laws about flying over people's property.

Food photography is a specific still-life field. Dan Wynn, a food photographer, and his wife Rita, a food stylist, talk about its special features:

There are always logistical problems in food photography: keeping, storing, and preparation of food, especially within the shooting schedule. Speed becomes an essential problem the day of the shooting; things can be cooked many times before they're right. In still shots, you can put in substitutes, but in commercials, authenticity is required. There are many secrets to making the picture look better in print. Turkeys need a golden color, so we photograph them partially cooked and paint them with Angostura bitters beforehand. If you fully cook them, they just look wrinkled. Almost everything is painted to glisten. Vegetables wilt with time passing, so they have to be constantly sprayed. We put salt in beer to charge it up again, and it is shot in tall glasses to create the long head.

100% natural, just like Breyers ice cream.

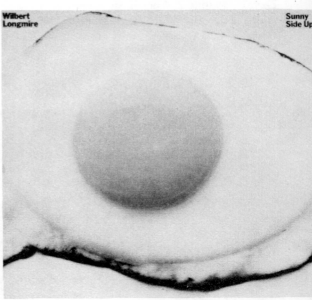

Wilbert Longmire

Sunny Side Up

It may come as a surprise that food photography is an extremely technically demanding specialization. The illusion of freshness must be maintained and even heightened to a surrealistic level in order to make the product appealing—despite the fact that these pictures are shot over long periods of time and under the withering heat of klieg lights. The applications of this specialization are wide-ranging, as witnessed by the examples above for Breyers ice cream and CBS Records. (The CBS shot was used as an album cover.)

Once when James Beard was making a flambé, the color of the flame and its height were a problem, so after six tries and six ruined flambés we set fire to rubber cement to get the right color. You almost always have to use five or six chickens or turkeys to get it right. With gourmet cooking, the recipes have to be reworked for the look rather than the taste. It's hard getting cakes to be the right texture—not too soft, not too dry.

There is a saying that the greatest food stylist can get a gourmet dinner together on a Sterno. A kitchen has to be well equipped, but the better you become at styling, the fewer accoutrements you need. The amateur needs the best equipment. Most of all, to work with food photography you have to appreciate food. Your studio has to be specialized, too. Electricity has to be brought in for sometimes up to eight or ten refrigerators, stoves, and ovens. There are air circulation problems and, of course, lots of refuse to be disposed of.

The areas that food photography has come to be used in are diverse and include all the markets. In any magazine there are stories that involve anything from desserts to vegetables, as there are in newspaper supplements, weekly columns on food, and special home, table-setting, and design sections, all on a regional and national basis. We do brochures for such diverse clients as the March of Dimes, dietary supplement information on minerals and nutrients, Jack Daniel's mixed-drink booklets. Companies in the meat-packing industry or conglomerates in the processing business hire us for their annual reports, and we do a lot of covers for them. For advertising we do everything from cereals to McDonald's, and this field requires very precise layouts, which we follow for positioning and sizing. Currently cookbooks are very popular, and we also do illustrations for general books, including special canning procedures.

ADVERTISING

In the 1950s, as the United States became increasingly more affluent, there was an enormous surge in the development of advertising photography. While huge amounts were being spent, photography for the advertising market made great progress and it was a golden age for photographers. Professionals like Bert Stern, Mel Sokolsky, Jerry Schatzberg, and Victor Keppler, the founding father of commercial photography, were able to build empires through their work for large clients, and the relationship between art director and photographer became set. If there is one element that separates advertising from all other areas, it is that the photographer works exclusively through an intermediary, the advertising agency. The concepts created by the art director provide the framework for the photographer, but the art director wants and needs expansion of his ideas, and this provides the photographer with limitless room for inventiveness.

Doyle Dane Bernbach, formed in 1949, has produced some of the more memorable advertising in the past thirty years. The Volkswagen, Polaroid, Chivas Regal, and Sony ads show some of their most creative accomplishments. Bob Gage, who has been at the company since its founding, was one of the first of the new gener-

Larry Robbins' action photograph, designed to show the durable quality of American Tourister luggage, combines the split-second timing of sports photography with the attention to detail of a product shot. This classic photo-illustration makes its point clear with or without a copy line.

*Because of the basic similarity of generic drugs, advertising for phar-
maceutical companies is especially competitive. Here Jay Maisel drama-
tizes the pathetic and desperate condition of a depressive patient in order
to stress the need for a specific mood-elevating medication manufactured
by Ciba. Although staged with a model, this photo-illustration has a
feeling of authenticity, and as an image can stand powerfully on its own.*

The Brooklyn Museum Art School

This poster for the Brooklyn Museum Art School is both provocative and witty in its reversal of the traditional role of students and model. All institutions, and this is especially true of adult education, need advertising and publicity. Perhaps a good place to start is the art school from which you were graduated. If not always the most lucrative kind of work, these jobs can provide excellent tear sheets for your portfolio.

ation of advertising art directors, and he made invaluable contributions. Helmut Krone, also an art director at Doyle Dane Bernbach, spoke of Gage at an awards ceremony for him at the Art Director's Club:

> When I was a kid, art directors were measured by how well they could indicate Bodoni Book with a chisel-point pencil. Bob Gage changed all that. He invented modern advertising art direction as we know it today. He insisted on working directly with the copywriter, contributed headlines, and immediately set them in type. Then he shot a rough photograph or found a "swipe" for the picture. He cut out dummy copy, pasted it in, and that was his comp. It started to catch on, and the old-timers in the field began to call these new art directors "pastepot art directors." Well, Bob was the original pastepot art director.

Although advertising is now more than ever based on research (documentation, testing—referred to as *berking*) before it reaches the market, proving that a particular approach will sell the product, the axioms of advertising remain the same: present something new to the public, catch its attention, and make it want to buy the product. The approaches to these problems are endless, although trends definitely exist and the basic intent never changes.

Frazier Purdy of Young & Rubicam discusses the advertising mediums:

> During the sixties when print was a predominant medium, as opposed to television, it attracted those people that television rules today. Television now consumes about 75 percent of the media dollars that are spent in advertising, so the better talent gravitates toward television. There are a lot of directors out there who were print photographers and moved away from it. You don't have the interpretive freedom that you used to have. Everything is pretested in one way or another. Clients have subscribed to marketing systems, so we have to subscribe to them also. So the ads that have to be shot have been through the mill and have worked. Print now is a supportive vehicle to television.

Art Kugelman presents his view of creativity in the advertising market:

> I don't think there is a trend of new ideas coming in to an already established, routine campaign. I think we will do the same thing over and over, a little bit differently or dramatically. This is not a gallery, this is business, and the underlying thing that we have to do is make money. As long as you approach it from that point of view you can do whatever you want. It must sell. The key is to be as creative as you can be in the framework of the business.

Sylvia Dudock explains what an art buyer does and the significance of that position within the advertising hierarchy. The art buyer is active in finding and knowing professionals who can meet specific needs in relation to the layout—that is, solve the specific technical problems. He or she is the liaison between the client, the agency, and the creative people outside who are doing the work:

> My function is basically that I have a greater perspective of the talent available in the business. For the client, I narrow it down to what will work with their budget because I know the style they are looking for and I try to connect them quickly. They'll say, "I need a picture of a very striking woman, for a cosmetic product. Who do you know?"
>
> The duties of an art buyer are to bring talent together, find the most exciting people, and introduce them to the people in the profession, but the job also has many parts. I work with an art director from the time of conception. I see his layout, and after he's done his thinking we discuss the best way to do the job. If it's a job that will require a photographer, we decide who works well with the type of idea in hand, and we work on getting the right talent.
>
> You have to know the personalities of the art directors you work with. I think the biggest contribution I make is understanding the art director and knowing what kind of person he will get the best results from. The person I choose may not even be the most talented, but if I feel that they will

Bert Stern was the first to use photography as a conceptual element in advertising. This fifties photograph virtually changed the direction that advertising was to take. Aside from the ingenious interaction of forms, this picture expresses the basic point of the Smirnoff vodka campaign—the dry martini—by the use of a pyramid in the desert. Incidentally, the ingenuity that Stern employed here made an American product with an obviously Russian name acceptable—even a household word—during the cold war with Russia.

Setting this shot in a swimming pool, photographer Walter Kaprielian (who also happens to be the art director on this account) has used a basic fashion photography style to create a provocative image for the cargo division of Air Jamaica.

The stroboscopic stop-action technique, often used to illustrate golf strokes or splashes of milk, is here employed to show the versatility and flexibility of Wrangler jeans. The multiple images add up to a collective image that underlines the exuberance and freedom symbolized by jeans to the American consumer.

These beauty shots were taken for the same company, John H. Woodbury, by two masters of modern photography. Hoyningen-Huene's surrealistic head is typical of the theatrical approach popular in the thirties. Steichen's ad for Jergens Lotion, a division of Woodbury, from the same period, leans more toward the sentimental and romantic. The different solutions to the same problem often arise from the emotional and aesthetic climates under which the photographer works.

Here's another approach to photo-illustration, this time involving a portrait and a product still life shot for Hoffritz knives by one of the great innovators of photography in the sixties. Jerrold Schatzberg, who later went on to become a motion picture director, came up with a dramatic resolution for what was traditionally a rather dull display of cutlery.

be compatible, I bring them together. I think that is the most important contribution that I make—to have people comfortable with each other and to ensure a good working relationship.

I would say that working with someone just entering the business is the most exciting part of my job: introducing him to all the creative and service free-lance talent and watching the relationships grow, so that I know I am setting him on a very good road for a very long time.

Bev Don, also an art buyer, explains the steps she takes and her relationship to the many parts of a project:

It is almost always the art director's decision to approve the photographer. He will come to me with the layout, we will discuss it and decide who will be good for the job. Many times the art director has an idea of who he wants to use. Or they will ask me who I

think would be good. Sometimes it's sixty-forty or fifty-fifty my decision. Then we will make selections on who to ask to shoot the job. Sometimes the need to bid depends on the client. If it is a creative decision rather than a bid situation, we will call the photographer and his agent in and have a preproduction meeting. Then we start casting. Any negotiating on behalf of the models is handled via the buyer before client approval. Once all that is out of the way, we get it in the works and shoot it. I handle retouching and lab work in order to get the picture perfect before it goes into engraving.

Louis Hernandez of Dancer Fitzgerald Sample believes the best relationships between the art director and the copywriter are symbiotic. "You have to learn about the mind and soul of the person you are working with. Then you begin to trust each other. When the fear barrier is broken down—that is the best working relationship.

Out of a seemingly chaotic subject, David Langley has pulled together an image that is graphically satisfying and at the same time makes you want to read the copy accompanying it. The strength of the ad lies in the effective photographic handling of an unlikely subject matter complemented by a clarifying statement.

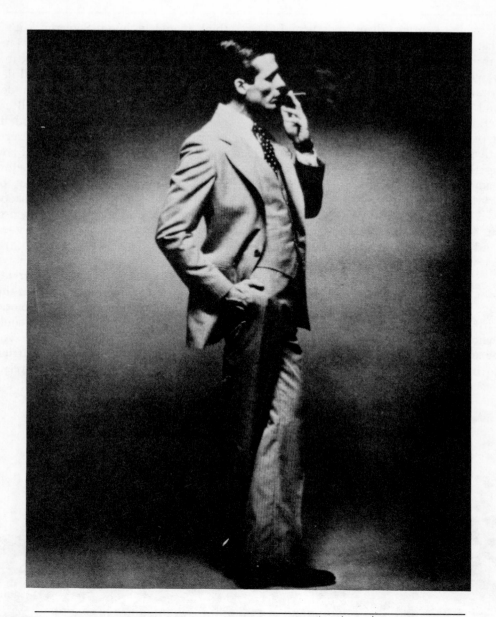

This ad for men's clothing presents an innovative solution that effectively deals with the well-known problem of men's resistance to seeing other men as models. Casual elegance is the key to instantaneous success. Here Hal Davis has achieved just that using a model in a way that presents no threat, looking off into limbo. The cardboard look that predominated men's wear for generations is gone. Naturalness in photographing men is, in large part, thanks to Bruce Weber, a trailblazer in men's fashion photography.

You must have the same point of view even if you have different approaches."

At the top of the hierarchy are the creative director and the client. Art Kugelman speaks of this relationship:

There is a lot of chemistry involved. Sometimes you do hit it off with a client, and he will give you a certain amount of trust and freedom. You develop a relationship. I feel twice as obligated to the client because I know he trusts me. I really want to go all out for him. Sometimes no one may like one another, but you are professionals, so you try to live with it. You try to do the best all the time, but when someone really has faith in you, you don't want to let them down.

Louis Hernandez speaks of his working relationship to the client and of approaching creative situations:

As an art director, you basically devise your strategy according to the market. You have to respect what the client wants. At the same time you have to be as creative as possible, and you have to be subtle in introducing something different. The thing is to take a risk. I think it's the only way you will get something. You have to be willing to go ahead and take poetic license. It is the execution of an idea that brings success. If the client doesn't like it, I'm out the door, out of a job. My basic philosophy is that of an artist: when someone tells me something is impossible, I find the challenge irresistible. It is the only way people begin to recognize what you do. There is basic bland advertising, but you have to take it a step further and be innovative.

Art Kugelman discusses the use of still life in advertising and its basis in the selling of a product:

Photo illustration has to tell a story independently of the words and product. The photographer is telling a story, so it has much more dimension as an ad. A still life has to be designed to have color, appetite, appeal; a still-life photo is much bigger than life. When you sit down to eat you don't really study a pat of butter. But on a page it has a life all its own, which is as it should be. It should be more appealing than looking at it live. No amount of drawing or sketching will do that. You are also being conditioned to thinking of ads as billboards —french fries and juicy hamburgers. When you are working in soft goods, the shirt is pinned so that it fits like a skin. Now, nobody is going to look like that in a shirt. It is the same thing with the hamburger. Everything is beautiful. We create the mood for selling the product.

The ability to make a still life "read" is considered invaluable in advertising, and in the case of Hiro, his strong graphic abilities coupled with his rapport with art directors make him an invaluable photographer. Art directors who have worked with a master still-life photographer point out the various uses still lifes can be put to.

David Deutsch, creative director of his own agency, recalls a campaign in which he was trying to illustrate the high reproduction quality of Mead paper. An exceptional photographer was needed to illustrate the ad. He selected pushpins as one subject of the campaign, and once real pins were placed next to the photographed pins, the quality of reproduction was very apparent. "It was meant to be a form of conceptual art. Hiro was selected because the agency knew he was capable of producing the sharpness and perspective needed and could make it work."

Philip Sykes, who was an art director of *Look*, also recollects working with Hiro:

While I was at *Look* we often used Hiro to help us with problems in the food, architecture, fashion, and design sections of the magazine. It was his ability to conceptualize ideas and combinations and his acute sense of graphic visual space that made him so important to us. We could give him carte blanche because he always produced very good work. I hadn't hired him to give him binding direction—I could just give him the direction and the freedom, and many times I didn't even have to go to the shooting.

Robert Petrocelli used Hiro at Warren Muller Dolobowsky:

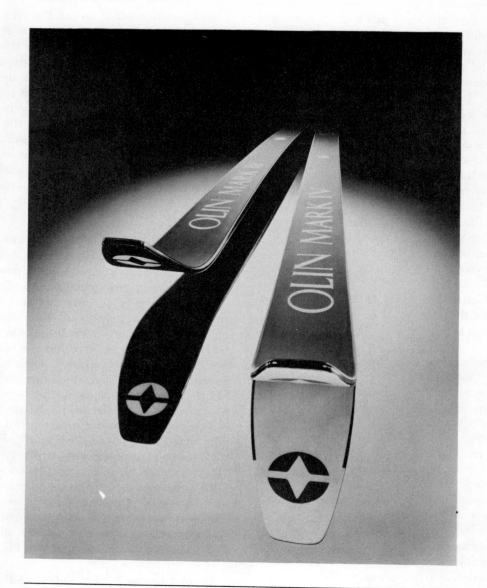

This advertisement for Olin skis was shot as a still life under studio conditions. The controlled environment allows the photographer to emphasize whichever details of the product are important to the ad's concept. Using no frills—just the product, an interesting camera angle, and lights—the photographer has successfully created a mood of sleakness and speed.

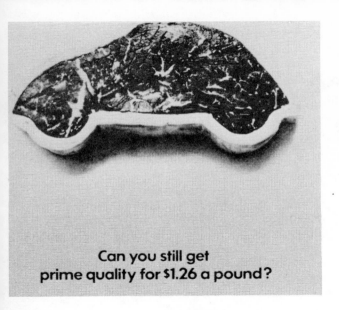

Can you still get prime quality for $1.26 a pound?

This Volkswagen of America ad has taken a still-life product shot to a surrealistic level—nevertheless, the very real problems involved in shooting food and making it look appetizing still apply. Once again the photograph forms the meat of the message. The copy simply provides a piquant sauce.

I did a very difficult shot with Hiro, and he was leaving for Atlanta the next day. He got the film, edited it, and sent it up to the agency before he left. As we were up against a deadline, I decided to retouch the small problems in the picture, as opposed to reshooting. Hiro called from Atlanta and I told him what I would have to do. He flew back from Atlanta and reshot the picture rather than have it retouched.

Walter Kaprielian of Ketchum New York adds:

We chose Hiro because we felt that he did not treat his pictures like normal still lifes; he worked for perfection and elegance. On the Olivetti account all the work had to be highly designed to be successful for the client. We wanted the pictures to be ageless and classic. The merchandise was shipped directly to Hiro's studio. The concept

would be worked out and enhanced by lighting and lens work. Hiro worked for hours making microscopic movements, hairline exposure changes, and experiments with mirrors to get the kickback lighting just right. He would get the visual to where it worked for the headline and within the planned copy design.

David Leddick has clear-cut ideas about Revlon's position in the beauty market and how advertising reinforces it.

At Revlon we are setting up an image. Fifty percent of an ad has to reflect upon the company. We try to guide the photographer, create a world for him. My role is to energize and keep track of the parameters that define Revlon. We have a very definite style—the self-confident woman who has not lost touch with her own femininity.
Revlon is a very specific kind of account—pure beauty faces, closeups. A lot of photographers have to be careful not to be swept away by their interest in photography. They have to be able to do what we are doing; that is, they can do beautiful work, but making a girl look good close up is a very special thing. There are not a lot of photographers who specialize in that. You really have to feel sure you can do that. In the commercial field you may see something in someone's work that makes you think they can do it. We have a very specific client, and we have to know if the photographer can deliver. We give them a very specific project. If they want to do something else, that's fine. I would say that 50 percent of the time we do the other idea, that is, something we did not anticipate getting. You must show the photographer what the makeup, hair, and clothes will be. The difference between a commercial job and an editorial one is enormous.

CORPORATE ASSIGNMENTS

This market is distinguished by the fact that the photographer or the rep services the corporation directly. While the field does not offer the so-

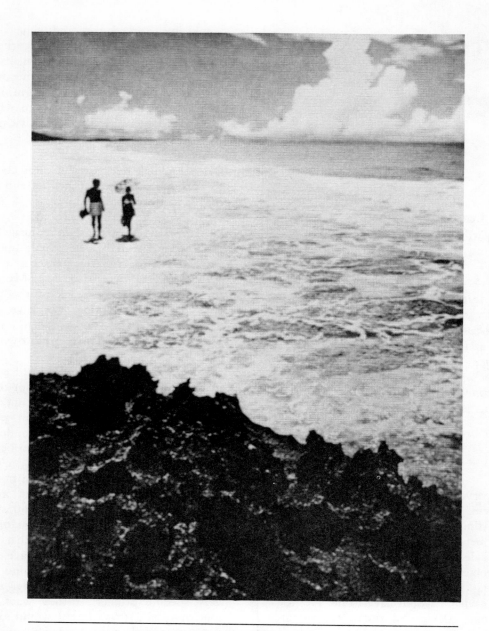

A master of the still life, Hiro has brought his unerring sense of design to a deceptively casual beach scene. The placement of every element in this picture was actually as carefully planned as if it had been an arrangement of precious jewels.

called glamour and glitter that exist in advertising or editorial, it has its own rewards. Executive portraiture, for instance, requires the photographer to photograph an often unwilling subject, while photographing the physical plant challenges him to enhance an essentially banal subject.

Corporate and nonprofit institutions, such as educational organizations, are required to publish an annual report recording yearly income and expenditure. In recent years, corporations have begun to concentrate on an annual report rather than publishing a number of smaller reports throughout the year. Hence, reports are glossier, more expensive documents enlivened with photographs—generally all four-color now —of all areas of an organization's activities. In the future there will probably be more concept-oriented annual reports so that companies can emphasize their separate identities. For annual reports, some companies give the work to a design firm, which in turn hires a photographer to record the plants, offices, and executives, almost always requiring him or her to travel long distances. This necessitates a great deal of organization of equipment and on-site organization of nonprofessional models (the workers), so logistically these can be very complex assignments.

Catalog houses can be considered corporate assignments, too, because they often hire photographers directly. The catalog houses run in seasonal cycles but can keep a photographer busy all year long. There are endless opportunities that can be had anywhere and everywhere. Some printing presses hire photographers, some stores even hire photographers. The record business is also related to the corporate market because assignments come directly from a corporate client. Album covers, posters, and related material are controlled by large corporations with in-house departments. Auction houses and insurance companies hiring for documentation purposes constitute other corporate clients.

Promotional photography is organized by a publicist whose job is to evaluate the client's image and public relations needs, and to find a photographer whose approach fits that definition. The clients associated with this field are generally in areas where publicity is imperative —performing and fine arts, sports, and book publishing. Press kits and brochures find their

This is a picture of CBS displays, some of them containing pictures themselves. Corporations have an almost voracious need for photographs, and many different departments within the same company can be separate buyers. If you are already working for a large company, try to discover what needs your photographs might fill in some of the various departments.

use in newspapers, trade publications, and television. When the pictures are to be used in a variety of media, it is essential that the photographer be aware of that and, of course, secure additional compensation for multiple use. Since it is to the benefit of the photographer when several applications are intended, he should be selective about those jobs that do not offer wider use.

Patricia Trainor, a fashion publicist, speaks of the function of the corporate image in assigning a photographer to a client:

When I look at a portfolio for publicity purposes, I look for the photographs that have a certain communion with the client. I first consider what client I am going to be promoting and make sure that this photograph adapts to his character, whatever the product is. I will choose a photographer who can produce the style but who is also unique. I can't fool around too much. That's why I see so many portfolios. I want to find the diversity for each style needed, but also the newness of an approach. I have

to be narrow-minded about what the client needs and how I would like to see those needs fulfilled. My preference is for hard-edge photography. If there are budgeting restrictions, I will use a drawing. I prefer not to use runway models because they don't give anything new to the client. I like to use fresh talent and faces, not necessarily ingenues and not the models who are all over the pages of the magazines. It gives the photographer the chance to work with the people he might wish to bring to the job. I do like to be able to suggest a photographer to someone else, though, if I cannot use him.

Annual reports should not be thought of as separate from other media. The qualities that make a special or unique photographer are ultimately applied across the board—editorial or otherwise. There is a good deal of graphic design in the industrial field, as well as composition, structure, and problem solving. A photographer who is covering the Metropolitan Opera is solving a certain kind of problem, but he might have more to work with. The average photographer doing a corporate assignment is not photographing a terribly glamorous or exciting subject. In effect, the photographer is being asked to bring qualities to this situation, to pick out the thing that is a jewel in a sea of plainness.

The photographer is not involved in the conception of this kind of work. The design firm does that. But he must bring enjoyment to the assignment for it to work. The way to get results is to become interested in the problem. Structure is important for him. This will then allow him freedom. To bring a photographer into a situation that has no structure is inhibiting to his work.

In a few instances, a photographer will be brought in early for consultation. In the next few years it might develop that the photographer is the key creative person when he is given more scope, but this will still be the exception rather than the rule.

Much of the work is shot in early winter because reports are published for the past year, and there are problems with transportation and equipment. The people who come through with all those things are more professional. The annual report is one of the more difficult media.

Executives in annual report group shots should look as if they can be touched. (What the people in that organization think is beside the point.) There should definitely be a humanity about them. It is a very difficult area to deal with. You can't really do anything overwhelming with your subject. Your approach should be to try to shoot a more informal situation, not the old bleacher approach.

Taking the executives out of the stiff surroundings and to different locations is unique, though. Most executives will not allow this. Many photographers will try to joke with the subject, and better photographers are not intimidated by them. They must strive to initiate the human factor since there is the potential of making the executives look like immortals.

The catalog industry has grown by leaps and bounds in recent years, in large part because of the industry's recognition that much shopping and selling can be done by mail, and the catalog is now a means of advertising and selling rolled into one.

While many companies rely on catalog houses with in-house photographers, many still assign other professional photographers to produce a special effect. There are creative limitations not encountered in other fields because catalog work is essentially recording an object within a specific context. The photographer is challenged to imbue that object with a little more spirit.

Photographer Peter Strongwater describes the market:

In catalog work you have to conform to the layout; the art director usually has drawn all the poses of the models, and you have to put the models into the shot. The shooting is tighter and a lot stricter than any other kind of photography. They already have the whole book laid out, and there is a minimum amount of space. They bring you photocopies of their layout, and you fill it in. But they are becoming somewhat looser. The art director might say we need two garments to be shown with two models, and some sort of design element, and the photographer can supply that. In general, though, the photographs are already taken for you conceptually. The majority of catalog work is done in the catalog houses, in studios where the photos look stiff and artificial, in

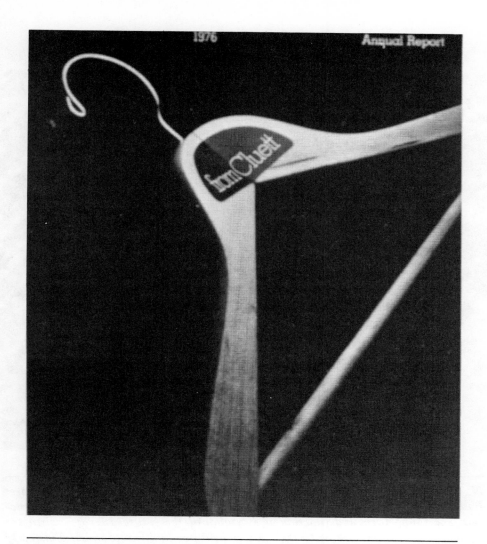

This cover for a Cluett, Peabody annual report features a design that is interesting, elegant, and eloquent in its simplicity of line. It is also appropriately noncommittal for an annual report.

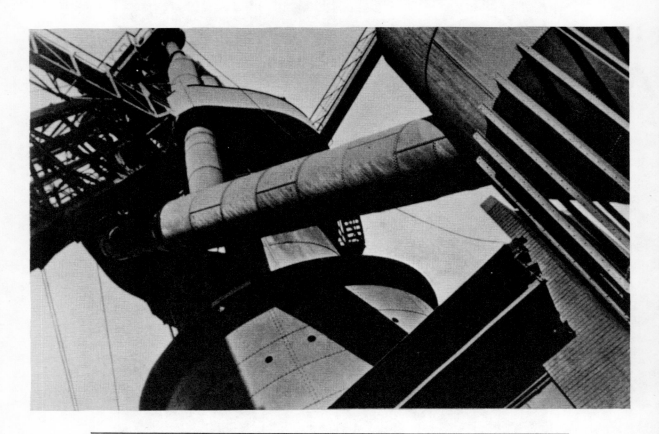

N. W. Ayer, one of the early giants of advertising, sought the talent of Margaret Bourke-White to define its own image. At this location, an industrial construction, she found form and function as a symbol of the future. In 1931, when the present seemed very dim, industrial power held out limitless promise. This early corporate image as a timeless expression of progress is a forerunner of the type of corporate ad used today by Exxon, Alcoa, and Mobil Oil in their recently revamped corporate advertising.

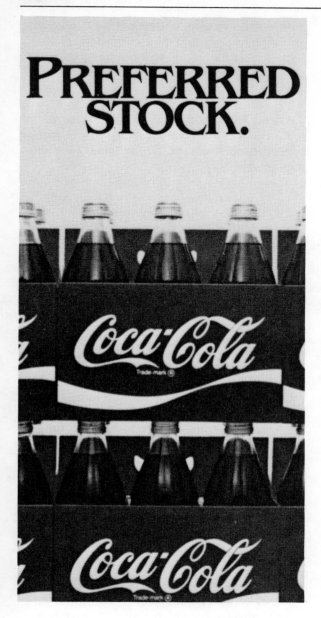

This trade ad once used in the industry publications is a straight still life that plays on a pun related to the stock market. It's directed to the seller of soft drinks. The use of multiple images is often an effective method of planting an idea or a visual memory that will stay in the mind of the viewer.

phony scenes. Whenever you bring a tree into a studio it still looks like a tree in a studio. There is no way we can make the sky we are using look like a real sky, no matter how it's painted. So you don't even try. I have worked on still lifes for catalogs with three or four people, the account executive, the art director, the copywriter, and the stylist all standing there putting their two cents in. In contrast, on an editorial shooting you will get a fashion director, maybe a couple of stylists, but usually not the art director.

Stan Freeman, creative director of Allied Graphic Arts, Inc., one of the largest catalog houses in the country, has seen the changes in the nature of catalogs and has a different perspective on the nature of catalog work:

Catalogs are moving in a different direction today; they have moved almost totally to the editorial approach. Photography is being done on location, as well as in imaginative sets. And we stopped doing the stiff photograph about ten years ago. Now most catalogs have freedom. And as a result, another change is here—everything moves. Another approach is a "no-background background," which involves a simple prop to provide a feeling of architecture.

What we do as a company is investigate the selling situation of our clients. With some major department stores, the investigation is on a general level: we try to capture the flavor of the area they are in—West, South, etc.—even though the merchandise is very similar from area to area. With others, the personality of the store is of first importance—each has a definite viewpoint and a personality. We find out what we need to know about them by visiting them, because we prefer to see clients at their stores, so as to absorb their environment, and discover who *they* think they are and where *they* want to go.

In a still photograph I look for good technical ability and composition—the same as in fashion photography. By the way, in this area we work primarily with sheet film. To me, lighting is what makes any photographer what he is. I find more and more

young photographers now who have better technical ability than they did before. Some of them really prefer still life, because they feel there can be as much creativity in still-life photography as in fashion. Of course, the art director has usually determined the general look by the design of the page. Therefore, achieving the third dimension is usually the element the still-life photographer must add. It is more difficult to find an art director or photographer who understands interiors. This is probably because it takes more years to acquire the experience necessary to put a complete room together.

Once you have worked on a catalog, you are a catalog photographer. There are mail order, direct response, and department store catalogs, and they have different purposes. Although mail and phone response is expected, department store catalogs are done to create store traffic as well. They also help build an image for the store. In mail order catalogs, you must be very careful the way that you present any garment. If it looks too good, you are in as much trouble as if it doesn't look good enough. On the other hand, department store catalogs have become fashion magazines. Customers spend time with a catalog, more than with a commercial on television, because they tend to save them and look through them more than once. Therefore, catalogs can be more effective than other media.

The people who succeed in this business must have a great deal of energy. You sense this when they come in. We can start out with novices by giving them simple assignments, but we expect the result to be professional. We like to choose from two or three qualified photographers for a particular assignment. However, the time available dictated by the schedule usually affects the decision. The final decision rests on the rapport between the art director and the photographer. It would be as wrong to put an art director and photographer who do not work well together, as it would be for a photographer to have to photograph a model he dislikes. There is a great deal of exciting photography being done in catalogs today, and it is being done by top photographers, so there is a good chance that they will create new directions. Of course, really great photography is timeless. Horst, Penn, Avedon were all innovators, so that their early work is as fresh today as it was when it was first done.

Arlene McDonald, who as an art director of J. C. Penney deals with catalogs on a regular basis, describes one particular kind of photographic need:

There are catalog houses all over the country that specialize in interiors for mail order. One in particular is a catalog house in North Carolina that specializes in interior studio space setups. They have huge movie-lot spaces with their own photographers and printing presses—all the services needed to turn out a catalog. The photographer there is just one more technician on the set. Some of them are very good and do wonderful things with lighting and still life, but everything is delegated: the prop men do one thing, the lighting men do their job. From the wall painting to the plumping of the pillows to making the bed, each job has a specific person who performs that function.

Toby Aurelia, head art director at J. C. Penney, gives his insight into the needs of the retail area:

In this work we are not necessarily concerned with a mood but in getting the merchandise across without gimmicks or wild things in the background. A shooting can take place indoors or outdoors, but we're mainly trying to show the merchandise in a pleasant manner. We are looking for an attitude sometimes—that is, a mood related to copy. Generally we pick a photographer who can suit our needs. Not everyone can handle children; even though they may be good photographers, they get frustrated. Other photographers are pleasant, and they can make the children work for them.

We use a photographer who may specialize in room settings. If you need a triple-level platform, they can build it because they have the facilities to build a set in half

a day. We do use people who can shoot on location, like in a house, and paint and set the shot up. The still-life photographers are all kinds. Some specialize in glassware or cosmetics or pillows and blankets. The attitudes are different. It takes a lot of time, and you have to know how to shoot crystal, for instance—it has to be lit well and it can't blend into the background and into the accessories.

Medical photography is a growing profession, but one which is primarily limited to hospitals. This means that you are required to be on staff. Allan Brown, Director of Bio-Medical Communications at Methodist Hospital in Brooklyn, talks about the field:

Medical photography is the recording of scientific images, basically for teaching, diagnostic purposes, publication, and record keeping in hospitals. For example, we photograph patients with skin lesions and follow them up. The photographs are used for teaching at the hospital. We produce all the visual aids for the hospital—charts, graphs, and copying for internal teaching. Surgical procedures, which are usually color slides, are used for internal teaching and publication, and if a doctor is doing an article, we will do the photographs he needs.

The photographs are seen in medical journals or any medical book if they are good quality. Any films done of procedures are done by the medical photography team at that hospital. People don't realize that. They usually think you just take X rays. We have a closed-circuit TV system in this hospital. We also do video, motion studies, and patient education.

Up to now there hasn't been great formal training in the area. One should know medical terminology. There are books on it if one wants to study on one's own, to learn the prefixes and suffixes. If a doctor asks you to take a picture of a particular area, you should know what he's talking about. For the same reason there should be a knowledge of anatomy. Of course, you have to have knowledge of photography, since the varieties of film and equipment are totally different from those in any other

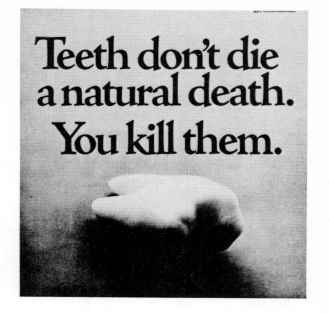

Teeth don't die a natural death. You kill them.

In addition to the documentary photography needed by hospitals and doctors, there is the highly lucrative and extremely competitive area of ads for the various medical professions. Many types of photography—witness the still life above—can be appropriate.

photographic industry. For example, slide film for black-and-white is called LPD 4, which is a 150-foot spool that gives you a direct positive slide dry to dry in 15 minutes. For color we use a variety of films. We are now using Ektachrome 400, whether it is for surgery or the skin clinic, because of the fast processing. We use electronic flash, although some people use tungsten illumination. Novices usually have to have a year or two at a school or demonstrate a good knowledge of photography. When our degree program begins, however, you will have to take all of the basic photography courses required by Pratt and then meet the medical course requirements. The students will work with someone in the field who will teach the specific area.

Out of the program you will get a good knowledge of what medical photography is about, including how to run the department and budgeting. After that, you can go out and get a job.

My theory of teaching is that you have to be at the hospital to do it. If everything is classwork, then you're not really learning. The only practical experience the students can get is in a summer internship. You can do as much classwork as you want, but if you see a patient with some blood and you faint, it won't get you very far.

The students can apply to a variety of hospitals. Even Veterans Administration has a photography department, and every major hospital in New York City has one, although it may not be called a medical photography department.

There are about 1,400 members nationally in the Biological Photography Association, but they claim that is only about 10 percent of the medical photographers in the country. The New York chapter has about 140 members. Some of them are free-lance, but most work in institutions. Some institutions have ten people, some have one or two.

The Biological Photography Association is a nonprofit organization used for information and teaching. In New York we have the largest chapter in the country, and we have seven or eight meetings a year. There is a national meeting every year with a three- or four-day seminar.

Police photography is another specialty that requires you to be on staff. Sergeant James Ferguson of the New York Police Academy talks about his field of expertise. "I started as a kid in vocational high school, and then I worked in the Navy as a photographer—a photographer's mate. When I joined the police force, I filled out a questionnaire relating to my past skills. They needed a person with my photographic skills. This was for teaching purposes—motion picture clips—to show, for instance, the proper way to apply handcuffs, or to enlarge a summons form. My unit does not photograph at the scene of the crime. That is the crime lab's job. Many aspects of police work are documented with photographs taken by a photographer working for that unit. Examples are identification shots of suspects, and evidence that has been collected."

Gene Grief, an art director at CBS Records, describes the *music business:*

I do about fifty or sixty album covers a

year. I work on five or six things at a time. There are photographers whom I use who are sort of like house photographers, and I use them because they get the job done.

In this business a lot of people have to be stroked all day long, and I'm the one who has to do the stroking. Many times the photographer will be the one in that role, and so I will choose a photographer who can work well with people. In general, photographers think that doing album covers is glamorous, but it's mostly a lot of stroking and a lot of hype. Other times when the person you are shooting is totally for the idea you have presented, you don't have to have so much finesse. But I have to take all of these intangible factors into consideration because of the amounts of time and money being spent. There are too many people who have no rapport with the people they are shooting.

Alan Septoff, creative director of CBS Records, relates his experiences with the photographers and the art directors in the music business, explaining the peculiarities within this corporate field:

I think there's an illusion about the record business. We do ads and posters, not album covers. We're closer to what an ad agency is looking for rather than what an album cover designer is looking for. But it's more than what I looked for when I was an art director in advertising. I'm not limited to looking for a package shot or a fashion shot. I'm looking for theater.

You latch on to something in the name of the artist, the name of the album, or the name of the song. One works here as in an agency; it's a writer and an art director sitting down and collaborating. The concept usually comes from one of the three things I just mentioned. There are times when it's really hard, when the only name you have is the name of the act. And if it's a person's name, then you're really stuck. You really have to start pulling things from nowhere. Sometimes you just want to shoot the artist, like Ron Wood, and not bother with anything else. But he's one of the Rolling Stones and people will respond to that. This

Record companies constantly demand arresting images, predominately photographic, to draw attention to their products. Here are three different interpretations from three different artists. The photograph of Ramsey Lewis's hands for his album cover is a dynamic treatment of a classic approach (the part standing for the whole). The photograph of the two babies is a pun on the title of an album. Andy Warhol's classic cover for a Rolling Stones album, Sticky Fingers, plays on the well-known raunchiness of the group. The original photograph was a Polaroid snapshot. The record industry utilizes photography in a variety of different ways. Aside from album covers, there are ads (the babies) concert posters, publicity photos for bios, and even decals for T-shirts.

was my concept for his album, but you can't sell him in any better way than using him.

You have to remember that it's an ad, not an album cover. (Unless there is something on the cover we can't beat, we don't use cover art.) The essence of an ad never changes. You want the viewer to get your message right away. On an album cover there's no copy, it's a visual message. In new-wave stuff, a lot of people think that sloppy type and unretouched photos are punk, but in new wave it can be all that and still give you the message you are looking for. I just hired a woman who is a new-wave photographer/designer. She's never had any printed pieces, but I'm going to use her when I have to shoot a new-wave band because her photographs are very unique and very original. I look for the combination of design and photography. I am just beginning to understand that it's a sociological thing, that not every photographer or art director has to go in and do it. You could be misled by thinking that new-wave design is just sloppiness—it's not. This woman had a very bold approach. It was fairly academic stuff, it felt like art school, but it had a certain uniqueness about it. It was very simple and very hard to describe. I thought I could take a chance on her. She did a job for us, and I coached her and helped her along. With the next gig I give her, I'm hoping it will be easier because I don't have the time to spend hours and hours telling them what I want to see. We improvise a lot here. We don't have an art buyer, like an ad agency, or someone to spec the type. We have to look for our own

props sometimes, which makes the job more fun. It's not as automated as in an agency. I look for efficiency in a photographer—one who is organized for wardrobe, for instance —and I can usually see in their portfolios if they are experienced or whether they've had a stylist working for them. I have to really trust the photographer.

In this business there is no such thing as a reshoot. We just don't have the time. It's like newspaper work—an album is released, and you've got to be able to present an ad.

You have to be very tactful, and in many cases the music people are going to be firm. They're dealing with an incredible ego in a rock star. You have to be confident. There are times when it boils down to having to say, "Your expertise is in music and mine is in photography and design, so please listen to me."

Many recording artists have an incredible mistrust of the record company and anybody who is shooting them. It helps to know music. I'm an ex-musician, and I was brought up on rock and roll. When I worked with one artist, I had to go through his wardrobe and tell him what to wear for the shoot. Some musicians are used to being pampered, others are very mature and responsible. Each artist and each situation is different. Some stars expect to be told exactly what to do, others need very little direction. Michael Jackson has a great instinct for modeling and gives you great poses, while another person or band may feel awkward posing and need a good deal of coaching and T.L.C. The photographer I'm working with has to be able to bend with all of these idiosyncrasies.

7

INTO THE BIG TIME

Career Strategies

The most direct route to success in professional photography is based on a combination of well-thought-out strategy and applied tactics. While strategies may be different for different individuals, it is absolutely essential to have a plan and a goal in mind toward which to work.

For instance, if your goal is to work for a top fashion magazine such as *Vogue*, and to get prestigious and well-paying assignments in advertising, your strategy would be to get as much work as possible for other fashion publications such as *Seventeen, Mademoiselle,* and *Gentlemen's Quarterly*. This will guarantee that your work will be noticed and put you in a competitive position. In other words, it will make you desirable as a *Vogue* photographer.

An example of a tactic would be to catch the attention of the *Vogue* art director by submitting arresting images that are in the *Vogue* style to the other magazines. This shows that your work can be applicable. Other tactical moves, of course, involve making the personal contacts with art directors and clients necessary to ensure a smooth transition from the minor leagues to the big time.

Your strategy, as in the case of Bert Stern, can be equally effective in reverse. You can start with provocative work in advertising that leads to editorial assignments.

I cannot stress enough the effectiveness of the European connection. At a certain point in your career, going to Europe to work in fashion will give you experience and tear sheets that cannot help but be impressive to American art directors. You cannot be a high-fashion photographer without an intimate knowledge of high fashion. This only comes from contact with that world. There is no way to accomplish this in Kalamazoo, Michigan. This rule applies to every other market: advertising (including beauty), still life, photo-illustration and food photography, corporate, or reportage.

My advice to those with developed skills, to those who have already achieved a degree of professionalism outside of New York and who are ready to accelerate their careers, is to consolidate by picking a specialty. Careful planning of your next move will ensure that you do not overreach your goals. In other words, make sure of your footing before climbing the next rung

of the ladder. In practical terms, this means finding a solid hometown buyer (such as a magazine or newspaper) that uses your work regularly. This buyer can also be an advertising agency, department store, or any client.

Set realistic goals. Your first priority should be to keep as much of your work in print as possible, even if this means going back to your hometown occasionally to do assignments for old clients. At this stage, volume is extremely important as it shows both productivity and continuity.

In the beginning you will have to survive without the help of a rep. This means that you will have to represent yourself until you get to a position where someone will find it profitable to handle your career. At a certain point, if you are to work effectively, it will be essential to get representation. Presumably by this time you will have a substantial enough body of work to interest an established agent. It may take you six to eight weeks of searching to find an agent who wants you and with whom you can be happy, but the research and interviews are important because this is a relationship that you will want to maintain for a long time. Once you have a rep, it will probably take six to eight months to get really solid work.

Flexibility is your greatest asset during this period of transition. Your ability to solve different photographic problems quickly and consistently will demonstrate that you are professional. Remember always to try to reflect the attitudes of the accounts that you are working on, and to concentrate on those assignments to which you can bring your own vision and skills. If your motivation is parallel to that of the client, you will find the working process easier. As in film, it is the client that gets the final edit, even though your name goes on the picture. Don't be discouraged if a client doesn't buy an imaginative solution to a problem; you may be able to apply it to another situation later on.

Once you have established yourself as a professional in any given field, you will be in a position that will allow you to consider switching to advertising, the most lucrative area of commercial photography. There are many obstacles in going from editorial to advertising. First, your photographs have to have a market value. Potential clients always need prodding to experiment with new styles. A simple proof of marketability is your ability to sell as a stock photographer. A simple twist on the style you have developed—such as applying reportage, landscape, or portrait skills to corporate industrial or annual report photography—will often provide the key to get from one market to another. This is also true of editorial fashion photography. Still-life principles of design and lighting, for example, can be readily applied to fashion advertising.

Addressing yourself to the field of advertising requires a large investment of "personal public relations" time, including making the rounds and following up on contacts. You have to work hand-in-hand with your rep to keep in touch with clients or potential clients. Whenever a specific type of picture is needed by an art director as a piece of swipe, layout, or for client meeting, get it to him quickly. Your reliability will be shown by these gestures and will be the foundation for a solid working relationship. Other self-promotion techniques of joint promotional calendars with a printer, postcards, announcements, or tear sheets, and advertising in publications such as the *Black Book* should be used wherever possible.

Advertising constantly needs new ideas and images to promote its products. Have the courage of your own convictions. The most important thing for any photographer is to be in sync with a part of the American self-image. If you want to reach a mass audience, you may have to rethink your objectives. As a photographer, you must realize that what you have experienced is pretty much what is going to be projected in your images.

When I was a rep, photographers came into my office, having tried to break into New York before, looking for a rep and editorial work. Most of their pictures were slavish copies of any number of current styles. This simply isn't good enough. Your style must be well developed, original, consistent, and up to the standards of the industry. Nothing less than this will do. Very rarely would I see the portfolio of an unknown photographer whose work I could not ignore. When this happens, any rep will go to any lengths to get that photographer seen. This is the easiest type of person to get work for because people respond immediately to their talent. Then comes the slow process of acceptance, of projecting the image of a professional and established New York photographer. Availability

is often a key factor in one photographer being given an assignment over another. Now that your big break has come, it is important to make the most of it. Don't let carelessness over detail undermine years of preparation.

THREE TOP PHOTOGRAPHERS AND HOW THEY DID IT

The following examples are intended to give you an idea of the diverse personalities, backgrounds, and working habits of successful photographers. In each case, you will find the elements of success that have been repeated throughout the book. As you read these sketches, keep in mind that it is up to you to recognize your potential, your limits, and your capabilities, and to make them work for you. As many people have pointed out, it is a process of exploration, of growth, and of coming to terms with the future and the potential it holds.

Bert Stern is credited with many innovations in color photography. He attributes this to the luxuries of time and generous budgets that his first clients gave him. In order to produce quality photographs, the clients allowed Bert to do single pictures for as long as a month at a time, and then to take three months to perfect them. He was able to experiment and work over and over on his photographs until he had produced the images he wanted. If he knew what the final image would be, he worked backward because "at times the pictures are in my head, and I have to wait for them to work their way out. These can be the best pictures; all the best pictures come from experience." His intention was to make an arresting page in a magazine, one where the viewer would study the photograph. This is an extremely effective advertising technique, which the client became aware of while working with him. Photography at this point was beginning to usurp illustration's place in advertising. These initial efforts by Stern began to prove that photography was indeed a more effective method of reaching consumers. Speaking about these years in *Infinity* magazine in 1960, Stern relates: "It was good photography that was creating the ideas and selling the products." And Bert found that the photographs

with which he was most pleased were the ones that won awards. This inspired him to continue his work, bolstering his confidence in the quality of his photographs. The landmark photographs that followed included the *McCall's* folio on children; the Smirnoff vodka ad campaigns; the I. Miller shoe campaign, in which Bert introduced the superwide-format camera to advertising photography; and the last sitting of Marilyn Monroe. Bert never felt limited in advertising photography because he valued it as a responsive medium: the photographer sees his work in print almost immediately after its production, generating instantaneous gratification.

Bert will go to any length to ensure a good photograph. When Marvin Israel was creative director at *Seventeen* magazine in the late fifties, he was impressed with Bert's confidence, which Marvin attributes to Bert's success. Bert had been given an assignment, and he had not only asked for a lot of money, but said he would only do the whole issue, not just a single spread. He himself found the model he wanted, Carol Lynley, now an actress. He had ideas about every phase of the project and moved twice as fast as anyone else working on it. Instead of doing the pictures according to a generally agreed upon layout, Bert took liberties not usually tolerated. When he presented the pictures, Marvin changed the entire layout to fit Bert's pictures, not at all the standard process. It is that sort of confidence, the breaking of the rules, and the fact that Bert had spared no extreme to produce a quality photograph, that enabled him to produce his hits.

Bert's solution to a problematic assignment is an example of his commitment to getting the best possible picture. For a travel assignment, he went to Miami and found he absolutely hated the city, so he followed the sunset all day long, looking for a location. He wound up in Naples, on Florida's Gulf Coast, where he finally took a sunset picture.

Bert learned to take pictures based on the way he felt, following an axiom that if it doesn't feel good, it isn't going to look good. "It was a very personal approach. I felt like a gunfighter, and I could be quick on the draw with the camera. It seemed like the American thing to do was good shots." Stern, who had never been an assistant or had any darkroom experience, had learned techniques in the Army while working on a film unit

during the occupation of Japan. Prior to his Army stint, Stern had been the art director at *Flair* magazine and *Fashion and Travel* magazine. Much earlier, while working at *Look* magazine as a mailroom boy, he had met Hershel Bramson. Bramson was taken with young Stern's confidence and intelligence and tutored him in the elements of advertising work. Bramson had studied with the painter André Lhote, a pupil of Cézanne's, and he had the rare quality in an art director of relating to the photographer's point of view and prompting the photographer's insight.

When Stern returned from the Army, he bought a Rollei camera and went directly into advertising photography, skipping the normal route of editorial work. He very much wanted to work for *Vogue,* which to him, and to others, represented quintessential American taste and style. In 1953–55 Bert took over the Pepsi account when it moved from illustration to photography. The success of that campaign brought him the Coca-Cola account, for which he created a campaign that celebrated American life circa 1960. Bill Backer, then creative director for Coca-Cola, says that it was Bert's positiveness and desire for freshness and the way he viewed Americana that meshed with the client image in the Coca-Cola ads.

Bert had had an ambition to do a film before he was thirty, and he accomplished this goal with *Jazz on a Summer's Day* in 1958, a film of the Newport Jazz Festival. Backer had wanted to do something different from all the other commercials running in 1962, so he arranged a screening of Bert's film. He talks about his impressions of Bert:

> The best illustration and advertising photographers bring their own concepts to the campaign. That is what is so extraordinary about Bert Stern. We were looking for someone to fill out the layout. Bert's own feelings for Americana were parallel to that of the campaign. Bert was in tune with the times, and he believed in Americana, which was the Coke belief. We looked for a still photographer who could extend the concept of what had already been worked out, more from the general point of view than the specific. A photographer's concept realizes a general idea. It takes great intelligence

to then actually record it. Bert thinks in terms of movies, not just a single image, so there is a cinematic interpretation of things happening before and after.

Kourken Pakchanian describes the intense motivation and single-minded determination needed to succeed in photography. (His advice will help you get through the beginning stages.)

There is a dedication to your chosen field that is compulsory, and a passion to pursue your work hard enough to discover yourself in it. It may be difficult sometimes and require years. You have to experience by doing it from day to day to become aware of the similarities and differences, subtle and great, between other photographers and yourself. It requires a critical scrutiny of what you understand, your likes and dislikes, what makes you pleased with yourself and your work, and the unique message that you can possibly convey in your work. It is knowledge, practice, and experience, including mistakes, that make us able to identify within ourselves our individual style. It is inspiration in ways of seeing—an awareness—that enables one to test and then to duplicate and to put the elements together to come out with the photograph that has not been seen before just that way.

My advice to one striving, looking, and working is not to worry but to keep on shooting even though at times other photographers' work can be recognized within your own. If you remain the main critic of your work and keep an objective point of view without easy acceptance, style will come. But keep on shooting. It takes practice to visualize, fantasize, and dream within the context of beautiful images. Photographs must be conceived environments, and all the trappings of lighting, wardrobe, clothes, hair have to be related. To bring an honest and true interpretation to a photograph comes from your putting those elements together. It is being open to learning to get the most out of the person or the situation in a very short eight-hour period. When you turn a corner and see a woman bent over, fixing her shoe, it is your interpretation that makes the picture unique. Simply keep shooting and remain dedicated

to your work, be tough on yourself, don't let yourself get away easy, push yourself further. It is trial and error, and continuing until your work is good enough to be published and you can reproduce that picture yourself. You have to keep it up, over and over, until you find that the satisfaction is starting to come.

A rep can minimize the time that it takes to establish yourself, especially if there is a compatibility at the beginning stages of a career. A rep can bring a continuity to the flow of work. Because of the instantaneousness of Polaroids and the speed of processing, with film coming back from a lab overnight, you can see a photograph in print and get a reaction to it only a few months later. There is little lost because of time. But a career that has been built up over years can disintegrate when the rep is inappropriate for the photographer.

Kourken called me after seeing a newspaper promotion I had put out. He thought that I would represent him well and thoroughly. He told me he had one rep with whom he had worked successfully for ten years before the rep moved to California. He had worked with one other rep who had unfortunately pursued inappropriate accounts, did not understand Kourken's approach to photography, and had slowly lost established accounts. Gradually the rep had been unable to provide a sufficient amount of work. Between a combination of loyal clients and hard work, within two months good accounts were back with Kourken—Revlon, *McCall's*, and Chanel. After nine months of hard work, the momentum had been rebuilt, and there is now very steady work.

Deborah Turbeville had worked for many years as an editor at *Bazaar* and *Mademoiselle* before she decided to switch to professional photography. Her years of exposure to sophisticated fashion and style gave her a solid perspective on the markets she was attempting to break into. But it was her own unique vision, bolstered by a rep's commitment to her personal photographic style, that catapulted her into prominence.

One major account that approached her was Elizabeth Arden. The initial problem was how to mesh Deborah's personal style with a major market application of lipstick and creams. It is difficult to find anything truly new to apply to markets with established techniques for the selling of a product. This is an instance where the courage of the client to experiment, within limits, won out over the general conservatism representative of many accounts. There was much hesitation in the company about whether or not to go ahead. The circumstances were tricky because of in-house politics. It is often very hard for artists and their reps to understand the complex workings of a major corporation and its approach to creating a new image. It takes a long time for a large company to support a new idea because there are concerns about its efficiency from every department. Marketing wants the product to be visible and recognizable. The sales department is concerned with the product's acceptability in the marketplace. The creative department wants something new, special, exciting, and above all different. All of these points of view have to be respected and blended—the needs of each department must be satisfied. You cannot think about what is in *Vogue*. The main issue is always what will sell.

The corporate concern was whether Deborah's style would be workable, and there were two conflicting opinions within the company. One group felt it would work; the other felt it would not. The quality of the photographs was never in question. From a marketing standpoint, the steps that had to be taken to prove that Deborah's style was appropriate seemed extreme, although it was fully understood that Elizabeth Arden was making a large commitment, with many implications that could not be immediately evaluated.

In some ways it was a very swift decision. Paulette De Fault, the Elizabeth Arden advertising director, concurs:

If I knew at the beginning what I know now, I would say the time it took, from April to October, was very fast. Since a company of this scale operates six months ahead of the present time, introducing Deborah's photographs as a new image for the company within that time frame was a nearly immediate shift of direction. It is especially amazing when you consider how unique Deborah's style is and the challenge

it was to apply that to a commercial framework. She did a great job of meshing her style with that of Arden's selling needs and its image of women. It forced her to work within a structure provided by the company, not that of an editorial environment.

Elizabeth Arden was exactly the right client to make use of Deborah's style because of the long-standing image of the company as the Rolls-Royce of the industry. Arden and *Vogue* magazine represent chic and sophisticated American style, and Deborah's photographic style fit the image. The communication allowed Deborah and her rep to pursue the account to any length because all parties could be sure of appropriateness.

Deborah's Visible Difference skin-cream picture has all the elements that had been so carefully considered: it sets a style and a look that express the company's marketing strategy, and it is new and exciting. For the sales department it is acceptable because even if it is not so hard sell, the advertisement could be given enough exposure to compensate for that.

There are many contingencies that have to occur simultaneously to get a company to go with you. It may take months or years of carefully building up relationships within the company. But you do not have to be a pest or a bore before your talents and the company's goals can be merged harmoniously. The Visible Difference photographs remain timeless, both aesthetically and commercially. Deborah affected the way people viewed Arden, and that awareness in turn made the company consider its approach in a different light.

IT'S A SNAP:
REALIZING YOUR POTENTIAL

Recently I was asked why a particular photographer never reached his potential. My analysis was the following: the photographer stayed too long doing low-priced ads, let opportunities slide by without showing outstanding work, and lastly, let photographs be published in insignificant places that showed too narrow and self-centered a vision, thus making potential big-time buyers wary. These buyers do not have the time or money to risk using photographers who are not consistently producing quality work in appropriate modes because there are many photographers who are. This does not mean that there is not plenty of room for personal style to be expressed. It must, however, represent a current or universal theme. A photographer therefore must follow his own instincts in regard to developing his style. It may not have immediate mass appeal, but if it is original and well worked out, an application will undoubtedly be found.

The road to becoming a professional photographer can be tricky to maneuver. It is the function of a good rep to calculate the risks and clear the road of obstacles that could get in the way. Every photographic career is different and therefore the approaches and techniques that will lead to a successful resolution vary tremendously. The direction, the points of growth, or stagnation will only emerge after the strategy and tactics of the career have been determined by the photographer and the rep. This process can take anywhere from nine to sixteen months, depending on the amount of potential and the amount of work accomplished prior to the photographer-rep association. Few results may be seen during most of this period, and this time lag is something for which the photographer should be prepared.

Photographers, to become successful professionals, must be able to conceive and perfect unique images. They must have the drive and the determination to work their way up, and they must be identifiable by a personal style. They must be able to promote themselves by mailings and in personal contact with clients. They cannot allow themselves to fall into the trap of believing their own hype or getting involved in the games that are being played around them. Inflation of ego is so common in this business that any art director will be relieved if he or she doesn't have to add you to a long list of temperamental artists. A sense of perspective as well as a healthy sense of humor is essential to survival in this business.

To make it as a professional requires intense dedication and passion. Photography is a highly competitive field, but there is always a place for fresh talent.

APPENDIX

Where to Find . . . *

PHOTOGRAPHERS' REPRESENTATIVES

New York City

KEN ABBEY & ASSOCIATES
421 Seventh Ave.,
New York, NY 10001
(212) 758-5259

ADAMS, KRISTINE
62 W. 45th St.,
New York, NY 10036
(212) 869-4170

ADRIAO, ANTONIO
353 W. 53rd St.,
New York, NY 10019
(212) 682-2462

ANDRIULLI, ANTHONY
60 E. 42nd St.,
New York, NY 10165
(212) 682-1490

ANTON, JERRY
107 E. 38th St.,
New York, NY 10016
(212) 689-5886

PETER ARNOLD INC.
1466 Broadway
New York, NY 10036
(212) 840-6928

ARONOW, PETER
New York, NY
(212) 580-2637

ARTISTS ASSOCIATES
211 E. 51st St.,
New York, NY 10022
(212) 755-1365

AUGENBLICK, DEBORAH
12 Charles St., ⚹1A,
New York, NY 10014
(212) 243-4065

BACHE, DIANE
50 W. 71st St.,
New York, NY 10023
(212) 724-7400

BACKER, VIC
178 E. 73rd St.,
New York, NY 10021
(212) 620-0944

ANDY BADIN & ASSOCIATES, INC.
333 E. 49th St.,
New York, NY 10017
(212) 734-4533

BAHM, DARWIN
6 Jane St.,
New York, NY 10014
(212) 989-7074

BARCLAY, R. FRANCIS
5 W. 19th St.,

* PUBLISHER'S NOTE: The information contained in this Appendix is as accurate and up-to-date as possible at the time this book went to press.

New York, NY 10011
(212) 255-3440

BARNELL, JOE
60 E. 42nd St.,
New York, NY 10165
(212) 687-0696

BASILE, RON
381 Fifth Ave.,
New York, NY 10016
(212) 689-3333

BECKER, NOEL
150 W. 55th St.,
New York, NY 10019
(212) 757-8987

BEILIN, FRANK
405 E. 56th St.,
New York, NY 10022
(212) 751-3074

BELL, BARBARA
New York, NY
(212) 982-9785

BISHOP, LYNN
134 E. 24th St.,
New York, NY 10010
(212) 254-5737

BLACK, JOEL P.
29 E. 32nd St.,
New York, NY 10016
(212) 685-1555

BLATT, ABBY
45 W. 90th St.,
New York, NY 10024
(212) 362-1487

BLUM, FELICE
79 W. 12th St.,
New York, NY 10011
(212) 243-3942

BOGHOSIAN, MARTY
7 E. 35th St.,
New York, NY 10016
(212) 685-8939

BOHMARK LTD.
43 E. 30th St.,
New York, NY 10016
(212) 889-9670

BONART, BEN
311 E. 71st St.,
New York, NY 10021
(212) 734-3773

TOM BOOTH INC.
435 W. 23rd St.,
New York, NY 10011
(212) 243-2750

BRINDLE, CAROLYN
203 E. 89th St., ⌗3D,
New York, NY 10028
(212) 249-8883

BRODY, SAM
141 E. 44th St.,
New York, NY 10017
(212) 758-0640

BROWN, DAVE
6 W. 20th St.,
New York, NY 10011
(212) 675-8067

BROWN, DOUG
400 Madison Ave.,
New York, NY 10017
(212) 980-4971

PEMA & PERRY BROWNE
LTD.
185 E. 85th St.,
New York, NY 10028
(212) 369-1925

BRUCK, JOE
157 W. 57th St.,
New York, NY 10019
(212) 247-1130

BUSH, NAN
56 E. 58th St.,
New York, NY 10022
(212) 751-0996

BYRNES, CHARLES
New York, NY
(212) 982-9480

CAFIERO, CHARLES
294 Elizabeth St.,
New York, NY 10012
(212) 777-2616

CAHILL, JOE
135 E. 50th St.,
New York, NY 10022
(212) 751-0529

CAMERA 5
6 W. 20th St.,
New York, NY 10011
(212) 989-2004

WOODFIN CAMP &
ASSOCIATES
415 Madison Ave.,
New York, NY 10017
(212) 750-1020

CANFIELD, JOAN
64 W. 15th St.,
New York, NY 10011
(212) 255-6579

CARP, STANLEY
8 E. 48th St.,
New York, NY 10017
(212) 759-8880

CARUSO, FRANK
523 E. 9th St.,
Brooklyn, NY 11218
(212) 854-8346

CHIE
15 E. 11th St., ⌗3M,
New York, NY 10003
(212) 685-6854

CHISLOVSKY, CAROL
444 Madison Ave.,
New York, NY 10022
(212) 758-2222

COLLINS, CHUCK
543 W. 45th St.,
New York, NY 10036
(212) 765-8812

COLLINS, PATRICK
24 E. 55th St.,
New York, NY 10022
(212) 698-2598

ROBERT CRANDALL
ASSOCIATES
306 E. 45th St.,
New York, NY 10017
(212) 661-4710

CRECCO, MICHAEL
New York, NY
(212) 682-3422

CULLOM, ELLEN
55 E. 9th St.,
New York, NY 10003
(212) 777-1749

DABNER, ROGER
342 Madison Ave.,
New York, NY 10017
(212) 883-0242

DAVIES, NORA
370 E. 76th St.,
New York, NY 10021
(212) 628-6657

DEDELL, JACQUELINE
58 W. 15th St.,
New York, NY 10011
(212) 741-2539

DENNER, ANN
249 W. 29th St.,
New York, NY 10001
(212) 947-6220

DES VERGES, DIANA
73 Fifth Ave.,
New York, NY 10003
(212) 691-8674

DEVITO, KITTY
43 E. 30th St.,
New York, NY 10016
(212) 889-9670

DIBARTOLO, JOSEPH
270 Madison Ave.,
New York, NY 10016
(212) 532-0018

DICARLO, BARBARA
500 E. 85th St.,

New York, NY 10028
(212) 734-2509

DIMARTINO, JOSEPH
200 E. 58th St.,
New York, NY 10022
(212) 935-9522

DIPARISI, PETER
54 W. 39th St.,
New York, NY 10018
(212) 840-8225

DOLL, MARY ANN
45 W. 88th St.,
New York, NY 10028
(212) 877-8620

DPI-ALFRED FORSYTH
521 Madison Ave.,
New York, NY 10022
(212) 752-3930

DU BANE, JEAN-JACQUES
300 E. 33rd St.,
New York, NY 10016
(212) 697-6860

DUBNER, LOGAN
342 Madison Ave.,
New York, NY 10017
(212) 883-0242

DWORKOW, SOL
322 E. 39th St.,
New York, NY 10016
(212) 686-5000

FEDER, THEODORE H.
342 Madison Ave.,
New York, NY 10017
(212) 697-1136

FELD, ROBIN
336 E. 81st St.,
New York, NY 10028
(212) 288-4108

FELDMAN, ROBERT
171 First Ave.,
New York, NY 10003
(212) 473-2500

FICALORA, MICHAEL
28 E. 29th St.,
New York, NY 10016
(212) 679-7700

FINERMAN, BONNIE
322 E. 39th St.,
New York, NY 10016
(212) 686-5000

FLOCK & LOMBARDI ASSOC.
 LTD.
145 E. 27th St.,
New York, NY 10016
(212) 689-3902

FLOOD, PHYLLIS RICH
67 Irving Pl.,

New York, NY 10003
(212) 674-8080

FOSTER, PETER
870 United Nations Plz.,
New York, NY 10017
(212) 593-0793

FRATTOLILLO, RINALDO
360 E. 55th St.,
New York, NY 10022
(212) 486-1901

FURST, FRANZ
420 E. 55th St.,
New York, NY 10022
(212) 753-3148

GARTEN, JAN AND JACK
50 Riverside Dr.,
New York, NY 10024
(212) 787-8910

GELB, ELIZABETH
330 W. 28th St.,
New York, NY 10001
(212) 243-4539

GOLDSTEIN, MICHAEL L.
107 W. 69th St.,
New York, NY 10023
(212) 874-6933

GOLDSTEIN, SUZANNE
60 E. 56th St.,
New York, NY 10022
(212) 758-3420

GOODMAN, BARBARA L.
435 E. 79th St.,
New York, NY 10021
(212) 288-3076

GOODWIN, PHYLLIS A.
10 E. 81st St.,
New York, NY 10028
(212) 570-6021

BARBARA GORDON
 ASSOCIATES
165 E. 32nd St.,
New York, NY 10016
(212) 686-3514

GOULD, LINDA
New York, NY
(212) 935-0143

GOULD, STEPHEN JAY
225 E. 31st St.,
New York, NY 10016
(212) 686-1690

GRAYSON, JAY
230 Park Ave.,
New York, NY 10169
(212) 689-1468

GREEN, ANITA
160 E. 26th St.,

New York, NY 10010
(212) 532-5083

GREENBLATT, EUNICE N.
370 E. 76th St.,
New York, NY 10021
(212) 628-3842

GREY, BARBARA L.
1519 50th St.,
Brooklyn, NY 11219
(212) 851-0332

GRINNELL, KATE
New York, NY
(212) 532-8072

GROVES, MICHAEL
113 E. 37th St.,
New York, NY 10016
(212) 532-2074

HARWOOD, PAULA
225 E. 36th St.,
New York, NY 10016
(212) 685-1209

HECK, DOROTHEA
5 E. 16th St.,
New York, NY 10003
(212) 685-1209

HENRY, JOHN
237 E. 31st St.,
New York, NY 10016
(212) 686-6883

HOLLYMAN, AUDREY
300 E. 40th St., #19R,
New York, NY 10016
(212) 867-2383

HOLT, RITA
280 Madison Ave.,
New York, NY 10016
(212) 683-2002

HORNER, PAT
1127 78th St.,
Forest Hills, NY 11375
(212) 261-7505

HOTTELET, MARY
156 Fifth Ave., #900,
New York, NY 10010
(212) 675-2727

HOVDE, NOB
829 Park Ave.,
New York, NY 10021
(212) 753-0462

HUREWITZ, GARY
5 E. 19th St.,
New York, NY 10003
(212) 982-9480

INCANDESCENT INC.
111 Wooster St.,

New York, NY 10012
(212) 925-0491

**INTERNATIONAL
PHOTOGRAPHY
MANAGEMENT, INC.**
130 W. 57th St.,
New York, NY 10019
(212) 582-1501

JACOBSEN, VI
333 Park Ave. S.,
New York, NY 10010
(212) 677-3770

JEDELL, JOAN
370 E. 76th St.,
New York, NY 10021
(212) 861-7861

JENKINS-COVINGTON INC.
510 E. 74th St.,
New York, NY 10021
(212) 879-6200

**EVELYNE JOHNSON
ASSOCIATES**
201 E. 28th St.,
New York, NY 10016
(212) 532-0928

KAHN, HARVEY
50 E. 50th St.,
New York, NY 10022
(212) 752-8490

KAMMLER, FRED
225 E. 67th St.,
New York, NY 10021
(212) 249-4446

BARNEY KANE INC.
120 E. 32nd St.,
New York, NY 10016
(212) 689-3233

KAUFMAN, GITA
New York, NY
(212) 759-2763

KEATING, PEGGY
30 Horatio St.,
New York, NY 10014
(212) 691-4654

KENNEY, JOHN
12 W. 32nd St.,
New York, NY 10001
(212) 594-1543

KIM
209 E. 25th St.,
New York, NY 10010
(212) 679-5628

**KIRCHMEIER, SUSAN,
c/o N. LEE LACY**
160 E. 61st St.,
New York, NY 10021
(212) 758-4222

KLEIN, LESLIE D.
130 E. 37th St.,
New York, NY 10016
(212) 832-7220

KLEINER, GOLDIE
295 Central Pk. W.,
New York, NY 10024
(212) 799-8050

KNOTT, JUNE
180 West End Ave., #3H,
New York, NY 10023
(212) 724-9652

KOPEL, SHELLY
342 Madison Ave., #261,
New York, NY 10017
(212) 986-3282

JOAN KRAMER & ASSOCIATES
720 Fifth Ave.,
New York, NY 10019
(212) 224-1758

KREIS, URSULA G.
63 Adrian Ave.,
Bronx, NY 10463
(212) 562-8931

LADA, JOE
330 E. 19th St.,
New York, NY 10003
(212) 475-3647

LAIHO, IRMELI
1466 Broadway,
New York, NY 10036
(212) 944-2250

LAKIN, GAYE
345 E. 81st St.,
New York, NY 10028
(212) 861-1892

JANE LANDER ASSOCIATES
333 E. 30th St.,
New York, NY 10016
(212) 679-1358

LANE TALENT INC.
444 E. 82nd St.,
New York, NY 10028
(212) 861-7225

**FRANK & JEFF LAVATY
ASSOCIATES**
45 E. 51st St.,
New York, NY 10022
(212) 355-0910

LEE, BARBARA
307 W. 82nd St.,
New York, NY 10024
(212) 724-6176

LEFF, JERRY
342 Madison Ave.,
New York, NY 10173
(212) 697-8525

LEGRAND/SAUNDERS
41 W. 84th St.,
New York, NY 10024
(212) 724-5981

LENTO, JULIA
101 Ocean Pkwy.,
Brooklyn, NY 11218
(212) 233-8989

LERMAN, GARY
40 E. 34th St.,
New York, NY 10016
(212) 683-5777

LEVINSTONE, DONNA
171 E. 88th St.,
New York, NY 10028
(212) 348-9664

**LOVINGER TARDIO
MELSKY INC.**
157 E. 35th St.,
New York, NY 10016
(212) 532-3311

LUPPI, JUDITH
117 E. 24th St.,
New York, NY 10010
(212) 677-1910

MADRIS, STEPHEN
445 E. 77th St.,
New York, NY 10021
(212) 744-6668

MANDEL, BETTE
265 E. 66th St.,
New York, NY 10021
(212) 737-5062

MANN, KEN
313 W. 54th St.,
New York, NY 10019
(212) 245-3192

MANN, WILLIAM THOMPSON
219 W. 71st St.,
New York, NY 10023
(212) 595-6260

MARINO, FRANK
35 W. 36th St.,
New York, NY 10018
(212) 563-2730

MARINO, LOUISE A.
5 E. 19th St.,
New York, NY 10003
(212) 677-6310

MARIUCCI, MARIE A.
32 W. 39th St.,
New York, NY 10018
(212) 944-9590

MARSHALL, MEL
40 W. 77th St.,

New York, NY 10024
(212) 877-3921

MARTIN, BRUCE
333 E. 30th St.,
New York, NY 10016
(212) 679-1358

MATTHEWS, BARBARA
2 Charlton St.,
New York, NY 10014
(212) 989-9030

MAUTNER, JANE
85 Fourth Ave.,
New York, NY 10003
(212) 777-9024

METSKY, BARNEY
157 E. 35th St.,
New York, NY 10016
(212) 532-3311

MELTON, MARY L.
223 Water St.,
Brooklyn, NY 11201
(212) 596-5663

MENDELSOHN, RICHARD
353 W. 53rd St.,
New York, NY 10019
(212) 682-2462

MENDOLA, JOSEPH
230 Park Ave.,
New York, NY 10017
(212) 986-5680

MESSING, PATRICIA
New York, NY
(212) 724-1627

MICHALSKI, BEN
118 E. 28th St.,
New York, NY 10016
(212) 683-4025

MILEWICZ, MAREK
45 W. 18th St.,
New York, NY 10011
(212) 243-2174

MILSOP, FRAN
514 E. 83rd St.,
New York, NY 10028
(212) 794-0922

MORETZ, EILEEN P.
141 Wooster St.,
New York, NY 10012
(212) 254-3766

MORGAN, VICKI
194 Third Ave.,
New York, NY 10003
(212) 475-0440

MOSKOWITZ, MARION
516 Fifth Ave.,
New York, NY 10026
(212) 472-9474

MULVEY ASSOCIATES
1457 Broadway,
New York, NY 10036
(212) 246-3660

NELSON, GEORGE L.
64 W. 15th St.,
New York, NY 10011
(212) 255-6579

OPTICALUSIONS
9 E. 32nd St.,
New York, NY 10016
(212) 688-1080

O'ROURKE, GENE & COREY
200 E. 62nd St., #8C,
New York, NY 10021
(212) 935-5027

PALEVITZ, BOB
333 E. 30th St.,
New York, NY 10016
(212) 684-6026

PALMER-SMITH, GLENN
160 Fifth Ave.,
New York, NY 10010
(212) 807-1855

PATTERSON, SYLVIA
448 W. 20th St.,
New York, NY 10011
(212) 675-2805

BARBARA PENNY
ASSOCIATES
114 E. 32nd St., #902,
New York, NY 10016
(212) 685-2770

PERRON, BEA
New York, NY
(212) 953-9046

PETERS, BARBARA
377 Park Ave. S.,
New York, NY 10016
(212) 683-2830

PHOTO RESEARCHERS
60 E. 56th St.,
New York, NY 10022
(212) 758-3420

POPPER, SERGE
315 E. 68th St.,
New York, NY 10021
(212) 737-4334

THE QUINLAN ARTWORK
CO.
230 Park Ave.,
New York, NY 10169
(212) 867-0930

GERALD & CULLEN RAPP
INC.
251 E. 51st St.,

New York, NY 10022
(212) 751-4656

RAY, MARLYS
350 Central Pk. W.,
New York, NY 10025
(212) 222-7680

KAY REESE & ASSOCIATES
156 Fifth Ave., #1107,
New York, NY 10010
(212) 924-5151

REMLER, GLADYS
New York, NY
(212) 758-0338

RENARD, MARC
1 W. 30th St.,
New York, NY 10001
(212) 736-3266

RICHARDS, GARY
1462 First Ave.,
New York, NY 10021
(212) 691-7950

RILEY, CATHERINE
12 E. 37th St.,
New York, NY 10016
(212) 532-8326

RIVELLI, CYNTHIA
303 Park Ave. S.,
New York, NY 10010
(212) 254-0990

ROSENBERG, ARLENE
377 W. 11th St., Suite 2G,
New York, NY 10014
(212) 675-7983

ROTHENBERG, JUDITH A.
667 Madison Ave.,
New York, NY 10022
(212) 308-0488

RUBIN, ELAINE R.
301 E. 38th St.,
New York, NY 10016
(212) 725-8313

RUBIN, MEL
1619 Third Ave.,
New York, NY 10028
(212) 860-3959

RUDOFF, STAN
271 Madison Ave.,
New York, NY 10016
(212) 679-8780

RUSSO, KAREN
175 W. 92nd St.,
New York, NY 10025
(212) 243-6778

SACRAMONE, DARIO D.
302 W. 12th St.,

New York, NY 10014
(212) 929-0487

SALOMON, ALLYN
271 Madison Ave., #207,
New York, NY 10016
(212) 684-5586

SAMUELS, ROSEMARY
39 E. 12th St.,
New York, NY 10003
(212) 477-3567

SANDER, VICKI
48 Gramercy Pk. N., #3B,
New York, NY 10010
(212) 674-8161

SAUNDERS, MARVIN
306 E. 45th St.,
New York, NY 10017
(212) 661-4710

SAVELLO, DENISE
381 Park Ave. S.,
New York, NY 10016
(212) 674-0491

SCANLON, HENRY
32 E. 31st St., 9th Fl.,
New York, NY 10016
(212) 989-0500

SCERRA, PETER
342 Madison Ave.,
New York, NY 10173
(212) 490-1610

SCHICKLER, PAUL
135 E. 50th St.,
New York, NY 10022
(212) 355-1044

SCHIFRIN, JOAN I.
200 E. 27th St.,
New York, NY 10016
(212) 686-0907

SCHON, HERB
1240 Lexington Ave.,
New York, NY 10028
(212) 737-2945

SCHUB, PETER & ROBERT
 BEAR
37 Beekman Pl.,
New York, NY 10022
(212) 246-0679

SHAMILZADEH, SOL
1155 Broadway, 3rd Fl.,
New York, NY 10001
(212) 532-1977

SHAPIRO, ELAINE
New York, NY
(212) 867-8220

SHEPHERD, JUDITH
186 E. 64th St.,

New York, NY 10021
(212) 838-3214

SHOSTAL ASSOCIATES
60 E. 42nd St.,
New York, NY 10165
(212) 687-0696

SIGAL, BARRY
105 E. 38th St.,
New York, NY 10016
(212) 684-3416

SIGMAN, JOAN
336 E. 54th St.,
New York, NY 10022
(212) 832-7980

SIMON, DEBRA
New York, NY
(212) 421-5703

SIMS, JENNIFER
1150 Fifth Ave.,
New York, NY 10028
(212) 532-4010

SINGER, SUSAN
241 Ave. of the Americas,
New York, NY 10014
(212) 741-3228

SMITH, EMILY
30 E. 21st St.,
New York, NY 10010
(212) 674-8383

SOBERING, GUY
New York, NY
(212) 799-4121, (212) 874-1711

SOKOLSKY, STANLEY
New York, NY
(212) 686-5000

SOLON, JOAN
873 Broadway,
New York, NY 10003
(212) 228-5322

KATHY SORKIN ASSOCIATES
127 Lexington Ave.,
New York, NY 10016
(212) 685-1606

STATHIS, TONY
202 E. 42nd St.,
New York, NY 10017
(212) 490-0355

STERMER, CAROL LEE
114 E. 32nd St.,
New York, NY 10016
(212) 685-2770

STEVENS, NORMA
1075 Park Ave.,
New York, NY 10028
(212) 427-7235

STOCKLAND, BILL

7 W. 16th St.,
New York, NY 10011
(212) 242-7693

STOTO, BERNSTEIN &
 ANDRIULLI
60 E. 42nd St.,
New York, NY 10165
(212) 682-1490

STUDER, LILLIAN
305 E. 24th St.,
New York, NY 10010
(212) 683-2082

SUN, EDWARD
19 E. 21st St.,
New York, NY 10010
(212) 674-7288

SUNLIGHT
322 E. 39th St.,
New York, NY 10016
(212) 686-5000

SUSSE, ED
40 E. 20th St.,
New York, NY 10003
(212) 477-0674

SWEE, ANDREW
31 W. 27th St.,
New York, NY 10001
(212) 683-6060

TANNENBAUM, DENNIS
New York, NY
(212) 279-2838

TERRERO, ROBERT
315 E. 206th St.,
New York, NY 10467
(212) 881-7146

UMLAS, BARBARA
400 E. 73rd St.,
New York, NY 10021
(212) 249-4555

VALDETAIRE, ANNE
137 E. 38th St.,
New York, NY 10016
(212) 685-5753

VAN ARNAM, LEWIS
154 W. 57th St.,
New York, NY 10019
(212) 541-4787

WALKER, ELEANORA
20 E. 63rd St.,
New York, NY 10021
(212) 752-6132

WASSERMAN, TED
342 Madison Ave.,
New York, NY 10173
(212) 867-5360

WAYNE, TONY
154 W. 57th St.,

New York, NY 10019
(212) 757-5398

WEIN, GITA
320 E. 58th St.,
New York, NY 10022
(212) 759-2763

WEISSMAN, LYDIA
211 E. 51st St.,
New York, NY 10022
(212) 755-1365

WICK, WALTER
New York, NY
(212) 243-2687

WIDDER, CAROLE
New York, NY
(212) 832-9032

WITT, JOHN
New York, NY
(212) 679-8620

WOHLBERG, HELEN
New York, NY
(212) 688-9366

BERT YELLEN & ASSOCIATES
838 Ave. of the Americas,
New York, NY 10001
(212) 889-4701

YORK, JIM
360 E. 55th St.,
New York, NY 10022
(212) 688-7232

ZANETTI, LUCY
139 Fifth Ave.,
New York, NY 10010
(212) 473-4999

ZELDA
New York, NY
(212) 279-2838

Northeast

BANCROFF, CAROL
185 Goodhill Rd.,
Weston, CT 06883
(203) 226-7674

BLOCH, PEGGY J.
464 George Rd., #5A,
Cliffside Park, NJ 07010
(201) 943-9435

BEN BONART & ASSOC. INC.
1070 T. Jefferson St. N.W., #302,
Washington, DC 20011
(202) 965-2218

WOODFIN CAMP INC.
925½ F St. N.W.,
Washington, DC 20004
(202) 638-5705

CHANDOHA, SAM
R.D. 1, P.O. Box 287,
Annandale, NJ 08801
(201) 782-3666

CLEMENTS, JOHN
124 Lake St.,
Englewood, NJ 07631
(201) 567-3308

CREED, GEORGE L.
255 Park St.,
Upper Montclair, NJ 07043
(212) 532-4500

CURTIN, SUSAN
323 Newbury St.,
Boston, MA 02115
(617) 536-6600

DUNN, TRIS
20 Silvermine Rd.,
New Canaan, CT 06840
(203) 966-9791

EISMAN, JOYCE
518 S. 4th St.,
Philadelphia, PA 19147
(215) 625-9010

FISCHER, JEFFREY
7th and Ranstead,
Philadelphia, PA 19106
(215) 925-7073

GROSKINSKY, ALMA
Port Washington, NY
(516) 883-3294

HUBBELL, MARIAN
57 Wood Rd.,
Bedford Hills, NY 10507
(914) 666-5792

IMAGE 4 PRODUCTIONS
111 Bowinar Ave.,
Port Chester, NY 10573
(914) 384-9090

KENNY, ELLA
103 Broad St.,
Boston, MA 02110
(617) 426-3565

KOCHER, JOHN E.
Montville, NJ
(201) 489-7744

LANDSMAN, GARY
1629 K St. N.W., #500,
Washington, DC 20006
(202) 223-1590

LENSMAN STOCK PHOTO
3246 Jones Bridge Ct. N.W.,
Washington, DC 20007
(202) 337-8014

McNAMARA, PAUL B.
182 Broad St.,
Wethersfield, CT 06109
(203) 563-6159

MURPHY, MICHAEL
818 Liberty Ave.,
Pittsburgh, PA 15206
(412) 261-2022

NICHOLS, EVA
1241 University Ave.,
Rochester, NY 14607
(716) 275-9666

RADZEVICH, ELAINE
58 Pine St.,
Malden, MA 02148
(617) 933-8090

SAVADOW, RICK
Baltimore, MD
(301) 685-6652

STEVENS, RICH
925 Penn Ave.,
Carlton Ctr. Bldg., #404,
Pittsburgh, PA 15222
(412) 765-3565

SULLIVAN, NOREEN
17 Commerce Wy.,
Woburn, MA 01801
(617) 933-8090

LIZ TALBOT GROUP
Hartford, CT
(203) 232-2285

TAYLOR, CORY
103 E. Read St.,
Baltimore, MD 21202
(301) 385-1716

TISE, KATHERINE
239 Allston St.,
Cambridge, MA 02139
(617) 661-1361

VALEN ASSOCIATES
P.O. Box 8,
Westport, CT 06881
(203) 227-7806

WATSON, SHARON
1330 Lombard St.,
Philadelphia, PA 19147
(215) 546-8355

WIECH, BETSY
129 South St.,
Boston, MA 02111
(617) 426-7262

Southeast

AYRES, BEVERLY
114 Karland Dr. N.W.,
Atlanta, GA 30305
(404) 262-2740

LIBBEY, PICA

1114 W. Peachtree St.,
Atlanta, GA 30309
(404) 875-0086

McGEE, LINDA
1816 Briarwood Industrial Ct. N.E.,
Atlanta, GA 30345
(404) 633-1286

McLEAN, BOB
1800 Peachtree St. N.W., ⌗315,
Atlanta, GA 30309
(404) 355-4897

THE PHELPS AGENCY
32 Peachtree St. N.W.,
Atlanta, GA 30303
(404) 523-1234

VULLO PHOTOGRAPHY
565 Dutch Valley Rd. N.E.,
Atlanta, GA 30324
(404) 874-0822

WALKER, NANCY
285 Meeting St.,
Charleston, SC 29401
(803) 649-4936

Midwest

AIKO
Chicago, IL
(312) 869-7081

AREMMLER, PAUL
405 N. Wabash,
Chicago, IL 60611
(312) 527-1114

ASAD, SUSAN
215 Superior St.,
Chicago, IL 60610
(312) 751-2526

ASSID, CAROL
1330 Coolidge Hwy.,
Troy, MI 48084
(313) 280-0090

BALL, JOHN
203 N. Wabash,
Chicago, IL 60601
(312) 332-6041

BERK, IDA
1350 N. La Salle,
Chicago, IL 60610
(312) 944-1339

BERNSTEIN, JIM
520 N. Michigan Ave.,
Chicago, IL 60611
(312) 822-0560

BRAWAR, WENDY
316 N. Michigan Ave., ⌗803,

Chicago, IL 60601
(312) 642-0880

BRENNER, HARRIET
660 W. Grand Ave.,
Chicago, IL 60610
(312) 751-1470

BUERMANN, JERI
689 Craig Rd.,
St. Louis, MO 63141
(314) 872-7506

CHAMBERS, RON
1546 N. Orleans,
Chicago, IL 60610
(312) 642-8715

CHRISTELL, JIM
664 N. Michigan Ave., ⌗1010,
Chicago, IL 60611
(312) 236-2396

CLARKE, JIM
St. Louis, MO
(314) 872-7506

CLAUSSEN, BO
Chicago, IL
(312) 871-1242

COHEN, JANICE
120 W. Hubbard,
Chicago, IL 60610
(312) 467-0190

CONTEMPORARY
 ILLUSTRATORS
300 W. 19th Terr.,
Kansas City, MO 64050
(800) 821-5623

DeGRADO, JAMES
730 N. Franklin,
Chicago, IL 60610
(312) 943-5757

DORMAN, PAUL
70 E. Longlake Rd.,
Bloomfield Hills, MI 48013
(313) 645-2222

DREWEL, JUDIE
St. Louis, MO
(314) 533-6665

EAKIN, DANA
Chicago, IL
(312) 782-2703

ERDOS, KITTY
429 W. Superior,
Chicago, IL 60610
(312) 787-4976

FERRERI, ROSEMARY
Chicago, IL
(312) 644-8282

FRANKE, LON
740 W. Washington,
Chicago, IL 60606

(312) 454-1856

GOLDEN, CHERYL
3838 W. Pine,
St. Louis, MO 63108
(314) 533-6665

HARLIB, JOEL
4 E. Ohio St.,
Chicago, IL 60611
(312) 329-1370

HARTIG, MICHAEL
3620 Pacific,
Omaha, NB 68105
(402) 345-2164

HARWOOD, TIM
646 N. Michigan,
Chicago, IL 60611
(312) 828-9117

MYRNA HOGAN & ASSOC.
333 N. Michigan,
Chicago, IL 60601
(312) 372-1616

HOWZE, WALTER
747 N. Wabash, ⌗204,
Chicago, IL 60611
(312) 332-5700

JOHNSON, GINGER TODD
1915 N. Honore,
Chicago, IL 60622
(312) 772-2292

KAMIN, VINCE
42 E. Superior,
Chicago, IL 60610
(312) 787-8834

KAPES, JACK
218 E. Ontario,
Chicago, IL 60611
(312) 664-8282

KEZELIS, ELENA
215 W. Illinois,
Chicago, IL 60610
(312) 644-7108

KORALIK, CONNIE
1211 W. Webster,
Chicago, IL 60614
(312) 348-5393

LASKO, PAT
452 N. Halsted,
Chicago, IL 60622
(312) 787-1316

McMASTERS, DEBORAH
501 N. Rush,
Chicago, IL 60611
(312) 467-4770

McNAUGHTON, TONI
230 N. Michigan,
Chicago, IL 60601
(312) 782-4422

McNULTY, LUCY
Minneapolis, MN
(612) 544-4557

MILES, THOMAS
Minneapolis, MN
(612) 871-0333

MOORE, CONNIE
1540 N. Park,
Chicago, IL
(312) 787-4422

MORAVICK, DON
Chicago, IL
(312) 664-9012

MOSIER-MALONEY
535 N. Michigan,
Chicago, IL 60611
(312) 943-1668

MURPHY, SALLY
70 W. Hubbard,
Chicago, IL 60610
(312) 751-2977

O'BRIEN, DAN
Chicago, IL
(312) 856-0007

OSLER, SPIKE
2616 Industrial Row,
Detroit, MI
(313) 280-0640

PARKER, TOM
114 W. Kedzie,
Chicago, IL
(312) 266-2891

POTTS, CAROLYN
415 N. Dearborn,
Chicago, IL 60610
(312) 935-1707

PULVER, OWEN
Chicago, IL
(312) 642-1275

PUTNAM, BARBARA
22 W. Erie,
Chicago, IL 60610
(312) 266-8352

QUICK, SUE
Chicago, IL
(312) 644-7557

BILL RABIN & ASSOC.
600 N. McClurg Ct.,
Chicago, IL 60611
(312) 944-6655

SCHUCK, JOHN
614 Fifth Ave. S.,
Minneapolis, MN 55415
(612) 238-7829

SCHWARTZ/McCARTHY
Chicago, IL
(312) 236-4135

SELL, DAN
307 N. Michigan Ave.,
Chicago, IL 60601
(312) 332-5168

SHARRARD, CHICK
1546 N. Orleans,
Chicago, IL 60610
(312) 751-1470

SHULMAN, SALO
215 W. Ohio,
Chicago, IL 60610
(312) 337-3245

SKILLCORN, ROY
410 W. Chicago, #529,
Chicago, IL 60610
(312) 663-4313

STRICKLAND, JOANN
405 N. Wabash, #1003,
Chicago, IL 60611
(312) 467-1890

TENEBRINI, PAUL
230 W. Superior,
Chicago, IL 60610
(312) 236-4135

THIELE, ELIZABETH
Chicago, IL
(312) 944-4477

THOMPSON, CATHY
Minneapolis, MN
(612) 332-7007

TIDWELL, BETTY
1546 N. Orleans,
Chicago, IL 60610
(312) 751-1470

TILLERASS, PERRY
Minneapolis, MN
(612) 338-7234

CLAY TIMON & ASSOC. INC.
405 N. Wabash,
Chicago, IL 60611
(312) 527-1114

TUKE, JONI
368 W. Huron,
Chicago, IL 60610
(312) 664-4235

VARGO, GLYNIS
1115 W. Washington,
Chicago, IL 60607
(312) 236-1105

WALSH, RICHARD
411 N. LaSalle,
Chicago, IL 60610
(312) 944-4477

WEST, KAREN
920 Judson,
Evanston, IL 60202
(312) 664-5954

WILDE, NANCY
2033 N. Orleans,
Chicago, IL 60614
(312) 528-7711

WITMER, BOB
Chicago, IL
(312) 642-0242

ZIMMERMAN, AMY
4 E. Ohio, Suite 9,
Chicago, IL 60611
(312) 642-4426

Southwest

CALLAHAN, JOE
224 N. Fifth Ave.,
Phoenix, AZ 85003
(602) 253-6560

CROWDER, BOB
3603 Parry Ave.,
Dallas, TX
(214) 821-9661

DI ORIO ASSOC.
1535 Hawthorne, #D,
Houston, TX 77006
(713) 528-1131

FULLER, ALYSON
5610 Maple Ave.,
Dallas, TX 75226
(214) 688-1855

LAURANCE
 LYNCH/REPERTOIRE
4403 Woodhead, #1,
Houston, TX 77098
(713) 520-9938

LINDA SMITH ART REP., INC.
3511 Cedar Springs,
Dallas, TX 75219
(214) 521-5156

UNTERSEE, ANITA
2747 Seelcco,
Dallas, TX 75235
(214) 358-2306

West

AFTER IMAGE INC.
6855 Santa Monica Blvd.,
Los Angeles, CA 90038
(213) 467-6033

ALEXA, MAROS
1428 N. Fuller Ave.,
Los Angeles, CA 90046
(213) 874-7083

ALINE, FRANCE, AND
 MARSHA FOX
4121 Wilshire Blvd., #406,
Los Angeles, CA 90010
(213) 383-0498

ANTONIOLI, GINA
613 S. La Brea Ave.,
Los Angeles, CA 90036
(213) 930-1144

ARMISTEAD, ANN
1716 Oak Ave.,
Manhattan Beach, CA 90266
(213) 545-9687

ASHTON, JAMIE
Los Angeles, CA
(213) 658-5737

ASTOR'S PEOPLE
Los Angeles, CA
(213) 851-0185

AZZARA, MARILYN
3165 Ellington Dr.,
Los Angeles, CA 90068
(213) 876-2551

BARBE, LERENA
1220 S. Manning Ave.,
Los Angeles, CA 90024
(213) 470-1557

BARROW, RANDI
Los Angeles, CA
(213) 383-7677

BAUM, KERRY
1218 Washington Ave.,
Fullerton, CA 92632
(213) 323-7315

BEST SCHOT
501 N. Poinsettia Pl.,
Los Angeles, CA 90036
(213) 938-8367

BONAR, ELLEN
1925 S. Beverly Glenn,
Los Angeles, CA 90025
(213) 474-7911

BOSWORTH, JANNA
Los Angeles, CA
(213) 475-5513, (213) 855-1010

ASHLEY BOWLER & ASSOC.
2194 Ponet Dr.,
Los Angeles, CA 90068
(213) 467-8200

BROOKS
6628 Santa Monica Blvd.,
Los Angeles, CA 90038
(213) 463-5678

BROWN, DIANNE
632 N. Highland Ave.,
Los Angeles, CA 90038
(213) 464-2775

BURKE, DONNA
8142 W. 3rd St.,
Los Angeles, CA 90048
(213) 655-4012

BURLINGHAM, TRICIA
8275 Beverly Blvd.,
Los Angeles, CA 90048
(213) 651-3212

BURNETT, WILLIAM
823 N. Edinburgh Ave.,
Los Angeles, CA 90046
(213) 653-0811

CALO, RICHARD
1230 N. Horn, #515
Los Angeles, CA 90069
(213) 855-0383

CAMPAGNA, DEBRA
215 Newhall St.,
San Francisco, CA 94124
(415) 546-6536

CAPLAN, MARILYN
P.O. Box 49191,
Los Angeles, CA 90049
(213) 459-3301

CAROFANO, CYNTHIA
Gardena, CA
(213) 542-3255

CARROLL, J. J.
7207 Melrose Ave.,
Los Angeles, CA 90046
(213) 934-8214

CHARDON, SONIA
8921 National Blvd.,
Los Angeles, CA 90034
(213) 836-2611

CHARLY
1300 N. Wilton Pl.,
Los Angeles, CA 90028
(213) 935-1939

CHERPITEL, LATIFAH
500 Newport Ctr. Dr., #705,
Newport Beach, CA 92660
(714) 644-6723

CHUREY, SPENCER
South Seattle, WA
(206) 324-1199

CLOUTIER, CHANTAL
Los Angeles, CA
(213) 656-8195, (213) 937-3894

COLLAMER, CAROL
46 Bayview Ave.,
Mill Valley, CA 94941
(415) 383-6723

COLLIER, JAN
1535 Mission St.,
San Francisco, CA 94103
(415) 552-4252

CONNOR, TOD
520 N. Western Ave.,
Los Angeles, CA 90004
(213) 463-2109

CORMANY, PAUL
11607 Clover Ave.,
Los Angeles, CA 90066
(213) 828-9653

CORNELL, KATHLEEN
90 Corona, #508,
Denver, CO 80218
(303) 778-6016

COSTA, PAT
2201 Summertime Ln.,
Culver City, CA 90230
(213) 836-1556

COSTELLO, JAMES
506 S. San Vicente Blvd.,
Los Angeles, CA 90048
(213) 655-0408

COSTELLO, JIM
Los Angeles, CA
(213) 851-8602, (213) 851-2890

COUNTS, CYNDY
Los Angeles, CA
(213) 933-6688, (213) 464-8382

CREATIVE ASSOC.
11939 Weddington St.,
North Hollywood, CA 91607
(213) 251-1178

DARCY
135 S. Detroit St.,
Los Angeles, CA 90036
(213) 934-6737

DAVIS, THOMAS
4618 Los Feliz Blvd.,
Los Angeles, CA 90027
(213) 662-0602

DESHONG, DIANE
Los Angeles, CA
(213) 275-2620

DESIGN POOL
11936 Darlington Ave.,
Los Angeles, CA 90049
(213) 826-1551, (213) 820-3654

DICUS, ALEXIS
3131 16th St.,
Santa Monica, CA 90405
(213) 396-3094

DILTS, GALE
4271 W. 3rd St.,
Los Angeles, CA 90020
(213) 383-0214

DIMMITT, GREGORY
303 S. Hewitt St., #320,
Los Angeles, CA 90013
(213) 628-0816

DISKIN, DONNELL
1823 El Cerrito Pl.,
Hollywood, CA 90068
(213) 383-9157

DRAYTON, SHERYL
5018 Dumont Pl.,
Woodland Hills, CA 91364
(213) 347-2227

DU BOW & HUTKIN
7461 Beverly Blvd.,
Los Angeles, CA 90036
(213) 938-5177

DUVALL, LYNN
5455 Wilshire Blvd., #1212,
Los Angeles, CA 90036
(213) 937-4472

EARL, AL
5761 Tuxedo Terr.,
Los Angeles, CA 90068
(213) 994-3620

EHRLICH, STUART
9701 Wilshire Blvd., #800,
Beverly Hills, CA 90046
(213) 550-5935

CAROL EISENRAUCH &
 ASSOC.
1105 Alta Loma, #3,
Los Angeles, CA 90069
(213) 652-4183

ELIAS, ANNIKA
8301 W. 3rd St.,
Los Angeles, CA 90048
(213) 655-3527

ENGLISH, JACKIE
846 N. Cahuenga Blvd.,
Los Angeles, CA 90038
(213) 464-0141

ERICSON, WILLIAM
1714 N. Wilton Pl.,
Hollywood, CA 90028
(213) 461-4969

FELDMAN, DEBORAH
Los Angeles, CA
(213) 874-4107

FELLOWS, KATHLEEN
1111 N. Tamarind,
Los Angeles, CA 90038
(213) 469-6205

FERGUS, MEG
2201 E. Winston Rd., #K,
Anaheim, CA 92806
(714) 776-0170

FLEMING, LAIRD TYLER
6433 Sunset Blvd.,
Los Angeles, CA 90012
(213) 470-3042

FOWLER, BARBARA

832 S. Alvarado St., Penthouse,
Los Angeles, CA 90057
(213) 384-8354

FOX, RUTA
Los Angeles, CA
(213) 476-9102

FRIEDMAN, TODD, & LEWIS
 PORTNOY
7348 Santa Monica Blvd.,
Beverly Hills, CA 90046
(213) 550-7005

GALE, PHILIP
6546 Hollywood Blvd., #210,
Hollywood, CA 90028
(213) 461-1598

GARDNER, GAIL
800 S. Citrus Ave.,
Los Angeles, CA 90036
(213) 931-1108

GARVIN, GEORGE
827 2nd St.,
Santa Monica, CA 90403
(213) 395-8267

GEORGE, NANCY
360½ N. Mansfield Ave.,
Los Angeles, CA 90036
(213) 935-4696

GERMINERO, RICHARD
8001½ Blackburn Ave.,
Los Angeles, CA 90048
(213) 653-6407

TOM GILBERT & ASSOC.
420½ 32nd St.,
Manhattan Beach, CA 90266
(213) 469-8767

GILBERT, SAM
410 Sheridan,
Palo Alto, CA 94306
(415) 325-2102

GLOBE PHOTOS
8430 Santa Monica Blvd.,
Los Angeles, CA 90069
(213) 654-3350

RICHARD GOLDSTONE
 PRODUCTIONS
7174 Melrose Ave.,
Los Angeles, CA 90046
(213) 654-3350

GORDON, LINDA
1516 N. Formosa,
Los Angeles, CA 90046
(213) 851-5051

GRAPHIC ARTS AGENCY
12121 Wilshire Blvd., #100,
Los Angeles, CA 90017
(213) 820-3791

GRAY, CONNIE

25 Cervantes Blvd.,
San Francisco, CA 94123
(415) 922-4304

GREENWALD, KIM
823B 21st St.,
Santa Monica, CA 90403
(213) 932-1241, (213) 829-0943

HACKETT, PAT
1008 Western Ave., #618,
Seattle, WA 98104
(206) 623-9459

HAIGH, NANCY
90 Natoma St.,
San Francisco, CA 94105
(415) 391-1646

HALLOWELL, WAYNE
11046 McCormick,
North Hollywood, CA 91601
(213) 769-5694

HAMBLIN, BRIAN
1011¼ W. 190th St.,
Gardena, CA 90248
(213) 515-0310

HAMIK, PEGGY
P.O. Box 1677,
Sausalito, CA 94966
(415) 521-3422

HAMMOND, ROGER
5455 Wilshire Blvd.,
Los Angeles, CA 90036
(213) 937-4472

HAPPE, MICHELE L.
1183 N. Michigan,
Pasadena, CA 91104
(213) 684-3037

HAYES, ANNIE
31770 Broadbeach Rd.,
Malibu, CA 90265
(213) 457-7670

HEDGE, JOANNE
1838 El Cerrito Pl., #3,
Hollywood, CA 90068
(213) 874-1661

HEWSON, JANIE CELESTE
15234 Dickens St.,
Sherman Oaks, CA 91403
(213) 995-7264

HILLMAN, BETSY
65 Cervantes Blvd.,
San Francisco, CA 94123
(415) 563-2243

HMS BOOKINGS
749½ N. Hudson,
Los Angeles, CA 90038
(213) 469-4610, (213) 464-1112

HOGAN, PAT
P.O. Box 209,

Hermosa Beach, CA 90254
(213) 374-1184

HOLDER, JANE
355 S. Robertson Blvd.,
Beverly Hills, CA 90048
(213) 659-3880

HOWARD, LINDA
2049 Century Pk. E., #3385,
Los Angeles, CA 90067
(213) 277-6561

HUNT, TERRI
437 N. Sycamore Ave., #101,
Los Angeles, CA 90036
(213) 934-3343

HYATT, NADINE
P.O. Box 2455,
San Francisco, CA 94126
(415) 543-8944

HYNES, KATHRYN
2449 Santa Anita Ave.,
Altadena, CA 91001
(213) 798-3695

ITS PRODUCTIONS
MANAGEMENT
611 N. Sweetzer Ave.,
Los Angeles, CA 90048
(213) 655-1666

JAY, BARTON
2120 N. Beverly Glen,
Los Angeles, CA 90077
(213) 279-1750

JULIAN
2401 N. Beachwood Dr., #6,
Hollywood, CA 90068
(213) 464-4910

KAPLAN-WINTZ, ROYCE
4453 Coldwater Canyon Ave.,
Studio City, CA 91604
(213) 762-9234

KHOURY, PHILIP
900 Hammond St., #533,
Los Angeles, CA 90069
(213) 659-1939

KNABLE, ELLEN
P.O. Box 67725,
Los Angeles, CA 90067
(213) 990-8084

KOWAL, TAD
7955 W. 3rd St.,
Los Angeles, CA 90048
(213) 933-9185

KOWALENKO, ZINA
9531 Washington Blvd.,
Culver City, CA 90015
(213) 838-3116

LAGERSON, KITTY
6916 Melrose Ave.,

Los Angeles, CA 90038
(213) 937-7214

LANCASTER, CORELLI
6525 W. Sunset Blvd.,
Hollywood, CA 90028
(213) 461-1122

LANDSMAN, ELYSE
672 S. Lafayette Pk. Pl., #35,
Los Angeles, CA 90057
(213) 388-3142

LAPPLE, FRANK
2975 Wilshire Blvd.,
Los Angeles, CA 90010
(213) 381-3977

LARSON, MARYANNE
2019 Pontius Ave.,
Los Angeles, CA 90025
(213) 475-7794

LAUESEN, PAM
8165 Sunset Blvd.,
Hollywood, CA 90046
(213) 656-7690

LAWSON, KAREN
5817 Sunset Blvd.,
Hollywood, CA 90027
(213) 464-3364

LAYCOCK, LOUISE
3450 Glorietta Pl.,
Sherman Oaks, CA 91423
(213) 501-6055

LERWILL, PHYLLIS
6635 Leland Wy.,
Los Angeles, CA 90028
(213) 461-5540

JOAN LESSER/ETCETERA
1674 17th St.,
Santa Monica, CA 90404
(213) 450-3977

LILIE, JIM
1801 Franklin St., #404
San Francisco, CA 94109
(415) 441-4384

LIND, TOMMY
4901B Topanga Canyon Blvd.,
Woodland Hills, CA 91364
(213) 348-7422

LIPPERT, TOM
1100 Glendon Ave.,
Los Angeles, CA 90024
(213) 279-1539

LIST, GLORIA
1100 Glendon Ave., #1700,
Los Angeles, CA 90024
(213) 279-1539

LOEWENKAMP, SUSAN
P.O. Box 4154,
Venice, CA 90291
(213) 396-6650

LONDON, VALERIE EVE
820 N. Fairfax Ave.,
Los Angeles, CA 90046
(213) 655-4214

LOVEJOY, PAMELA
5619 W. 4th St.,
Los Angeles, CA 90036
(213) 936-1616

LUCK, DONNA LEE
P.O. Box 75464,
Los Angeles, CA 90075
(213) 874-0537

LUNA, TONY
45 E. Walnut,
Pasadena, CA 91103
(213) 681-3130

MACARELLI, SANDRA
6546 Hollywood Blvd., #215,
Hollywood, CA 90028
(213) 466-1785

MAHONEY, KERRY
Beverly Hills, CA
(213) 323-7315, (213) 821-5871

MAITER, DICK
28605 Mount Lassen,
San Pedro, CA 90732
(213) 831-0965

RITA MARIE & ASSOCIATES
306½ S. Clark Dr.,
Los Angeles, CA 90048
(213) 247-0135

MARLENE
7801 Beverly Blvd.,
Los Angeles, CA 90036
(213) 466-3709, (213) 467-7340

MARLOWE, CHRIS
P.O. Box 635,
Hollywood, CA 90028
(213) 466-3709, (213) 467-7340

MARSH, CYNTHIA
923 N. San Vicente Blvd., #3,
Los Angeles, CA 90048
(213) 854-4991

MARTIN & BENEDICT, INC.
Los Angeles, CA 90046
(213) 655-3965

MARTIN, STEVE
140 N. La Brea,
Los Angeles, CA 90036
(213) 936-3131

MATTEI, MICHELE
8983 Hollywood Hills Rd.,
Los Angeles, CA 90046
(213) 656-7407

MAXIM, FRAN
713 Navy St.,
Santa Monica, CA 90405
(213) 396-8713

McCULLAH, TIMOTHY
Beverly Hills, CA 90026
(213) 852-0808

McCULLOUGH, DON
638 S. Van Ness,
Los Angeles, CA 90005
(213) 382-6281

MILLER, KATIE
10739 Landale,
Toluca Lake, CA 91602
(213) 766-2806

MILLER, KYLE
450 Westbourne Dr.,
Los Angeles, CA 90048
(213) 855-8058

MIRSKY, ROBERT
8434 Vine Valley Dr.,
Sun Valley, CA 91352
(213) 875-0292

MORICO, MIKE
638 S. Van Ness,
Los Angeles, CA 90005
(213) 382-6281

NICHOLS, PAM
2256 N. Beachwood Dr.,
Hollywood, CA 90068
(213) 467-6797

OGDEN, ROBIN
412 N. Doheny Dr.,
Los Angeles, CA 90035
(213) 858-0946

PALIN, DEBORAH
1415 N. Beverly Dr.,
Beverly Hills, CA 90026
(213) 276-0968

PENTECOST, HARRY
3638 Midvale Ave.,
Los Angeles, CA 90403
(213) 395-8500

PEPPER, DON
638 S. Van Ness,
Los Angeles, CA 90005
(213) 382-6281

PHILBROOK, BILL
5455 Wilshire Blvd.,
Los Angeles, CA 90036
(213) 463-7717

PHOTO ARTISTS
141 N. St. Andrews Pl.,
Los Angeles, CA 90004

PIERCEALL, KELLY
25260 Piuma Rd.,
Malibu, CA 90265
(213) 559-4327

PONE, BOB
1949 N. Wilton Pl.,
Hollywood, CA 90068
(213) 464-6443, (714) 554-0834

PRAPAS, CHRISTINE
3757 Wilshire Blvd., #205,
Los Angeles, CA 90010
(213) 385-1743

PRE-PRODUCTION WEST
1406½ Havenhurst Dr.,
Los Angeles, CA 90046
(213) 656-8766

QUINLAN, KATHLEEN
520 N. Western Ave.,
Los Angeles, CA 90004
(213) 467-2135

RESERVA, OLGA
2521 S. 4th Ave.,
Arcadia, CA 91006
(213) 446-5350

RICHARD, MARILYN
30708 Monte Lado Dr.,
Malibu, CA 90265
(213) 457-3363

RICHARDS, RUSSELL
4849 San Rafael Ave.,
Los Angeles, CA 90042
(213) 255-9549

ROBERTSON, TERI
9328 Orion Ave.,
Sepulveda, CA 91343
(213) 892-3765

ROSENTHAL, ELISE
3336 Tilden Ave.,
Los Angeles, CA 90034
(213) 204-3230

ROSENTHAL REPRESENTS
Santa Monica, CA
(213) 459-0669

ROSS, MARCIA
621¼ Westmount Dr.,
Los Angeles, CA 90069
(213) 855-0508

ROTHOUSE, SUSAN
Pacific Palisades, CA
(213) 459-4591

ROYBAL, HEC
217 S Ave. 54, #17,
Los Angeles, CA 90001
(213) 258-6500

SALISBURY, SHARON
185 Berry St.,
San Francisco, CA 94107
(415) 495-4665

SATO, CAROLYN
645 N. Martel Ave.,
Los Angeles, CA 90036
(213) 658-8645

SCHIFF, ANTHONY
8153 W. Blackburn Ave.,
Los Angeles, CA 90048
(213) 658-6179

SCHMIDT, TERRY
9465 Wilshire Blvd., #725,
Beverly Hills, CA 90210
(213) 641-7248

SCHUMACHER, RICHARD
4766 Melrose Ave.,
Los Angeles, CA 90029
(213) 660-1644

SEKULER, SUSIE
12805 Collins St.,
North Hollywood, CA 91607
(213) 769-9039

SELWYN, HARRIET
1853 Franklin Canyon Dr.,
Beverly Hills, CA 90210
(213) 274-3051

SHOT, SARA
Los Angeles, CA
(213) 938-8367

SHUPER, KAY
Los Angeles, CA
(213) 852-0075

SIDORE, SHARRI
609 21st St.,
Hermosa Beach, CA 90254
(213) 374-4315

SIMPSON, LINDY
454 S. La Brea Ave.,
Los Angeles, CA 90036
(213) 936-5208

SLOBODIAN, BARBARA
6630 Santa Monica Blvd.,
Los Angeles, CA 90038
(213) 935-6668

SMITH, DOMINIC
122 Rees,
Marina del Rey, CA 90291
(213) 827-1089

SOBOL, LYNNE
4302 Melrose Ave.,
Los Angeles, CA 90046
(213) 665-5141

THE SOURCE
4723 Colfax Ave.,
North Hollywood, CA 91602
(213) 985-2400

SPELMAN, MARTHA
8757½ Chalmers,
Los Angeles, CA 90403
(213) 395-9551

SPRADING, DAVID
2019 Pontius Ave.,
Los Angeles, CA 90025
(213) 475-7794

STEINBERG, JOHN
10434 Corfu Ln.,
Los Angeles, CA 90210
(213) 279-1775

STERN, GREGG
23870 Madison St.,
Torrence, CA 90505
(213) 545-0359, (213) 373-6789

STUDIO & ARTISTS REP. CO.
1714 N. Wilton Pl.,
Los Angeles, CA 90028
(213) 461-4969

SULLIVAN, DIANE
10 Hawthorne St.,
San Francisco, CA 94105
(415) 543-6777

SWEET, RON
716 Montgomery St.,
San Francisco, CA 94111
(415) 433-1222

TERRY, GLORIA
511 Wyoming St.,
Pasadena, CA 91103
(213) 681-4115

TODD, DEBORAH
259 Clara St.,
San Francisco, CA 94111
(415) 433-1292

TORRES, GILBERT
1110 N. Hudson Ave., #B,
Los Angeles, CA 90038
(213) 464-5016

TOS, DEBBIE
7360 Melrose Ave.,
Los Angeles, CA 90046
(213) 655-1911

TURNER, DANA
661 S. Lake Ave.,
Pasadena, CA 91106
(213) 681-9229

VANDAMME, VICKI & MARY
431 Jackson St.,
San Francisco, CA 94111
(415) 433-1292

VANDERPUTTE, KAREN
12349 Milbank,
Studio City, CA 91604
(213) 761-2627

VARIE, CHRIS
2210 Wilshire Blvd., #505,
Santa Monica, CA 90403
(213) 395-9337

WAGONER, JAE
202 Westminster Ave.,
Venice, CA 90291
(213) 392-4877

WALSH, SAM
P.O. Box 5298, University Sta.,
Seattle, WA 98105
(206) 522-0154

WALTON, AL
7300 Melrose Ave.,

Los Angeles, CA 90046
(213) 506-0834

WATSON, AILENE
6363 Wilshire Blvd.,
Los Angeles, CA 90048
(213) 651-3015

WEARLEY, ROXANNE
West Los Angeles, CA
(213) 473-6793

WEILAGE, M. B.
316 S. Crescent Heights Blvd.,
Los Angeles, CA 90048
(213) 651-2878

WEINGARTEN, LILLY
Los Angeles, CA
(213) 858-8989

WIEGAND, CHRIS
7106 Waring Ave.,
Los Angeles, CA 90046
(213) 931-5942

WIHNYK, MARTHA
1033 S. Orlando Ave.,
Los Angeles, CA 90035
(213) 655-7734

WILENS, RANDI
4000 Warner Blvd.,
Burbank, CA 91505
(213) 843-6000, ext. 1107

WILLIAMS, GEORGE
638 S. Van Ness Ave.,
Los Angeles, CA 90005
(213) 382-6281

WILLIE
Los Angeles, CA
(213) 464-7734,
 (213) 464-7687

WILSON, CHERYL
5514 Wilshire Blvd., #801,
Los Angeles, CA 90036
(213) 932-9026

WOOD, JOAN
141 N. St. Andrews Pl.,
Los Angeles, CA 90004
(213) 463-7717

WORMALD, TORREY
Los Angeles, CA
(213) 383-0498

YOUMANS, JILL
830 N. La Brea,
Los Angeles, CA 90038
(213) 469-8624

YOUNGSTROM, JOE
1100 Glendon Ave., #1700,
Los Angeles, CA 90024
(213) 279-1539

ZIMMERMAN, DELORES H.
9135 Hazen Dr.,

Beverly Hills, CA 90210
(213) 273-2642

STOCK PHOTO AGENCIES

New York City

AIR PIXIES COMPANY
515 Madison Ave.,
New York, NY 10022
(212) 486-9828

ALPHA PHOTO ASSOC.
251 Park Ave. S.,
New York, NY 10010
(212) 777-4210

AMERICAN LIBRARY COLOR
 SLIDE CO.
222 W. 23rd St.,
New York, NY 10011
(212) 255-5356

ANIMALS ANIMALS
 ENTERPRISES
203 W. 81st St.,
New York, NY 10024
(212) 580-9595

PETER ARNOLD INC.
1466 Broadway,
New York, NY 10036
(212) 840-6928

BARNETT, PEGGY
26 E. 22nd St.,
New York, NY 10010
(212) 673-0500

BUDDY BASCH FEATURE
 SYNDICATE
771 West End Ave.,
New York, NY 10025
(212) 666-2300

BERNSEN'S INTERNATIONAL
 PRESS SERVICE LTD. (BIPS)
15 E. 40th St.,
New York, NY 10016
(212) 685-0464

BETTMANN ARCHIVE INC.
136 E. 57th St.,
New York, NY 10022
(212) 758-0362

BLACK BOX STUDIOS
126 Fifth Ave.,
New York, NY 10011
(212) 255-4164

BLACK STAR PUBLISHING
 CO.
450 Park Ave. S.,
New York, NY 10016
(212) 679-3288

BLACKSTONE-SHELBURNE
N.Y. INC.
42 W. 48th St.,
New York, NY 10036
(212) 736-9100

CAMERA CLIX INC.
404 Park Ave. S.,
New York, NY 10016
(212) 684-3526

CAMERA
5/6 W. 20th St.,
New York, NY 10011
(212) 989-2004

CAMERA MD STUDIOS INC.
122 E. 76th St.,
New York, NY 10021
(212) 628-4331

WOODFIN CAMP &
ASSOCIATES
415 Madison Ave.,
New York, NY 10017
(212) 750-1020

CAMERIQUE, PAUL
DUCKWORTH
124 W. 23rd St.,
New York, NY 10011
(212) 243-6113

CESARE PHOTO AGENCY
148 Broadway,
New York, NY 10031
(212) 926-7086

COHEN, JUDITH
1586 York Ave.,
New York, NY 10028
(212) 986-1224

BRUCE COLEMAN INC.
381 Fifth Ave.,
New York, NY 10016
(212) 683-5227

COLLEGE NEWSPHOTO
ALLIANCE
342 Madison Ave.,
New York, NY 10173
(212) 697-1136

COLOUR LIBRARY
INTERNATIONAL
99 Park Ave.,
New York, NY 10016
(212) 557-2929

CONSOLIDATED POSTER
SERVICE, INC.
341 W. 44th St.,
New York, NY 10036
(212) 581-3105

CONTACT PRESS IMAGES
INC.
135 Central Pk. W.,

New York, NY 10023
(212) 799-9570

JERRY COOKE INC.
161 E. 82nd St.,
New York, NY 10028
(212) 288-2045

CREATIVE EYE
1586 York Ave.,
New York, NY 10028
(212) 986-1224

CULVER PICTURES INC.
660 First Ave.,
New York, NY 10016
(212) 684-5054

DESIGN PHOTOGRAPHERS
INTL. INC.
521 Madison Ave.,
New York, NY 10022
(212) 752-3930

DE VANEY, GEORGE A.
415 Lexington Ave.,
New York, NY 10017
(212) 682-1017

DEWYS, LEO
200 Madison Ave.,
New York, NY 10016
(212) 986-3190

DPI INC.
521 Madison Ave.,
New York, NY 10022
(212) 752-3930

DUNINGAN, JOHN V.
443 Park Ave. S.,
New York, NY 10016
(212) 889-7594

EASTFOTO AGENCY
25 W. 43rd St.,
New York, NY 10036
(212) 921-1922

EASTERN PHOTO SERVICE
INC.
60 E. 42nd St.,
New York, NY 10165
(212) 986-3190

EARTH SCENES
203 W. 81st St.,
New York, NY 10024
(212) 580-9595

EDITORIAL PHOTOCOLOR
ARCHIVES
342 Madison Ave.,
New York, NY 10017
(212) 697-1136

EUROPEAN ART COLOR
SLIDES
120 W. 70th St.,

New York, NY 10023
(212) 877-9654

EWING, GALLOWAY
466 Broadway,
New York, NY 10036
(212) 719-4720

FAIRCHILD PUBLICATIONS
INC.
7 E. 12th St.,
New York, NY 10003
(212) 741-4000

FEDER, THEODORE H.
342 Madison Ave.,
New York, NY 10173
(212) 697-1136

ENRICO FERORELLI STOCK
50 W. 29th St.,
New York, NY 10001
(212) 685-8181

FERRONE, JOANN
451 Broome St.,
New York, NY 10013
(212) 431-3583

FLYING CAMERA INC.
140 Pearl St.,
New York, NY 10005
(212) 943-5095

FOCUS ON SPORTS
222 E. 46th St.,
New York, NY 10017
(212) 661-6860

FORD FOUNDATION PHOTO
LIBRARY
320 E. 43rd St.,
New York, NY 10017
(212) 573-5000

FOUR BY FIVE INC.
485 Madison Ave.,
New York, NY 10022
(212) 355-2323

FREE-LANCE
PHOTOGRAPHERS GUILD
251 Park Ave. S.,
New York, NY 10010
(212) 777-4210

GAMMA/LIAISON PRESS
AGENCY
150 E. 58th St.,
New York, NY 10155
(212) 888-7272

GENERAL PRESS FEATURES
130 W. 57th St.,
New York, NY 10019
(212) 265-6842

GLOBE PHOTOS INC.
404 Park Ave. S.,
New York, NY 10016
(212) 689-1340

GORDON, JOEL
5 E. 16th St.,
New York, NY 10003
(212) 989-9207

GRANGER COLLECTION
1841 Broadway,
New York, NY 10023
(212) 586-0971

GRAPHIC HOUSE INC.
280 Madison Ave.,
New York, NY 10016
(212) 686-8826

LEE GROSS ASSOC. INC.
366 Madison Ave., Room 1603,
New York, NY 10017
(212) 682-5240

GROUP 4
225 E. 67th St.,
New York, NY 10021
(212) 249-4446

HAYES, KERRY
156 Fifth Ave.,
New York, NY 10010
(212) 242-2012

HEYMAN, KEN
64 E. 55th St.,
New York, NY 10022
(212) 980-9552

IMAGE BANK
633 Third Ave.,
New York, NY 10017
(212) 953-0303

INTERNATIONAL CENTER
FOR PHOTOGRAPHY
1130 Fifth Ave.,
New York, NY 10028
(212) 860-1777

INTERPRESS OF LONDON &
NEW YORK
400 Madison Ave., Suite 1406,
New York, NY 10017
(212) 832-2839

KEYSTONE PRESS AGENCY
INC.
156 Fifth Ave.,
New York, NY 10010
(212) 924-8123

JOAN KRAMER & ASSOC.
720 Fifth Ave.,
New York, NY 10019
(212) 224-1758

HAROLD M. LAMBERT
STUDIOS
15 W. 38th St.,
New York, NY 10018
(212) 921-2850

LEWIS, FREDERIC
15 W. 38th St.,
New York, NY 10018
(212) 921-2850

LIFE PHOTO SERVICE
1271 Ave. of the Americas,
Room 2858,
New York, NY 10020
(212) 841-4800

MAGNUM PHOTOS INC.
251 Park Ave. S.,
New York, NY 10010
(212) 475-7600

MAISEL, JAY
190 Bowery,
New York, NY 10012
(212) 431-5013

MEMORY SHOP INC.
109 E. 12th St.,
New York, NY 10003
(212) 473-2404

MENDEZ, RAYMOND A.
220 W. 98th St., Apt. 128,
New York, NY 10025
(212) 864-4689

MONKMEYER PRESS PHOTO
AGENCY
118 E. 28th St.,
New York, NY 10016
(212) 689-2242

MOVIE STAR NEWS
212 E. 14th St.,
New York, NY 10003
(212) 982-8364

MUSEUM OF MODERN ART
11 W. 53rd St.,
New York, NY 10019
(212) 956-6100

MUSEUM OF THE CITY OF
NEW YORK
Fifth Ave. & 103rd St.,
New York, NY 10029
(212) 534-1672

MUNSEY NEWS SERVICE
41 Union Sq. W.,
New York, NY 10003
(212) 989-7151

NEW YORK DAILY NEWS
220 E. 42nd St.,
New York, NY 10017
(212) 949-3570

NEW-YORK HISTORICAL
SOCIETY
170 Central Pk. W.,
New York, NY 10024
(212) 873-3400

NYT PICTURES
229 W. 43rd St.,
New York, NY 10036
(212) 556-7119 (New York *Times*)

NANCY PALMER PHOTO
AGENCY
129 Lexington Ave.,
New York, NY 10016
(212) 683-9309

PENGUIN PHOTO
COLLECTION
663 Fifth Ave.,
New York, NY 10022
(212) 758-7328

PHOTOFILE
32 E. 31st St.,
New York, NY 10016
(212) 989-0500

PHOTOGRAPHY FOR
INDUSTRY
850 Seventh Ave.,
New York, NY 10019
(212) 757-9255

PHOTO PHILE
381 Fifth Ave.,
New York, NY 10016
(212) 689-3333

PHOTO RESEARCHERS INC.
60 E. 56th St.,
New York, NY 10022
(212) 758-3420

PHOTO TRENDS
1328 Broadway,
New York, NY 10001
(212) 279-2130

PHOTOUNIQUE
New York, NY
(212) 689-3333

PHOTO WORLD INC.
251 Park Ave. S.,
New York, NY 10010
(212) 777-4214

PICTORIAL PARADE INC.
130 W. 42nd St.,
New York, NY 10036
(212) 840-2026

PLESSNER INTL.
95 Madison Ave.,
New York, NY 10016
(212) 686-2444

PRESS FEATURES INTL.
150 E. 35th St.,

New York, NY 10016
(212) 532-2508

RDR PRODUCTIONS
351 W. 54th St.,
New York, NY 10019
(212) 586-4432

RELIGIOUS NEWS SERVICE
43 W. 57th St.,
New York, NY 10019
(212) 688-7094

RETNA (REDFERN)
414 Park Ave. S.,
New York, NY 10016
(212) 683-6560

ROBERTS, H. ARMSTRONG
420 Lexington Ave.,
New York, NY 10170
(212) 682-6626

SCALA FINE ARTS
 PUBLISHERS
342 Madison Ave.,
New York, NY 10017
(212) 354-9646

SEKAI BUNKA PHOTO
501 Fifth Ave.,
New York, NY 10017
(212) 490-2180

SEIDMAN, SY
303 Park Ave. S.,
New York, NY 10010
(212) 982-4318

SHOSTAL ASSOC.
60 E. 42nd St.,
New York, NY 10165
(212) 687-0696

SO STUDIO INC.
34 E. 23rd St.,
New York, NY 10010
(212) 475-0090

SOVFOTO
25 W. 43rd St.,
New York, NY 10036
(212) 922-1922

SPORTS ILLUSTRATED
Time & Life Bldg.,
Rockefeller Center,
New York, NY 10020
(212) 841-3663

STOCK PHOTOS UNLIMITED
 INC.
275 Seventh Ave.,
New York, NY 10001
(212) 421-8980

STOCK SHOP
279 E. 44th St.,
New York, NY 10017
(212) 687-8080

SYGMA PHOTO NEWS
225 W. 57th St.,
New York, NY 10019
(212) 765-1820

TAURUS PHOTOS
118 E. 28th St.,
New York, NY 10016
(212) 683-4025

THREE LIONS INC.
150 Fifth Ave.,
New York, NY 10011
(212) 691-8640

TIME-LIFE PICTURE AGENCY
1271 Ave. of the Americas,
New York, NY 10020
(212) 586-1212

TRANSWORLD FEATURE
 SYNDICATE
142 W. 44th St.,
New York, NY 10036
(212) 997-1880

UNITED NATIONS
 PHOTOGRAPH LIBRARY
United Nations,
New York, NY 10017
(212) 754-6927

UNITED PRESS INTL. NEWS
 PICTURES
220 E. 42nd St.,
New York, NY 10017
(212) 850-8600

UNIVERSITY NEWS SERVICE
16 E. 53rd St.,
New York, NY 10022
(212) 724-6716

WECKLER'S WORLD
90 Lexington Ave.,
New York, NY 10016
(212) 683-6161

WIDE WORLD PHOTOS INC.
50 Rockefeller Plz.,
New York, NY 10020
(212) 262-6300

KATHERINE YOUNG
 AGENCY
140 E. 40th St.,
New York, NY 10016
(212) 684-0999

Northeast

BERGMAN ASSOC.
E. Mountain Rd. S.,
Cold Spring, NY 11724
(914) 265-3656

BOSTON STOCK
 PHOTOGRAPHS

739 Boylston St.,
Boston, MA 02116
(617) 266-2573

CAMERIQUE
1701 Skippack Pike Box 175,
Blue Ball, PA 19422
(215) 272-7649

CHANDOHA, WALTER
RD. 1, Box 287,
Annandale, NJ 08801
(201) 782-3666

CYR COLOR PHOTO AGENCY
Box 2148,
Norwalk, CT 06852
(203) 838-8280

ESTO PHOTOGRAPHS
222 Valley Pl.,
Mamaroneck, NY 10543
(914) 698-4060

FRANKLIN PHOTO AGENCY
39 Woodcrest Ave.,
Hudson, NH 03051
(603) 889-1289

GLOBE PRESS
 INTERNATIONAL
Box 2046,
York, PA 17405
(717) 845-2805

IMAGE PHOTOS
Main St.,
Stockbridge, MA 01262
(413) 298-5500

KRAMER, IRWIN
5 N. Clover Dr.,
Great Neck, NY 11021
(516) 466-5582

HAROLD M. LAMBERT
 STUDIOS
2801 W. Cheltenham Ave.,
Philadelphia, PA 19150
(215) 224-1400

LENSMEN INC.
1560 Wisconsin Ave., N.W., #3246,
Washington, DC 20007
(202) 337-8014

LUMIERE
512 Adams St.,
Centerport, NY 11721
(516) 271-6133

MANGURIAN, DAVID
8504 Garfield St.,
Bethesda, MD 20817
(301) 530-5110

NATIONAL CATHOLIC NEWS
 SERVICE
1312 Massachusetts Ave. N.W.,
Washington, DC 20005
(202) 659-6722

THE PICTURE CUBE
131 State St.,
Boston, MA 02109
(617) 367-1532

PICTUREMAKERS INC.
1 Paul Dr.,
Succasunna, NJ 07876
(201) 584-3000

PUTNEY PHOTO LIBRARY
Box 236,
Claymont, DE 19703
(302) 792-1900

H. ARMSTRONG ROBERTS
4203 Locust St.,
Philadelphia, PA 19104
(215) 386-6300

SICKLES PHOTO-REPORTING
Box 98, Maplewood, NJ 07040
(201) 763-6355

SKYVIEWS SURVEY INC.
50 Swalm St.,
Westbury, NY 11590
(516) 333-3600

TRANS-WORLD NEWS
 SERVICE
923 National Press Bldg.,
Washington, DC 20045
(202) 638-5568

UNIPHOTO
P.O. Box 3678,
Washington, DC 20007
(202) 333-0500

Southeast

ASSOCIATED PICTURE
 SERVICE
Northside Sta., Box 52881,
Atlanta, GA 30355
(404) 948-2671

EARTHWORK STUDIO
2131 Liddell Dr. N.E.,
Atlanta, GA 30324
(404) 873-3636

ENGELMAN, SOREMIE
446 Brazilian Ave.,
Palm Beach, FL 33480
(305) 655-7929

JAMISON, CHIPP
2131 Liddell Dr. N.E.,
Atlanta, GA 30324
(404) 873-3636

NOVAK, JACK
505 W. Windsor Ave.,
Alexandria, VA 22302
(703) 836-4439

THE PHELPS AGENCY
32 Peachtree St. N.W.,
Atlanta, GA 30303
(404) 524-1234

PHOTO RESEARCH
 INTERNATIONAL
505 W. Windsor Ave.,
Alexandria, VA 22302
(703) 836-4439

ROLOC PICTORIAL
 RESEARCH
326 South Pickett St.,
Alexandria, VA 22304
(703) 751-8668

S & S PHOTOGRAPHY
Box 8101,
Atlanta, GA 30306
(404) 876-7260

SHERMAN, RON
P.O. Box 28656,
Atlanta, GA 30358
(404) 993-7197

SOUTHERN STOCK PHOTO
P.O. Box 693726,
Fort Lauderdale, FL 33169
(305) 949-5191

MAX THARPE PHOTO
 LIBRARY
520 N.E. Seventh Ave., #3,
Fort Lauderdale, FL 33301
(305) 763-5449

VANCE, DAVID
13760 N.W. 19th St.,
Miami, FL 33182
(305) 685-2433

VWR SCIENTIFIC INC.
1050 N.W. 167th St.,
Miami, FL 33169
(305) 625-7181

Midwest

AAAA CREATIVE INC.
1030 N. State St.,
Chicago, IL 60610
(312) 645-0611

AIRPIX
2610 N. Laramie,
Chicago, IL 60639
(312) 662-7755

AMERICAN INTERNATIONAL
 MARKETING
47 E. Fullerton,
Addison, IL 60101
(312) 279-8081

ARMSTRONG, ROBERT H.
203 N. Wabash,

Chicago, IL 60601
(312) 726-0880

ARTSTREET
25 E. Delaware,
Chicago, IL 60611
(312) 664-3049

BLESSING, HEDRICH
11 W. Illinois St.,
Chicago, IL 60610
(312) 321-1151

BRANDT & ASSOC.
148 Route 2,
Barrington Hills, IL 60010
(312) 428-6363

CAMPBELL STOCK PHOTO
 SERVICE
18711 W. Ten Mile Rd.,
Southfield, MI 48075
(313) 559-6870

CANDIDA PHOTOS INC.
4711 W. Byron,
Chicago, IL 60641
(312) 736-5544

COLLECTORS SERIES
161 W. Harrison,
Chicago, IL 60605
(312) 427-5311

ENGH, ROHN
Pine Lake Farm,
Star Prairie, WI 54026
(715) 248-3800

GRESS-RUPERT
251 E. Grand,
Chicago, IL 60611
(312) 642-1188

HISTORICAL PICTURE
 SERVICES
17 N. State St.,
Chicago, IL 60602
(312) 346-0599

IBID INC.
125 W. Hubbard,
Chicago, IL 60610
(312) 644-0515

IMAGE BANK
510 N. Dearborn,
Chicago, IL 60610
(312) 329-1817

THE INDUSTRIAL
 REVOLUTION
2956 N. Racine,
Chicago, IL 60657
(312) 549-2588

KLINGMAN, FRAN
88 W. Schiller,
Chicago, IL 60610
(312) 943-5646

LAMBERT, HAROLD M.
29 E. Madison,
Chicago, IL 60602
(312) 332-5350

PHOTO LIBRARY INC.
9 N. 4th St.,
Minneapolis, MN 55401
(612) 338-7234

PILES & FILES OF PHOTOS
1030 N. State St.,
Chicago, IL 60610
(312) 642-7110

REDMAN, LEE F.
7029 N. Glenwood,
Chicago, IL 60626
(312) 973-3441

STOCK PHOTO FINDERS
1030 N. State St.,
Chicago, IL 60610
(312) 645-0611

STOCK/CHICAGO
42 E. Superior St.,
Chicago, IL 60611
(312) 787-8834

TRW
23555 Euclid Ave.,
Cleveland, OH 44117
(216) 383-3176

WEBB PHOTOS
1999 Shepherd Rd.,
St. Paul, MN 55116
(612) 647-7317

ZEHRT, JACK
4211 Flora Pl.,
St. Louis, MO 63110
(314) 773-2298

Southwest

AMERICAN WEST PHOTOS
2211 W. Rovey Ave.,
Phoenix, AZ 85015
(602) 242-2975

BENNETT, SUE PATERSON
P.O. Box 1574,
Flagstaff, AZ 86002
(602) 282-3899

TOM CAMPBELL PHOTO
4352 N. Central Ave.,
Phoenix, AZ 85012
(602) 264-1151

FAR WEST PHOTOGRAPHY &
 ASSOC.
1611 San Pedro Dr. N.E.,
Albuquerque, NM 87110
(505) 255-0646

FOTO INC.
233 Edison St.,
Salt Lake City, UT 84111
(801) 355-8282

McLAUGHLIN, HERB &
 DOROTHY
2350 W. Holly,
Phoenix, AZ 85009
(602) 258-6551

THE PHOTO CIRCLE INC.
P.O. Box 66288,
Houston, TX 77266
(713) 522-0554

PHOTO UNIQUE
1588 S. Major,
Salt Lake City, UT 84115
(801) 486-1517

PHOTOWORKS/UNIPHOTO
 INTERNATIONAL
215 Asbury,
Houston, TX 77007
(713) 864-3638

RUNNING PRODUCTIONS
P.O. Box 1237,
Flagstaff, AZ 86002
(602) 774-2923

SMITH GRAFTON MARSHALL
P.O. Box 3212,
Aspen, CO 81612
(303) 925-7120

TOM STACK ASSOC.
3350 Cortina Dr.,
Colorado Springs, CO 80918
(303) 599-9441

TRAVEL ARTS
Box 52,
Reno, NV 89504
(702) 849-2201

VISUAL MEDIA INC.
2661 Vassar St.,
Reno, NV 89502
(702) 322-8868

West

ACKERMAN, SHARON
955 Maltman Ave.,
Los Angeles, CA 90026
(213) 662-0748

AFTER IMAGE
6855 Santa Monica Blvd., #402,
Los Angeles, CA 90028
(213) 467-6033

ALASKA PHOTO
1431 W. Ninth Ave.,

Anchorage, AL 99501
(907) 272-0252

AMERICAN STOCK PHOTOS
6842 Sunset Blvd.,
Los Angeles, CA 90028
(213) 469-3908

ARNOLD, MARK
145 N. Swall Dr.,
Beverly Hills, CA 90048
(213) 659-4760

MORTON BEEBE & ASSOC.
151 Union,
San Francisco, CA 94111
(415) 362-3530

CARLSON, KEN
1141 S. La Cienega Blvd.,
Los Angeles, CA 90069
(213) 657-4242

CORNWALL, DAVID
1311 Kalakaua Ave.,
Honolulu, HI 96826
(808) 949-7000

CHERKIS, DAVID
2257 28th St.,
Santa Monica, CA 90405
(213) 450-3700

CLARK, EILERT "RIC"
3642 Fredonia Dr.,
Los Angeles, CA 90068
(213) 851-6929

THE COLLECTION INC.
843 N. Fairfax Ave.,
Los Angeles, CA 90046
(213) 653-0811

DANDELET INTERLINKS
126 Redwood Rd.,
San Anselmo, CA 94960
(415) 456-1260

ENVIRONMENTAL
 COMMUNICATIONS
66 Winward Ave.,
Venice, CA 90291
(213) 392-4964

EYERMAN, JR.
475 17th St.,
Santa Monica, CA 90402
(213) 394-7841

FOTOS INTERNATIONAL
4230 Ben Ave.,
Studio City, CA 91604
(213) 762-2181

GEMINI SMITH INC.
5858 Desert View Dr.,
La Jolla, CA 92037
(714) 454-4321

GLOBE PHOTOS INC.
8400 Sunset Blvd., #2,
Los Angeles, CA 90069
(213) 654-3350

GOTTLIEB, JANE
2348 Kelton Ave.,
Los Angeles, CA 90064
(213) 474-9549

THE IMAGE BANK/WEST
5455 Wilshire Blvd., #1610,
Los Angeles, CA 90036
(213) 937-2667

IMAGE & DESIGN
7466 Beverly Blvd.,
Los Angeles, CA 90036
(213) 934-7520

IMAGE IMAGINATION
2139 Beachwood Terr.,
Los Angeles, CA 90068
(213) 937-1314

JACOBS, MICHAEL
7466 Beverly Blvd.,
Los Angeles, CA 90036
(213) 934-7863

KAHANA, YORAM
1909 N. Curson Pl.,
Los Angeles, CA 90046
(213) 876-8208

KELLEY, TOM
8525 Santa Monica Blvd.,
Los Angeles, CA 90069
(213) 657-1780

LEAVITT, DEBBIE
7219 Hazeltine Ave.,
Van Nuys, CA 91405
(213) 780-4755

LENSMEN c/o Karen
 Vanderputte
12349 Milbank,
Studio City, CA 91604
(213) 761-2627

LONG, GEORGE
1265 S. Cochran Ave.,
Los Angeles, CA 90019
(213) 933-7219

MARESCHAL, NIKI
1725 Camino Palmero,
Los Angeles, CA 90046
(213) 874-5330

MERCURY ARCHIVES
1574 Crossroads of the World,
Hollywood, CA 90028
(213) 463-8000

NEST PHOTO/VISUAL
 COMMUNICATIONS
7101 Saroni Dr.,
Oakland, CA 94611
(415) 339-9733

PHOTOGRAPHS
P.O. Box 5298, University Sta.,
Seattle, WA 98105
(206) 522-0154

PHOTOPHILE
2311 Kettner Blvd.,
San Diego, CA 92101
(714) 234-4431

PROBSTEIN, BOBBIE
16126 Hartsook St.,
Encino, CA 91436
(213) 788-9156

RICHARDS COMMERCIAL
 PHOTO SERVICE
734 Pacific Ave.,
Tacoma, WA 98402
(206) 627-9111

SIMPSON, ED
P.O. Box 397,
South Pasadena, CA 91030
(213) 799-8979, (213) 682-3131

B. P. SINGER FEATURES INC.
3164 Tyler Ave.,
Anaheim, CA 92801
(714) 527-5650, (714) 522-4945

SLAUGHTER, PAUL
1365 Kelton, #5,
Los Angeles, CA 90024
(213) 479-2706

STANMAN, CRAIG
8920 Wilshire Blvd., #320,
Beverly Hills, CA 90048
(213) 657-2126, (213) 455-3036

STOCK, RICHARD ALAN
1767 N. Orchid Ave., #312,
Los Angeles, CA 90028
(213) 876-7436

SUMMA, ANN
900 Sanborn Ave.,
Los Angeles, CA 90029
(213) 661-5303

VON STROHEIM, III, ERIC
1055 Stradella Rd.,
Los Angeles, CA 90077
(213) 472-8548, (303) 482-2769

WORLD WIDE PHOTO
6912 Hollywood Blvd., #308,
Los Angeles, CA 90028
(213) 464-4403

PHOTOGRAPHIC
RESEARCH

New York City

BATES, ELIZABETH BIDWELL
323 W. 84th St.,

New York, NY 10024
(212) 724-9367

BRYSAC, SHAREEN
50 W. 96th St.,
New York, NY 10025
(212) 663-0162

CASTLE, MIRIAM
555 Kapock St.,
Riverdale, NY 10463
(212) 549-3866

CLARKE, MURIEL
552 E. 87th St.,
New York, NY 10028
(212) 737-6015

EVANS, MERYLE
325 E. 52nd St.,
New York, NY 10022
(212) 355-1926

FLEX INC. (FREE-LANCE
 EXCHANGE INC.)
342 Madison Ave.,
New York, NY 10173
(212) 682-3042

FORBES, SALLY
81 Columbia Hts.,
Brooklyn, NY 11201
(212) 855-6346

FREUND, YVONNE R.
67 Riverside Dr.,
New York, NY 10024
(212) 724-7550

GALYN, RHODA
Box 102, FDR Sta.,
New York, NY 10150
(212) 744-8634

GOVE, GEOFFREY R.
117 Waverly Pl.,
New York, NY 10011
(212) 260-6051

GUERETTE, ROBERTA
670 West End Ave.,
New York, NY 10025
(212) 362-7379

HAMILTON, LEE DAVID
Box 1029, Radio City Sta.,
New York, NY 10101
(212) 586-5395

JACOBS, CONSTANCE
486 Independence Ave.,
Bronx, NY 10463
(212) 884-1305

KING, INGE
1553 York Ave.,
New York, NY 10028
(212) 535-1158

KLASS, ENID
155 E. 43rd St.,

New York, NY 10017
(212) 686-8647

LANDY, LYNN
55 East End Ave.,
New York, NY 10028
(212) 737-9679

LIPTON, E. TRINA
60 E. 8th St.,
New York, NY 10003
(212) 533-3148

LOPEZ, ANNA MARIA
215 Thompson St.,
New York, NY 10012
(212) 477-1566

McRAE, MARGARET
5 Tudor City Pl.,
New York, NY 10017
(212) 697-9625

MALLINSON, JUDY
173 Bergen St.,
Brooklyn, NY 11217
(212) 625-0546

ESTELLE MANDEL INC.
65 E. 8oth St.,
New York, NY 10021
(212) 737-5062

MENSCHENFREUND, JOAN
175 W. 73rd St.,
New York, NY 10023
(212) 362-8234

ORKIN, FRANCIS L.
102 E. 22nd St.,
New York, NY 10010
(212) 254-2688

PENGUIN PHOTO
 COLLECTION
663 Fifth Ave.,
New York, NY 10022
(212) 758-7328

PHOTO RESEARCHERS INC.
60 E. 56th St.,
New York, NY 10022
(212) 758-3420

PHOTOGRAPHIC RESEARCH
 SERVICE
65 E. 8oth St.,
New York, NY 10021
(212) 988-4630

PICTUREBOOK PHOTO
 RESEARCH
520 Fifth Ave.,
New York, NY 10036
(212) 682-5844

RACKOW, MARCIA
15 Charles St.,
New York, NY 10014
(212) 691-9743

RESEARCH REPORTS
315 W. 78th St.,
New York, NY 10024
(212) 595-6770

ROSENSTEIN, CLAIRE
24 W. 55th St.,
New York, NY 10019
(212) 246-2798

SCAFARELLO, JOAN
221 E. 50th St.,
New York, NY 10022
(212) 355-2397

SCHAD, FERN MAGONET
135 E. 74th St.,
New York, NY 10021
(212) 249-5653

STONE, ERIKA
327 E. 82nd St.,
New York, NY 10028
(212) 737-6435

TYRRASCH, MARIANNE
20 E. 74th St.,
New York, NY 10021
(212) 288-4502

URBAN, MARION B.
12 E. 75th St.,
New York, NY 10021
(212) 988-1248

WECHSLER, SUSAN
420 West End Ave.,
New York, NY 10024
(212) 873-9880

WINSTOCK, NANCY J.
280 First Ave.,
New York, NY 10009
(212) 459-7227

WORTMAN, BYRNA
110 Shore Blvd.,
Brooklyn, NY 11235
(212) 891-3295

WUNDERLICH, GABRIELE
138 E. 36th St.,
New York, NY 10016
(212) 689-6985

ZIMMERMAN, SANDRA
145 W. 55th St.,
New York, NY 10019
(212) 586-0842

Northeast

CAHN, WILLIAM
488 Norton Pkwy.,
New Haven, CT 06511
(203) 562-5508

DAVIDSON, MARTHA
134 Hancock St.,
Cambridge, MA 02139
(617) 491-8365

FILM FACTS ENGINEERING
 INC.
75 Wiggins Ave.,
Bedford, MA 01730
(617) 275-1670

FOX, SALLY
195 Tappan St.,
Brookline, MA 02146
(617) 738-0860

FREYBERGER, ELAINE
82 N. Rockledge Rd.,
Hartsdale, NY 10530
(914) 472-7550

GALWAY, ALICE P.
Box 953,
East Quogue, NY 11942
(516) 653-4648

GREEN, SHIRLEY L.
5910 Johnson Ave.,
Bethesda, MD 20034
(301) 530-7273

LINDROTH, LINDA
8 Crescent Rd.,
Florham Park, NJ 07932
(201) 377-1251

NORTH COUNTRY HISTORY
 CENTER
State University College,
Plattsburgh, NY 12903
(518) 564-2207, (518) 562-0508

HERBERT PEMBROKE
 PICTURE RESEARCH
 CONSULTANTS
26 Canterbury Hill,
Topsfield, MA 01983
(617) 887-2158

OLD, PHYLLIS
Prince's Pine Rd.,
Norwalk, CT 06850
(203) 838-6762

PONTIUS, JOHN F.
130 N. Carolina Ave. S.E.,
Washington, DC 20003
(202) 543-0415

RAPPORT PHOTOGRAPHY
2021½ Murray Ave.,
Pittsburgh, PA 15217
(412) 421-8386

SCHACHNE, MIRA
6040 Boulevard E.,
West New York, NJ 07093
(201) 868-8532

SMITH, DIANE
41 Hawthorne St.,
Cambridge, MA 02138
(617) 864-3484

STARR, GRACE C.
2151 Center Ave.,
Fort Lee, NJ 07024
(201) 944-6898

Southeast

THURER, ARLEN PENNY
7400 S.W. 133rd St.,
Miami, FL 33183
(305) 233-0585

Midwest

SYNTHEGRAPHICS
 CORPORATION
75 E. Wacker Dr.,
Chicago, IL 60601
(312) 236-7075

West

CARTER, WILLIAM
535 Everett Ave.,
Palo Alto, CA 94301
(415) 326-1318, (415) 328-3561

DEFOREST RESEARCH
 SERVICE
780 Gower,
Los Angeles, CA 90038
(213) 469-2271

FOSTER, LEE
6774 Manor Crest,
Menlo Park, CA 94025
(415) 654-1318

TRADE PUBLICATIONS

ADVERTISING AGE
6404 Wilshire Blvd.,
Los Angeles, CA 90048
(213) 651-3710

ADWEEK
514 Shatto Pl.,
Los Angeles, CA 90020
(213) 384-7100

ART DIRECTION
19 W. 44th St.,

New York, NY 10036
(212) 354-0450

COMMUNICATION ARTS-CA
410 Sherman Ave.,
Palo Alto, CA 95050
(415) 326-6040

MAGAZINE AGE
6931 Van Nuys Blvd.,
Van Nuys, CA 91405
(213) 873-7600

OCULAR
159 Platte St.,
Denver, CO 80202
(303) 458-6064

DIRECTORIES

ASMP BOOK
205 Lexington Ave.,
New York, NY 10016
(212) 889-9144

AMERICAN SHOWCASE
724 Fifth Ave.,
New York, NY 10019
(212) 245-0981

ART DIRECTOR'S INDEX
415 W. Superior,
Chicago, IL 60610
(312) 337-1901

THE BOOK
P.O. Box 794,
Westport, CT 06880
(203) 226-4207

THE CHICAGO CREATIVE
 DIRECTORY
333 N. Michigan,
Chicago, IL 60601
(312) 236-7337

THE CREATIVE BLACK BOOK
80 Irving Pl.,
New York, NY 10003
(212) 228-9750

CREATIVE DIRECTORY OF
 THE SUN BELT
1103 S. Shepard,
Houston, TX 77019
(713) 532-0506

THE GOLDEN PAGES
P.O. Box 560696,
Miami, FL 33156
(305) 233-6510

THE L.A. WORKBOOK
6140 Lindenhurst Ave.,
Los Angeles, CA 90048
(213) 856-0008

THE MADISON AVE.
 HANDBOOK
17 E. 48th St.,
New York, NY 10017
(212) 688-7940

THE RED BOOKS
6300 Wilshire Blvd.,
Los Angeles, CA 90048
(213) 651-5950

RSVP
P.O. Box 314,
Brooklyn, NY 11238
(212) 857-9267

MAGAZINES

AFTER DARK
161 W. 54th St., #1202,
New York, NY 10019
(212) 246-7979

AIR CALIFORNIA
1465 South Coast Hwy.,
Laguna Beach, CA 92651
(714) 497-1727

AIR LINE PILOT
1825 Massachusetts Ave. N.W.,
Washington, DC 20036
(202) 797-4176

ALASKA
130 Second Ave. S.,
Edmonds, WA 98020
(206) 774-4111

ALOHA
P.O. Box 3404,
Honolulu, HI 96801
(808) 523-9871

AMERICAN BABY
575 Lexington Ave.,
New York, NY 10022
(212) 752-0775

AMERICAN GIRL
830 Third Ave.,
New York, NY 10022
(212) 940-7500

AMERICAN HOME
641 Lexington Ave.,
New York, NY 10022
(212) 983-3200

AMERICAN PHOTOGRAPHER
111 Eighth Ave.,
New York, NY 10011
(212) 924-0760

APARTMENT LIFE
750 Third Ave.,
New York, NY 10017
(212) 557-6600

APPLAUSE
3636 Fifth Ave., Suite 305,
San Diego, CA 92103
(714) 297-6430

ARCHITECTURAL DIGEST
5900 Wilshire Blvd.,
Los Angeles, CA 90036
(213) 937-4740

ART IN AMERICA
850 Third Ave.,
New York, NY 10022
(212) 593-2100

AUDUBON
950 Third Ave.,
New York, NY 10022
(212) 832-3200

BARRON'S
22 Cortlandt St.,
New York, NY 10007
(212) 285-5243

BIG VALLEY
16161 Roscoe,
Sepulveda, CA 91343
(213) 894-2223

BILLBOARD
9000 Sunset Blvd.,
Los Angeles, CA 90077
(213) 273-7040

BLACK ENTERPRISE
295 Madison Ave.,
New York, NY 10017
(212) 889-8220

BOATING
1 Park Ave.,
New York, NY 10016
(212) 725-3982

BON APPETIT
9 W. 57th St.,
New York, NY 10019
(212) 753-6683

BOOK DIGEST
730 Fifth Ave.,
New York, NY 10022
(212) 397-1560

BOYS' LIFE
271 Madison Ave.,
New York, NY 10016
(212) 532-0985

BRIDE'S MAGAZINE
350 Madison Ave.,
New York, NY 10017
(212) 880-8800

BUSINESS WEEK
1221 Ave. of the Americas,
New York, NY 10020
(212) 997-1221

CALIFORNIA FARMER
83 Stevenson St.,
San Francisco, CA 94105
(415) 495-3340

CAMERA 35
150 E. 58th St.,
New York, NY 10155
(212) 355-5705

CAR CRAFT
8490 Sunset Blvd.,
Los Angeles, CA 90069
(213) 657-5100

CAR & DRIVER
1 Park Ave.,
New York, NY 10016
(212) 994-0055

CARTE BLANCHE
3460 Wilshire Blvd.,
Los Angeles, CA 90010
(213) 480-3210

CHAMBER OF COMMERCE
1615 H St. N.W.,
Washington, DC 20062
(202) 659-6000

CIGAR
149 Fifth Ave.,
New York, NY 10010
(212) 228-2800

CO-ED
50 W. 44th St.,
New York, NY 10036
(212) 944-7700

COLORADO
1139 Delaware Plz., P.O. Box 4305,
Denver, CO 80204
(303) 573-1433

COMMENTARY
165 E. 56th St.,
New York, NY 10021
(212) 751-4000

COMPUTER
5855 Naples Marine Plz.,
Long Beach, CA 90801
(213) 438-9951

COSMOPOLITAN
224 W. 57th St.,
New York, NY 10019
(212) 262-5700

CRUISING WORLD
524 Thames St.,
Newport, RI 02840
(401) 847-1588

CUISINE
420 Lexington Ave.,
New York, NY 10017
(212) 661-2700

CYCLE GUIDE
1440 W. Walnut St.,

Compton, CA 90220
(213) 537-0857

CYCLE NEWS EAST
P.O. Box 498,
Long Beach, CA 90801
(213) 427-7433

CYCLE NEWS WEST
2201 Cherry Ave.,
Signal Hill, CA 90806
(213) 427-7433

DALLAS
2902 Carlisle St.,
Dallas, TX 75204
(214) 748-9166

DANCE MAGAZINE
1180 Ave. of the Americas,
New York, NY 10036
(212) 921-9300

EBONY
1270 Ave. of the Americas,
New York, NY 10020
(212) 586-2911

ELKS
425 W. Diversey,
Chicago, IL 60614
(312) 528-4500

ESQUIRE
2 Park Ave.,
New York, NY 10016
(212) 561-8100

FAMILY CIRCLE
488 Madison Ave.,
New York, NY 10022
(212) 593-8000

FIELD & STREAM
1515 Broadway,
New York, NY 10036
(212) 975-4321

FINANCIAL EXECUTIVE
633 Third Ave.,
New York, NY 10017
(212) 953-0500

FINANCIAL WORLD
919 Third Ave.,
New York, NY 10022
(212) 826-4360

FLYING
1 Park Ave.,
New York, NY 10016
(212) 725-3799

FORBES
60 Fifth Ave.,
New York, NY 10011
(212) 620-2200

FORTUNE
1271 Ave. of the Americas,
New York, NY 10020
(212) 586-1212

GALLERY
800 Second Ave.,
New York, NY 10017
(212) 986-9600

GAMES
515 Madison Ave.,
New York, NY 10022
(212) 421-5984

GENTLEMEN'S QUARTERLY
350 Madison Ave.,
New York, NY 10017
(212) 880-8800

GEO
600 Madison Ave.,
New York, NY 10022
(212) 223-0001

GLAMOUR
350 Madison Ave.,
New York, NY 10017
(212) 880-8800

GOLF DIGEST
495 Westport Ave.,
Norwalk, CT 06856
(203) 847-5811, (212) 593-8000

GOLF MAGAZINE
380 Madison Ave.,
New York, NY 10017
(212) 687-3000

GOLF WORLD
600 Access Rd.,
Southern Pines, NC 28387
(919) 692-6856

GOOD HOUSEKEEPING
959 Eighth Ave.,
New York, NY 10019
(212) 262-5700

GOOD HOUSEKEEPING
 COUNTRY LIVING
224 W. 57th St.,
New York, NY 10019
(212) 262-3636

GOOD HOUSEKEEPING
 NEEDLECRAFT
224 W. 57th St.,
New York, NY 10019
(212) 262-3636

GOURMET
777 Third Ave.,
New York, NY 10017
(212) 754-1500

GRIT
208 W. Third St.,
Williamsport, PA 17701
(717) 326-1771

GUNS & AMMO
8490 Sunset Blvd.,

Los Angeles, CA 90069
(213) 657-5100

HARPER'S BAZAAR
717 Fifth Ave.,
New York, NY 10022
(212) 935-5900

HARVARD
1341 Massachusetts Ave.,
Cambridge, MA 02138
(617) 495-5746

HARVARD BUSINESS REVIEW
Soldier's Field Sta.,
Boston, MA 02163
(617) 495-6190

HOT ROD
8490 Sunset Blvd.,
Los Angeles, CA 90069
(213) 657-5100

HOUSE BEAUTIFUL
717 Fifth Ave.,
New York, NY 10022
(212) 935-5900

HOUSE & GARDEN
350 Madison Ave.,
New York, NY 10017
(212) 880-8800

HUMAN BEHAVIOR
12031 Wilshire Blvd.,
Los Angeles, CA 90017
(213) 478-2061

HUNTING
8490 Sunset Blvd.,
Los Angeles, CA 90069
(213) 657-5100

IDAHO HERITAGE
P.O. Box 9365,
Boise, ID 83707
(208) 345-0060

KIWANIS
101 E. Erie St.,
Chicago, IL 60611
(312) 943-2300

LADIES' HOME JOURNAL
641 Lexington Ave.,
New York, NY 10022
(212) 872-8000

LADY'S CIRCLE
23 W. 26th St.,
New York, NY 10010
(212) 689-3933

LIFE
1271 Ave. of the Americas,
New York, NY 10020
(212) 586-1212

LOS ANGELES
1888 Century Pk. E.,
Los Angeles, CA 90067
(213) 552-1021

LUTHERAN
2900 Queen Ln.,
Philadelphia, PA 19129
(215) 848-6800

MADEMOISELLE
350 Madison Ave.,
New York, NY 10017
(212) 880-8800

McCALL'S
230 Park Ave.,
New York, NY 10169
(212) 551-9500

MECHANIX ILLUSTRATED
1515 Broadway,
New York, NY 10036
(212) 719-6630

MODERN BRIDE
1 Park Ave.,
New York, NY 10016
(212) 725-3886

MODERN HANDCRAFT
4251 Pennsylvania Ave.,
Kansas City, MO 64111
(816) 531-5730

MODERN PHOTOGRAPHY
130 E. 59th St.,
New York, NY 10022
(212) 265-8360

MONEY
1271 Ave. of the Americas,
New York, NY 10020
(212) 586-1212

MOODY MONTHLY
2101 Howard St.,
Chicago, IL 60645
(312) 274-2535

MOTHER EARTH NEWS
P.O. Box 70,
Hendersonville, NC 28739
(704) 693-0211

MOTOR BOATING & SAILING
224 W. 57th St.,
New York, NY 10019
(212) 262-5700

MOTOR TREND
437 Madison Ave.,
New York, NY 10022
(212) 935-9150

MS.
119 W. 40th St.,
New York, NY 10018
(212) 719-9800

NATIONAL DRAGSTER
10639 Riverside Dr.,
North Hollywood, CA 91602
(213) 980-3724

NATIONAL ENQUIRER
6 E. 45th St.,
New York, NY 10017
(212) 682-2665

NATIONAL FISHERMAN
21 Elm St.,
Camden, ME 04843
(207) 236-4342

NATIONAL GEOGRAPHIC
1251 Ave. of the Americas,
New York, NY 10020
(212) 974-1700

NATIONAL REVIEW
150 E. 35th St.,
New York, NY 10016
(212) 679-7330

NATION'S BUSINESS
1615 H St. N.W.,
Washington, DC 20062
(202) 659-6010

NATURAL HISTORY
Central Pk. W. at 79th St.,
New York, NY 10024
(212) 873-1300

NEW HAMPSHIRE PROFILES
2 Stream Mill Ct.,
Concord, NH 03301
(603) 224-5193

NEW MEXICO
113 Washington Ave.,
Santa Fe, NM 87501
(505) 827-2642

NEWSWEEK
444 Madison Ave.,
New York, NY 10022
(212) 350-2000

NEW WEST
9665 Wilshire Blvd.,
Beverly Hills, CA 90212
(213) 273-7516

NEW YORK
755 Second Ave.,
New York, NY 10017
(212) 880-0700

NEW YORKER
25 W. 43rd St.,
New York, NY 10036
(212) 840-3800

NORTHWEST FARM
P.O. Box 9365,
Boise, ID 83707
(208) 342-9376

ORANGE COAST
2041 Business Ctr. Dr.,
Irvine, CA 92715
(714) 752-9376

OUI
8560 Sunset Blvd.,
Los Angeles, CA 90069
(213) 652-7870

PALM SPRINGS LIFE
250 E. Palm Canyon Dr.,
Palm Springs, CA 92262
(714) 325-2333

PARENTS
685 Third Ave.,
New York, NY 10017
(212) 878-8700

PEOPLE
1271 Ave. of the Americas,
New York, NY 10020
(212) 586-1212

PENTHOUSE
909 Third Ave.,
New York, NY 10022
(212) 593-3301

PHOENIX
4707 N. 12th St.,
Phoenix, AZ 85006
(602) 248-8900

PLANTS ALIVE
2603 Third Ave.,
Seattle, WA 98121
(206) 623-9364

PLAYBOY
919 N. Michigan,
Chicago, IL 60611
(312) 751-8000

PLAYGIRL
1801 Century Pk. E.,
Los Angeles, CA 90067
(213) 450-0900

POPULAR MECHANICS
224 W. 57th St.,
New York, NY 10019
(212) 262-5700

POPULAR PHOTOGRAPHY
1 Park Ave.,
New York, NY 10016
(212) 725-3779

POPULAR SCIENCE
380 Madison Ave.,
New York, NY 10017
(212) 687-3000

PSYCHOLOGY TODAY
1 Park Ave.,
New York, NY 10016
(212) 725-3900

READER'S DIGEST
Pleasantville, NY 10570
(914) 769-7000, (212) 972-4000

REDBOOK
230 Park Ave.,

New York, NY 10169
(212) 850-9300

RETIREMENT LIVING
150 E. 58th St.,
New York, NY 10155
(212) 593-2100

ROAD & TRACK
1499 Monrovia Ave.,
Newport Beach, CA 92663
(714) 646-4451

ROLLING STONE
745 Fifth Ave.,
New York, NY 10151
(212) 758-3800

THE ROTARIAN
1600 Ridge Ave.,
Evanston, IL 60201
(312) 328-0100

SACRAMENTO
2620 La Mesa Wy.,
Sacramento, CA 95825
(916) 446-7548

SALT WATER SPORTSMAN
10 High St.,
Boston, MA 02110
(617) 426-4074

SAN DIEGO
3254 Rosecrans,
San Diego, CA 92110
(714) 225-8953

SAN FERNANDO VALLEY
12345 Ventura Blvd.,
Studio City, CA 91604
(213) 985-2624

SAN FRANCISCO
973 Market St.,
San Francisco, CA 94103
(415) 777-5555

SATURDAY REVIEW
150 E. 58th St.,
New York, NY 10155
(212) 826-4290

SAVVY
111 Eighth Ave.,
New York, NY 10011
(212) 255-0990

SCIENCE DIGEST
888 Seventh Ave.,
New York, NY 10106
(212) 262-7990

SCIENTIFIC AMERICAN
415 Madison Ave.,
New York, NY 10017
(212) 754-0550

SCOUTING
1325 Walnut Hill Ln.,
Irving, TX 75062
(214) 659-2373

SELF
350 Madison Ave.,
New York, NY 10017
(212) 880-8800

SEVENTEEN
850 Third Ave.,
New York, NY 10022
(212) 759-8100

SHOOTING COMMERCIALS
6407 Moore Dr.,
Los Angeles, CA 90048
(213) 936-2138

SIGNATURE
880 Third Ave.,
New York, NY 10022
(212) 888-9450

SKI
380 Madison Ave.,
New York, NY 10017
(212) 687-3000

SKIN DIVER
8490 Sunset Blvd.,
Los Angeles, CA 90069
(213) 657-5100

SMITHSONIAN
900 Jefferson Dr. S.W.,
Washington, DC 20560
(202) 357-2600

SOUTHERN LIVING
820 Shades Creek Pkwy.,
Birmingham, AL 35209
(205) 870-4440

SPORT
641 Lexington Ave.,
New York, NY 10022
(212) 872-8000

SPORTING NEWS
1212 N. Lindbergh Blvd.,
St. Louis, MO 63132
(314) 997-7111

SPORTS AFIELD
250 W. 55th St.,
New York, NY 10019
(212) 262-5700

SPORTS ILLUSTRATED
1271 Ave. of the Americas,
New York, NY 10020
(212) 586-1212

SURFER
P.O. Box 1028,
Dana Point, CA 92629
(714) 496-5922

SUNSET
Middlefield & Willow Rds.,
Menlo Pk., CA 94025
(415) 321-3600

TEEN
8490 Sunset Blvd.,
Los Angeles, CA 90069
(213) 657-5100

TEXAS MONTHLY
P.O. Box 1569,
Austin, TX 78761
(512) 476-7085

TIME
1271 Ave. of the Americas,
New York, NY 10020
(212) 586-1212

TODAY'S EDUCATION
1201 16th St. N.W.,
Washington, DC 20036
(202) 833-5435

TRAVEL
51 Atlantic Ave.,
Floral Pk., NY 11001
(516) 352-9700

TRAVEL & LEISURE
1350 Ave. of the Americas,
New York, NY 10019
(212) 399-2500

TUCSON
2500 N. Pantano Rd.,
Tucson, AZ 85715
(602) 298-3308

TV GUIDE
4 Radnor Corporation Ctr.,
Radnor, PA 19087
(215) 293-8500

US
488 Madison Ave.,
New York, NY 10022
(212) 593-8000

U.S. NEWS & WORLD REPORT
2300 N St. N.W.,
Washington, DC 20037
(202) 861-2000

VFW
406 W. 34th St.,
Kansas City, MO 64111
(816) 756-3390

VOGUE
350 Madison Ave.,
New York, NY 10017
(212) 880-8800

"W"
7 E. 12th St.,
New York, NY 10003
(212) 741-4000

WASHINGTONIAN
1828 L St. N.W.
Washington, DC
(202) 296-3600

WESTERN HORSEMAN
3850 N. Nevada Ave.,

Colorado Springs, CO 80907
(303) 633-5524

WESTWAYS
6290 Sunset Blvd.,
Los Angeles, CA 90028
(213) 746-4760

WOMAN'S DAY
1515 Broadway,
New York, NY 10036
(212) 975-4321

WOMEN'S SPORTS
314 Town & Country Village,
Palo Alto, CA 95050
(415) 321-5102

YACHTING
1 Park Ave.,
New York, NY 10016
(212) 725-7800

PHOTO GALLERIES

New York City

ALONZO PHOTO GALLERY
P.O. Box 1544,
Radio City Station,
New York, NY 10101
(212) 477-4138

ALTERNATIVE CENTER FOR
 INTERNATIONAL ARTS,
 INC.
17 White St.,
New York, NY 10013
(212) 966-4444

ARRAS
29 W. 57th St.,
New York, NY 10019
(212) 421-1177

BERKEY K & L GALLERY OF
 PHOTOGRAPHIC ART
222 E. 44th St.,
New York, NY 10017
(212) 661-5600

CAMERA CLUB OF NEW
 YORK
37 E. 60th St.,
New York, NY 10022
(212) 223-9751

CARLTON GALLERY
127 E. 69th St.,
New York, NY 10021
(212) 288-6270

CASTELLI GRAPHICS
4 E. 77th St.,
New York, NY 10021
(212) 288-3202

CINQUE GALLERY, INC.
36 W. 62nd St.,
New York, NY 10023
(212) 245-6944

CITYANA GALLERY
212 W. 79th St.,
New York, NY 10024
(212) 496-6460

ANDREW CRISPO GALLERY
41 E. 57th St.,
New York, NY 10022
(212) 758-9190

DIANA GALLERY/DIANA
 CUSTOM PRINTS
21 W. 46th St.,
New York, NY 10036
(212) 719-1770

DISCOVERY
 GALLERIES/MODERNAGE
1150 Ave. of the Americas,
New York, NY 10036
(212) 997-1800

EDUCATIONAL ALLIANCE
 PHOTOGRAPHY INSTITUTE
197 E. Broadway,
New York, NY 10002
(212) 475-6200

ELEVENTH ST. PHOTO
 GALLERY
330 E. 11th St.,
New York, NY 10003
(212) 673-2024

EX LIBRIS
160-A E. 70th St.,
New York, NY 10021
(212) 249-2618

FLOATING FOUNDATION OF
 PHOTOGRAPHY
Pier 40 N. River,
New York, NY 10014
(212) 242-3177

FOCAL POINT GALLERY
278 City Island Ave.,
Bronx, NY 10464
(212) 885-1403

FOTO GALLERY
492 Broome St.,
New York, NY 10013
(212) 925-5612

FOURTH ST. PHOTO
 GALLERY
67 E. 4th St.,
New York, NY 10003
(212) 673-1021

ROBERT FREIDUS GALLERY
158 Lafayette St.,

New York, NY 10013
(212) 925-0113

FRENCH CULTURAL
 SERVICES, FRENCH
 EMBASSY
972 Fifth Ave.,
New York, NY 10021
(212) 570-4400

FRENCH INSTITUTE
22 E. 60th St.,
New York, NY 10022
(212) 355-6100

HANSEN GALLERIES
41 E. 57th St.,
New York, NY 10022
(212) 223-0830

HARRIS, O. K.
383 W. Broadway,
New York, NY 10013
(212) 431-3600

FRIEDRICH HEINER, INC.
393 W. Broadway,
New York, NY 10012
(212) 925-9380

HELIOS
18 E. 67th St.,
New York, NY 10021
(212) 988-5593

HORTICULTURAL SOCIETY
 OF NEW YORK
128 W. 58th St.,
New York, NY 10019
(212) 757-0915

IMAGE PHOTOGRAPHIC
 SERVICES, INC.
565 Fifth Ave.,
New York, NY 10017
(212) 867-4747

IMAGES
11 E. 57th St.,
New York, NY 10022
(212) 838-8640

INTERNATIONAL CENTER
 OF PHOTOGRAPHY
1130 Fifth Ave.,
New York, NY 10028
(212) 860-1777

SIDNEY JANIS LTD.
6 W. 57th St.,
New York, NY 10019
(212) 586-0110

JAPAN HOUSE GALLERY
333 E. 47th St.,
New York, NY 10017
(212) 832-1155

JEWISH MUSEUM
1109 Fifth Ave.,

New York, NY 10028
(212) 860-1888

KATA GALLERY
130 Greene St.,
New York, NY 10012
(212) 925-8772

KIMMEL/COHN GALLERY
1 W. 64th St.,
New York, NY 10023
(212) 799-6675

KODAK PHOTO GALLERY
1133 Ave. of the Americas,
New York, NY 10036
(212) 262-6170

JANET LEHR GALLERY
Box 617, Gracie Sq. Sta.,
New York, NY 10028
(212) 288-1802

LIGHT GALLERY
724 Fifth Ave.,
New York, NY 10019
(212) 582-6552

LIGOA DUNCAN "ARTS"
22 E. 72nd St.,
New York, NY 10021
(212) 988-3110

L & L PHOTO SHOP
337 Park Ave. S.,
New York, NY 10010
(212) 677-8290

MARLBOROUGH GALLERY
40 W. 57th St.,
New York, NY 10019
(212) 541-4900

EDWARD MERRIN GALLERY
724 Fifth Ave.,
New York, NY 10019
(212) 257-2884

METROPOLITAN MUSEUM OF
 ART
Fifth Ave. at 82nd St.,
New York, NY 10028
(212) 879-5500

MIDTOWN Y GALLERY
344 E. 14th St.,
New York, NY 10003
(212) 674-7200

MINORITY
 PHOTOGRAPHERS, INC.
Fourth Street Photo Gallery,
67 E. 4th St.,
New York, NY 10003
(212) 673-1021

MODERNAGE GALLERY
319 E. 44th St.,
New York, NY 10017
(212) 532-4050

MUSEUM OF THE CITY OF
 NEW YORK
1220 Fifth Ave.,
New York, NY 10029
(212) 534-1674

MUSEUM OF HOLOGRAPHY
11 Mercer St.,
New York, NY 10013
(212) 925-0526

MUSEUM OF MODERN ART
11 W. 53rd St.,
New York, NY 10019
(212) 956-2696

NATIONAL ARTS CLUB
15 Gramercy Pk. S.,
New York, NY 10003
(212) 475-3424

NEIKRUG GALLERY
224 E. 68th St.,
New York, NY 10021
(212) 288-7741

NEW GALLERY
 EDUCATIONAL ALLIANCE
197 E. Broadway,
New York, NY 10007
(212) 475-6200

NEW-YORK HISTORICAL
 SOCIETY
170 Central Pk. W.,
New York, NY 10013
(212) 873-3400

NEW YORK PUBLIC LIBRARY
Fifth Ave. at 42nd St.,
New York, NY 10017
(212) 661-7220

NIKON HOUSE
620 Fifth Ave.,
New York, NY 10020
(212) 586-3907

NOHO GALLERY
542 LaGuardia Pl.,
New York, NY 10012
(212) 473-9619

LEE NORDNESS GALLERIES
252 W. 38th St.,
New York, NY 10018
(212) 840-0428

PACE UNIVERSITY
Student Gallery Lounge,
41 Park Row,
New York, NY 10038
(212) 285-3000

PARSONS-DREYFUS GALLERY
24 W. 57th St.,
New York, NY 10019
(212) 247-7480

MARCUSE PFEIFER GALLERY
825 Madison Ave.,
New York, NY 10021
(212) 925-3818

A PHOTOGRAPHER'S PLACE
71 Greene St.,
New York, NY 10012
(212) 431-9358

PHOTO WORKS
105 Hudson St.,
New York, NY 10013
(212) 925-3818

POP PHOTO GALLERY
1 Park Ave.,
New York, NY 10016
(212) 725-3785

PRAKAPAS GALLERY
19 E. 71st St.,
New York, NY 10021
(212) 737-6066

JULIAN PRETTO & CO.
150 Spring St.,
New York, NY 10012
(212) 925-7322

RAFFI PHOTO GALLERY
21 W. 46th St.,
New York, NY 10036
(212) 247-5465

DONNA SCHNEIER GALLERY
251 E. 71st St.,
New York, NY 10021
(212) 988-6714

ROBERT SCHOELKOPF
 GALLERY
825 Madison Ave.,
New York, NY 10021
(212) 879-4638

SCHOOL OF VISUAL ARTS
209 E. 23rd St.,
New York, NY 10010
(212) 679-7350

SOHO-AT-PORTOGALLO
72 W. 45th St.,
New York, NY 10036
(212) 840-2636

SOHO PHOTO
15 White St.,
New York, NY 10013
(212) 226-8571

SOHO PHOTO GALLERY
34 W. 13th St.,
New York, NY 10011
(212) 675-9721

SOHO 20
99 Spring St.,
New York, NY 10012
(212) 226-4167

HOLLY SOLOMAN GALLERY
392 W. Broadway,
New York, NY 10014
(212) 925-1900

SONNABEND GALLERY, INC.
420 W. Broadway,
New York, NY 10012
(212) 966-6160

SOTHEBY PARKE BERNET
Photo Dept.,
980 Madison Ave.,
New York, NY 10021
(212) 472-3592

SOUTH ST. SEAPORT
 MUSEUM
203 Front St.,
New York, NY 10038
(212) 766-9020

THE ALFRED STEIGLITZ
 GALLERY
34 W. 13th St.,
New York, NY 10011
(212) 675-9721

STUDIO 505 GALLERY
39 Walker St.,
New York, NY 10013
(212) 431-7748

STUDIO MUSEUM IN
 HARLEM
2033 Fifth Ave.,
New York, NY 10035
(212) 427-5959

TERRAIN GALLERY
141 Greene St.,
New York, NY 10012
(212) 777-4426

THIRD EYE PHOTO GALLERY
17 Seventh Ave. S.,
New York, NY 10011
(212) 691-5897

WARD-NASSE GALLERY
178 Prince St.,
New York, NY 10012
(212) 925-6951

WHITNEY MUSEUM OF
 AMERICAN ART
945 Madison Ave.,
New York, NY 10021
(212) 794-0600

WITKIN GALLERY, INC.
41 E. 57th St.,
New York, NY 10022
(212) 355-1461

DANIEL WOLF, INC.
30 W. 57th St.,
New York, NY 10019
(212) 586-8432

ZABRISKIE GALLERY
29 W. 57th St.,
New York, NY 10019
(212) 832-9034

Northeast

ADDISON GALLERY OF
 AMERICAN ART
Phillips Academy,
Andover, MA 01810
(617) 475-7515

ALDRICH MUSEUM OF
 CONTEMPORARY ART
258 Main St.,
Ridgefield, CT 06877
(203) 438-4519

ALLENTOWN ART MUSEUM
Fifth at Court St.,
P.O. Box 117,
Allentown, PA 18105
(215) 432-4333

ANYART CONTEMPORARY
 ARTS CENTER
5 Steeple St.,
Providence, RI 02903
(401) 861-0830

ARCHTYPE
89 Church St.,
New Haven, CT 06510
(203) 776-9454

BALTIMORE MUSEUM OF
 ART
Art Museum Dr.,
Baltimore, MD 21218
(201) 396-7100

BARNES GALLERIES, LTD.
1 Nassau Blvd. S.,
Garden City, NY 11530
(516) 538-4503

BERKSHIRE MUSEUM
39 South St.,
Pittsfield, MA 01201
(413) 443-7171

BORIS GALLERY OF
 PHOTOGRAPHY
35 Landsdowne St.,
Boston, MA 02215
(617) 261-1152

BOSTON PUBLIC LIBRARY
Copley Sq.,
Boston, MA 02116
(617) 536-5400

BOWDOIN COLLEGE
 MUSEUM OF ART
Walker Art Bldg.,
Brunswick, ME 04011
(207) 725-8731, ext. 275

DIANE BROWN GALLERY
2028 P St. N.W.,
Washington, DC 20036
(202) 296-4022

CAMERA WORK GALLERY
326 Main St.,
Port Washington, NY 11050
(516) 944-6748

CAPE COD ART ASSOCIATION
Box 85,
Barnstable, MA 02630
(617) 362-2909

THE CATSKILL CENTER FOR
 PHOTOGRAPHY
59A Tinker St.,
Woodstock, NY 12498
(914) 679-9957

CHEVY CHASE COLORFAX
 PHOTO GALLERY
5511 Connecticut Ave. N.W.,
Washington, DC 20015
(202) 966-4009

COLORFAX LABS
11961 Tech Rd.,
Silver Spring, MD 20904
(301) 622-1500

REBECCA COOPER GALLERY
2130 P St. N.W.,
Washington, DC 20037
(202) 223-3680

CONNECTICUT AVE.
 COLORFAX PHOTO
 GALLERY
1601 Connecticut Ave. N.W.,
Washington, DC 20009
(202) 797-9035

CORCORAN GALLERY
17th St. at New York Ave. N.W.,
Washington, DC 20006
(202) 638-3211

CREATIVE PHOTOGRAPHY
 GALLERY
Massachusetts Institute of
 Technology
120 Massachusetts Ave.,
Cambridge, MA 02139
(617) 253-4424

DAYTON ART INSTITUTE
Box 941,
Dayton, OH 45402
(513) 223-5277

DELAWARE ART MUSEUM
2301 Kentmere Pkwy.,
Wilmington, DE 19806
(302) 571-9590

DRAKE WELL MUSEUM
R.D. #3,

Titusville, PA 16354
(814) 827-2797

EAST END ARTS GALLERY
133 Main St.,
Riverhead, NY 11901
(516) 727-0900

ENJAY GALLERY
35 Lansdowne St.,
Boston, MA 02215
(617) 262-5725

ERIE ART CENTER
338 W. 6th St.,
Erie, PA 16507
(814) 459-5477

EVERSON MUSEUM OF ART
401 Harrison St.,
Syracuse, NY 13202
(315) 474-6064

KATHLEEN
 EWING-QUINDACQUA LTD.
3614 Ordway St. N.W.,
Washington, DC 20016
(202) 965-3133

FAIRFIELD HISTORICAL
 SOCIETY
636 Old Post Rd.,
Fairfield, CT 06430
(203) 259-1598

FARMINGTON VALLEY ARTS
 CENTER
Box 220, Avon Pk. N.,
Avon, CT 06001
(203) 677-2132

JANET FLEISHER GALLERY
211 S. 17th St.,
Philadelphia, PA 19103
(215) 545-7562

FOCUS POINT
1020 Lancaster Ave.,
Bryn Mawr, PA 19010
(215) 525-4250

FOGG ART MUSEUM
32 Quincy St.,
Cambridge, MA 02138
(617) 495-2387

FRANKLIN INSTITUTE
Benjamin Franklin Pkwy. at 20th
 St.,
Philadelphia, PA
(215) 448-1000

GALLERY ONE
New England School of
 Photography,
537 Commonwealth Ave.,
Boston, MA 02210
(617) 261-1869

GEORGETOWN UNIVERSITY
LIBRARY
Special Collections Division,
37th St. at O St. N.W.,
Washington, DC 20057
(202) 625-4567, (202) 625-4678

LENORE GREY GALLERY
15 Meeting St.,
Providence, RI 02903
(401) 274-3900

HAGLEY MUSEUM
Barley Mill Rd. at Brandywine
Creek,
Wilmington, DE 19807
(302) 658-2401

HALLWALLIS GALLERY/CEPA
30 Essex St.,
Buffalo, NY 14213
(716) 885-2852

HARTFORD JEWISH
COMMUNITY CENTER
335 Bloomfield Ave.,
West Hartford, CT 06117
(203) 236-4571

HOPKINS CENTER ART
GALLERY
Dartmouth College,
Hanover, NH 03755
(802) 646-2422

HUNTINGTON GALLERIES
2033 McCoy Rd., Park Hills,
Huntington, WV 25701
(304) 529-2701

IMAGE COOP
18 Langdon St.,
Montpelier, VT 05602
(802) 229-9712

INSTITUTE OF
CONTEMPORARY ART
955 Boylston St.,
Boston, MA 02115
(617) 266-5152

INTERNATIONAL MUSEUM
OF PHOTOGRAPHY
900 East Ave.,
Rochester, NY 14607
(716) 271-3361

INTUITIVEYE
641 Indiana Ave. N.W.,
Washington, DC 20004
(202) 638-3232

JEB GALLERY
347 Main St.,
Providence, RI 02917
(401) 272-3312

CLARENCE KENNEDY
GALLERY
770 Main St.,

Cambridge, MA 02139
(617) 864-6000, ext. 2177

KIVA GALLERY
231 Newbury St.,
Boston, MA 02116
(617) 266-9160

HARCUS KRAKOW
GALLERY
7 Newbury St.,
Boston, MA 02116
(617) 262-4483

L STREET COLORFAX PHOTO
GALLERY
1523 L St. N.W.,
Washington, DC 20005
(202) 347-6609

LIBRARY OF CONGRESS
PRINTS & PHOTO DIVISION
1st St. S.W.,
Washington, DC 20540
(202) 287-6394

LIGHT IMPRESSIONS
GALLERY
Seneca Terrace, Midtown Plz.,
Rochester, NY 14604
(716) 271-8960

LONDON GALLERY
23rd St. at Fairmont Ave.,
Philadelphia, PA
(215) 978-4545

LUNN GALLERY
3243 P St. N.W.,
Washington, DC 20007
(202) 338-5792

ALLYN LYMAN MUSEUM
100 Mohegan Ave.,
New London, CT 06320
(203) 443-3433

MATTATUCK MUSEUM
119 W. Main St.,
Waterbury, CT 06525
(203) 753-0381

MEMORIAL ART GALLERY
490 University Ave.,
Rochester, NY 14607
(716) 275-3081

MUNSON-WILLIAMS-
PROCTOR INSTITUTE
310 Genesee St.,
Utica, NY 13502
(315) 797-0000

MUSEUM OF ART
Rhode Island School of Design,
244 Benefit St.,
Providence, RI 02903
(401) 331-3511

MUSEUM SHOP
57 Boylston St.,

Cambridge, MA 02116
(617) 661-7210

NATIONAL PORTRAIT
GALLERY
8th St. at F St. N.W.,
Washington, DC
(202) 628-4422

NATURE CENTER
10 Woodside Ln.,
Westport, CT 06880
(203) 227-7253

NEGATIVE GALLERY
19 Walnut St.,
West Chester, PA 19013
(215) 353-4547

NEW ENGLAND FOTO
CENTER
100 Sycamore St.,
Glastonbury, CT 06033
(203) 633-3926

NEW JERSEY STATE
MUSEUM
205 W. State St.,
Trenton, NJ 08625
(609) 292-6300

NEWTON FREE LIBRARY
414 Centre St.,
Newton, MA 02158
(617) 552-7145

NORTH COUNTRY PHOTO
Box 868, Main St.,
N. Conway, NH 03860
(603) 356-5018

THE OCTAGON HOUSE
American Institute of Architects
Foundation,
1799 New York Ave. N.W.,
Washington, DC 20006
(202) 638-3105

PANOPTICON, INC.
187 Bay State Rd.,
Boston, MA 02215
(617) 267-2961

PERCEPTION GALLERIES
71 Buckram Rd.,
Locust Valley, NY 11560
(516) 676-2792

PHILADELPHIA ALLIANCE
251 S. 18th St.,
Philadelphia, PA 19103
(215) 545-4302

PHILADELPHIA MUSEUM OF
ART
26th St. at B. Franklin Pkwy.,
Philadelphia, PA 19101
(215) 763-8100

THE PHOTIC GALLERY
Maryland Institute College of Art,

1300 Mt. Royal,
Baltimore, MD 21217
(301) 669-9200

PHOTO GARDEN GALLERY
115 S. Winooski Ave.,
Burlington, VT 05401
(802) 863-1256

PHOTO GRAPHICS
WORKSHOP
212 Elm St.,
New Canaan, CT 06840
(203) 966-8711

THE PHOTOGRAPHIC EYE,
INC.
5 Boylston St.,
Boston, MA 02116
(617) 661-2950

PHOTOGRAPHY PLACE
132 S. 17th St.,
Philadelphia, PA 19103
(215) 563-6381

PHOTOPIA
1728 Spruce St.,
Philadelphia, PA 19103
(215) 546-5266

PHOTOWORKS
755 Boylston St.,
Boston, MA 02116
(617) 267-1138

PITTSBURGH FILM MAKERS'
GALLERY
P.O. Box 7200,
Pittsburgh, PA 15213
(412) 681-5449

POLAROID GALLERY
549 Technology Sq.,
Cambridge, MA 02139
(617) 577-2000

PORTLAND MUSEUM OF ART
111 High St.,
Portland, ME 04101
(207) 774-4058

PORT WASHINGTON PUBLIC
LIBRARY
245 Main St.,
Port Washington, NY 11050
(516) 883-4400

PRINT CLUB
1614 Latimer St.,
Philadelphia, PA 19103
(215) 735-6090

PROJECT
141 Huron St.,
Cambridge, MA 02138
(617) 491-0187

PROSPECT STREET GALLERY
188 Prospect St.,

Cambridge, MA 02139
(617) 354-8299

PROVIDENCE PUBLIC
LIBRARY
150 Empire St.,
Providence, RI 02903
(401) 521-7722

WILLIAM RIS GALLERIES
2208 Market St.,
Camp Hill, PA 17011
(717) 737-8818

ROCHESTER INST. OF
TECHNOLOGY PHOTO
GALLERY
1 Lomb Memorial Dr.,
Rochester, NY 14623
(716) 475-2716

ROSE, STEPHEN T.
23 Miner St.,
Boston, MA 02215
(617) 267-1758

SANDER GALLERY
2604 Connecticut Ave.,
Washington, DC 20008
(202) 797-7307

SEA CLIFF PHOTOGRAPH CO.
310 Sea Cliff,
Sea Cliff, NY 11579
(516) 671-6070

SHARADIN ART GALLERY
Kutztown State College,
Kutztown, PA 19530
(215) 683-3511

SHY PHOTOGRAPHER
100 Dorset St.,
South Burlington, VT 05401
(802) 863-6910

SIEMBAB GALLERY
162 Newbury St.,
Boston, MA 02116
(617) 262-0146

SMITH-MASON GALLERY
1207 Rhode Island Ave. N.W.,
Washington, DC 20005
(202) 462-6323

SMITHSONIAN INSTITUTION
1000 Jefferson Dr. S.W.,
Washington, DC 20560
(202) 357-1300

SOHO PHOTO GALLERY
162 N. 3rd St.,
Philadelphia, PA 19106
(215) 925-2324

TEMPLE BAR BOOKSHOP
9 Boylston St.,
Cambridge, MA 02138
(617) 354-8299

UNIVERSITY OF MAINE ART
GALLERY
Carnegie Hall,
Orono, ME 04469
(207) 581-7165

VISION
216 Newbury St.,
Boston, MA 02116
(617) 266-9481

VISUAL STUDIES WORKSHOP
31 Prince St.,
Rochester, NY 14607
(716) 442-8676

THE WASHINGTON
GALLERY OF
PHOTOGRAPHY AND YOUR
LAB
216 7th St. S.E.,
Washington, DC 20003
(202) 544-1274

WORCESTER ART MUSEUM
65 Salisbury St.,
Worcester, MA 01609
(617) 799-4406

YALE UNIVERSITY ART
GALLERY
1111 Chapel St.,
New Haven, CT 06510
(203) 432-4055

South

AFTERIMAGE
The Quadrangle,
2800 South Blvd.,
Dallas, TX 75215
(214) 748-2521

ALLEN ST. GALLERY
2817 Allen St.,
Dallas, TX 75204
(214) 742-5207

AMARILLO ART CENTER
2200 S. Van Buren,
Amarillo, TX 79109
(806) 372-8356

ART CENTER
100 7th St.,
St. Petersburg, FL 33701
(813) 822-7872

THE ART CENTER
Box 5396,
Waco, TX 76708
(817) 752-4371

ATLANTA GALLERY OF
PHOTOGRAPHY
3077 E. Shadowlawn Ave. N.E.,
Atlanta, GA 30305
(404) 233-1462

BEAUX ARTS GALLERY
7711 60th St. N.,
Pinellas Park, FL 33565
(813) 544-7087

JAY R. BROUSSARD
MEMORIAL GALLERIES
Louisiana State Department of Art,
Old State Capitol,
North Blvd. at St. Philip St.,
Baton Rouge, LA 70801
(504) 389-5086

AMON CARTER MUSEUM
3501 Camp Bowie,
Ft. Worth, TX 76107
(817) 738-1933

THE CENTER FOR
PHOTOGRAPHIC STUDIES
772 Main St.,
Louisville, KY 40202
(502) 583-5170

CENTER FOR VISUAL
COMMUNICATIONS
2817 Allen St.,
Dallas, TX 75204
(214) 742-5207

CONTEMPORARY ART
CENTER
9000 Camp St.,
New Orleans, LA 70118
(504) 523-1216

CRONIN GALLERY
2008 Peden,
Houston, TX 77019
(713) 526-2548

DALLAS PUBLIC LIBRARY
1954 Commerce,
Dallas, TX 75201
(214) 748-9071

THE DARKROOM
4228 Duval,
Austin, TX 78751
(512) 454-4036

DEL RIO, SOL
1020 Townsend,
San Antonio, TX 78209
(512) 828-5555

DW CO-OP GALLERY
3305 McKinney,
Dallas, TX 75204
(214) 526-3240

STEPHEN FERRIS GALLERY
2417 West End Ave.,
Nashville, TN 37203
(615) 327-2418

FINE ARTS MUSEUM OF THE
SOUTH
P.O. Box 8426, Museum Dr.,
Mobile, AL 36608
(205) 343-2667

FLORIDA CENTER FOR THE
ARTS
University of South Florida,
4202 E. Fowler Ave.,
Tampa, FL 33620
(813) 974-2271

FRONT ST. GALLERY
130 S. Front St.,
Wilmington, NC 28401
(919) 763-3835

FULLER AND D'ALBERT
GALLERY
3170 Campbell Dr.,
Fairfax, VA 22031
(804) 649-7111

GALLERY FOR FINE
PHOTOGRAPHY
5432 Magazine St.,
New Orleans, LA 70115
(504) 891-1002

GALLERY 25
620½ W. 4th St.,
Winston-Salem, NC 27101
(704) 768-9571

GOETHE INSTITUTE
400 Colony Sq. N.E.,
Atlanta, GA 30309
(404) 892-2388

HUNTER MUSEUM OF ART
10 Bluff View,
Chattanooga, TN 37403
(615) 267-0968

IMAGE OF SARASOTA
1323 Main St.,
Sarasota, FL 33577
(813) 366-5097

IRIS PHOTOGRAPHIC
PRINTWORKS
15 W. Walnut St.,
Asheville, NC 28801
(704) 254-6103

JACKSONVILLE ART
MUSEUM
4160 Boulevard Ctr.,
Jacksonville, FL 32207
(904) 398-8336

LIGHT FACTORY
110 E. 7th St.,
Charlotte, NC 28202
(704) 333-9755

MENIL FOUNDATION INC.
3363 San Felipe Rd.,
Houston, TX 77019
(713) 622-5651

THE MUSEUM OF FINE ARTS
1001 Bissonnet St., Box 6826,
Houston, TX 77005
(713) 526-1361

MUSEUM OF FINE ARTS
255 Beach Dr. N.,
St. Petersburg, FL 33701
(813) 896-2667

NEW ORLEANS MUSEUM OF
ART
P.O. Box 19123, City Pk.,
New Orleans, LA 70119
(504) 488-2631

NEXUS
608 Forrest Rd. N.E.,
Atlanta, GA 30312
(404) 233-1462

OATES GALLERY
97 N. Tillman,
Memphis, TN 38111
(901) 323-5659

PHOTOGRAPHIC ARCHIVES
University of Louisville,
University Library, Belknap
Campus,
Louisville, KY 40206
(502) 636-4916

PHOTOGRAPHIC GALLERY
Middle Tennessee State University,
Box 305,
Murfreesboro, TN 37130
(615) 898-2491

POLK PUBLIC MUSEUM
800 Palmetto,
Lakeland, FL 33801
(813) 688-7743

ROSSLYN PLAZA COLORFAX
PHOTO GALLERY
1611 N. Kent St.,
Arlington, VA 22209
(703) 527-8336

SOHO PHOTO GALLERY
134 Exchange Pl.,
New Orleans, LA 70130
(504) 891-8578

THE PHOTOGRAPHER'S
GALLERY
1554 Periwinkle Wy.,
Sanibel Island, FL 33597
(813) 472-5777

TRINITY HOUSE
607 Trinity,
Austin, TX 78701
(512) 747-9904

UNIVERSITY ART GALLERY
University of Alabama,
Tuscaloosa, AL 35401
(205) 348-5967

VALENTINE MUSEUM
1015 E. Clay St.,
Richmond, VA 23219
(804) 649-7111

Midwest

DUDLEY PETER ALLEN
MEMORIAL ART MUSEUM
Oberlin College,
Oberlin, OH 44074
(216) 775-8665

THE ANTIQUE CAMERA
MUSEUM
1065 Jer Les Dr.,
Milford, OH 45150
(513) 831-0915

ARC GALLERY
6 W. Hubbard St.,
Chicago, IL 60610
(312) 266-7607

ART INSTITUTE OF
CHICAGO
Michigan Ave. at Adams St.,
Chicago, IL 60603
(312) 443-3600

ARTEMISTA GALLERY
9 W. Hubbard St.,
Chicago, IL 60610
(312) 751-2016

JACQUES BARUCH GALLERY
900 N. Michigan Ave.,
Chicago, IL 60611
(312) 944-3377

BATTLE CREEK CIVIC ART
CENTER
265 Emmett St.,
Battle Creek, MI 49017
(616) 963-7385

BLANDEN ART GALLERY
920 Third Ave. S.,
Ft. Dodge, IA 50501
(515) 573-2316

BLIXT GALLERY
229 Nickels Arcade,
Ann Arbor, MI 48104
(313) 662-0282

BUTLER INSTITUTE OF
AMERICAN ART
524 Wick Ave.,
Youngstown, OH 44502
(216) 743-1711

CINCINNATI ART MUSEUM
Eden Pk.,
Cincinnati, OH 45202
(513) 721-5204

THE CLEVELAND MUSEUM
OF ART
11150 East Blvd.,
Cleveland, OH 44106
(216) 421-7340

COLUMBIA GALLERY OF
PHOTOGRAPHY
1015 E. Broadway,
Columbia, MO 65201
(314) 443-0504

C101 GALLERY
415 W. 45th Ave.,
Gary, IN 46408
(219) 887-5251

DARKROOM
2424 N. Racine Ave.,
Chicago, IL 60614
(312) 248-8861

DES MOINES ART CENTER
Greenwood,
Des Moines, IA 52803
(515) 277-4405

DETROIT INSTITUTE OF
ARTS
5200 Woodward Ave.,
Detroit, MI 48226
(313) 833-7914

ELOQUENT LIGHT
419 Main St.,
Rochester, MI 40863
(313) 652-4686

F STOP OF ST. LOUIS
PHOTOGRAPHY GALLERY
522 S. Hanley Rd.,
Clayton, MO 63105
(314) 726-6202

FIELD MUSEUM OF
NATURAL HISTORY
Roosevelt Rd. at Lake Shore Dr.,
Chicago, IL 60605
(312) 922-9410

FILM IN THE CITIES
2388 University Ave.,
St. Paul, MN 55103
(612) 646-6104

ALLAN FRUMPKIN GALLERY
620 N. Michigan Ave.,
Chicago, IL 60611
(312) 787-0563

GALLERY 614
614 W. Berry St.,
Ft. Wayne, IN 46802
(219) 422-6203

GREENBERG GALLERY
7526 Forsyth Blvd.,
St. Louis, MO 63105
(314) 361-7600

HALSTED GALLERY
560 N. Woodward,
Birmingham, MI 48011
(313) 644-8284

HAYES GALLERY
2520 E. Capitol Dr.,
Milwaukee, WI 53211
(414) 962-8660

HONEYWELL MEMORIAL
COMMUNITY CENTER
275 W. Market St.,
Wabash, IN 46992
(219) 563-1102

J. HUNT GALLERIES
3011 E. 25th St.,
Minneapolis, MN 55406
(612) 721-3146

INDIANAPOLIS MUSEUM OF
ART
1200 W. 38th St.,
Indianapolis, IN 46208
(317) 923-1331

INFINITE EYE GALLERY
207 E. Buffalo St.,
Milwaukee, WI 53202
(414) 963-9440

JOSLYN ART MUSEUM
2200 Dodge St.,
Omaha, NB 68102
(402) 342-3300

KALAMAZOO INSTITUTE OF
THE ARTS
314 S. Park St.,
Kalamazoo, MI 49007
(616) 349-7775

CHARLOTTE CROSBY
KEMPER GALLERY
Kansas City Art Institute,
4415 Warwick Blvd.,
Kansas City, MO 64111
(816) 561-4852

DOUGLAS KENYON
GALLERY
155 E. Ohio,
Chicago, IL 60611
(312) 642-5300

KOEHNLINE GALLERY
Oakton Community College,
7900 Nagle,
Morton Grove, IL 60053
(312) 967-5120

PETER J. KONDOS ART
GALLERIES
2233 N. Prospect Ave.,
Milwaukee, WI 53202
(414) 278-8000

MADISON ART CENTER
720 E. Gorham,
Madison, WI 53703
(608) 257-0158

MASTER SLIDE, INC.
118 E. Lockwood Ave.,
Webster Groves, MO 63119
(314) 961-4463

MILWAUKEE ART CENTER
GALLERY OF
PHOTOGRAPHY
750 N. Lincoln Memorial Dr.,
Milwaukee, WI 53202
(414) 271-9508

MILWAUKEE CENTER FOR
PHOTOGRAPHY
207 E. Buffalo St.,
Milwaukee, WI 53202
(414) 273-5016

MUSEUM GALLERY
Western Illinois University,
Macomb, IL 61455
(309) 298-1355

MUSEUM OF ART
University of Kansas,
Lawrence, KS 66045
(913) 864-4710

MUSEUM OF
CONTEMPORARY ART
237 E. Ontario St.,
Chicago, IL 60611
(312) 280-2660

PALLAS PHOTOGRAPHICA
315 W. Erie St.,
Chicago, IL 60610
(312) 664-1257

PHOTOGENESIS, INC.
4930 N. High St.,
Columbus, OH 43214
(614) 436-1400

PHOTOGRAPHY GALLERY OF
EVANSTON ART CENTER
2603 Sheridan Rd.,
Evanston, IL 60436
(312) 475-5300

SILVER IMAGE GALLERY
Ohio State University,
Dept. of Photography and Cinema,
206 Haskett Hall,
156 W. 19th Ave.,
Columbus, OH 43210
(614) 422-5957, (614) 422-1766

SIOUX CITY ART CENTER
513 Nebraska St.,
Sioux City, IA 51101
(712) 279-6272

SOUTH SIDE COMMUNITY
ART CENTER
3831 S. Michigan Ave.,

Chicago, IL 60653
(312) 373-8666

UNIVERSITY MUSEUM
AND ART GALLERIES
Southern Illinois University,
Carbondale, IL 62901
(618) 453-3493

VANDERPOOL GALLERY
2153 W. 11th St.,
Chicago, IL 60607
(312) 445-3838

WALKER ART CENTER
Vineland Pl.,
Minneapolis, MN 55403
(612) 377-7500

WRIGLEY GALLERY
Chicago Historical Society,
N. Clark at W. North Ave.,
Chicago, IL 60610
(312) 642-4600

West

ACE GALLERY
185 Windward,
Venice, CA 90291
(213) 392-4931

ALPHA PHOTO GALLERY
560 20th St.,
Oakland, CA 94612
(415) 893-1436

ANCHORAGE HISTORICAL
AND FINE ARTS MUSEUM
121 W. Seventh Ave.,
Anchorage, AK 99501
(907) 274-2525, ext. 326

AMEKA
1507 G St.,
Arcata, CA 95221
(707) 822-9564

ANHALT BARNES GALLERY
750 N. La Cienega,
Los Angeles, CA 90034
(213) 488-0038

ANNEX PHOTOGRAPHY
GALLERY
604 College Ave.,
Santa Rosa, CA 95401
(707) 564-7352

THE ANSEL ADAMS
GALLERY
Box 455,
Yosemite National Pk., CA 95389
(209) 372-4413

ARCO CENTER FOR VISUAL
ARTS
515 S. Flower St.,
Los Angeles, CA 90071
(213) 488-0038

ART SPACE
10550 Santa Monica Blvd.,
Los Angeles, CA 90025
(213) 474-9813

ARTWORKS
66 Windward Ave.,
Venice, CA 90291
(213) 392-4203

ASHER/FAURE GALLERY
8221 Santa Monica Blvd.,
Los Angeles, CA 90046
(213) 654-6214

BANK OF AMERICA WORLD
HQ. GALLERIES
555 California St.,
San Francisco, CA 94104
(415) 391-1697

MOLLY BARNES GALLERY
750 N. La Cienega Blvd.,
Los Angeles, CA 90034
(213) 657-4038

JAN BAUM/IRIS SILVERMAN
GALLERY
8225 Santa Monica Blvd.,
Los Angeles, CA 90046
(213) 656-8225

BAXTER ART GALLERY
California Institute of Technology,
Pasadena, CA 91125
(213) 795-6811, ext. 1371

BELMAR MUSEUM
797 S. Wadsworth Blvd.,
Lakewood, CO 80226
(303) 234-8778

AL BELSON GALLERY
Newport School of Photography,
3720 Canoys Dr.,
Newport Beach, CA 92660
(714) 557-1126

JOHN BERGGRUEN GALLERY
228 Grant Ave.,
San Francisco, CA 94108
(415) 781-4629

BOLLEN GALLERY
2910 Main St.,
Venice, CA 90291
(213) 399-3977

KAY BONFOEY GALLERY
1157 S. Swan Rd.,
Tucson, AZ 85711
(602) 748-1173

BRAND LIBRARY AND ART
 CENTER
1601 W. Mountain St.,
Glendale, CA 91201
(213) 956-2015

BRICS GALLERIES
818 W. 7th St.,
Los Angeles, CA 90017
(213) 626-2254

BROCKMAN GALLERY
 PRODUCTIONS
4334 Degnan Blvd.,
Los Angeles, CA 90008
(213) 294-3766, (213) 294-5201

BULL'S EYE GALLERY
153 Picnic St.,
San Rafael, CA 94901
(415) 454-4209

CALIFORNIA ACADEMY OF
 SCIENCES
Golden Gate Pk.,
San Francisco, CA 94115
(415) 221-5100

CALIFORNIA HISTORICAL
 SOCIETY
1120 Old Mill Rd.,
San Marino, CA 91108
(213) 449-5450

CALIFORNIA HISTORICAL
 SOCIETY
2090 Jackson St.,
San Francisco, CA 94109
(415) 567-1848

CALIFORNIA INSTITUTE OF
 THE ARTS
24700 W. McBean Pkwy.,
Valencia, CA 91355
(805) 255-1050

CALIFORNIA STATE MUSEUM
 OF SCIENCE & INDUSTRY
700 State Dr.,
Exposition Pk.,
Los Angeles, CA 90037
(213) 749-0101, ext. 235

CAMERAVISION
4121 Wilshire Blvd.,
Los Angeles, CA 90010
(213) 380-4266

CAMERAWORK GALLERY
898 Folsom,
San Francisco, CA 94107
(415) 777-3353

CAMERA WORK GALLERY
104 El Paseo de Saratoga,
San Jose, CA 95113
(408) 379-9890

CAMERA WORK/SOHO
 PHOTO
8221 Santa Monica Blvd.,

Los Angeles, CA 90046
(213) 656-9960

CANON HOUSE GALLERY
776 Market St.,
San Francisco, CA 94102
(415) 433-5640

CARTER-SARKIN GALLERY
540 N. San Vicente Blvd.,
Los Angeles, CA 90048
(213) 657-4652

CENTER FOR CREATIVE
 PHOTOGRAPHY
University of Arizona,
843 E. University Blvd.,
Tucson, AZ 85719
(602) 626-4636

CENTER FOR THE ARTS
6525 Sunset Blvd.,
Los Angeles, CA 90028
(213) 476-9777

CIRRUS GALLERY
708 N. Manhattan Pl.,
Los Angeles, CA 90038
(213) 462-1157

CITYSCAPE PHOTO GALLERY
97 E. Colorado Blvd.,
Pasadena, CA 91105
(213) 796-2036

THE COBBLESTONE
 GALLERY
3908 E. 4th St.,
Long Beach, CA 90814
(213) 438-3424

THE COLLECTOR'S GALLERY
311B Forest Ave.,
Pacific Grove, CA 93950
(408) 649-8717

COLORADO PHOTOGRAPHIC
 ARTS CENTER
1301 Bannock St.,
Denver, CO 80204
(303) 572-9996

COLORS OF THE WIND
2900 Main St.,
Venice, CA 90291
(213) 399-2080

JAMES CORCORAN GALLERY
8223 Santa Monica Blvd.,
Los Angeles, CA 90046
(213) 656-0662

CRAFT AND FOLK ART
 MUSEUM
5814 Wilshire Blvd.,
Los Angeles, CA 90036
(213) 937-5544

DARKROOM
 WORKSHOP/GALLERY
2051 San Pablo Ave.,

Berkeley, CA 94702
(415) 849-1000

DAVIDSON GALLERY
8113 Melrose Ave.,
Los Angeles, CA 90046
(213) 653-6157

DENVER ART MUSEUM
100 W. 14th Ave.,
Denver, CO 80204
(303) 297-2793

KIRK DE GOOYER GALLERY
830 S. Central,
Los Angeles, CA 90021
(213) 623-8333

M. H. DE YOUNG MUSEUM
Golden Gate Pk.,
San Francisco, CA 94115
(415) 752-5561

DIABLO VALLEY COLLEGE
 ART GALLERY
Diablo Valley College,
Golf Club Rd.,
Pleasant Hills, CA 94523
(415) 685-1230

DREAM MASTERS GALLERY
6399 Wilshire Blvd.,
Los Angeles, CA 90048
(213) 933-7726

DUNAWAY/O'NEILL
 GALLERY
2716 Main St.,
Santa Monica, CA 90405
(213) 392-8445

ECLIPSE GALLERY
2012 10th St.,
Boulder, CO 80302
(303) 443-9790

EDISON STREET GALLERY
231 Edison St.,
Salt Lake City, UT 84111
(801) 359-7703

80 LANGTON STREET
80 Langton St.,
San Francisco, CA 94103
(415) 626-5416

DOUGLAS ELLIOTT INC.
1151 Mission St.,
San Francisco, CA 94103
(415) 621-2107

EQUIVALENTS
1822 Broadway,
Seattle, WA 98122
(203) 322-7765

ROSAMUND FELSEN
 GALLERY
669 N. La Cienega Blvd.,
Los Angeles, CA 90034
(213) 652-9172

FIFTH AVE. GALLERY OF
 PHOTOGRAPHY
6960 Fifth Ave.,
Scottsdale, AZ 85251
(602) 941-0738

FINE ARTS GALLERY
Long Beach City College,
4901 E. Carson St.,
Long Beach, CA 90808
(213) 420-4317

FOCUS GALLERY
2146 Union St.,
San Francisco, CA 94123
(415) 921-1565

FOOLS RUSH IN
8470 Melrose Ave.,
Los Angeles, CA 90069
(213) 653-8420

FOWLER MILLS GALLERIES
210 Pier Ave.,
Santa Monica, CA 90405
(213) 392-3313

FRAEKEL GALLERY
55 Grant Ave.,
San Francisco, CA 94108
(415) 981-2661

FRESNO ARTS CENTER
3033 E. Yale Ave.,
Fresno, CA 92631
(209) 237-2070

FRIENDS OF PHOTOGRAPHY
P.O. Box 239,
Carmel, CA 93922
(408) 624-6330

GALLERIE
1051 Westwood Blvd.,
Los Angeles, CA 90024
(213) 477-5085

GALLERY F22
338 Camino del Monte Sol,
Santa Fe, NM 87501
(505) 982-9034

GALLERY HOUSE
538 Ramona St.,
Palo Alto, CA 94301
(415) 326-1668

GEL GEMINI
8365 Melrose Ave.,
Los Angeles, CA 90069
(213) 651-0513

J. PAUL GETTY MUSEUM
17985 Pacific Coast Hwy.,
Malibu, CA 90265
(213) 459-2306

GRAPESTAKE GALLERY
2876 California St.,

San Francisco, CA 94115
(415) 931-0779

GROSVENOR TOWERS
 GALLERY
1177 California St.,
San Francisco, CA 94108
(415) 441-1661

GUZARTZ GALLERY
1601 W. Washington Blvd.,
Venice, CA 90291
(213) 396-2579

HANSEN-FULLER GALLERY
228 Grant Ave.,
San Francisco, CA 94108
(415) 982-6177

HAWKINS, G. RAY
9002 Melrose Ave.,
Los Angeles, CA 90069
(213) 550-1504

HOT FLASH OF AMERICA
2351 Market St.,
San Francisco, CA 94114
(415) 625-4800

JANUS GALLERY
7549 Melrose Ave.,
Los Angeles, CA 90046
(213) 399-9122

JOLLY WALL GALLERY
7549 Melrose Ave.,
Los Angeles, CA 90046
(213) 852-1240

KRESS-MAGGIE GALLERY
Guadalupe Plz.,
Taos, NM 87571
(505) 758-9514

KROMA
2700 Pacific Ave.,
Venice, CA 90291
(213) 822-3320

LACE GALLERY
240 S. Broadway,
Los Angeles, CA 90012
(213) 620-0104

LAWSON/DE CELLE
 GALLERY
54 Kissling St.,
San Francisco, CA 94103
(415) 626-1159

MARGO LEAVIN GALLERY
812 N. Robertson Blvd.,
Los Angeles, CA 90069
(213) 273-0603

LIVING ROOM GALLERY
12240 Sherman Wy.,
Studio City, CA 91605
(213) 875-0950

LONG BEACH MUSEUM OF
 ART
2300 E. Ocean Blvd.,
Long Beach, CA 90803
(213) 439-2119

LOS ANGELES
 CONTEMPORARY
 EXHIBITIONS
240 S. Broadway, 3rd Fl.,
Los Angeles, CA 90012
(213) 620-0104

LOS ANGELES COUNTY
 MUSEUM OF ART
5905 Wilshire Blvd.,
Los Angeles, CA 90036
(213) 937-4250

LOS ANGELES INSTITUTE
 FOR CONTEMPORARY ART
2020 S. Robertson Blvd.,
Los Angeles, CA 90034
(213) 559-5033

LOS ANGELES
 PHOTOGRAPHY CENTER
412 S. Parkview St.,
Los Angeles, CA 90057
(213) 383-7342

LOUVER ART GALLERY
55 N. Venice Blvd.,
Venice, CA 90291
(213) 396-6633

LOWINSKY AND ARAI
542 S. Alameda St.,
Los Angeles, CA 90013
(213) 687-8943

LOYOLA MARYMOUNT
 UNIVERSITY ART GALLERY
Loyola Blvd. at W. 8th St.,
Los Angeles, CA 90045
(213) 642-2880

MALIBU ART AND DESIGN
3900 Cross Creek Rd.,
Malibu, CA 90265
(213) 456-1776

MAIN STREET GALLERY
2803 Main St.,
Venice, CA 90291
(213) 399-9122

MIZUNO
210 E. 2nd St.,
Los Angeles, CA 90012
(213) 625-2491

MENDOCINO COUNTY
 MUSEUM
400 Commercial,
Willits, CA 95490
(707) 459-2736

MIRAGE GALLERY
1662 12th St.,

Santa Monica, CA 90404
(213) 459-3017

MOODY GALLERY
899 E. Green St.,
Pasadena, CA 91106
(213) 793-6191

MONTEREY PENINSULA
MUSEUM OF ART
559 S. Pacific St.,
Monterey, CA 93940
(408) 372-5477

MOUNT ST. MARY'S COLLEGE
ART GALLERY
12001 Chalon Rd.,
Los Angeles, CA 90049
(213) 476-2237

MUCKENTHALER CULTURAL
CENTER
1201 W. Malvern Ave.,
Fullerton, CA 92633
(714) 738-6595

MUNICIPAL ART GALLERY
Barnsdall Pk.,
4804 Hollywood Blvd.,
Hollywood, CA 90027
(213) 660-2200

MUSEUM OF ART
Stanford University,
Museum Wy. at Lomita,
Stanford, CA 94305
(415) 497-4177

MUSEUM OF FINE ARTS
Northside Plz.,
Santa Fe, NM 87502
(505) 827-2351

MUSEUM OF FINE ARTS
Museum of New Mexico,
Box 2087,
Santa Fe, NM 87502
(505) 827-2440

MUSEUM MOUNT GALLERY
1731 S. La Cienega,
Los Angeles, CA 90035
(213) 240-3994

NEWPORT HARBOR ART
MUSEUM
850 San Clemente Dr.,
Newport Beach, CA 92660
(714) 759-1122

NEWSPACE
5241 Melrose Ave.,
Los Angeles, CA 90038
(213) 469-9353

NORTHLIGHT GALLERY
Arizona State University,
Fine Arts Annex,
University Dr. at College Ave.,

Tempe, AZ 85281
(602) 965-6517

OAKLAND MUSEUM ART
DEPARTMENT
1000 Oak St.,
Oakland, CA 94607
(415) 834-2413

ORANGE COAST COLLEGE
Fine Arts Bldg.,
 Photography Gallery,
2701 Fairview Rd.,
Costa Mesa, CA 92626
(714) 556-5844

OREGON PHOTOGRAPHY
WORKSHOPS
3241 Donald St.,
Eugene, OR 97405
(503) 345-4606

OREGON HISTORICAL
SOCIETY
1230 S.W. Park Ave.,
Portland, OR 97205
(503) 222-1741

ORLANDO GALLERY
17037 Ventura Blvd.,
Encino, CA 91436
(213) 789-6012

THE OTIS ART INSTITUTE
OF PARSONS SCHOOL OF
DESIGN ART GALLERY
2401 Wilshire Blvd.,
Los Angeles, CA 90057
(213) 387-5288

NEIL G. OVSEY GALLERY
13814 Ventura Blvd., 2nd Fl.,
Sherman Oaks, CA 91423
(213) 788-5382

PHOENIX
257 Grant Ave.,
San Francisco, CA 94108
(415) 982-2171

PHOENIX ART MUSEUM
165 N. Central Ave.,
Phoenix, AZ 85004
(602) 257-1222

THE PHOTO ALBUM
GALLERY
835 N. La Cienega Blvd.,
Los Angeles, CA 90069
(213) 657-6995

PHOTOCOPIA
403 W. Holly St.,
Bellingham, WA 98225
(206) 734-6107

PHOTODECOR, INC.
336 N. Foothill Rd., #1,
Beverly Hills, CA 90201
(213) 278-7238

PHOTOGRAPHIC ARCHIVES
Museum of New Mexico,
Box 2087,
Santa Fe, NM 87502
(505) 827-2559

PHOTOGRAPHY GALLERY
100 W. 14th Ave.,
Denver, CO 80204
(303) 575-2036

PHOTO SUITE 175
Metropolitan State College,
Denver, CO 80204
(303) 629-2400

PHOTO-SYNTHESIS
64 Shaw Rd.,
Clovis, CA 93612
(209) 298-7527

PORTLAND ART MUSEUM
S.W. Park Ave. at Madison,
Portland, OR 97205
(503) 226-2811

PORTLAND CENTER FOR
THE VISUAL ARTS
117 N.W. Fifth Ave.,
Portland, OR 97209
(503) 222-7107

THE PRINTWORKS
1769 E. 4th St.,
Long Beach, CA 90802
(213) 436-4123

QUIVIRA BOOKSHOP AND
GALLERY
111 Cornell Dr. S.E.,
Albuquerque, NM 87106
(505) 266-1788

REESE/PALLEY, INC.
Sir Francis Drake Hotel,
550 Sutter St.,
San Francisco, CA 94102
(415) 433-0818

SALT LAKE ART CENTER
20 S. West Temple,
Salt Lake City, UT 84101
(801) 328-4201

GEORGE SAND GALLERY
9011 Melrose Ave.,
Los Angeles, CA 90069
(213) 858-1648

SAN FRANCISCO
CAMERAWORK
79 12th St.,
San Francisco, CA 94103
(415) 621-1001

SAN FRANCISCO
DAGUERREAN GALLERY
3382 18th St.,
San Francisco, CA 94110
(415) 864-5966

SAN FRANCISCO MUSEUM OF
 MODERN ART
Van Ness Ave.,
San Francisco, CA 94102
(415) 863-8800

SAN JACINTO
 PHOTOGRAPHIC AND
 PRINTING EQUIPMENT
 MUSEUM
147 N. Franklin Ave.,
Hemet, CA 92343
(714) 925-5070

SANTA BARBARA MUSEUM
 OF ART
1130 State St.,
Santa Barbara, CA 93101
(805) 963-4364

SANTA BARBARA
 PHOTOGRAPHY GALLERY
1118 State St.,
Santa Barbara, CA 93101
(805) 969-3153

SEATTLE ART MUSEUM
Volunteer Pk.,
Seattle, WA 98104
(206) 572-4710

SECRET CITY GALLERY
306 Fourth Ave.,
San Francisco, CA 94107
(415) 752-5251

SHADOW GALLERY
621 Main St.,
Oregon City, OR 97045
(503) 222-1741

SILVER IMAGE GALLERY
92 S. Washington St.,
Seattle, WA 98104
(206) 623-8116

SILVER PALM
1356 W. Washington Blvd.,
Venice, CA 90291
(213) 822-3683

SILVER SUNBEAM
3409 Central N.E.,
Albuquerque, NM 87102
(505) 256-7103, (505) 256-3409

NORTON SIMON MUSEUM
411 W. Colorado Blvd.,
Pasadena, CA 91105
(213) 449-3730

SMITH/ANDERSON GALLERY
200 Homer Ave.,
Palo Alto, CA 94301
(415) 327-7762

SMITH, NEAL R.
734 17th St.,
Denver, CO 80204
(303) 825-4150

SOCIAL SECURITY GALLERY
549 Northgate Dr., Box 6279,
San Rafael, CA 94903
(415) 454-4209

SOHO CAMERAWORKS
 GALLERY
8221 Santa Monica Blvd.,
Los Angeles, CA 90046
(213) 656-9960

SPACE, BC.
235 Forest Ave.,
Laguna Beach, CA 92651
(714) 497-1880

SPACE GALLERY
6015 Santa Monica Blvd.,
Los Angeles, CA 90038
(213) 461-8199

SPARK
685 Venice Blvd.,
Venice, CA 90291
(213) 822-9560

SPIRTUS, SUSAN
3336 Via Lido,
Newport Beach, CA 92663
(714) 673-5110

SPRINGVILLE MUSEUM OF
 ART
126 E. 400th St., Box 258,
Springville, UT 84663
(801) 489-7305

STATE HISTORICAL SOCIETY
 OF COLORADO
1300 Broadway,
Denver, CO 80203
(303) 892-2305

STEPS INTO SPACE
7518 Melrose Ave.,
Los Angeles, CA 90046
(213) 852-0070

SUN VALLEY CENTER
 GALLERY
P.O. Box 656,
Sun Valley, ID 83353
(208) 622-9371

THACKREY AND
 ROBERTSON
2266 Union St.,
San Francisco, CA 94123
(415) 454-4209

1307 GALLERIES
The Camera's Eye,
1307 S.W. Broadway,
Portland, OR 97201
(503) 227-7828

TIDEPOOL GALLERY
22762 Pacific Coast Hwy.,
Malibu, CA 90265
(213) 456-2551

TORTUE GALLERY
2917 Santa Monica Blvd.,
Santa Monica, CA 95401
(213) 828-8878

UNICORN GALLERY
Unicorn Cinema/Bookstore,
7456 La Jolla Blvd.,
La Jolla, CA 92037
(213) 459-4343

VANGUARD GALLERY
1317 W. 17th St.,
Los Angeles, CA 90006
(213) 483-6609

WALNUT CREEK CIVIC ARTS
 GALLERY
1641 Locust St.,
Walnut Creek, CA 94596
(415) 935-3300

WESTON GALLERY
Sixth Ave. at Delores,
Carmel, CA 93923
(408) 624-4453

STEPHEN WHITE GALLERY
8642 Melrose Ave.,
Los Angeles, CA 90069
(213) 657-6995

FREDERICK S. WIGHT
 GALLERIES
University of California at L.A.,
405 Hilgard Ave.,
Los Angeles, CA 90024
(213) 825-9345

STEPHEN WIRTZ GALLERY
228 Grant Ave.,
San Francisco, CA 94108
(415) 433-6879

WOMEN'S BUILDING
1727 N. Spring St.,
Los Angeles, CA 90012
(213) 221-6161

YELLOWSTONE ART
 CENTER
401 N. 27th St.
Billings, MT 59101
(406) 259-1869

YUEN LUI GALLERY
906 Pine St.,
Seattle, WA 98101
(206) 622-0991

MODELS AND TALENT

New York City

ACT 48 MGT. INC.
1501 Broadway, #1713,
New York, NY 10036
(212) 354-4250

ADAIR, ROSE
250 W. 57th St.,
New York, NY 10019
(212) 582-1957

ADAMS, BRET
36 E. 61st St.,
New York, NY 10021
(212) 752-7864

AGENCY FOR PERFORMING
ARTS
888 Seventh Ave.,
New York, NY 10106
(212) 582-1500

AGENTS FOR THE ARTS
1650 Broadway,
New York, NY 10019
(212) 247-3220

ALEXANDER, WILLARD
660 Madison Ave.,
New York, NY 10021
(212) 751-7070

MICHAEL AMATO
THEATRICAL AGENCY
1650 Broadway,
New York, NY 10019
(212) 247-4456

AMBROSE COMPANY:
A THEATRICAL AGENCY,
INC.
1466 Broadway,
New York, NY 10036
(212) 921-0230

AMERICAN INTL. TALENT
166 W. 125th St.,
New York, NY 10027
(212) 663-4626

AMERICAN TALENT
INTERNATIONAL, INC.
888 Seventh Ave.,
New York, NY 10106
(212) 977-2300

ANDERSON, BEVERLY
1472 Broadway,
New York, NY 10036
(212) 944-7773

ARCARA BAUMAN & HILLER
250 W. 57th St.,
New York, NY 10107
(212) 757-0098

ASSOCIATED BOOKING
1995 Broadway,
New York, NY 10023
(212) 874-2400

ASSOCIATED TALENT
AGENCY
41 E. 11th St.,

New York, NY 10003
(212) 674-4242

ASTOR, RICHARD
119 W. 57th St.,
New York, NY 10019
(212) 581-1970

BALDWIN SCULLY INC.
501 Fifth Ave.,
New York, NY 10017
(212) 922-1330

BARBIZON AGENCY OF REGO
PARK
95–20 63rd Rd.,
Rego Park, NY 11374
(212) 275-2100

BARRY AGENCY
165 W. 46th St.,
New York, NY 10036
(212) 869-9310

BEAUMONT MANAGEMENT
667 Madison Ave.,
New York, NY 10021
(212) 758-6411

BEILIN, PETER
230 Park Ave.,
New York, NY 10017
(212) 949-9119

BIG BEAUTIES UNLIMITED
159 Madison Ave.,
New York, NY 10016
(212) 685-1270

BISHOP, LOLA
160 W. 46th St.,
New York, NY 10036
(212) 997-1836

BLOOM, J. MICHAEL
400 Madison Ave.,
New York, NY 10017
(212) 832-6900

DON BUCHWALD & ASSOC.
INC.
10 E. 44th St.,
New York, NY 10017
(212) 867-1070

RICHARD CATALDI AGENCY
250 W. 57th St.,
New York, NY 10107
(212) 245-6660

CEREGHETTI AGENCY
119 W. 57th St.,
New York, NY 10019
(212) 765-5260

CLAIRE CASTING
118 E. 28th St.,
New York, NY 10016
(212) 889-8844

COLEMAN-ROSENBERG
667 Madison Ave.,
New York, NY 10021
(212) 838-0734

COLUMBIA ARTISTS
165 W. 57th St.,
New York, NY 10019
(212) 397-6900

BILL COPPER ASSOC.
224 W. 49th St.,
New York, NY 10019
(212) 758-6491

CUNNINGHAM, W. D.
919 Third Ave.,
New York, NY 10022
(212) 832-2700

JANE DEACY INC.
200 E. 75th St.,
New York, NY 10021
(212) 752-4865

DE VORE, OPHELIA
1697 Broadway,
New York, NY 10019
(212) 586-2144

DIAMOND ARTISTS
119 W. 57th St.,
New York, NY 10019
(212) 247-3025

DMI TALENT ASSOC.
250 W. 57th St.,
New York, NY 10019
(212) 246-4650

GLORIA DOLAN
MANAGEMENT LTD.
850 Seventh Ave.,
New York, NY 10019
(212) 246-1420

STEPHEN DRAPER AGENCY
37 W. 57th St.,
New York, NY 10019
(212) 421-5780

DULCINA EISEN ASSOC.
154 E. 51st St.,
New York, NY 10021
(212) 355-6617

ELITE MODEL
MANAGEMENT CORP.
150 E. 58th St.,
New York, NY 10155
(212) 935-4500

MARJE FIELDS INC.
250 W. 57th St.,
New York, NY 10107
(212) 581-7240

FILOR MODELS INC.
140 E. 56th St.,
New York, NY 10022
(212) 832-1636

FLIGHT 485
295 Madison Ave.,
New York, NY 10017
(212) 751-6522

FOR CHILDREN ONLY
333 Central Pk. W.,
New York, NY 10025
(212) 663-4570

FORD MODELS INC.
344 E. 59th St.,
New York, NY 10022
(212) 753-6500

FORD TALENT GROUP
344 E. 59th St.,
New York, NY 10022
(212) 753-6500

FOSTER-FELL
26 W. 38th St.,
New York, NY 10018
(212) 944-8520

FUNNY FACE
527 Madison Ave.,
New York, NY 10022
(212) 752-6090

GAGE GROUP INC.
1650 Broadway,
New York, NY 10019
(212) 541-5250

MARIA GRECO & ASSOC.
888 Eighth Ave.,
New York, NY 10019
(212) 757-0681

H. A. ARTISTS & ASSOC.
575 Lexington Ave.,
New York, NY 10022
(212) 935-8980

PEGGY HADLEY ENT.
250 W. 57th St.,
New York, NY 10107
(212) 246-2166

ELLEN HARTH INC.
515 Madison Ave.,
New York, NY 10022
(212) 593-2332

MICHAEL HARTIG
 AGENCY LTD.
527 Madison Ave.,
New York, NY 10022
(212) 759-9163

HENDERSON-HOGAN
200 W. 57th St.,
New York, NY 10019
(212) 765-5190

HENRY, JUNE
119 W. 57th St.,

New York, NY 10019
(212) 582-8140

HESSELTINE BAKER ASSOCS.
119 W. 57th St.,
New York, NY 10019
(212) 489-0966

DIANA HUNT
 MANAGEMENT
246 W. 44th St.,
New York, NY 10036
(212) 391-4971

HUNTER, JEFF
119 W. 57th St.,
New York, NY 10019
(212) 245-1919

HUTTO MANAGEMENT INC.
110 W. 57th St.,
New York, NY 10019
(212) 581-5610

INTERNATIONAL CREATIVE
 MANAGEMENT
40 W. 57th St.,
New York, NY 10019
(212) 556-5600

INTERNATIONAL MODEL
 AGENCY
232 Madison Ave.,
New York, NY 10016
(212) 686-9053

INTERNATIONAL TOP
 MODELS INC.
677 Fifth Ave.,
New York, NY 10022
(212) 355-4410

ITM MANAGEMENT, INC.
677 Fifth Ave.,
New York, NY 10022
(212) 355-4636

JACOBSEN-WILDER INC.
499 Madison Ave.,
New York, NY 10022
(212) 759-0860

JAN J. AGENCY
224 E. 46th St.,
New York, NY 10017
(212) 490-1875

JOE JORDAN TALENT
 AGENCY
400 Madison Ave.,
New York, NY 10017
(212) 838-4910

JERRY KAHN INC.
853 Seventh Ave.,
New York, NY 10019
(212) 582-1280

KENNEDY ARTISTS
881 Seventh Ave.,
New York, NY 10019
(212) 675-3944

BONNIE KID AGENCY
250 W. 57th St.,
New York, NY 10107
(212) 246-0223

KIMBLE/PARSEGHIAN INC.
250 W. 57th St., #1201,
New York, NY 10107
(212) 489-8100

KIRK, ROSEANNE
527 Madison Ave.,
New York, NY 10022
(212) 888-6711

KING, ARCHER
1440 Broadway,
New York, NY 10018
(212) 764-3905

KLEIN, DYANN
330 Third Ave.,
New York, NY 10010
(212) 840-1234

KNA ASSOCIATES
303 W. 42nd St.,
New York, NY 10036
(212) 581-4610

KOLMAR-LUTH
 ENTERTAINMENT INC.
1776 Broadway,
New York, NY 10019
(212) 581-5833

KROLL, LUCY
390 West End Ave.,
New York, NY 10024
(212) 877-0556

THE LANTZ OFFICE
114 E. 55th St.,
New York, NY 10022
(212) 751-2107

LIONEL LARNER LTD.
850 Seventh Ave.,
New York, NY 10019
(212) 246-3105

LA ROCKA MODELING
 AGENCY
147 W. 24th St.,
New York, NY 10011
(212) 691-0645

LBH ASSOC.
1 Lincoln Plz.,
New York, NY 10023
(212) 787-2609

LEACH, DENNIS
100 Fifth Ave.,
New York, NY 10011
(212) 691-3450

GARY LEAVERTON INC.
1650 Broadway,
New York, NY 10019
(212) 541-9640

SANFORD LEIGH AGENCY
527 Madison Ave.,
New York, NY 10022
(212) 752-4450

LEIGHTON, JAN
205 W. 57th St.,
New York, NY 10019
(212) 757-5242

JACK LENNY ASSOC.
140 W. 58th St., #1B,
New York, NY 10019
(212) 582-0270

LESTER LEWIS ASSOC.
156 E. 52nd St.,
New York, NY 10022
(212) 753-5082

LONG ISLAND MODEL
 AGENCY
153 Sidney St.,
Oyster Bay, NY 11771
(516) 922-1759

MANNEQUIN FASHION
 MODELS INC.
730 Fifth Ave.,
New York, NY 10019
(212) 586-7716

MARTIAL ARTS TALENT &
 MODELS
30 W. 90th St.,
New York, NY 10024
(212) 580-2236

MARTINELLI ATTRACTIONS
888 Eighth Ave.,
New York, NY 10019
(212) 586-0963

MASTERWORKS GLAMOUR
 MANAGEMENT
135 E. 55th St.,
New York, NY 10022
(212) 758-6295

MAYR, ERIC
23 W. 36th St.,
New York, NY 10018
(212) 594-0955

McDEARMON, HAROLD
45 W. 139th St.,
New York, NY 10030
(212) 283-1005

McDERMOTT, MARGE
214 E. 39th St.,
New York, NY 10016
(212) 889-1583

MEW COMPANY
370 Lexington Ave.,
New York, NY 10017
(212) 889-7272

MMG ENT./MARCIA'S KIDS
250 W. 57th St.,
New York, NY 10107
(212) 246-4360

MODELS SERVICE AGENCY
1457 Broadway,
New York, NY 10036
(212) 944-8896

WILLIAM MORRIS AGENCY
1350 Sixth Ave.,
New York, NY 10019
(212) 586-5100

NEW YORK PRODUCTION
 STUDIO
250 W. 57th St.,
New York, NY 10107
(212) 765-3433

NOLAN, PHILIP
134 W. 58th St.,
New York, NY 10019
(212) 243-8900

O'CONNELL, CONNIE
241 E. 75th St.,
New York, NY 10021
(212) 737-2998

ONE O ONE STUDIO INC.
1030 Ave. of the Americas,
New York, NY 10018
(212) 840-8446

OPPENHEIM-CHRISTIE
565 Fifth Ave.,
New York, NY 10017
(212) 661-4330

OSCARD, FIFI
19 W. 44th St.,
New York, NY 10036
(212) 764-1100

BARNA OSTERTAG AGENCY
501 Fifth Ave.,
New York, NY 10017
(212) 697-6339

OTHER DIMENSIONS
393 Seventh Ave.,
New York, NY 10001
(212) 736-4260

HARRY PACKWOOD TALENT
 LTD.
342 Madison Ave.,
New York, NY 10173
(212) 682-5858

PALMER, DOROTHY
250 W. 57th St.,
New York, NY 10107
(212) 765-4280

PERKINS MODELS
156 E. 52nd St.,
New York, NY 10022
(212) 752-4488

PFEFFER & ROELFS INC.
79 Madison Ave.,
New York, NY 10016
(212) 689-9020

JOEL PITT AGENCY
144 W. 57th St.,
New York, NY 10019
(212) 765-6373

JAMES POWERS INC.
12 E. 41st St.,
New York, NY 10017
(212) 686-9066

PLUS WOMEN MODEL
 MANAGEMENT LTD.
49 W. 37th St.,
New York, NY 10018
(212) 997-1785

POKO PUPPETS, INC.
12 Everitt St.,
Brooklyn, NY 11201
(212) 522-0225

PREMIER TALENT ASSOC.
3 E. 54th St.,
New York, NY 10022
(212) 758-4900

RAGLYN-SHAMSKY
60 E. 42nd St.,
New York, NY 10165
(212) 661-6690

RICE-McHUGH AGENCY
445 Park Ave.,
New York, NY 10022
(212) 752-0222

WALLACE ROGERS INC.
160 E. 56th St.,
New York, NY 10022
(212) 755-1464

GILLA ROOS LTD.
501 Madison Ave.,
New York, NY 10022
(212) 758-5480

ROSEN, LEWIS MAXWELL
1650 Broadway,
New York, NY 10019
(212) 582-6762

RUBENSTEIN, BERNARD
342 Madison Ave.,
New York, NY 10173
(212) 986-1317

CHARLES RYAN AGENCY
200 W. 57th St.,
New York, NY 10019
(212) 245-2225

HONEY SANDERS AGENCY
 LTD.
220 W. 42nd St.,
New York, NY 10036
(212) 947-5555

WILLIAM SCHULLER
 AGENCY
667 Madison Ave.,
New York, NY 10021
(212) 758-1919

SEGAL, JACK
101 W. 57th St.,
New York, NY 10019
(212) 265-7489

MONTY SILVER AGENCY
200 W. 57th St.,
New York, NY 10019
(212) 765-4040

SMITH, SUSAN
850 Seventh Ave.,
New York, NY 10019
(212) 581-4490

THE STARKMAN AGENCY
1501 Broadway,
New York, NY 10036
(212) 921-9191

STE REPRESENTATION
888 Seventh Ave.,
New York, NY 10106
(212) 246-1030

STEIN, LILLIAN
1501 Broadway,
New York, NY 10036
(212) 840-8299

STEWART ARTISTS CORP.
140 W. 63rd St.,
New York, NY 10023
(212) 752-0944

STEWART MODELS
140 E. 63rd St.,
New York, NY 10021
(212) 753-4610

STROUD MANAGEMENT
18 E. 48th St.,
New York, NY 10017
(212) 688-0226

SUMMA
250 W. 57th St., #2231,
New York, NY 10019
(212) 582-7035

SUTTON ARTISTS CORP.
505 Park Ave.,
New York, NY 10022
(212) 832-8302

RUTH SZOLD PROMOTIONAL
 MODELS
644 Broadway,

New York, NY 10012
(212) 777-4998

TALENT REPS. INC.
20 E. 53rd St.,
New York, NY 10022
(212) 752-1835

TATIANAS MODELS AND
 FITTERS, INC.
138 Broadway,
New York, NY 10001
(212) 840-8558

TEN PLUS
18 W. 56th St.,
New York, NY 10019
(212) 247-6888

THEATER NOW INC.
1515 Broadway,
New York, NY 10036
(212) 840-4400

THOMAS, JEAN
342 Madison Ave.,
New York, NY 10173
(212) 490-3954

MICHAEL THOMAS AGENCY
22 E. 60th St.,
New York, NY 10022
(212) 755-2616

TRANUM ROBERTSON
 HUGHES INC.
2 Dag Hammarskjold Plz.,
New York, NY 10017
(212) 371-7500

TROY, GLORIA
1790 Broadway,
New York, NY 10019
(212) 582-0260

UNIVERSAL ATTRACTIONS
888 Seventh Ave.,
New York, NY 10106
(212) 582-7575

UNIVERSAL TALENT
1 E. 42nd St.,
New York, NY 10017
(212) 661-3896

VAN DER VEER PEOPLE INC.
225A E. 59th St.,
New York, NY 10022
(212) 688-2880

BOB WATERS AGENCY
510 Madison Ave.,
New York, NY 10022
(212) 593-0543

WILHELMINA MODELS
9 E. 37th St.,
New York, NY 10016
(212) 532-6800

PETER WITT ASSOC. INC.
215 E. 79th St.,
New York, NY 10021
(212) 861-3120

ANN WRIGHT ASSOC.
136 E. 57th St.,
New York, NY 10022
(212) 832-0110

ZOLI
121 E. 62nd St.,
New York, NY 10021
(212) 758-5959

Northeast

THE ADAIR AGENCY
225 Church St.,
Philadelphia, PA 19106
(215) 922-0558

THE ADAIR AGENCY
3288 M St. N.W.,
Washington, DC 20007
(202) 296-1570

ALBERT, MILDRED
35 Commonwealth Ave.,
Boston, MA 02116
(617) 266-1282

AMERICAN RESIDUALS &
 TALENT INC.
69 Newbury St.,
Boston, MA 02116
(617) 536-4827

JO ANDERSON MODELS, INC.
Lafay Bldg.,
5th St. at Chestnut,
Philadelphia, PA 19106
(215) 922-0989, (609) 779-2447

JOSEPH A. BANKS & ASSOC.
Oxon Hill, MD 20745
(301) 839-3285

ROSEMARY BRIAN AGENCY
50 E. Palisades Ave.,
Englewood, NJ 07631
(212) 564-8616

CAMEO MODELS
392 Boylston St.,
Boston, MA 02116
(617) 536-6004

CARNEGIE TALENT AGENCY
300 Northern Blvd.,
Great Neck, NY 11021
(516) 487-2260

CENTRAL CASTING
1000 Connecticut Ave. N.W.,
Washington, DC 20036
(202) 659-8272

CONNECTICUT TALENT
 CORP.
136 Main St., #5,
Westport, CT 06880
(203) 838-7449

JOYCE CONOVER AGENCY
33 Galloway,
Westfield, NJ 07090
(201) 232-0908

COPLEY 7 MODELS & TALENT
29 Newbury St.,
Boston, MA 02116
(617) 267-4444

DANLINE MANAGEMENT
 INC.
260 N. Michigan Ave.,
Kenilworth, NJ 07033
(201) 241-2086

FACES MODELING & TALENT
 AGENCY
1726 Reisterstown Rd.,
Baltimore, MD 21208
(301) 484-8133

FORD MODELS OF BOSTON
176 Newbury St.,
Boston, MA 02116
(617) 266-6939

HART MODEL AGENCY
137 Newbury St.,
Boston, MA 02116
(617) 262-1740

MAGGIE-ART
69 Newbury St.,
Boston, MA 02116
(617) 536-4827

MAIN LINE MODELS GUILD
160 King of Prussia Pl.,
King of Prussia, PA 19406
(215) 687-4759

MIDIRI MODELS, INC.
1920 Chestnut St.,
Philadelphia, PA 19103
(215) 561-5028

MODELS GUILD OF PHILA.,
 INC.
1512 Spruce St.,
Philadelphia, PA 19102
(215) 735-5606, (215) 735-4067

CAROL NASHE AGENCY
228 Beacon St.,
Boston, MA 02116
(617) 247-3627

PENNINGTON
 ENTERTAINMENT LTD.
72 Edmund St.,
Edison, NJ 08817
(201) 985-9090

JOSEPH ROCCO AGENCY
Public Ledger Bldg.,
Philadelphia, PA 19106
(215) 923-8790

STUDIO GUILD OF
 PROFESSIONAL MODELS
1126 Walnut St.,
Philadelphia, PA 19107
(215) 925-2101

Southeast

A CENTRAL CASTING OF
 FLORIDA
2451 Brickell,
Miami, FL 33129
(305) 379-7526

ACT 1 CASTING AGENCY
1460 Brickell Ave.,
Miami, FL 33131
(305) 371-1371

ACT 1, SCENE II CASTING,
 INC.
5424 Central Ave.,
St. Petersburg, FL 33707
(813) 343-5375

ADAM PRODUCTIONS
2501 S. Ocean Dr.,
Hollywood, FL 33019
(305) 925-1799

A. DEL CORRAL MODEL &
 TALENT AGENCY
5830 Argonne Blvd.,
New Orleans, LA 70124
(504) 482-8963

THE AGENCY SOUTH
1501 Sunset Dr.,
Coral Gables, FL 33143
(305) 667-6746

ALSTON, ANN
3166 Maple Dr. N.E.,
Atlanta, GA 30305
(404) 237-4040

AMARO AGENCY
1617 Smith St.,
Orange Park, FL 32073
(904) 264-0771

ARTISTS REPRESENTATIVES
 OF NEW ORLEANS
3206 St. Charles St.,
New Orleans, LA 70115
(504) 524-4683

ATLANTA MODELS &
 TALENT INC.
3030 Peachtree Rd. N.W.,
Atlanta, GA 30305
(404) 261-9627

BARBIZON
3340 Peachtree St. N.E.,
Atlanta, GA 30326
(404) 261-7332

BARBIZON MODELING
 SCHOOL OF CHARLOTTE
5200 Park Rd., #226,
Charlotte, NC 28209
(704) 527-5985

BARBIZON OF BIRMINGHAM
 INC.
2 Metroplex Dr., #220,
Birmingham, AL 35209
(205) 870-9790

BB&A
3098 Piedmont Rd. N.E.,
Atlanta, GA 30305
(404) 231-9369

BELUE AGENCY
1 Kenlock Pl. N.E.,
Atlanta, GA 30305
(404) 231-2315

BIRMINGHAM MODELS &
 TALENT
2001 Eleventh Ave. S.,
Birmingham, AL 35205
(205) 933-1280

BLACKTHORN MODEL
 AGENCY
7 Lake Worth Casino,
Lake Worth, FL 33480
(305) 582-3311

BOB BROWN MARIONETTES
6216 N. Morgan St.,
Alexandria, VA 22312
(703) 920-1040

JAY BROWN THEATRICAL
 AGENCY INC.
221 W. Waters Ave.,
Tampa, FL 33604
(813) 933-2456

BRUCE ENTERPRISES
1022 Sixteenth Ave. S.,
Nashville, TN 37212
(615) 255-5711

DOT BURNS MODEL &
 TALENT AGENCY
478 Severn Ave.,
Tampa, FL 33606
(813) 251-5882

RUSS BYRD ASSOCIATES
9450 Kroger Blvd.,
St. Petersburg, FL 33702
(813) 577-1555

CAMELOT TALENT AGENCY
2233 Executive Sq.,
Winter Pk., FL 32763
(305) 644-0201

CASSANDRA MODELS
AGENCY
635 N. Hyner Ave.,
Orlando, FL 32803
(305) 423-7872

CASTING BY MARBEA
104 Crandon Blvd.,
Key Biscayne, FL 33149
(305) 361-1144

THE CASTING DIRECTORS
INC.
1524 N.E. 147th St.,
North Miami, FL 33161
(305) 944-8559

CASTING & PRODUCTION
SERVICES
12434 Largo Dr.,
Savannah, GA 31406
(912) 927-3807

CHARISMA MODELING
AGENCY
5748 Swift Rd.,
Sarasota, FL 33581
(813) 921-7080

CHEZ AGENCY
225 Peachtree St.,
Atlanta, GA 30303
(404) 588-1215

COCONUT GROVE TALENT
AGENCY
3525 Vista Ct.,
Miami, FL 33133
(315) 446-0047

COVER GIRL
20923 N.W. Second Ave.,
Miami, FL 33169
(305) 653-2636, (305) 652-7994

CREATIVE ENTERPRISES
TALENT AGENCY
2863 First Ave. S.,
St. Petersburg, FL 33712
(813) 823-3700

PETER DASSINGER
INTERNATIONAL
MODELING
1018 Royal,
New Orleans, LA 70116
(504) 525-8382

DENISON MODELING
AGENCY
7220 S.W. 58th Ct.,
South Miami, FL 33143
(305) 665-3652

BARBARA DODD STUDIOS
4004 Hillsboro Rd.,
Nashville, TN 37215
(615) 385-0740

EAST COAST TALENT, INC.
4111 Johnson St.,
Hollywood, FL 33021
(305) 625-1722, (305) 963-0935

TRAVIS FALCON MODELING
AGENCY
17070 Collins Ave.,
Miami, FL 33160
(305) 947-7957

FAME CRAFT CORP.
830 Broad St.,
Portsmouth, VA 23707
(804) 393-9000

FASHIONCREST
INTERNATIONAL
777 N.W. 72nd Ave.,
Miami, FL 33126
(305) 261-6821

FLAIR MODELS
P.O. Box 17372,
Nashville, TN 37217
(615) 361-3737

FLORIDA CASTING AGENCY
300 Biscayne Blvd., #310,
Miami, FL 33132
(305) 358-3228

FLORIDA TALENT AGENCY
2631 E. Oakland Pk.,
Ft. Lauderdale, FL 33306
(305) 565-3552

GEMINI TALENT
2809 Edgewater Dr.,
Orlando, FL 32804
(305) 423-2682

GOLD COAST MODEL
THEATRICAL AGENCY
1 Lincoln Rd.,
Miami Beach, FL 33139
(305) 532-8617

JERRY GRANT
PRODUCTIONS, INC.
7915 East Dr.,
Miami Beach, FL 33141
(305) 944-1011

GROVE ENTERPRISES
3886 Paces Ferry Rd. N.W.,
Atlanta, GA 30327
(404) 237-5249

JANICE HANEY MODELS
AGENCY & SCHOOL
North Palm Beach, FL 33480
(305) 842-0298

JEAN HENDERSON TALENT
AGENCY
709 S. Federal Hwy.,
Pompano Beach, FL 33062
(305) 943-1291

HOUSE OF TALENT OF CAIN
& SONS
996 Lindridge Dr. N.E.,
Atlanta, GA 30324
(404) 267-5543

JO-SUSAN MODELING &
FINISHING SCHOOL
3022 Millwood Dr.
Nashville, TN 37217
(615) 383-5850

GLYNE KENNEDY LTD. INC.
1828 N.E. Fourth Ave.,
Miami, FL 33132
(305) 358-5998

LEOPOLD, STRATTON
3210 Verdun Dr. N.W.,
Atlanta, GA 30305
(404) 237-3776

MILLIE LEWIS MODELING &
FINISHING SCHOOL
3022 Millwood Ave.,
Columbia, SC 29205
(803) 254-5161

MAR BEA TALENT AGENCY
104 Crandon Blvd., #305,
Key Biscayne, FL 33149
(305) 361-1144

MARILYN'S MODELING
AGENCY
44 Kemp Rd. E.,
Greensboro, NC 27410
(919) 852-0847

McDERMOTT, BEVERLY
923 N. Gold Dr.,
Hollywood, FL 33021
(305) 625-5111, (305) 983-1455

MODEL'S WORLD, INC.
3835 N. Andrews Ave.,
Ft. Lauderdale, FL 33309
(305) 565-3227

NASHVILLE TALENT
SERVICES
Box 121182, Acklen Sta.,
Nashville, TN 37212
(615) 327-1847

SARAH PARKER MODELS &
TALENT
230 Royal Palm Wy., #212,
Palm Beach, FL 33480
(305) 467-2838

MARIAN POLAN TALENT
AGENCY
721 E. Las Olas Blvd.,
Ft. Lauderdale, FL 33301
(305) 462-0802

JOHN ROBERT POWERS
SCHOOL
828 S.E. 4th St.,

Ft. Lauderdale, FL 33301
(305) 467-2838

PROFESSIONAL MODELS GUILD & WORKSHOP
2425 Chesterfield Ave.,
Charlotte, NC 28205
(704) 377-9299

REEVE, BONNIE
545 Pharr Rd.,
Atlanta, GA 30305
(404) 881-1385

SERENDIPITY AGENCY
3166 Maple Dr.,
Atlanta, GA 30305
(404) 237-4040

SIGNATURE TALENT INC.
P.O. Box 221086,
Charlotte, NC 28222
(704) 542-0034

LYNN SIMS FASHION COLLEGE
1925 Marion St.,
Columbia, SC 29201
(803) 252-3914

SOUTHEAST CASTING SERVICE
14875 N.E. 20th Ave.,
North Miami, FL 33181
(305) 944-2911

SPIVA, ED
P.O. Box 38097,
Atlanta, GA 30334
(404) 656-3552

PATRICIA STEVENS MODELING AGENCY
3330 Peachtree Rd. N.W.,
Atlanta, GA 30326
(404) 351-9502

STUDIO PRODUCTIONS
17070 Collins Ave.,
Miami, FL 33160
(305) 893-5611

SUNSHINE PRODUCTIONS
5501 N.W. Seventh Ave.,
Miami, FL 33127
(305) 751-3634

SW PRODUCTIONS
2405 N. McRae St.,
Orlando, FL 32803
(305) 898-4688

TAKE ONE TALENT
1360 Brooklawn Rd. N.E.,
Atlanta, GA 30319
(404) 231-2315

THE TALENT AGENTS/ SHIRLEY BURNETT
1528 N.E. 147th St.,
Miami, FL 33161
(305) 940-7076

TALENT ENTERPRISES INC.
1603 N.E. 123rd St.,
North Miami, FL 33181
(305) 891-1832

THE TALENT SHOP INC.
3379 Peachtree St. N.W., #606,
Atlanta, GA 30326
(404) 261-0770

JAN THOMPSON AGENCY
1800 East Blvd.,
Charlotte, NC 28203
(704) 377-5987

TOP BILLING INC.
P.O. Box 121077,
Nashville, TN 37212
(615) 383-8883

TRIM MODELING AGENCY
600 Queens Rd.,
Charlotte, NC 28207
(704) 332-6601

YOUNG MODELS ASSOCIATION INC.
3107 Barron Ave.,
Memphis, TN 38111
(901) 744-3394

Midwest

ADVERTISERS' CASTING AGENCY
9205 W. Center St.,
Milwaukee, WI 53222
(404) 259-1611

ADVERTISERS' CASTING SERVICE
15324 E. Jefferson Ave.,
Grosse Point, MI 48230
(313) 823-1800

AFFILIATED TALENT & CASTING SERVICE
28860 Southfield Rd., #100,
Southfield, MI 48076
(313) 559-3110

THE AGENCY
512 Nicollet Mall,
Minneapolis, MN 55402
(612) 330-3661

AGENCY FOR PERFORMING ARTS
203 N. Wabash,
Chicago, IL 60601
(312) 664-7703

A-PLUS TALENT AGENCY CORP.
666 N. Lakeshore Dr.,
Chicago, IL 60611
(312) 642-8151

ASSOC. BOOK CORP.
2700 River Rd.,
Des Plaines, IL 60018
(312) 296-0930

BARBIZON SCHOOL OF MODELING
17600 W. Eight Mile Rd.,
Southfield, MI 48076
(313) 569-1300

BEVERLY'S INC.
19111 W. Ten Mile Rd.,
Southfield, MI 48075
(313) 354-6160

BURNS SPORTS CELEBRITY SERVICE
230 N. Michigan,
Chicago, IL 60601
(312) 236-2377

CHICAGO TALENT SERVICE
101 E. Ontario St.,
Chicago, IL 60611
(312) 440-7300

CREATIVE CASTING INC.
430 Oak Grove,
Minneapolis, MN 55403
(612) 871-7866

SHARON DI ANTONIO ENTERPRISES
1550 Mt. Prospect Rd.,
Des Plaines, IL 60018
(312) 297-6075

LESLIE FARGO AGENCY
280 N. Woodward Ave.,
Birmingham, MI 48025
(313) 645-5506

GAIL & RICE TALENT—A-PLUS MODELS
11845 Maryfield St.,
Livonia, MI 48150
(313) 427-9315

GEDDES, INC.
875 N. Michigan Ave.,
Chicago, IL 60611
(312) 664-9890

GEM ENTERPRISES
5100 Eden Ave.,
Minneapolis, MN 55436
(612) 927-8000

GLAMOUR
140 N. Main St.,
Dayton, OH 45402
(513) 222-8321

SHIRLEY HAMILTON INC.
620 N. Michigan Ave.,
Chicago, IL 60611
(312) 644-0300

HOGAN, FRANK J.
307 N. Michigan Ave.,
Chicago, IL 60601
(312) 263-6910

IDC SERVICES
303 E. Ohio,
Chicago, IL 60611
(312) 943-7500

JEWELL RADIO & TV PROD.
612 N. Michigan,
Chicago, IL 60611
(312) 664-5757

DAVID LEE MODELS
936 N. Michigan,
Chicago, IL 60611
(312) 649-0500

DAVID LEE MODELS
1801 E. 12th St.,
Cleveland, OH 44114
(216) 522-1300

DAVID LEE MODELS
64 E. Walton,
Chicago, IL 60611
(312) 649-0500

LIMELIGHT ASSOC. INC.
3460 Davis Ln.,
Cincinnati, OH 45237
(513) 631-8276

ELILIO LORENCE LTD.
619 N. Wabash,
Chicago, IL 60611
(312) 943-4558

THE MODEL SHOP
415 N. State St.,
Chicago, IL 60610
(312) 822-9663

MONZA TALENT AGENCY
911 Main St.,
Commerce Tower,
Kansas City, MO 64105
(816) 421-0222

ELEANOR MOORE AGENCY
1610B W. Lake St.,
Minneapolis, MN 55408
(612) 827-3823

JACK MORTON INC.
111 E. Wacker Dr.,
Chicago, IL 60601
(312) 644-0620

NEW FACES MODELS & TALENT INC.
310 Groveland Ave.,
Minneapolis, MN 55403
(612) 871-6000

NTN NATIONAL TALENT NETWORK, INC.
101 E. Ontario,
Chicago, IL 60611
(312) 280-2225

PANACHE, LTD.
10411 Clayton Rd.,
St. Louis, MO 63131
(314) 993-2440

PERFORMERS SERVICE
4120 W. 189,
Country Club Hill, IL 60477
(312) 798-6400

PHILBIN TALENT AGENCY
2323 W. Devon,
Chicago, IL 60659
(312) 465-2490

PLAYBOY MODELS
919 N. Michigan,
Chicago, IL 60611
(312) 644-9024

JOHN ROBERT POWERS AGENCY
5900 Roche Dr.,
Columbus, OH 43229
(614) 846-1047

RH ENTERPRISES
625 N. Michigan,
Chicago, IL 60611
(312) 642-2974

RIGHT FACE
625 N. Michigan,
Chicago, IL 60611
(312) 951-7210

RIGHT FACE
465 Cleveland Plz.,
Cleveland, OH 44115
(216) 687-1770

JACK RUSSELL & ASSOC.
244 Constance Ln.,
Chicago Heights, IL 60411
(312) 756-7060

NORMAN SCHUCART ENT.
1417 Green Bay Rd.,
Highland Park, IL 60035
(312) 433-1113

SCHULTZ, HOWARD
2525 W. Peterson,
Chicago, IL 60659
(312) 769-2244

SHAPIRO, SEYMOUR
307 N. Michigan,
Chicago, IL 60601
(312) 236-9596

NORMA SHARKEY AGENCY, INC.
1299 Lyons Rd.,
Dayton, OH 45402
(513) 434-4461

SPOTLIGHT INTERNATIONAL
1726 Lakefront Ave.,
E. Cleveland, OH 44112
(216) 541-6263

SR TALENT POOL
206 S. 44th St.,
Omaha, NE 68131
(402) 553-1164

STATION 12-PRODUCERS EXPRESS
24333 Southfield Rd.,
Southfield, MI 48075
(313) 569-7707

STEVENS MODEL & TALENT AGENCY
512 Nicollet Mall,
Minneapolis, MN 55402
(612) 339-3661

TALENT CENTRAL
1845 N. Farewell Ave.,
Milwaukee, WI 53202
(414) 643-9108

TALENT PHONE PRODUCTIONS
612 N. Michigan Ave.,
Chicago, IL 60611
(312) 664-5757

TALENT & RESIDUALS INC.
303 E. Ohio St.,
Chicago, IL 60611
(312) 943-7500

THE VOICE CASTERS
739 N. Wells,
Chicago, IL 60610
(312) 951-6080

CAROL VERBLEN CASTING SERVICE
323 W. Webster,
Chicago, IL 60614
(312) 348-0047

WHITE, EVERETT
215 W. Pershing Rd.,
Kansas City, MO 64108
(816) 931-8671

WHITE HOUSE STUDIOS
229 Ward Pkwy.,
Kansas City, MO 64112
(816) 931-3608

Southwest

ACCENT INC.
6051 N. Brookline,
Oklahoma City, OK 73112
(405) 843-1303

ASSOCIATED BOOKING
 CORPORATION
4055 Spencer,
Las Vegas, NV 89109
(702) 734-8155

BOBBY BALL AGENCY
808 E. Osborn,
Phoenix, AZ 85014
(602) 264-5007

BARBIZON SCHOOL &
 AGENCY
1647A W. Bethany Home Rd.,
Phoenix, AZ 85015
(602) 249-2950

TANYA BLAIR AGENCY
2320 N. Griffin St.,
Dallas, TX 75202
(214) 748-8353

BEVERLY BUTLER
 FREE-LANCE TALENT
P.O. Box 5158,
Little Rock, AR 72205
(501) 664-1641

CREATIVE ENTERTAINMENT
 ASSOC.
1629 E. Sahara Ave.,
Las Vegas, NV 89104
(702) 733-7575

CREME DE LA CREME
5643 N. Pennsylvania,
Oklahoma City, OK 73112
(405) 840-4419

KIM DAWSON AGENCY
1643 Apparel Mart,
Dallas, TX 75207
(214) 638-2414

FLAIR-CAREER FASHION &
 MODELING
9301 Candelaria Rd. N.E.,
Albuquerque, NM 87112
(505) 296-5571

FOSI'S TALENT AGENCY
2777 N. Campbell Ave., #209,
Tucson, AZ 85719
(602) 795-3534

FULLERTON, JO ANN
6100 N. Grand Blvd.,
Oklahoma City, OK 73118
(405) 848-4839

GERRI HALPIN AGENCY
3606 Montrose St.,
Houston, TX 77006
(713) 526-5747

GRISSOM AGENCY
2909 E. Grant Rd.,
Tucson, AZ 85716
(602) 327-5692

HARRISON-GERS MODELING
 AGENCY
1707 Wilshire Blvd. N.W.,
Oklahoma City, OK 73116
(405) 840-4515

HEINA MODELING AGENCY
1100 W. 34th St.,
Little Rock, AR 72206
(501) 375-3519

IMAGE MAKERS
2961 Avenida de la Colina,
Tucson, AZ 85715
(602) 749-4381

THE MAD HATTER
1400 S. Post Oak Rd.,
Houston, TX 77056
(713) 621-3720

MODELS AND TALENT OF
 TULSA
4528 S. Sheridan Rd.,
Tulsa, OK 74145
(918) 664-5340

NEW FACES INC.
5108B N. 7th St.,
Phoenix, AZ 85014
(602) 279-3200

NORTON AGENCY
2829 W. Northwest Hwy., #703,
Dallas, TX 75220
(213) 357-6439

NUMBER ONE
 MANAGEMENT
P.O. Box 42164,
Houston, TX 77242
(713) 960-1798

PLAZA THREE TALENT
 AGENCY
4343 N. 16th St.,
Phoenix, AZ 85016
(602) 264-9703

PLAZA THREE
5055 Broadway,
Tucson, AZ 85711
(602) 745-2500

JOHN ROBERT POWERS
 AGENCY
3005 S. University Dr.,
Fort Worth, TX 76109
(817) 923-7305

SCARBROUGH, CHARLIE
1201 N. Pierce, #62,
Little Rock, AR 72207
(501) 666-7838

BEN SHAW MODELING
 STUDIOS
408 Westheimer,
Houston, TX 77006
(713) 526-4301

SIMORGH MODELING &
 TALENT AGENCY
4150 N. 19th Ave., #16,
Phoenix, AZ 85015
(602) 274-8532

SOUTHERN ARIZONA
 CASTING CO.
2777 N. Campbell Ave., #209,
Tucson, AZ 85719
(602) 795-3534

THE STOWER GROUP
5555 W. Lover's Lane,
Dallas, TX 75209
(214) 352-2166

STRAWN, LIBBY
3612 Foxcroft Rd.,
Little Rock, AR 72207
(501) 227-5874

PEGGY TAYLOR TALENT
 INC.
3616 Howell,
Dallas, TX 75204
(214) 526-4800

PEGGY TAYLOR INC.
4228 N. Central Expwy.,
Dallas, TX 75204
(214) 827-7292

PEGGY TAYLOR INC.
5806 Southwest Frwy.,
Houston, TX 77057
(713) 789-6835

West

ABRAMS-RUBALOFF & ASSOC.
 INC.
9012 Beverly Blvd.,
Los Angeles, CA 90048
(213) 273-5711

WILLIAM ADRIAN AGENCY
520 S. Lake Ave.,
Pasadena, CA 91101
(213) 681-5750

ANAJA MODELS & TALENT
111 O'Farrell St.,
San Francisco, CA 94102
(415) 981-6170

TOM ANTHONY'S PRECISION
 DRIVING
1231 N. Harper,
Hollywood, CA 90046
(213) 462-2301

ARTISTS MANAGEMENT
 AGENCY
2232 Fifth Ave.,
San Diego, CA 92101
(714) 233-6655

ASPEN CASTING & PROD. INC.
710 E. Durant,
Aspen, CO 81611
(303) 925-8304

BARBIZON MODELING &
 TALENT AGENCY
15477 Ventura Blvd.,
Sherman Oaks, CA 91403
(213) 995-8238

BARBIZON SCHOOL OF
 MODELING
452 Fashion Valley,
San Diego, CA 92108
(714) 291-2937

BCI CASTING
9200 Sunset Blvd.,
Los Angeles, CA 90069
(213) 550-0156

BERMYCE CRONIN TYLER
 KJAR
439 S. La Cienega Blvd.,
Los Angeles, CA 90048
(213) 273-8144

THE BLAIR BUNCH INC.
7561 Woodman Pl.,
Van Nuys, CA 91405
(213) 994-8811

BLANCHARD, NINA
1717 N. Highland Ave.,
Hollywood, CA 90028
(213) 462-7274

BRANDT, WERNER
9229 Sunset Blvd.,
Los Angeles, CA 90069
(213) 273-8554

BREBNER AGENCIES, INC.
161 Berry St.,
San Francisco, CA 94107
(415) 495-6700

CASTING & CO-ORDINATING
7156 Convoy Ct.,
San Diego, CA 92111
(714) 292-7243

CELEBRITY LOOK ALIKES
9000 Sunset Blvd.,
West Hollywood, CA 90069
(213) 273-5566

CHN INTERNATIONAL
428 Santa Monica Blvd.,
Los Angeles, CA 90046
(213) 874-8252

COMMERCIALS UNLIMITED
7461 Beverly Blvd.,
Los Angeles, CA 90036
(213) 937-2220

THE COORDINATOR
2130 Fourth Ave.,

San Diego, CA 92103
(714) 234-7911

MARY CROSBY TALENT
 AGENCY
2130 Fourth Ave.,
San Diego, CA 92103
(714) 234-7911

WILLIAM D. CUNNINGHAM &
 ASSOC.
261 S. Robertson,
Beverly Hills, CA 90211
(213) 855-0200

MARY WEBB DAVIS AGENCY
515 N. La Cienega Blvd.,
Los Angeles, CA 90048
(213) 655-6747

DEMETER AND REED LTD.
445 Bryant,
San Francisco, CA 94107
(415) 777-1337

ELITE
9255 Sunset Blvd.,
Los Angeles, CA 90069
(213) 274-9395

DALE GARRICK INT'L.
 AGENCY
8831 Sunset Blvd.,
Los Angeles, CA 90069
(213) 657-2661

MARY GRADY AGENCY
10850 Riverside Dr.,
North Hollywood, CA 91602
(213) 985-9800

THE GRANITE AGENCY
1920 S. La Cienega Blvd.,
Los Angeles, CA 90034
(213) 934-8383

GRIMME AGENCY
214 Grant Ave.,
San Francisco, CA 94108
(415) 392-9175

LOLA HALLOWELL MODEL &
 TALENT AGENCY
158 Thomas,
Seattle, WA 98109
(206) 623-7311

CAROLYN HANSEN AGENCY
1516 Sixth,
Seattle, WA 98101
(206) 622-1406

BEVERLY HECHT AGENCY
8949 Sunset,
Los Angeles, CA 90069
(213) 278-3544

ILLINOIS TALENT
2664 S. Krameria,
Denver, CO 80222
(303) 757-8675

INTERNATIONAL CREATIVE
 MANAGEMENT
8899 Beverly Blvd.,
Los Angeles, CA 90048
(213) 550-4000

JOSEPH JAYE AGENCY
439 S. La Cienega Blvd.,
Los Angeles, CA 90048
(213) 273-2000

TONI KELMAN & ASSOC.
7813 Sunset Blvd.,
Los Angeles, CA 90046
(213) 851-8822

KTLA/GOLDEN WEST
 PRODUCTIONS
5800 Sunset Blvd.,
Hollywood, CA 90028
(213) 469-3181

LA BELLE AGENCY
El Paseo Studio III,
Santa Barbara, CA 93101
(805) 965-4575

LA VONNE, VALENTINE
2133 Van Ness,
San Francisco, CA 94109
(415) 673-7965, (415) 885-9604

CAROLINE LEONETTI LTD.
6526 Sunset Blvd.,
Los Angeles, CA 90028
(213) 462-2345

LIEBES SCHOOL OF
 MODELING INC.
1807 Broadway,
San Francisco, CA 94109
(415) 673-7171

THE LIGHT COMPANY
 TALENT AGENCY
1443 Wazee St.,
Denver, CO 80202
(303) 572-8363

ROBERT LONGENECKER
 AGENCY
11704 Wilshire,
Los Angeles, CA 90025
(213) 477-0039

JESS MACK AGENCY
111 Las Vegas Blvd. S.,
Las Vegas, NV 89101
(702) 382-2193

JOAN MAGNUM AGENCY
8831 Sunset Blvd.,
Los Angeles, CA 90069
(213) 659-7230

MARKETEAM MODELS INC.
1089 Mission,
San Francisco, CA 94103
(415) 621-4404



MEDIA TALENT CENTER
2720 N.E. Flanders,
Portland, OR 97232
(503) 231-1111

MODEL MANAGEMENT INC.
1400 Castro St.,
San Francisco, CA 94114
(415) 282-8855

MODEL WAY
 INTERNATIONAL
1110 N. Hudson Ave.,
Los Angeles, CA 90019
(213) 462-1704

MODELS, INC.
2504 Sacramento St.,
San Francisco, CA 94115
(415) 463-5399

LOLA MOORE AGENCY
6117 Reseda Blvd.,
Reseda, CA 91335
(213) 276-6097

WILLIAM MORRIS AGENCY
151 El Camino Dr.,
Beverly Hills, CA 90212
(213) 274-7451

DOROTHY DAY OTIS
 AGENCY
6430 W. Sunset Blvd.,
Los Angeles, CA 90028
(213) 461-4911

PACIFIC ARTISTS, LTD.
515 N. La Cienega,
Los Angeles, CA 90048
(213) 657-4080

PERFORMING ARTS CASTING
 DIRECTORY
7805 Sunset Blvd.,
Hollywood, CA 90046
(213) 851-8270

PLAYBOY MODEL AGENCY
8560 Sunset Blvd.,
Los Angeles, CA 90046
(213) 659-4080

TINA REAL AGENCY
3108 Fifth Ave.,
San Diego, CA 92103
(714) 298-0544

REB-SUNSET
 INTERNATIONAL
6912 Hollywood Blvd.,
Hollywood, CA 90028
(213) 464-4440

RYDEN-FRAZER AGENCY
1901 S. Bascom Ave.,
Campbell, CA 95008
(408) 371-1973

SABINA MODELS & TALENT
25 Maiden Ln.,
San Francisco, CA 94108
(415) 781-6424

DON SCHWARTZ AGENCY
8721 Sunset Blvd.,
Los Angeles, CA 90069
(213) 657-8910

SEATTLE'S MODEL GUILD
1610 Sixth,
Seattle, WA 98101
(206) 622-1406

SEATTLE'S NEWEST FACES
424 Second W.,
Seattle, WA 98119
(206) 283-3137

GLEN SHAW AGENCY
3330 Barham Blvd.,
Los Angeles, CA 90068
(213) 657-8910

GLENN SHOW AGENCY
3330 Graham Blvd.,
Hollywood, CA 90068
(213) 851-6262

DOROTHY SHREVE AGENCY
13444 Ventura,
Sherman Oaks, CA 91423
(213) 783-1128

SMILING FACES
843 Montgomery St.,
San Francisco, CA 94133
(415) 989-6866

CHARLES H. STERN AGENCY
9220 Sunset Blvd.,
Los Angeles, CA 90069
(213) 273-6890

STUNTS UNLTD.
3518 Cahuenga Blvd. W.,
Los Angeles, CA 90068
(213) 874-0050

HERB TONNEN & ASSOC.
6640 W. Sunset Blvd.,
Los Angeles, CA 90028
(213) 466-6191

WILHELMINA WEST, INC.
1800 Century Pk. E.,
Los Angeles, CA 90067
(213) 553-9625

WORMSER HELDFOND &
 JOSEPH
1717 N. Highland,
Los Angeles, CA 90028
(213) 466-9111

ANN WRIGHT ASSOC.
8422 Melrose Pl.,
Los Angeles, CA 90069
(213) 655-5040

STYLISTS

New York City

BALDASSANO, IRENE
New York, NY
(212) 255-8567

BANDIERO, PAUL
New York, NY
(212) 586-3700

BASS, ANNE
New York, NY
(212) 741-0924

BATTEAU, SHARON
New York, NY
(212) 977-7157

BEAUTY BOOKINGS
New York, NY
(212) 977-7157

BENNER, DYNE
New York, NY
(212) 688-7571

BERMAN, BENICA
New York, NY
(212) 737-9627

BIEBER, ANDREA
New York, NY
(212) 758-6295

BODIAN, BETTY
New York, NY
(212) 473-4413

BORDEN, MICHAEL
New York, NY
(212) 581-6470

BRAFF, BURTON
New York, NY
(212) 486-1474

BRODERSON, CHARLES
New York, NY
(212) 925-9392

BROMBERG, FLORENCE
New York, NY
(212) 255-4033

CHAMPLIN, JUDY
New York, NY
(212) 473-5330

CHEVERTON, LINDA
New York, NY
(212) 533-3247

CHIN, FAY L.
New York, NY
(212) 254-7667, (212) 869-3050

COLEMAN, LINDA
New York, NY
(212) 832-0271, (212) 541-7600

CONNOLLY, MARY T.
New York, NY
(212) 861-5263

CORELLO, CHRISTINE
New York, NY
(212) 929-1273

COWEN, LORAYNE
New York, NY
(212) 929-6864

D'ARCY, TIMOTHY
New York, NY
(212) 580-8804

DARRAH, SANDRA DAVIS
New York, NY
(212) 724-2800, (212) 247-6249

DE JESU, JOANNA
New York, NY
(212) 255-3895

DIMORE, JEAN
New York, NY
(212) 889-2493

DONLEAVY/SCOTT
New York, NY
(212) 675-5939, (212) 490-0077

EDWARDS, LINDA
New York, NY
(212) 977-7157

EDWARDS, RONNIE
New York, NY
(212) 777-7134

ELLER, ANN
New York, NY
(212) 238-5454

EHRENREICH, SALLY
New York, NY
(212) 687-2996

EVANS, PAT
New York, NY
(212) 884-4274

FAGEN, TINA
New York, NY
(212) 628-0905

FARKAS, FANNY
New York, NY
(212) 684-4299

FEINGOLD, HELEN
New York, NY
(212) 353-8362

FINAL TOUCH
New York, NY
(212) 435-6800

FISHER, MICHAEL J.
New York, NY
(212) 929-0489

FRIEDMAN, ANN
New York, NY
(212) 581-6460

GENET, BARBARA
New York, NY
(212) 362-6786, (212) 869-3050

GEORGE, GEORGIA A.
New York, NY
(212) 759-4131

GHOSSN, EDWARD
New York, NY
(212) 765-4254

GLENN, JANET
New York, NY
(212) 243-8070

GODAY, DALE
New York, NY
(212) 586-6300

GOLDBERG, GAYLE
New York, NY
(212) 475-6789

GOODFRIEND, BARBARA S.
New York, NY
(212) 889-9120

GREENE, JAN
New York, NY
(212) 233-8989

GUCCIONE
New York, NY
(212) 279-3602

GUERIN, POLLY
New York, NY
(212) 685-6919

HADDOCK, SHERRY
New York, NY
(212) 888-7937

HAMMOND, CLAIR
New York, NY
(212) 838-0712

HART, EDNA
New York, NY
(212) 242-2850

HELLER, ANN
New York, NY
(212) 238-5454

HERMAN, JOAN
New York, NY
(212) 724-3287

HIRSCH, MAUREEN
New York, NY
(212) 288-3783

HOFFMAN, TERESE
New York, NY
(212) 673-4100

HOUGH, THERESA
New York, NY
(212) 673-4100

HOWARD, LINDA
New York, NY
(212) 787-6580

HUDSON, KAREN
New York, NY
(212) 472-1179

JACKSON, OPHELIA
New York, NY
(212) 868-3330

JENRETTE, PAMELA
New York, NY
(212) 673-4748, (212) 233-8989

JOFFE, CAROLE REIFF
New York, NY
(212) 725-4928

JORRIN, SYLVIA
New York, NY
(212) 977-7157

JUST, JUDI SACKS
New York, NY
(212) 532-1332

KAPLAN, HOWARD
New York, NY
(212) 741-2180, (212) 674-1000

KIMMEL, LILY
New York, NY
(212) 687-2996

KLEIN, DYANN
New York, NY
(212) 840-1234

KLEIN, MARY ELLEN
New York, NY
(212) 683-6351

KURZ, PAT
New York, NY
(212) 758-4523

LANE TALENT
New York, NY
(212) 861-7225

LANGAN, MARIANNE E.
New York, NY
(212) 749-5869, (212) 327-2666

LEE, GRETTA
New York, NY
(212) 977-7157

LEE, NORA
New York, NY
(212) 245-5218

LEONARDS, RONNIE
New York, NY
(212) 777-7134

LEVIN, LAURIE
New York, NY
(212) 691-7950

LIGUORI, DEBORAH
New York, NY
(212) 691-9618

LONG, ALLAN
New York, NY
(212) 691-3325

LOPES, SANDRA
New York, NY
(212) 249-8706

LUTZ, ROBIN
New York, NY
(212) 730-2567

MAGIDSON, PEGGY
New York, NY
(212) 570-6252

MAIN, ELIZABETH
New York, NY
(212) 689-0144

MAKEUP MASTERS
New York, NY
(212) 254-7339

MANIA, PETER
New York, NY
(212) 288-1090

MARTIN, ALICE M.
New York, NY
(212) 688-0117

McCABE, CHRISTINE
New York, NY
(212) 799-4121

McDONALD, MEREDITH
New York, NY
(212) 348-3677

McLOUGHLIN, ROSEMARY
New York, NY
(212) 674-8964

MEYERHOFF, JANE
New York, NY
(212) 753-3923

MEYERS, PAT
New York, NY
(212) 620-0069

MILLER, LORNA
New York, NY
(212) 243-3599

MINCOU, CHRISTINE
New York, NY
(212) 838-3881

MORGAN, ALIDA
New York, NY
(212) 977-7157

MORIN, GENE
New York, NY
(212) 691-6923

MURPHY, VANESSA
New York, NY
(212) 799-0004

MURRAY, DIANA
New York, NY
(212) 861-7225

NAGLE, PATSY
New York, NY
(212) 682-0364

NORTON, SALLY
New York, NY
(212) 867-1579

NOSOFF, FRANK
New York, NY
(212) 873-4214

O'NEIL, CAROL
New York, NY
(212) 535-7829

O'NEILL, PEGGY
New York, NY
(212) 734-6288, (212) 757-6300

OUELLETTE, DAWN
New York, NY
(212) 799-9190

PEISTER, ELLYN
New York, NY
(212) 759-7582

PUSKARCIK, JOANN
New York, NY
(212) 679-5537

RANDAZZO, BARBARA
New York, NY
(212) 592-1835

RAPP, NANCY
New York, NY
(212) 986-4393

REILLY, VERONICA
New York, NY
(212) 840-1234

ROBERTS, ANGELA
New York, NY
(212) 652-7073

ROBINS, JOAN C.
New York, NY
(212) 977-7157

RYANN, VERONICA
New York, NY
(212) 675-4359

SAMPSON, LINDA
New York, NY
(212) 925-6821

SCUPP, KATHLEEN
New York, NY
(212) 673-7960

SENATORE, BEVERLY
New York, NY
(212) 473-3525, (212) 675-8800

SEYMOUR, CELESTE
New York, NY
(212) 744-3545

SILVER, BEVERLY
New York, NY
(212) 684-2094

SILVERBLATT, JOANNA
New York, NY
(212) 977-7157

SINGER, LAURA
New York, NY
(212) 255-5506

SLATTERY, SHARON
New York, NY
(212) 930-2551

SLOTE, INA
New York, NY
(212) 679-4584

SMITH, HELEN
New York, NY
(212) 533-5384

SMITH, ROSE
New York, NY
(212) 758-8711

SOKOLEE, JERRI
New York, NY
(212) 888-6030

SPECHT, MEREDITH
New York, NY
(212) 832-0750

STALEY, ETHELEEN
New York, NY
(212) 362-6428

STOCKLAND, JILLAYNE
New York, NY
(212) 243-6493

STYLE ANTICS
New York, NY
(212) 223-0032

SWENSON, ANDREA B.
New York, NY
(212) 673-0810

TAYLOR, BILLY
New York, NY
(212) 532-2925

TILLMAN, EDNA
New York, NY
(212) 691-3325

TINT, FRANCINE
New York, NY
(212) 233-8989, (212) 475-3366

TURK, BARBARA
New York, NY
(212) 674-6605

WALLACE, REGIS
New York, NY
(212) 684-6026

WALSH, HONORE
New York, NY
(212) 737-7107

WATSON, LORYE
New York, NY
(212) 247-6639

WELSH, BILL
New York, NY
(212) 741-0935

WILLIS, BARBARA
New York, NY
(212) 582-4240

WILSON, PAT
New York, NY
(212) 285-1154

WILSON, PATTI
New York, NY
(212) 861-7225

WINNIE, JOANNE
New York, NY
(212) 691-8997

WINSTON, MARY ELLEN
New York, NY
(212) 879-0766

YNOCENCIO, JO
New York, NY
(212) 348-5332

ZINO, JENNIE
New York, NY
(212) 254-0198

Northeast

BAILEY DESIGNS
Malden, MA
(617) 321-4448

BALDWIN, KATHERINE
Boston, MA
(617) 267-0508

CASE, CAROL
Alpine, NJ
(201) 767-1041

GOLD, JUDY
Scarsdale, NY
(914) 723-5036

GUTMAN, LIZ
New Haven, CT
(203) 777-8170

IMMERMAN, KATHY
Oyster Bay, NY
(516) 922-3360

JUDY
Suffern, NY
(914) 357-7494

LITTMAN, ROSEMARY
Teaneck, NJ
(201) 833-2417

MONA, DIANA
Baltimore, MD
(301) 235-5971

MULLE, CHARLES
Deer Park, NY
(516) 242-5637

PINDART, MANETTE
Haddam, CT
(203) 345-4450

ROSEMARY'S CAKES INC.
Teaneck, NJ
(201) 833-2417

ROSS, GRETCHEN
Montclair, NJ
(201) 746-1607

SHEERAN, KAY
Upper Montclair, NJ
(201) 744-0333

TRUPP, TERRI
Baltimore, MD
(301) 462-4085

VOLK, SUSAN
Baltimore, MD
(301) 425-0653

Southeast

AMBERGER, SHARYN
Miami Beach, FL
(305) 531-4932

BOLQUERIN, PATTI
Longwood, FL
(305) 862-4746

COLBY, TERRY
Atlanta, GA
(404) 876-6676

DOERR, DEAN
Oklahoma City, OK
(405) 751-0313

FEINMAN, ELLYN
Coral Gables, FL
(305) 666-1520

FERTITTA, SALLY
Key Biscayne, FL
(305) 361-7202

GAFFNEY, JANET D.
Atlanta, GA
(404) 355-7556

GILLEN, NANCY
North Miami Beach, FL
(305) 944-7334

IVEY, DON
North Miami, FL
(305) 681-3735

KERWIN, ROONEY
Ft. Lauderdale, FL
(305) 791-0514

KUPERSMITH, AL
Atlanta, GA
(404) 577-5319

LIPSINER, LORENE S.
Miami, FL
(305) 932-6112

MARINA POLVAY ASSOC.
Miami Shores, FL
(305) 759-4375

MARX, MICHELE
Miami, FL
(305) 661-8501

NAIMAN (BYRNE),
　VALERIE E.
Miami, FL
(305) 358-9506

SHIELDS, JOANNE
Atlanta, GA
(404) 892-0754

STAR STYLED OF MIAMI
Miami, FL
(305) 649-3030

STAR STYLED OF TAMPA
Tampa, FL
(813) 872-8706

TAYLOR, BILLY
Miami, FL
(305) 665-0942

WEBB, CHARLENE H.
Atlanta, GA
(404) 458-4575, (404) 448-1739

Midwest

ALAN, JEAN
Chicago, IL
(312) 929-9768

BENVENTI, ROBBIE
Chicago, IL
(312) 975-0004

BOYD, SUE
Crystal, MN
(612) 533-8247

CAMYLLE
Chicago, IL
(312) 579-0100

CHEVAUX LTD.
Chicago, IL
(312) 935-5212

DOLBY, KATHY
Winnetka, IL
(312) 664-8526, (312) 835-3578

EASONT, ESTHER
Chicago, IL
(312) 944-6539

EMRUH STYLE DESIGN
Chicago, IL
(312) 871-4659

FLIS, DIANE
Minneapolis, MN
(612) 332-0441

FRENCH, FLORENCE
LaGrange, IL
(312) 246-5851

JACOBS, ROGER
Chicago, IL
(312) 787-1541

JOHNSON, KAREN
Deerfield, IL
(312) 664-6919

KRONE, JANE
Glen Ellyn, IL
(312) 469-4593

LANGE, ANN
Minneapolis, MN
(621) 378-2231

LARSON ASSOC.
Troy, MI
(512) 339-9289

MARTIN (GODSTED), PAT
Chicago, IL
(312) 881-4897

MATTS, DENNIS
Chicago, IL
(312) 329-1715

PAULSON, FRAN
Chicago, IL
(312) 943-2540

PETERSON, DOROTHY
Elmwood Pk., IL
(312) 453-0051

RABERT, BONNIE
Chicago, IL
(312) 743-7755

SAGER, SUE
Chicago, IL
(312) 642-3789

SCHEIMACHER, CAROLYN
Evanston, IL
(312) 787-8220

SEEKEN, CHRISTOPHER
Chicago, IL
(312) 944-4311

STANCIK, ILENE
Chicago, IL
(312) 929-7605

SZYMAREK, NANCY
Chicago, IL
(312) 625-9323

TWOLIPS
Chicago, IL
(312) 472-6550

Southwest

BISHOP, CINDY
Houston, TX
(713) 666-7224

COSTUME STUDIO
Lubbock, TX
(806) 763-3758

DIENES, BARBARA
Phoenix, AZ
(602) 264-9703

INGRAM, MARILYN WYRICK
Dallas, TX
(214) 349-2113

JENICCI
Dallas, TX
(214) 748-0939

West

ADELE
Los Angeles, CA
(213) 661-6539

AKIMBO PROD.
West Hollywood, CA
(213) 657-4657

ALAIMO, DORIS
Los Angeles, CA
(213) 851-7044

ALBERTA, W.
Los Angeles, CA
(213) 466-8466

ALLEN, JAMIE R.
Los Angeles, CA
(213) 655-9351

ALTBAUM, PATTI
Beverly Hills, CA
(213) 553-6269

ALYSKA
Los Angeles, CA
(213) 489-7456

ANABEL'S DIVERSIFIED
 SERVICES
Pacific Palisades, CA
(213) 454-1566

ANDERSON, JANE
Los Angeles, CA
(213) 655-8743

ASHLEY, LINDA
Studio City, CA
(213) 985-1484

AST, PAT
Los Angeles, CA
(213) 463-9381

AZZARA, MARILYN
Los Angeles, CA
(213) 876-2551

BAER, NONA
Los Angeles, CA
(213) 465-5853

BANKS, ROBBI
Los Angeles, CA
(213) 475-6338

BARBA, DAVID
Los Angeles, CA
(213) 388-2388

BECK, DORITA P.
North Hollywood, CA
(213) 980-6132

BELLOMO, MARILYN
Los Angeles, CA
(213) 475-9164

BERRY, MARILYN
Sepulveda, CA
(213) 546-1894, (213) 894-8835

BILES, SUZANNE
West Los Angeles, CA
(213) 475-6338

BOLES, RON
San Francisco, CA
(415) 731-3949

BOLOMET, PATRICIA
Los Angeles, CA
(213) 550-8500, (213) 466-4106

BURK, MARIE H.
Los Angeles, CA
(213) 855-1010, (213) 656-8766

BUTTER, SAMANTHA
Los Angeles, CA
(213) 650-5118

CARLTON, AMY
Los Angeles, CA
(213) 824-5846

CASTALDI, DEBBIE
Los Angeles, CA
(213) 475-4312

CHARLES, CORA
Los Angeles, CA
(213) 939-8655

CHINAMOON
Los Angeles, CA
(213) 937-8251

CHINN, JERRY
Seattle, WA
(206) 743-0608

COHEN, PHYLLIS
Los Angeles, CA
(213) 385-7740

CORO, MARGARET
Santa Monica, CA
(213) 453-1200

CORWIN-HANKIN, ALEKA
Los Angeles, CA
(213) 665-7953

CRAIG, KENNETH
Studio City, CA
(213) 995-8717

D'ALLORSO, CHRISTINA
San Francisco, CA
(415) 543-6056

DAN, JUDITH
Beverly Hills, 'CA
(213) 272-4757

DANIEL, MALISSA
Los Angeles, CA
(213) 383-0074

DARDEN, CYNTHIA
 GOYETTE
Los Angeles, CA
(213) 935-4101

DAVIS, ROMMIE
West Lake Village, CA
(213) 889-9680

DESIGN POOL
Los Angeles, CA
(213) 826-1551

DONON, STEPHANIE
Marina del Rey, CA
(213) 823-8344

EASTMAN, ROBIN LYNN
Northridge, CA
(213) 360-3946

EIS, MARGIE
Encino, CA
(213) 345-9258

EKMEKJI, RAFFI
Bel Air, CA
(213) 476-4254

ELISE, DANA (R. E.)
Beverly Hills, CA
(213) 274-6395, (213) 934-5854

ENYART, NANCEE
West Hollywood, CA
(213) 657-4657

EVONNE
Los Angeles, CA
(213) 275-1658

FERRY, PATRICIA
Hollywood, CA
(213) 874-6372

FLATING, JANICE
Los Angeles, CA
(213) 653-1800

FOREMAN, BIRTE
Los Angeles, CA
(213) 933-1176

FOREMAN, SHARMAN
Los Angeles, CA
(213) 469-4610

FRANK, JUSTINE
Los Angeles, CA
(213) 933-0738

FRANK, TOBI
Los Angeles, CA
(213) 552-7921

GADBOIS, MAGGIE
Los Angeles, CA
(213) 380-9584

GAFFIN, LAURI
Santa Monica, CA
(213) 451-2045

GERBER, SANDI
Los Angeles, CA
(213) 935-9317

GILMORE, LILA
Los Angeles, CA
(213) 462-2735

GLESBY, ELLEN
Los Angeles, CA
(213) 477-4648

GOOD, LOIS B.
Los Angeles, CA
(213) 874-0839

GOVERNOR, JUDY
San Francisco, CA
(415) 861-5733

GRAHAM, VICTORY
Venice, CA
(213) 934-0990

GREENFIELD, RACHEL
Los Angeles, CA
(213) 656-8766

GRISWALD, SANDRA
San Francisco, CA
(415) 775-4272

GROWER, ROBIN
Venice, CA
(213) 392-5922

HAMILTON, BRYAN J.
Los Angeles, CA
(213) 654-9006

HANAAN, MARVA
Los Angeles, CA
(213) 654-8766

HANDEL, ERIC
Los Angeles, CA
(213) 483-8516

HANKINS, CONNIE
Los Angeles, CA
(213) 936-1869

HARKRIDER, JOHN
Los Angeles, CA
(213) 392-1780

HEALY, KIM
Tarzana, CA
(213) 705-1669

HENRY, LAUREN
Los Angeles, CA
(213) 343-8346

HEWETT, JULIE
Los Angeles, CA
(213) 852-9670

HILL, BONNIE
Los Angeles, CA
(213) 656-9766

HIRSCH, LAUREN
Los Angeles, CA
(213) 271-7052

HMS
Santa Monica, CA
(213) 829-5700

HMS BOOKINGS
Los Angeles, CA
(213) 469-4610, (213) 464-1112

HORNY, HARRIET
Venice, CA
(213) 392-6325

HOWELL, DEBORAH
Los Angeles, CA
(213) 935-7543

IGNON, MICHAELE
Los Angeles, CA
(213) 656-8766

JAMES, ELIZABETH
North Hollywood, CA
(213) 761-5718

JENKINS, J. J.
Los Angeles, CA
(213) 465-5016

JENKINS, LIZABETH
Los Angeles, CA
(213) 465-5016

JOHNSTON, RENEE
Los Angeles, CA
(213) 851-2525

JORDAN, SANDRA KARTOON
Los Angeles, CA
(213) 876-2552

KAMINSKI, DIANE
South Pasadena, CA
(213) 799-8830

ANN KARLTON TALENT INT.
Kailua, Hawaii
(808) 262-0849 Telex 7236396
 KRLTN

KEASBERRY, MARGARET

Beverly Hills, CA
(213) 652-6459

KEIKO
Los Angeles, CA
(213) 874-7337

KELLY, KRISTIE
Los Angeles, CA
(213) 876-8437

KIMBALL, LYNNDA
Beverly Hills, CA
(213) 656-5500

KING, MAX
Los Angeles, CA
(213) 938-0108

KITCHEN CONSULTANTS
Whittier, CA
(213) 696-8831

KOELLE
Venice, CA
(213) 396-4496

KUHN, ANNETTE
Culver City, CA
(213) 391-6094

LAWSON, KAREN
Los Angeles, CA
(213) 464-5770

LEARNED, SANDRA
San Francisco, CA
(415) 388-7791

LOMBARDI, PIE
Los Angeles, CA
(213) 462-7362, (213) 874-6339

LOVE, SANDI
Los Angeles, CA
(213) 656-8766

LYNCH, JODY
Malibu, CA
(213) 456-2383

MacGREGOR, HELEN
Los Angeles, CA
(213) 656-8766

MACIAS, FRANK
Los Angeles, CA
(213) 934-9118

MAGANA, SAUNDRA K.
Los Angeles, CA
(213) 938-4975

MANCHE, KATE
Los Angeles, CA
(213) 658-5635

MARCHER, JAME
Los Angeles, CA
(213) 478-2829

MARCUS, ANDREA
Beverly Hills, CA
(213) 274-7089

GAIL MARELL HAS STYLE
San Francisco, CA
(415) 543-3314

MARGO, SHERRY
Beverly Hills, CA
(213) 275-8091

MAXWELL, SUSAN
Los Angeles, CA
(213) 933-3067

McDERMOTT, KATE
Los Angeles, CA
(213) 935-4101

McLEAN, CONSTANCE
Studio City, CA
(213) 506-8930

MICHELS, PATTY
Culver City, CA
(213) 225-8919

MINCH, MICHELLE
Los Angeles, CA
(213) 938-1223

MIND'S EYE PRODUCTION
 SERVICE
Tiburon, CA
(415) 383-7839

MOHR, JANE
Encino, CA
(213) 986-0194

MOORE, FRANCIE
Los Angeles, CA
(213) 462-5404

MORROW, SUZANNE
Palos Verdes, CA
(213) 378-2909

MOUGIN, MAEERA
Los Angeles, CA
(213) 464-0497

NAGLE, PATSY
Los Angeles, CA
(213) 275-5575

NATASHA
Los Angeles, CA
(213) 663-1477

NATHAN, AMY
San Francisco, CA
(415) 457-0767

NEAL, ROBIN LYNN
Hollywood, CA
(213) 465-6037

NORMAN, JESSICA
Los Angeles, CA
(213) 473-4617

OLSEN, EILEEN
Beverly Hills, CA
(213) 273-4496

PARSHALL, MARY ANN

Malibu, CA
(213) 456-8303

PARTCH, PAVLA
Los Angeles, CA
(213) 934-5015, (213) 938-7667

PEARSON, KANDACE
Reseda, CA
(213) 705-4276

PEIFFER, FREDERIQUE
Los Angeles, CA
(213) 855-7895

PERSPECTIVES UNLIMITED
Honolulu, HI
(808) 734-6017

PHOTO PRODUCTIONS
San Francisco, CA
(415) 392-5985

PRE-PRODUCTION WEST
Los Angeles, CA
(213) 656-8766

PRINDLE, HOWARD
Los Angeles, CA
(213) 661-6996

PRINDLE, JUDY PECK
Los Angeles, CA
(213) 650-0962

READ, BOBBIE
Los Angeles, CA
(213) 352-0372

RICHARDSON, SARAH
Los Angeles, CA
(213) 738-9021, (213) 384-9952

ROHRER, SUE ELLEN
Los Angeles, CA
(213) 936-2695

ROSS, JEFFREY
Santa Monica, CA
(213) 306-2695, (213) 450-5016

RUSSO, LESLIE
Santa Monica, CA
(213) 395-8461

SACKS, JOAN MARSHALL
Pacific Palisades, CA
(213) 459-5748

SANNA MAKEUP & STYLING
Van Nuys, CA
(213) 989-1985

SCHWARTZ, FRIDAY
Los Angeles, CA
(213) 553-2548, (213) 278-5140

SEIDEL, ELIN
Los Angeles, CA
(213) 937-3894, (213) 656-7762

SHATSY
Hollywood, CA
(213) 275-2413

SHAPIRO, LORRAINE
Los Angeles, CA
(213) 653-8899

SILVERBLATT, JOANNA
Santa Monica, CA
(213) 829-5700, (213) 464-1112

SINCLAIR, SHARON
Los Angeles, CA
(213) 434-0676

SKINNER, RANDY
Los Angeles, CA
(213) 659-2936

SLAYTER, CHER
Los Angeles, CA
(213) 656-8766

SLOANE, HILARY
Van Nuys, CA
(213) 855-1010

CAROL SMITH CENTER
Fox Hills, CA
(213) 641-3719

SMITH, SYLVIA
Phoenix, AZ
(602) 956-7647

STYLE BY MICHELS & YOUNG
Los Angeles, CA
(213) 484-1852

SURKING, HELEN
Los Angeles, CA
(213) 464-6847

SWAIN, BARBARA
Pasadena, CA
(213) 681-1769

SYNTONY
Beverly Hills, CA
(213) 271-2637

TAYLOR, CAROL DERING
Sherman Oaks, CA
(213) 784-1279

THOMAS, LISA
West Hollywood, CA
(213) 858-6903

TOWNSEND, JEANNE
Beverly Hills, CA
(213) 851-7044

TUCKER, JOAN
Los Angeles, CA
(213) 876-3417

TYRE, SUSAN
Los Angeles, CA
(213) 877-3884

VALADE
Los Angeles, CA
(213) 659-7621

VINCENT, ANTONIA
Los Angeles, CA
(213) 826-0982

WALKER, ALBERTA
Pasadena, CA
(213) 681-1960

WALTERS, CANDACE
Los Angeles, CA
(213) 462-5955

WATJE, JANICE FOX
Los Angeles, CA
(213) 835-8650

WEINBERG, JULIA
Los Angeles, CA
(213) 274-2283, (213) 820-1280

WEINSTEIN, RANDI
Los Angeles, CA
(213) 652-8511

WEISS, FREDDA
Beverly Hills, CA
(213) 476-6275

WEISS, SHERI
Los Angeles, CA
(213) 470-1650

WILLETTE, WILLIAM
Los Angeles, CA
(213) 659-8725

WILLIAMS, GREGORY
Los Angeles, CA
(213) 463-2234, (213) 655-7091

WILLIAMS, JENNY
Topanga, CA
(213) 455-1137

WILSON, SANDE
Lomita, CA
(213) 325-6876

WONG, KIM
Sunland, CA
(213) 353-6420

WONG, RITA
Whittier, CA
(213) 683-1749

WOOD, DURINDA RICE
Santa Monica, CA
(213) 450-3250, (213) 467-2242

YOUNG, PAMELA
Los Angeles, CA
(213) 484-1852

ZEITSOFF, LESLIE
Los Angeles, CA
(213) 466-7126

HAIR

New York City

ALBER-CARTER
New York, NY
(212) 688-2045

ALONZO, LOUIS
New York, NY
(212) 759-2959

BENJAMIN SALON
New York, NY
(212) 535-1563

COLELLO, JACK
New York, NY
(212) 977-7157

DAVIA SALON HAIR
 STYLING
New York, NY
(212) 535-1563

DEMETRIO, BRUNO
New York, NY
(212) 581-2760

DePALMA, LAWRENCE
New York, NY
(212) 861-7225

DeVEGA, LEONARDO
New York, NY
(212) 582-6895

GARREN AT THE PLAZA
New York, NY
(212) 755-3330

GEIGER, PAMELA
New York, NY
(212) 245-3496

GEORGE V HAIR STYLIST
New York, NY
(212) 687-9097

GROCHALA, STANLEY
New York, NY
(212) 683-3814

HARRISON, HUGH
New York, NY
(212) 689-9749

KELLER, BRUCE CLYDE
New York, NY
(212) 593-3816

KILLEBREW, JOHN
New York, NY
(212) 755-3330

KING, HARRY
New York, NY
(212) 929-1599

LE SALON
New York, NY
(212) 581-2760

MODA SEVEN HUNDRED
New York, NY
(212) 935-9188

MONSIEUR MARC INC.
New York, NY
(212) 861-0700

MOYSON, PHILLIP
New York, NY
(212) 929-6180

PEARSON, ROBERT
New York, NY
(212) 977-7157

PETER'S BEAUTY HOME
New York, NY
(212) 247-2934

PIERRO, JOHN
New York, NY
(212) 977-7157

MICHEL PIERRE, COIFFEUR
New York, NY
(212) 757-5175

PIPINO, MARC
New York, NY
(212) 759-2959

RICHARD AT THE CARLTON
New York, NY
(212) 751-6240

WEEKS, MICHAEL
New York, NY
(212) 757-5537

Northeast

BROCKLEBANK, TOM
Elmont, NY
(516) 775-5356

Southeast

APARICIO, IRENE
Miami, FL
(305) 642-2798, (813) 229-1331

BONAPARTE
South Miami, FL
(305) 666-0621

McGOWAN, DONISIA
 KENNEDY
Miami, FL
(305) 681-9754, (305) 685-2855

REGINA, RUTH
Miami Beach, FL
(305) 866-1226, (305) 531-1343

YELLOW STRAWBERRY
Ft. Lauderdale, FL
(305) 463-4343

Midwest

ADAMS, JERRY
Chicago, IL
(312) 642-7986

BURNS, TERRY
Chicago, IL
(312) 944-7557

KNIGHT, MICHAEL
Chicago, IL
(312) 944-7557

MOY, FE
Chicago, IL
(312) 728-3865

Southwest

TOM BROCKLEBANK HAIR
 STYLIST
Dallas, TX
(214) 350-3158

CHELSEA CUTTERS
Houston, TX
(713) 529-4813

SOUTHERN HAIR DESIGNS
Austin, TX
(512) 346-1734

West

ABELL, HENRY
Beverly Hills, CA
(213) 652-5766

ABELL, SALLY
Beverly Hills, CA
(213) 652-5766

M. ANATRA HAIRCUTTERS
Los Angeles, CA
(213) 655-7160

BARRON, FRANK
Los Angeles, CA
(213) 659-4917

BARRONSON HAIR
Studio City, CA
(213) 763-4337

BECK, SHIRLEY
Los Angeles, CA
(213) 763-2930

BLONDELL, KATHY
Los Angeles, CA
(213) 342-6490

THE BOULEVARD
 HAIRCUTTERS
Los Angeles, CA
(213) 858-8951

BRADSHAW, RICHARD
Beverly Hills, CA
(213) 274-8575

CARRASCO, EDUARDO
Los Angeles, CA
(213) 938-0376

COMA, B.
Los Angeles, CA
(213) 657-4551

CROSBY, FERNANDO
Los Angeles, CA
(213) 826-1551, (213) 820-3654

DANIELLE
Los Angeles, CA
(213) 652-1125

DRAKE, LEONARD
Los Angeles, CA
(213) 851-6333

EBER, JOSE
Beverly Hills, CA
(213) 278-3109

EDWARDS, ALLEN
Beverly Hills, CA
(213) 274-8575

ELY, SHANNON
Los Angeles, CA
(213) 392-5832

FIGIOLI, SANDY
Hollywood, CA
(213) 462-2345

FISHER, JIM
Los Angeles, CA
(213) 550-5946

FRIED, TOM
Beverly Hills, CA
(213) 277-7045, (213) 934-5854

FRIER, GEORGE
Los Angeles, CA
(213) 393-0576

GERMAINE, SUSAN
Los Angeles, CA
(213) 874-5179

GRIEVE, GINGER
Los Angeles, CA
(213) 347-2947

GRILL, DAMION
Los Angeles, CA
(213) 841-2206

GURASICH, LYNDA
Los Angeles, CA
(213) 981-6719

THE HAIR CONSPIRACY
Studio City, CA
(213) 985-1126

HANNAN, MARVA
Los Angeles, CA
(213) 654-8766

HENDERSON, DALEE

West Hollywood, CA
(213) 659-0352

HILL, BONNIE
Los Angeles, CA
(213) 656-8766

HJERPE, WARREN
Los Angeles, CA
(213) 550-5946

HMS
Santa Monica, CA
(213) 829-5700

HOLCOMB, BRAD
Beverly Hills, CA
(213) 273-3310, (213) 852-9807

IVERSON, BETTY
Los Angeles, CA
(213) 462-2301

KAREEN
Beverly Hills, CA
(213) 278-4431

KEMP, LOLA
Los Angeles, CA
(213) 293-8710

LAWSON, PETER
Los Angeles, CA
(213) 469-4610, (213) 464-1112

LINTERMAN'S
Beverly Hills, CA
(213) 276-3109

LORENZ, BARBARA
Los Angeles, CA
(213) 657-0028

LU, PETER
Los Angeles, CA
(213) 657-4551

MALONE, JOHN
Los Angeles, CA
(213) 246-1649

McDOW, RAHN
Los Angeles, CA
(213) 413-5496, (213) 469-4610

MÉNAGE A TROIS
Beverly Hills, CA
(213) 278-4431

MICHAEL JOHN SALON
Beverly Hills, CA
(213) 278-8333

MILLER, PATTY
Los Angeles, CA
(213) 843-5208

MITSU
Beverly Hills, CA
(213) 278-7055

MITSU
Los Angeles, CA
(213) 658-6987

MOLONEY, JOHN
Studio City, CA
(213) 985-1126

MORRISSEY, JIMIE
Los Angeles, CA
(213) 657-4318

PASCAL
Beverly Hills, CA
(213) 278-8333

PAYNE, ALLEN
Los Angeles, CA
(213) 395-5259

JON PETER'S SALON
Beverly Hills, CA
(213) 274-8575

PHILLIPS, MARILYN
Los Angeles, CA
(213) 923-6996

REILLY, JEAN BURT
Los Angeles, CA
(213) 766-4716

RIGNEY, ROBERT
Los Angeles, CA
(213) 876-8500

ROBINETTE, STEVE
Los Angeles, CA
(213) 204-3168

RUMOURS
Los Angeles, CA
(213) 550-5946

SAMI
Los Angeles, CA
(213) 652-5816

SAMUEL, MARTIN
Los Angeles, CA
(213) 930-0794

SASSOON, VIDAL
Beverly Hills, CA
(213) 553-6100

SPIRIT, JEFFREY
Los Angeles, CA
(213) 657-5665

TORRES, RICHARD
Los Angeles, CA
(213) 657-4551

TRAINOFF, LINDA
Los Angeles, CA
(213) 769-0373

VECCHIO, FAITH
Los Angeles, CA
(213) 345-6152

WEIS, JIMMY
Los Angeles, CA
(213) 826-1551, (213) 820-3654

WILLIAM & DONALD HAIR
SALON

Venice, CA
(213) 399-7705

WOLFE, SAMUEL
Los Angeles, CA
(213) 998-8982, (213) 874-4000

ZENOBIA, KEITH
Beverly Hills, CA
(213) 858-1401

MAKEUP

New York City

ADAMS, RICHARD
New York, NY
(212) 977-7157

BARNES, BYRON
New York, NY
(212) 758-6295

BERTOLI, MICHELE
New York, NY
(212) 684-2480

BERZJON, ROBERT
New York, NY
(212) 977-7157

BONSIGNOR'S COSMETICS
New York, NY
(212) 267-1108

BOWDEN, PATRICIA
New York, NY
(212) 254-6990

ESPOSITO, PEGGY
New York, NY
(212) 244-4270

KRAMER & KRAMER
New York, NY
(212) 688-4364

LAWRENCE, ROSE
New York, NY
(212) 861-7225

LEVY, SOPHIE
New York, NY
(212) 759-2959

MAKEUP CENTER LTD.
New York, NY
(212) 977-9494

MALLER, BONNIE
New York, NY
(212) 594-3679

NASSO, VINCENT
New York, NY
(212) 925-6594

NUTRIANCE
New York, NY

(212) 288-2951

PLACE, STAN
New York, NY
(212) 977-7157

PUMA, JOAN
New York, NY
(212) 925-3058

RICHARDSON, JOHN
New York, NY
(212) 861-7225

ROSE ROSS COSMETICS
New York, NY
(212) 586-2590

JANET SARTIN OF PARK AVE
LTD.
New York, NY
(212) 751-5858

SNYDER, LYDIA
New York, NY
(212) 752-7676, (212) 861-7225

STAGE LIGHT COSMETICS
LTD.
New York, NY
(212) 757-4851

STOCKLAND, JILLAYNE
New York, NY
(212) 243-6493

WESTMORELAND, BILL
New York, NY
(212) 944-1947

SUZANNE DE PARIS
New York, NY
(212) 838-4024

Northeast

BROWN, BOBBI
Boston, MA
(617) 267-4062

DENTEL
Boston, MA
(617) 267-6400

DAMASKOS, ZOE E.
Cambridge, MA
(617) 547-4080

DAVIDSON, WENDY
Cambridge, MA
(617) 491-7898

ROBERT GILMORE ASSOC.
INC.
Dedham, MA
(617) 329-6633

KEHOE, VINCENT, JR.
Lowell, MA
(617) 459-9864

PHILLIPE, LOUISE MILLER
Brookline, MA
(617) 566-3608

PHILLIPE, ROBERT
Brookline, MA
(617) 566-3608

PISCES UNLIMITED INC.
Brookline, MA
(617) 566-3608

ZACK, SANDRA
E. Boston, MA
(617) 567-7581

Southeast

DEL RUSSO, GUY
Miami, FL
(305) 822-2472

FEINMAN, ELLYN
Coral Gables, FL
(305) 666-1250

LYNN GODDARD
PRODUCTION SERVICES
New Orleans, LA
(504) 367-0348

KERWIN, DUTCHESS
Ft. Lauderdale, FL
(305) 791-0514

KRIEGER, ELLYN
Coral Gables, FL
(305) 666-1250

LAWRENCE-BARRY, SUSAN
Miami Beach, FL
(305) 864-9820

SANTORO, LISA
Coconut Grove, FL
(305) 655-5183

STAR STYLED OF MIAMI
Miami, FL
(305) 649-3030

STAR STYLED OF TAMPA
Tampa, FL
(813) 872-8706

Midwest

BOYD, SUE
Crystal, MN
(612) 533-8247

CAMYLLE OF M. MIGLIN
Chicago, IL
(312) 943-1120

EKLUND, TERRY
Minneapolis, MN

(612) 522-7664

EMRICH STYLE & DESIGN
Chicago, IL
(312) 871-4659

PUFFER, LESLIE
Chicago, IL
(312) 649-9654

RUSO, AMBER
Minneapolis, MN
(612) 823-8851

THE WHITE HOUSE STUDIOS
Kansas City, MO
(816) 931-3608

Southwest

BECK, JACKIE J.
Dallas, TX
(214) 321-1400

CHELSEA CUTTERS
Houston, TX
(713) 529-4813

COPELAND, TOM
Austin, TX
(512) 825-0208

COREY, IRENE
Dallas, TX
(214) 528-4836

DOBES, PAT
Houston, TX
(713) 465-8102

THE GERALDON AGENCY
Dallas, TX
(214) 522-1430

INGRAM, MARILYN WYRICK
Dallas, TX
(214) 349-2113

JENICCI
Dallas, TX
(214) 748-0939

JONES, RICH L.
Houston, TX
(713) 772-9326

MAHOE, NANETTE
Dallas, TX
(214) 363-7519

MESSERSMITH,
CHRISTOPHER
Dallas, TX
(214) 522-1430

SOUTHERN IMAGE
PRODUCTIONS
Austin, TX
(512) 346-1734

STAMM, LOUIS M.

Hurst, TX
(817) 268-5037

WILSON, BEAU
Dallas, TX
(214) 357-7953

West

ALTOBELL, PETER
Los Angeles, CA
(213) 769-2125

ANGELL, JEFF
Los Angeles, CA
(213) 278-6565

ASTLER, GUY
Los Angeles, CA
(213) 826-1551

BANKS, ROBBI
Los Angeles, CA
(213) 763-7916

BATES, CHRISTIE
Los Angeles, CA
(213) 789-9339

BEIGEL, PATTY
Studio City, CA
(213) 506-0611

BERKOWITZ, GARY
Los Angeles, CA
(213) 874-7399

BLACKMAN, CHARLES F.
North Hollywood, CA
(213) 761-2177

BLACKMAN, GLORIA
North Hollywood, CA
(213) 761-2177

BLANCO, DANIEL
Los Angeles, CA
(213) 858-8951

BOYER, CHRISTINE
Los Angeles, CA
(213) 654-6048

BRAINARD-SMITH, DELORES
Tucson, AZ
(602) 299-0041

CASE, TOM
Encino, CA
(213) 788-5268

CHILDS, SALLY
Los Angeles, CA
(213) 656-2300, (213) 466-8309

CLEMENTS, JOYCE
Tucson, AZ
(602) 299-0925

COHEN,
 PHYLLIS/ARTROUBLE

Los Angeles, CA
(213) 385-7740

COLE, THOMAS
Van Nuys, CA
(213) 988-5686

CONDON, KATHRYN A.
Los Angeles, CA
(213) 464-0300

COOPER, DAVID
Los Angeles, CA
(213) 660-7326

COSMETIC CONNECTION
Beverly Hills, CA
(213) 550-6242

CRAIG, LORI
Los Angeles, CA
(213) 656-8766

DAWN, WES
Los Angeles, CA
(213) 761-7515

THE DESIGN POOL
Los Angeles, CA
(213) 826-1551

DiBELLA, JOE
Los Angeles, CA
(213) 347-0068

D'IFRAY, T. J.
Beverly Hills, CA
(213) 274-6776

DiLORENZO, JO-ANN
North Hollywood, CA
(213) 760-0064

DRUZ, KEN
Los Angeles, CA
(213) 653-3610

DUBOIS, ANTONIO
Beverly Hills, CA
(213) 276-2477

EASTMAN, ROBIN LYNN
Northridge, CA
(213) 360-3946

FACES BY MICHAEL
Los Angeles, CA
(213) 386-9083

FONG, ELAYNE
Los Angeles, CA
(213) 663-9862

FRADKIN, JOANNE
Beverly Hills, CA
(213) 858-7038

FRANCESCA
Los Angeles, CA
(213) 787-6618

FREDREK, ROSE
Los Angeles, CA
(213) 473-5010

FREED, GORDON
Los Angeles, CA
(213) 360-9473

FRIEDMAN, ALAN
Studio City, CA
(213) 980-1515

FRIER, GEORGE
Los Angeles, CA
(213) 393-0576

GANDY, JOY
Los Angeles, CA
(213) 874-5049

GEIKE, ZIGGY
Los Angeles, CA
(213) 789-1465

GOLDEN, JAN
Santa Monica, CA
(213) 454-6922, (213) 664-3149

HARRIS, NATHALIE
Santa Monica, CA
(213) 393-6317

HENRIKSEN, OLE OF
 DENMARK
Beverly Hills, CA
(213) 278-6112

HENRY, LAUREN
Los Angeles, CA
(213) 343-8346

HEWETT, JULIE
Los Angeles, CA
(213) 852-9670

HOWELL, DEBORAH
Los Angeles, CA
(213) 935-7543

INZERELLA, JOHN
Los Angeles, CA
(213) 654-4159

JOHNS, ARTHUR
Hollywood, CA
(213) 855-9306

JOHNSON, JULIE
Van Nuys, CA
(213) 988-2318

JONES, JEFFREY
Los Angeles, CA
(213) 256-4404

JOY, BOBBE
Beverly Hills, CA
(213) 659-7556

KOELLE
Beverly Hills, CA
(213) 668-1690

KRUSE, LEE C.
Los Angeles, CA
(213) 894-5408

KRUZ, KEN

Los Angeles, CA
(213) 653-3610

LAURENT
Beverly Hills, CA
(213) 278-4431

LAWRENCE, RON
Los Angeles, CA
(213) 660-1472

LEMEL, MIRIAM
Studio City, CA
(213) 985-0044

LILIANA
Los Angeles, CA
(213) 654-7404, (213) 464-0300

LOGAN, KATHRYN
Los Angeles, CA
(213) 988-7038

JAN LOUISE INFINITY
 COSMETICS INC.
Beverly Hills, CA
(213) 276-4290

MAKEUP EFFECTS LAB
North Hollywood, CA
(213) 982-1483

MALONE, JOHN E.
Los Angeles, CA
(213) 246-1646

MANGES, DELAINE (DEE)
Los Angeles, CA
(213) 763-3311

MANGES, G. EDWIN
North Hollywood, CA
(213) 769-2696

MANISCALCO, ANN S.
Los Angeles, CA
(213) 894-5408

MASSARELLI, WAYNE
Los Angeles, CA
(213) 469-4610, (213) 464-1112

MAXWELL, AUDREY
Los Angeles, CA
(213) 931-5587, (213) 826-1551

MAXWELL, NORA
Los Angeles, CA
(213) 376-3950

McDONNEL, JAK
Los Angeles, CA
(213) 652-2158

McLYNN, PATRICK
Sherman Oaks, CA
(213) 986-1827

MÉNAGE À TROIS
Beverly Hills, CA
(213) 278-4431

MICHI
Los Angeles, CA

(213) 833-7533

MINCH, MICHELLE
Los Angeles, CA
(213) 938-1223

MOORMAN, ANN
Santa Monica, CA
(213) 394-6006

MUNCHWEILER, JERRY
Beverly Hills, CA
(213) 271-8881, (213) 656-8766

NATASHA
Los Angeles, CA
(213) 663-1477

NEAL, ROBIN LYNN
Hollywood, CA
(213) 465-6037

NIELSEN, JIM
Los Angeles, CA
(213) 461-2168

NYE, DANA
Los Angeles, CA
(213) 477-0443

ODESSA
West Hollywood, CA
(213) 873-4309

PALMIERI, DANTE
Los Angeles, CA
(213) 396-6020

PEARL, DOTTIE
Hollywood, CA
(213) 851-4186

PENELOPE
Los Angeles, CA
(213) 654-6747

PEYRAMAURE, LILY
Glendale, CA
(213) 246-1646
(Nails)

PIGMENTS
Beverly Hills, CA
(213) 858-7038

REYNOLDS, ALISON
Studio City, CA
(213) 762-7893

ROMERO, BOB
Sherman Oaks, CA
(213) 784-4583

ROTHSCHILD, SUSAN
Los Angeles, CA
(213) 476-6401

RUMOURS
Los Angeles, CA
(213) 550-5946

SAGLIANI, RICHARD
Los Angeles, CA
(213) 394-7990

SANDERS, NADIA
Los Angeles, CA
(213) 465-2009

SANNA MAKEUP & STYLING
Van Nuys, CA
(213) 989-1985

SCHNEIDER, MELA
Los Angeles, CA
(213) 876-8066, (213) 851-8241

SCHOENFELD, DON
Los Angeles, CA
(213) 849-3669

SCHULTZ, LISA
Los Angeles, CA
(213) 550-5946

SHARAH, RICHARD
Los Angeles, CA
(213) 826-1551

SHATSY
Los Angeles, CA
(213) 275-2413, (213) 464-8381

SHAW, CAROL
Los Angeles, CA
(213) 855-1554, (213) 278-7646,
 (213) 466-7126

SHULMAN, SHERYL LEIGH
Los Angeles, CA
(213) 760-0101

SIDELL, BOB
Los Angeles, CA
(213) 360-0794

SIMON, DAVIDA
North Hollywood, CA
(213) 469-5126

SIRKUS, DENISE
Santa Monica, CA
(213) 393-4073

SMITH, CAROL CENTER
Fox Hills, CA
(213) 641-2688

SMITH, CHRISTINA
Reseda, CA
(213) 999-0019

SMITH, SIMMONS, HALLIE
Los Angeles, CA
(213) 658-6267

SPIRIT, BONNIE
Sherman Oaks, CA
(213) 789-1615, (213) 657-5665

STABHOLZ, LIZ
Los Angeles, CA
(213) 654-0610

STRIEPKE, DANNY
Marina del Rey, CA
(213) 823-5957

TAMKIN, WINDY

Los Angeles, CA
(213) 550-1630, (213) 826-1551

THOMAS, MERRY LISA
West Hollywood, CA
(213) 858-6903

TUTTLE, WILLIAM
Los Angeles, CA
(213) 454-2355

VACCORO, RACHAEL
Los Angeles, CA
(213) 854-1022

VANITY, INC.
Los Angeles, CA
(213) 659-7011

VINCENT, ANTONIO
Los Angeles, CA
(213) 826-1551

WARDELL, MARIE-CLAUDE
Hollywood, CA
(213) 464-8381

WARREN, DODIE
Los Angeles, CA
(213) 763-3172

WESTMORE, MARVIN
Los Angeles, CA
(213) 908-0780

WESTMORE, MICHAEL
Los Angeles, CA
(213) 763-3158

WESTMORE, MONTY
Los Angeles, CA
(213) 762-2094

WESTON, EUGENIA
Tarzana, CA
(213) 259-0383

WHITBY, JANICE
Los Angeles, CA
(213) 763-4641

WILDER, BRAD
Los Angeles, CA
(213) 985-1010

WILSON, CHRIS
Los Angeles, CA
(213) 274-2952

WINSTON, STAN
Los Angeles, CA
(213) 886-0630

WINTERS, JEAN
Los Angeles, CA
(213) 766-6382

WOLF, BARBARA
Los Angeles, CA
(213) 466-4660

ZEITSOFF, LESLIE
Los Angeles, CA
(213) 466-7126

HAIR AND MAKEUP

New York City

ABRACOYA, CAROL
New York, NY
(212) 759-3400

ABRAMS, RON
New York, NY
(212) 580-0705

BEDNARZ, JOSEPH
New York, NY
(212) 861-7225

BLAKE, MANON
New York, NY
(212) 977-7157

BOUSHELLE
New York, NY
(212) 861-7225

BRAITHWAITE, JORDAN
New York, NY
(212) 977-7157

CAPPARELLI
New York, NY
(212) 935-9188

CINANDRE
New York, NY
(212) 758-4770

COLLAZO, ISABELL
New York, NY
(212) 977-7157

COSTANTINI, RAYMOND
New York, NY
(212) 861-7225

DE FAZIO, GARREN
New York, NY
(212) 756-5774

DEZENDORF, GARY
New York, NY
(212) 581-6470

DOMINIQUE INC.
New York, NY
(212) 246-3939

DOWNEY, MARTIN
New York, NY
(212) 977-7157

DUFFY, SUSAN
New York, NY
(212) 977-7157

DURHAM, SHELLY
New York, NY
(212) 757-2233

GARCIA, A.
New York, NY
(212) 889-3028

GORDON, ROBERT
New York, NY
(212) 861-7225

HAMMOND, CLAIRE
New York, NY
(212) 838-0712

HARRISON, CHRISTOPHER
New York, NY
(212) 889-2493

EDITH IMRE BEAUTY SALON
New York, NY
(212) 758-0233

JACOBS, ERIC
New York, NY
(212) 877-8444

JENRETTE, PAMELA
New York, NY
(212) 673-4748

JOSEPH
New York, NY
(212) 677-3990, (212) 898-6869

LANE, JUDY
New York, NY
(212) 861-7225

LEONARD, DAVID
New York, NY
(212) 246-3737

LOGAN
New York, NY
(212) 977-7157

LONGOBARDI, GERARD
New York, NY
(212) 861-7225

WILLIAM MALLE INC.
New York, NY
(212) 753-2326

MASTERWORKS
New York, NY
(212) 758-6295

NARVAEZ, ROBIN
New York, NY
(212) 977-7157

PATTNER, EMILY
New York, NY
(212) 977-7157

PIPKIN, ARNOLD
New York, NY
(212) 541-4787

PITTMAN, JANE
New York, NY
(212) 977-7157

REECE, DEBRA
New York, NY
(212) 489-8870

ROBERTS, KIM
New York, NY

(212) 599-0947

RODRIGUEZ, THOMAS
New York, NY
(212) 977-7157

SACCO, AMY
New York, NY
(212) 988-2591

SANSONE, BARBARA
New York, NY
(212) 861-7225

SCOTT, ARTHUR
New York, NY
(212) 977-7157

SEHVEN, AUGUST
New York, NY
(212) 758-6295

VEGA, ROBERTO
New York, NY
(212) 758-3966

VERDI, ROBERT
New York, NY
(212) 977-7157

VON WECHMAR, IRNFRIED
New York, NY
(212) 736-3266

TONY WAYNE ASSOC.
New York, NY
(212) 757-5398

WELLS, REGGIE
New York, NY
(212) 977-7157

Southeast

COLBY, TERRY
Atlanta, GA
(404) 876-6676

**FREDERICK'S "HAIRPEOPLE"
INC.**
Miami, FL
(305) 446-6654, (305) 445-5255

LAWRENCE, STAN
Miami Beach, FL
(305) 864-9820

STEPHANIE-JILL
Miami, FL
(305) 552-6200

Midwest

CHEVEUX, LTD.
Chicago, IL
(312) 549-5644

J. GORDON DESIGN

Chicago, IL
(312) 871-0770

JACOBS, ROGER
Chicago, IL
(312) 787-1541

JONES, RON FREDERICK
Chicago, IL
(312) 337-3600

SECKER, CHRISTOPHER
Chicago, IL
(312) 944-4311, (312) 943-3491

SWANSON, KATHIE
Lindenhurst, IL
(312) 943-2333

Southwest

**BACON, NANCY 'LIZABETH
ROSE**
Dallas, TX
(214) 350-9214

KIM DAWSON AGENCY INC.
Dallas, TX
(214) 638-2414

GARCIA, FREDERICK C.
San Antonio, TX
(512) 828-4571

ROCKWELL, JANIS A.
Houston, TX
(713) 862-6573

West

ALDRICH, SYBELLE
Phoenix, AZ
(602) 264-9703

M. ANATRA HAIRCUTTERS
Los Angeles, CA
(213) 655-7160

ANDRE, MAURICE
Beverly Hills, CA
(213) 278-7646

ANTONIO V
Los Angeles, CA
(213) 826-1551

ANTONIO V
Studio City, CA
(213) 763-0671

**ARMANDO HAIR & MAKEUP
STUDIO**
West Hollywood, CA
(213) 657-5160

ARMANDO'S
Los Angeles, CA

(213) 273-6651

ASTOR'S PEOPLE
Los Angeles, CA
(213) 851-0185

BARRON
Studio City, CA
(213) 763-4337

BEVERLY HILLS TRAMPP
West Hollywood, CA
(213) 652-5766

BJORN
Beverly Hills, CA
(213) 550-5935

BOOKER, COLIN
Los Angeles, CA
(213) 654-4751

BOURGET, LORRAINE
Pacific Palisades, CA
(213) 454-3739

BRIGGS, RHAVAN
Los Angeles, CA
(213) 383-4291

CAREN
La Crescenta, CA
(213) 249-3623

CASSANDRE 2000
Tarzana, CA
(213) 881-8400

CHRISTENSEN, JAETTE
North Hollywood, CA
(213) 980-6132

CRAIG, KENNETH
Studio City, CA
(213) 995-8717

DAVIDA, SIMON
North Hollywood, CA
(213) 469-5126, (213) 760-1512

DESIGN POOL
Los Angeles, CA
(213) 826-1551, (213) 820-3654

ELISE, DANA (R. E.)
Beverly Hills, CA
(213) 274-6395, (213) 934-5854

EVONNE
Los Angeles, CA
(213) 275-1658

EXLEY, SUSAN
Hollywood, CA
(213) 467-7693

FLINT, BOBBY
Los Angeles, CA
(213) 650-6211

FRANCES, SHARON
Los Angeles, CA
(213) 456-7126, (213) 654-0422

GEIGER, PAMELA

Los Angeles, CA
(213) 274-5737

GOOD, ELAINE
Los Angeles, CA
(213) 275-6094, (213) 496-4610

HAMILTON, BRYAN J.
Los Angeles, CA
(213) 654-9006

HARRIS, GARY
Los Angeles, CA
(213) 466-7126

HIRST, WILLIAM
Los Angeles, CA
(213) 501-0993

HJERPE, WARREN
Los Angeles, CA
(213) 550-5946

HMS
Santa Monica, CA
(213) 829-5700

HMS BOOKINGS
Los Angeles, CA
(213) 496-4610, (213) 464-1112

JACKSON, VICKI
Los Angeles, CA
(213) 659-7549, (213) 826-1551

JACOBS, JOSEPH
Los Angeles, CA
(213) 656-8756

JOHNS, ARTHUR
West Hollywood, CA
(213) 855-9306

JONATHAN
Hollywood, CA
(213) 467-7693

JORDAN, SANDRA KARTOON
Los Angeles, CA
(213) 876-2552

JOSEPH, CINDY
San Francisco, CA
(415) 865-4665

KRAUSE, PAMELA
Los Angeles, CA
(213) 656-8766

LEONARD, DAVID
Los Angeles, CA
(213) 656-8766

LINWOOD
Los Angeles, CA
(213) 656-8766

LORETTA
Los Angeles, CA
(213) 275-7872

MAURICE, JOSE
Beverly Hills, CA
(213) 278-7646

McKAY, PAUL
North Hollywood, CA
(213) 761-6841

NEALZ, LE
Beverly Hills, CA
(213) 273-4309

OHEN
Los Angeles, CA
(213) 655-4452

OWEN, PAULA
Los Angeles, CA
(213) 824-5180

PARSONS, PATRICIA
Beverly Hills, CA
(213) 278-7103

PASCAL
Los Angeles, CA
(213) 933-3544

PAULI, DENISE
West Hollywood, CA
(213) 654-6155

PEARSON, KANDACE
Reseda, CA
(213) 705-4276

JON PETERS SALON
Beverly Hills, CA
(213) 274-8575

PILAIT, JOHN
Hollywood, CA
(213) 462-2345

PLAZA 3
Phoenix, AZ
(602) 264-9703

PRE-PRODUCTION WEST
Los Angeles, CA
(213) 656-8766

PROCTER-LAMBE, TONY
Los Angeles, CA
(213) 852-0860, (213) 826-1551

RAY, DAVID FRANK
Venice, CA
(213) 392-5640

ROSS, JEFFREY
Santa Monica, CA
(213) 306-2695, (213) 450-5016

SCHAFF, INGRID
Studio City, CA
(213) 766-9666

SERENA, ERIC
West Hollywood, CA
(213) 652-4267

SIMON, DAVIDA
North Hollywood, CA
(213) 760-1512, (213) 469-5126

SONG, MICKEY
Beverly Hills, CA

(213) 274-8575, (213) 469-4610

TOWSEND, JEANNE
Beverly Hills, CA
(213) 851-7044

TURNAGE, JERRY
Los Angeles, CA
(213) 656-0734

WELSH, FRANKLYN
Los Angeles, CA
(213) 656-8195

COSTUMES

New York City

ABET RENT-A-FUR
307 Seventh Ave.,
New York, NY 10011
(212) 989-5757

AM COSTUME WEAR
135–18 Northern Blvd.,
Flushing, NY 11354
(212) 358-8108

ANIMAL OUTFITS FOR
 PEOPLE CO.
252 W. 46th St.,
New York, NY 10036
(212) 840-6219

AUSTIN LTD.
140 E. 55th St.,
New York, NY 10022
(212) 752-7903

AUTHENTIQUES
255 W. 18th St.,
New York, NY 10011
(212) 675-2179

G. BANK'S THEATRICAL &
 COSTUME
320 W. 48th St.,
New York, NY 10036
(212) 586-6476

ALFRED BARRIS WIG MAKER
165 W. 46th St.,
New York, NY 10036
(212) 354-9043

BROOKS-VAN HORN
 COSTUME CO.
117 W. 17th St.,
New York, NY 10011
(212) 989-8000

CAPEZIO DANCE THEATER
 SHOP
755 Seventh Ave.,
New York, NY 10019
(212) 245-2130

CHENKO STUDIO

167 W. 46th St.,
New York, NY 10036
(212) 944-0215

CRAFT CLERICAL
915 Broadway,
New York, NY 10010
(212) 533-1160

DAVID'S OUTFITTERS INC.
36 W. 20th St.,
New York, NY 10011
(212) 691-7388

EAVES COSTUME CO. INC.
423 W. 55th St.,
New York, NY 10019
(212) 757-3730

FONDA'S
168 Lexington Ave.,
New York, NY 10016
(212) 679-9183

GRACE COSTUMES INC.
254 W. 54th St.,
New York, NY 10019
(212) 586-0260

HERBERT DANCEWARE CO.
902 Broadway,
New York, NY 10010
(212) 677-7606

IAN'S BOUTIQUE INC.
1151A Second Ave.,
New York, NY 10021
(212) 838-3969

KARINSKA
16 W. 61st St.,
New York, NY 10023
(212) 247-3341

KULYK
84E Seventh Ave.,
New York, NY 10011
(212) 674-0414

LANE COSTUME CO.
507 Fifth Ave.,
New York, NY 10017
(212) 697-3664

MANWARING STUDIO
232 Atlantic Ave.,
Brooklyn, NY 11201
(212) 855-2796

MARTIN, ALICE MANOUGIAN
239 E. 58th St.,
New York, NY 10022
(212) 688-0117

JIMMY MEYER & CO.
428 W. 44th St.,
New York, NY 10036
(212) 246-5769

MICHAEL-JON COSTUMES
 INC.

353 W. 12th St.,
New York, NY 10014
(212) 675-4508

MINCOU, CHRISTINE
405 E. 63rd St.,
New York, NY 10021
(212) 838-3881

NOSTALGIA ALLEY
 ANTIQUES
380 Second Ave.,
New York, NY 10010
(212) 988-3949

PAVLOVA'S POINTE LTD.
35 W. Eighth St.,
New York, NY 10011
(212) 260-7885

PURCELL, ELISABETH
105 Sullivan St.,
New York, NY 10012
(212) 925-1962

RUBIE'S COSTUME CO.
120-08 Jamaica Ave.,
Richmond Hill, NY 11418
(212) 846-1008

TRUDI SELIGMAN ANTIQUE
 ARTS
82 W. 12th St.,
New York, NY 10011
(212) 929-8944

SELVA RETAIL CENTER
1776 Broadway,
New York, NY 10019
(212) 586-5140

STAR COSTUMERS CO.
600 W. 57th St.,
New York, NY 10019
(212) 581-1246

STIVANELLO COSTUME CO.
 INC.
102 Fifth Ave.,
New York, NY 10011
(212) 651-7715

TINT, FRANCINE
1 University Pl.,
New York, NY 10003
(212) 475-3366

UNIFORM CENTER
59 E. 59th St.,
New York, NY 10022
(212) 759-7523

UNIVERSAL COSTUME CO.
 INC.
1540 Broadway,
New York, NY 10036
(212) 575-8570

VALERIE FURS
150 W. 30th St.,

New York, NY 10001
(212) 947-2020

WEISS & MAHONEY INC.
142 Fifth Ave.,
New York, NY 10011
(212) 675-1915

WINSTON, MARY ELLEN
11 E. 68th St.,
New York, NY 10021
(212) 879-0766

YNOCENCIO, JO
302 E. 88th St.,
New York, NY 10028
(212) 348-5332

Northeast

AT-A-GLANCE RENTALS
712 Main,
Boonton, NJ 07005
(201) 335-1488

COSTUME ARMOUR INC.
Stewart Airport, P.O. Box 6086,
Newburgh, NY 12550
(914) 564-7100

HOUSE OF COSTUMES LTD.
166 Jericho Tpk.,
Mineola, NY 11501
(516) 294-0170

WESTCHESTER COSTUME
 RENTALS
540 Netterhan Ave.,
Yonkers, NY
(914) 337-6674

Southeast

ABC COSTUME
185 N.E. 59th St.,
Miami, FL 33137
(305) 757-3492

ANDRE & DELPHINE
808 N.E. 14th Ave.,
Ft. Lauderdale, FL 33304
(305) 524-0079, (305) 463-6973

ATLANTIC COSTUME CO.
2089 Monroe Dr.,
Atlanta, GA 30324
(404) 874-7511

BETTY BOOP COSTUMES
2113 Elliston Pl.,
Nashville, TN 37203
(615) 320-0181

LEE CAROL INC.
2145 N.W. 2nd St.,

Miami, FL 33125
(305) 573-1759

COSTUME CRAFTERS
2979 Peachtree Rd.,
Atlanta, GA 30305
(404) 237-8641

COSTUMES BY FAYE
213 Clematis St.,
West Palm Beach, FL 33480
(305) 832-1723

DIXON COSTUME SHOP
1828 Biscayne Blvd.,
Miami, FL 33132
(305) 371-8418

LYNN GODDARD
 PRODUCTION SERVICES
712 Pelican Ave.,
New Orleans, LA 70114
(504) 367-0348

MIAMI DANCEWEAR
352 N.E. 167th St.,
North Miami Beach, FL 33162
(305) 940-1762

POINCIANA SALES
2252 W. Flagler St.,
Miami, FL 33135
(305) 885-9136

QUALITY COSTUMES
7441 N.W. 72nd Ave.,
Miami, FL 33166
(305) 885-9136

STAR STYLED
475 W. 42nd Ave.,
Miami, FL 33140
(305) 649-3030

Midwest

BAILEY'S
25 Van Buren,
Chicago, IL 60605
(312) 939-2172

BALLWARE
740 N. Wells,
Chicago, IL 60610
(312) 642-4920

BARRINGTON, KIM
4637 N. Dover,
Chicago, IL 60640
(312) 334-2603

BROADWAY COSTUMES INC.
932 W. Washington,
Chicago, IL 60607
(312) 829-6400

F. BRUESSER CO.
441 Macomb St.,
Detroit, MI 48226
(313) 962-8266

CARSON PIRIE SCOTT & CO.
1 S. State St.,
Chicago, IL 60603
(312) 744-2000

CHICAGO COSTUME CO. INC.
725 W. Wrightwood Ave.,
Chicago, IL 60614
(312) 528-1264

COSTUMES UNLIMITED
814 N. Franklin St.,
Chicago, IL 60610
(312) 642-0200

COUNTRY FASHIONS
5239 N. Harlem,
Chicago, IL 60656
(312) 631-2818

DIVINE IDEA
2959 N. Clark,
Chicago, IL 60657
(312) 975-0909

MARSHALL FIELD & CO.
111 N. State St.,
835 N. Michigan,
Chicago, IL 60611
(312) 781-1000

FOLLIES
6981 N. Sheridan,
Chicago, IL 60626
(312) 761-3020

HOLLYWOOD-COSTUMES
22135 Michigan St.,
Dearborn, MI 48124
(313) 563-9111

IRV'S FORMAL WEAR
190 N. State St.,
Chicago, IL 60601
(312) 332-1395

KAUFMAN COSTUMES
5117 N. Western,
Chicago, IL 60625
(312) 561-7529

LA BELLE NOVELLE
70 E. Oak,
Chicago, IL 60611
(312) 280-0969

NY COSTUME CO.
P.O. Box 483,
De Kalb, IL 60115
(815) 756-1188

PROGRESS FEATHERS
657 W. Lake,
Chicago, IL 60606
(312) 726-7443

Southwest

A. & J. COSTUME RENTAL,
 DESIGN & CONSTRUCTION
304 White Oaks Dr.,
Austin, TX 78753
(512) 836-2733

COREY, IRENE
4147 Herschel Ave.,
Dallas, TX 75219
(214) 528-4836

GRAFICA: A TOTAL DESIGN
 CO.
3110 Fairmount,
Dallas, TX 75201
(214) 741-3810

JILL'S COSTUME & SPECIALTY
 SHOPPE
2460 Harry Wurzbach,
San Antonio, TX 78209
(512) 824-1814

ANN LIND—SECOND
 CHILDHOOD
3010 Windsor Rd.,
Austin, TX 78703
(512) 472-9696

MOREAU, SUZANNE
1007B W. 22nd St.,
Austin, TX 78705
(512) 477-1532

NICHOLSON, CHRISTINE, c/o
 LOLA SPROUSE
Carrollton, TX 76436
(214) 245-0926

PAUL OSBORNE &
 ASSOCIATES, INC.
1162 Security Dr.,
Dallas, TX 75247
(214) 630-7800

I. M. ROSEBUD, INC.
410 W. Avenue D,
Rosebud, TX 76570
(817) 583-7951

SMITH, JO KAREN
222 E. Riverside Dr., #333,
Austin, TX 78704
(512) 441-6955

WELCH, VIRGINIA L.
3707 Manchaca, #138,
Austin, TX 78704
(512) 447-1240

West

AAA CINEMA COSTUMERS
5514 Hollywood Blvd.,

Hollywood, CA 90028
(213) 464-9894

AARDVARK
7579 Melrose Ave.,
Los Angeles, CA 90046
(213) 655-6769

ADELE'S OF HOLLYWOOD
5059 Hollywood Blvd.,
Hollywood, CA 90027
(213) 663-2231

AMERICAN COSTUME CORP.
12980 Raymer,
N. Hollywood, CA 90028
(213) 764-2239

AUNTIE MAME
1102 S. La Cienega Blvd.,
Los Angeles, CA 90035
(213) 652-8430

BOSERUP HOUSE OF CANES
1636 Westwood Blvd.,
West Los Angeles, CA 90024
(213) 474-2577

THE BURBANK STUDIOS
WARDROBE DEPT.
4000 Warner Blvd.,
Burbank, CA 90024
(213) 743-6000

CALIFORNIA SURPLUS MART
6263 Santa Monica Blvd.,
Los Angeles, CA 90038
(213) 465-5525

CAPEZIO DANCEWEAR
1777 Vine St.,
Hollywood, CA 90028
(213) 465-3744

CBS WARDROBE DEPT.
7800 Beverly Blvd.,
Los Angeles, CA 90036
(213) 852-2345

COURTNEY, ELIZABETH
8636 Melrose Ave.,
Los Angeles, CA 90069
(213) 657-4361

CRYSTAL PALACE
(RENTALS)
835 N. Fairfax,
Los Angeles, CA 90046
(213) 651-5458

CRYSTAL PALACE (SALES)
8457 Melrose Ave.,
Hollywood, CA 90069
(213) 653-6148

DESIGN STUDIO
6685–7 Sunset Blvd.,
Hollywood, CA 90028
(213) 469-3661

EC-2 COSTUMES

431 S. Fairfax,
Los Angeles, CA 90036
(213) 934-1131

FANTASY FAIR INC.
4310 San Fernando Rd.,
Glendale, CA 90039
(213) 245-7367

FLOWER FASHIONS
9960 Santa Monica Blvd.,
Beverly Hills, CA 90067
(805) 272-6063

GLORY-B! LTD.
523 Brinkerhoff Ave.,
Santa Barbara, CA 93101
(805) 962-1140

I. C. COSTUME CO.
6121 Santa Monica Blvd.,
Hollywood, CA 90038
(213) 469-2056

INTERNATIONAL COSTUME
CO.
1269 Sartori,
Torrance, CA 90501
(213) 320-6392

J. & M. COSTUMERS
5010 Sunset Blvd.,
Los Angeles, CA 90027
(213) 660-5153

KING'S WESTERN WEAR
6455 Van Nuys Blvd.,
Van Nuys, CA 91401
(213) 785-2586

KROFFT ENTERTAINMENT,
INC.
7200 Vineland Ave.,
Sun Valley, CA 91352
(213) 875-3250

L.A. UNIFORM EXCHANGE
5239 Melrose Ave.,
Los Angeles, CA 90038
(213) 469-3965

MGM STUDIOS WARDROBE
DEPT.
10202 W. Washington Blvd.,
Culver City, CA 90320
(213) 836-3000

MILITARY ANTIQUES & WAR
MUSEUM
208 Santa Monica Ave.,
Santa Monica, CA 90401
(213) 393-1180

MYERS COSTUME
5538 Hollywood Blvd.,
Hollywood, CA 90028
(213) 465-6589

NUDIES RODEO TAILOR
5015 Lanskershim Blvd.,

North Hollywood, CA 90068
(213) 762-3105

PARAMOUNT STUDIOS
WARDROBE DEPT.
5451 Marathon St.,
Hollywood, CA 90038
(213) 468-5000

PEABODY'S
1102½ S. La Cienega Blvd.,
Los Angeles, CA 90035
(213) 352-3910

JERRY PILLER'S
8163 Santa Monica Blvd.,
Hollywood, CA 90069
(213) 654-3038

SAHER, D.
P.O. Box 1202,
Venice, CA 90291
(213) 396-7365

TUXEDO CENTER
7360 Sunset Blvd.,
Los Angeles, CA 90046
(213) 874-4200

VALUE SHOE MART
5637 Santa Monica Blvd.,
Los Angeles, CA 90038
(213) 469-8560

WESTERN COSTUME CO.
5335 Melrose Ave.,
Los Angeles, CA 90038
(213) 469-1451

WORKROOM 27
425 W. Los Feliz Rd.,
Glendale, CA 90039
(213) 245-0222

LOCATIONS

New York City

ACT TRAVEL
310 Madison Ave.,
New York, NY 10017
(212) 697-9550

JACKIE'S
1229 E. 82nd St.,
Brooklyn, NY 11236
(212) 763-9668, (212) 239-4149

JUCKES, GEOFF
295 Bennett Ave.,
New York, NY 10040
(212) 567-5676

ED LEACH INC.
100 Fifth Ave.,
New York, NY 10011
(212) 691-3450

LOCATION CONNECTION
31 E. 31st St.,
New York, NY 10016
(212) 684-1888

LOCATION LOCATORS
225 E. 63rd St.,
New York, NY 10021
(212) 832-1866

LOFT LOCATIONS
50 White St.,
New York, NY 10013
(212) 966-6408

MARKS, ARTHUR
140 E. 40th St.,
New York, NY 10016
(212) 685-2761

MOORE, BOB CARMICHAEL
P.O. Box 5, Village Sta.,
New York, NY 10014
(212) 255-0465

MOVIE CARS
825 Madison Ave.,
New York, NY 10021
(212) 288-6000

TERRESTRIS
409 E. 60th St.,
New York, NY 10022
(212) 758-8181

THIS MUST BE THE PLACE
2119 Albermarie Terr.,
Brooklyn, NY 11219
(212) 282-3454

UNGER, CAPTAIN HOWARD
80 Beach Rd.,
New York, NY 10013
(212) 639-3578

Northeast

BALDWIN, KATHERINE
109 Commonwealth Ave.,
Boston, MA 02116
(617) 267-0508

FORMA, BELLE
433 Clafin Ave.,
Mamaroneck, NY 10543
(914) 698-2598

BELL, KENNETH
16 Sunset Rd.,
Somerville, MA 02180
(617) 628-6931

BENSON, JOSEPH
12 Porter Rd.,
Cambridge, MA 02140
(617) 547-0477

CINEMAGRAPHICS
101 Trowbridge St.,
Cambridge, MA 02138
(617) 491-0966

CONNECTICUT STATE
 TRAVEL OFFICE
210 Washington St.,
Hartford, CT 06106
(203) 566-3383

COOPER PRODUCTIONS
175 Walnut St.,
Brookline, MA 02146
(617) 738-7278

VIRGINIA DEAN—TRIANGLE
 PRODUCTIONS
36 Vernon St.,
Brookline, MA 02146
(617) 232-1934

DELAWARE STATE TRAVEL
 SERVICE
630 State College Rd.,
Dover, DE 19901
(302) 736-4254

TIM DEWART ASSOC.
83 Standley,
Beverly, MA 01915
(617) 922-2373

DUDA, JULES
24 Edison Dr.,
Huntington Sta., NY 11746
(516) 427-5863

CHARLES EADS—MEDIA
 ARTS INC.
253 Summer St.,
Boston, MA 02210
(617) 426-5998

FLORENTINE FILMS, INC.
25 Main St.,
Northampton, MA 01060
(413) 584-0806

GALLOWAY, MARY
33 Granville Rd.,
Cambridge, MA 02138
(617) 492-5930

ROBERT GILMORE
 ASSOCIATES, INC.
990 Washington St.,
Dedham, MA 02026
(617) 329-6633

MARTY GOLDSTEIN—
 TRIANGLE PRODUCTIONS
36 Vernon St.,
Brookline, MA 02146
(617) 232-1934

JURGIELEWICZ, ANNIE
P.O. Box 422,

Cambridge, MA 01432
(617) 628-1141

KRAUSE, JANET L.
43 Linnaean St., #26,
Cambridge, MA 02138
(617) 492-3223

LEWIS, JAY
87 Ripley St.,
Newton Center, MA 02159
(617) 332-1516

THE LOCATION HUNTER
16 Iselin Terr.,
Larchmont, NY 10538
(914) 834-2181

LOCATION SCOUTING
 SERVICE
153 Sidney St.,
Oyster Bay, NY 11771
(516) 922-1759

LOCATION UNLIMITED
90 Brayton St.,
Englewood, NJ 07632
(201) 567-2809

MAGRO, BOB
44 Ashford St.,
Allston, MA 02134
(617) 783-0980

MAINE STATE
 DEVELOPMENT OFFICE
193 State St.,
Augusta, ME 04330
(207) 289-2656

MARLIN, GLEN
44 Ashford St.,
Allston, MA 02134
(617) 783-0980

MARRS, DEBORAH
42 Allen St.,
Arlington, MA 02174
(617) 646-5168

MARYLAND STATE
 ECONOMIC DIVISION
2525 Riva Rd.,
Annapolis, MD 21401
(301) 269-2051

MASSACHUSETTS STATE
 FILM BUREAU
100 Cambridge St.,
Boston, MA 02202
(617) 727-3330

McGLYNN, JACK
34 Buffum St.,
Salem, MA 01970
(617) 745-8764

METTLER, JUDY
34 Buffum St.,
Salem, MA 01970
(617) 567-2809

NEW HAMPSHIRE VACATION
 TRAVEL
P.O. Box 856,
Concord, NH 03301
(603) 271-2666

NEW JERSEY STATE MOTION
 PICTURE & TV
 DEVELOPMENT COMM.
Gateway One,
Newark, NJ 07102
(201) 648-6279

NORCROSS, GAIL E.
140 Mt. Vernon St.,
Boston, MA 02108
(617) 723-8374

NOZIK, MICHAEL
9 Cutler Ave.,
Cambridge, MA 02138
(617) 783-4315

PENNSYLVANIA DIVISION OF
 FILM PROMOTION
South Office Bldg.,
Harrisburg, PA 17120
(717) 787-5333

MONICA RANDALL
 LOCATION INC.
P.O. Box 75,
Oyster Bay, NY 11771
(516) 921-7438

RHODE ISLAND STATE
 TOURIST DIVISION
7 Jackson Wkwy.,
Providence, RI 02903
(401) 277-2601

SHAWN, RITA
87 Walnut Ct.,
Englewood, NJ 07632
(201) 568-1586

STRAWBERRIES FINDERS
 SERVICE
Bucks County,
Riegelsville, PA 18077
(215) 346-8000

JOE VERANGE—CENTURY III
545 Boylston St.,
Boston, MA 02116
(617) 267-9800

VERMONT STATE TRAVEL
 DIVISION
61 Elm St.,
Montpelier, VT 05602
(802) 828-3236

WASHINGTON, D.C., PUBLIC
 SPACE COMMITTEE
415 12th St. N.W.,
Washington, DC 20004
(202) 629-4084

WEST VIRGINIA STATE

FILM DEPARTMENT
1900 Washington St. E.,
Charleston, WV 25311
(304) 348-3977

WOOD, CAROL
7 Merritt St.,
Marblehead, MA 01945
(617) 631-4232

Southeast

ALABAMA STATE FILM
 COMMISSION
532 S. Perry St.,
Montgomery, AL 36104
(800) 633-5898

FLORIDA STATE MOTION
 PICTURE, TV SERVICE
107 W. Gaines St.,
Tallahassee, FL 32301
(904) 487-1100

GEORGIA STATE FILM
 OFFICE
P.O. Box 1776,
Atlanta, GA 30301
(404) 656-3591

THE GREAT SOUTHERN
 STAGE
15221 N.E. 21st Ave.,
North Miami Beach, FL 33162
(305) 947-0430

HEN'S TEETH
1206 Clifton Rd. N.E.,
Atlanta, GA 30307
(404) 378-6076

BRUNS, KEN & GAYLE
7810 S.W. 48th Court,
Miami, FL 33143
(305) 666-2928

KENTUCKY FILM
 COMMISSION
Capital Plaza Tower,
Frankfort, KY 40601
(502) 564-2240

McGOWAN, LINDA
14035 N.W. First Ave.,
Miami, FL 33168
(305) 685-2095, (305) 685-7095

MISSISSIPPI STATE FILM
 COMMISSION
P.O. Box 849,
Jackson, MS 39205
(601) 354-6715

KURT NAGLE STUDIOS
511 N.W. 72nd St.,
Miami, FL 33150
(305) 751-6165

NORTH CAROLINA STATE

MOTION PICTURE DEV.
430 N. Salisbury St.,
Raleigh, NC 27603
(919) 733-7651

O'NEAL, ALAN
P.O. Box 248543,
Coral Gables, FL 33124
(305) 661-5068

P. & W. COLOR LAB
260 N.E. 70th St.,
Miami, FL 33138
(305) 757-3996

PETRIK, NIK
P.O. Box 17801,
Tampa, FL 33682
(813) 234-7575

SOUTH FLORIDA LOCATION
 FINDERS
1214 Cortez St.,
Coral Gables, FL 33134
(305) 445-0739

TENNESSEE STATE
 ECONOMICS &
 COMMERCIAL
 DEVELOPMENT DEPT.
1007 Andrew Jackson Bldg.,
Nashville, TN 37219
(615) 741-1888

USVI FILM PROMOTION
 OFFICE
St. Thomas, VI 00801
(809) 774-1331

VIRGINIA STATE TRAVEL
 SERVICE
6 N. 6th St.,
Richmond, VA 23219
(804) 786-2051

Midwest

ILLINOIS STATE FILM OFFICE
205 W. Wacker Dr.,
Chicago, IL 60606
(213) 793-3600

INDIANA STATE TOURISM
 DEVELOPMENT
440 N. Meridian,
Indianapolis, IN 46204
(317) 232-8860

IOWA STATE DEVELOPMENT
 COMMISSION
250 Jewett Bldg.,
Des Moines, IA 50309
(515) 281-3251

KANSAS STATE
 DEPARTMENT/ECONOMIC
 DIVISION

503 Kansas Ave.,
Topeka, KA 66612
(913) 296-3481

MANYA NOGG CO.
9773 Lafayette Plz.,
Omaha, NE 68114
(402) 397-8887

MICHIGAN STATE TRAVEL
 BUREAU
P.O. Box 30226,
Lansing, MI 48909
(517) 373-0670

MINNESOTA STATE
 TOURISM DIVISION
480 Cedar St.,
St. Paul, MN 55101
(612) 296-5017

MISSOURI STATE TOURISM
 COMMISSION
308 E. High St.,
Jefferson City, MO 65101
(314) 751-3051

NORTH DAKOTA STATE
 BUSINESS & INDUSTRIAL
 DEVELOPMENT
513 E. Bismarck Ave.,
Bismarck, ND 58505
(701) 224-2810

NEBRASKA STATE FILM
 ASSISTANCE BUREAU
1819 Farnam St.,
Omaha, NE 68102
(402) 444-5001

OHIO FILM BUREAU
30 E. Broad St.,
Columbus, OH 43215
(614) 466-2284

PIASTER MOTOR HOMES
79 Old Palatine Rd.,
Wheeling, IL 60090
(312) 498-5810

PLACES
7645 N. Kilbourn,
Skokie, IL 60022
(312) 675-5353

SCROUNGERS, INC.
401 N. 3rd St.,
Minneapolis, MN 55401
(612) 338-1802

STATION 12
24333 Southfield Rd.,
Southfield, MI 48075
(313) 569-7707

STOCK PHOTOGRAPHY
 OUTDOOR STUDIO
4211 Flora Pl.,
St. Louis, MO 63110

(314) 773-2298

TOPEL, JIM
3333 N. Halsted,
Chicago, IL 60657
(312) 929-1000

JESSIE WALKER, ASSOC.
241 Fairview,
Glencoe, IL 60022
(312) 835-0522

WHITE HOUSE STUDIOS
229 Ward Pkwy.,
Kansas City, MO 64112
(816) 931-3608

Southwest

ARKANSAS STATE DEPT. OF
 ECONOMICS
#1 Capital Mall,
Little Rock, AR 72201
(501) 371-1121

EL PASO FILM LIAISON
5 Civic Ctr. Plz.,
El Paso, TX 79901
(915) 544-3650

OKLAHOMA STATE
 TOURISM—RECREATION
 DEPT.
500 Will Rogers Bldg.,
Oklahoma City, OK 73105
(405) 521-3981

PAUL OSBORNE & ASSOC.
1162 Security Dr.,
Dallas, TX 75247
(214) 630-7800

SENN, LOYD C.
P.O. Box 6060,
Lubbock, TX 79413
(806) 792-2000

TEXAS FILM COMMISSION
P.O. Box 12428,
Austin, TX 78711
(512) 475-3785

West

ANABEL'S DIVERSIFIED
 SERVICES
P.O. Box 532,
Pacific Palisades, CA 90272
(213) 454-1566

BRILES WING & HELICOPTER,
 INC.
3011 Airport Ave.,
Santa Monica, CA 90405

(213) 390-3554

CALIFORNIA STATE MOTION
 PICTURE COUNCIL
6725 Sunset Blvd.,
Hollywood, CA 90028
(213) 736-2465

CHIMERA ANTIQUES
1807 Polk St.,
San Francisco, CA 94109
(415) 441-0326

CITY LIGHTS
Bonaventure Hotel,
404 S. Figueroa,
Los Angeles, CA 90071
(213) 680-9876

KARIL DANIELS—POINT OF
 VIEW PRODUCTIONS
2477 Folsom St.,
San Francisco, CA 94110
(415) 821-0435

DESIGN ART STUDIOS
800 Seward,
Hollywood, CA 90038
(213) 464-9118

FILM PERMITS UNLIMITED
8058 Allott Ave.,
Van Nuys, CA 91402
(213) 997-6197

FILM PRODUCERS
 WAREHOUSE
1624 E. Meadowbrook,
Phoenix, AZ 85016
(602) 263-8650

THE HOLLYWOOD STAGE
6650 Santa Monica Blvd.,
Hollywood, CA 90038
(213) 466-4393

THE LOCATION CO.
8646 Wilshire Blvd.,
Beverly Hills, CA 90221
(213) 855-7075

LOCATION ENTERPRISES
 INC.
6725 Sunset Blvd.,
Los Angeles, CA 90028
(213) 469-3141

MINDSEYE
394 Greenwood Beach,
Tiburon, CA 94920
(415) 383-7839

MOTION PICTURE MARINE
616 Venice Blvd.,
Marina del Rey, CA 90291
(213) 822-1100

NEWHALL RANCH
27050 Henry Mayo Rd.,
Valencia, CA 91355

(213) 362-1515

PHOTO PRODUCTIONS
400 Montgomery St.,
San Francisco, CA 94104
(415) 392-5985

PJM TRAFFIC CONSULTANTS
1322 N. Cole,
Los Angeles, CA 90028
(213) 467-4307

PRE-PRODUCTION WEST
1406½ Havenhurst Dr.,
Los Angeles, CA 90046
(213) 656-8766

PRODUCERS LOCATION
SERVICE
1617 El Centro,
Los Angeles, CA 90021
(213) 462-1133

SAN FRANCISCO
CONVENTION/VISITORS
BUREAU
1390 Market St., #260,
San Francisco, CA 94102
(415) 626-5500

STUNTS UNLIMITED
3518 Cahuenga Blvd.,
West Los Angeles, CA 90068
(213) 874-0050

SUPERSTAGE
5724 Santa Monica Blvd.,
Hollywood, CA 90034
(213) 464-0296

YOUNG FILM PRODUCTIONS
P.O. Box 50105,
Tucson, AZ 85703
(602) 623-5961

SETS

New York City

ABSTRACTA STRUCTURES
38 W. 39th St.,
New York, NY 10018
(212) 944-2244

ALCAMO MARBLE WORKS
541 W. 22nd St.,
New York, NY 10010
(212) 255-5224

ASSOCIATED THEATRICAL
DESIGNERS LTD.
220 W. 71st St.,
New York, NY 10023
(212) 362-2648

BRODERSON, CHARLES
873 Broadway,

New York, NY 10003
(212) 925-9392

CHC PRODUCTIONS
204 W. 84th St.,
New York, NY 10024
(212) 787-8594

THE FOCARINO STUDIO
156 E. 23rd St.,
New York, NY 10010
(212) 533-9872

GOLDEN EQUIPMENT
SERVICE CORP.
574 Fifth Ave.,
New York, NY 10036
(212) 719-5150

LINCOLN SCENIC STUDIOS
440 W. 15th St.,
New York, NY 10011
(212) 255-2000

PLEXABILITY LTD.
200 Lexington Ave.,
New York, NY 10016
(212) 679-7826

REJOICE PRODUCTIONS
40 W. 39th St.,
New York, NY 10018
(212) 869-8636

SANLU ART INDUSTRIES
25 E. 28th St.,
New York, NY 10016
(212) 696-0414

SCLIGHT, GREG
146 W. 29th St.,
New York, NY 10001
(212) 736-2957

SEGUIN MIRROR
202 E. 70th St.,
New York, NY 10021
(212) 628-1460

SET SHOP
3 W. 20th St.,
New York, NY 10011
(212) 929-4845

THEATER TECHNOLOGY
INC.
37 W. 20th St.,
New York, NY 10011
(212) 929-5380

VARIETY SCENIC STUDIO
25-19 Borden Ave.,
Long Island City, NY 11101
(212) 392-4747

Northeast

BILLINGTON 38
25 Reservoir St.,

Cambridge, MA 02167
(617) 492-0105

CENTEL
651 Beacon St.,
Boston, MA 02159
(617) 267-6400

FOX, CHARLES W., III
6 Oldham Rd.,
W. Newton, MA 02165
(617) 527-8979

RKO EAST
7 Bullfinch Pl.,
Government Center,
Boston, MA 02114
(617) 725-2816

SAMMONS, LARRY
28 Fisher Ave.,
Roxbury, MA 02120
(617) 442-8360

SILVERMAN, HANNAH
265A Elm St., #3,
Somerville, MA 02180
(617) 625-5743

THE THEATER MACHINE
20 River Rd.,
Bogota, N.J. 07603
(201) 488-5270

TRAPP, PATRICIA
33 Stanton Rd.,
Brookline, MA 02146
(617) 232-4194

VIDEO PICTURE COMPANY
1170 Commonwealth Ave.,
Boston, MA 02134
(617) 731-2990

VIDEOCOM, INC.
502 Sprague St.,
Dedham, MA 02026
(617) 329-4080

WB INCORPORATED
20 Penniman Rd.,
Boston, MA 02146
(617) 254-4040

WHITE OAK DESIGN
286 Congress St.,
Boston, MA 02210
(617) 426-7171

WORCESTER FOOTHILLS
THEATER CO.
P.O. Box 236,
Worcester, MA 01613
(617) 754-0546

Southeast

THE ALDERMAN CO.
2055 Francis St.,

High Point, NC 27263
(919) 883-6121

DOYLE, MIKE
15281 N.E. 21st St.,
Miami, FL 33137
(305) 944-2464

ENTER SPACE
20 14th St. N.E.,
Atlanta, GA 30309
(404) 885-1139

GILLEN, JEFFREY
15281 N.E. 21st Ave.,
Miami, FL 33137
(305) 944-2464

STUDIO 9 PRODUCTIONS,
INC.
777 Miami Circle,
Atlanta, GA 30324
(404) 261-1756

SUGAR CREEK SCENIC
STUDIO, INC.
1081 Memorial Dr. S.E.,
Atlanta, GA 30316
(404) 522-3270

WAGERER, J. & D.
1513 N.E. 130th St.,
North Miami, FL 33161
(305) 893-2424

Midwest

CADILLAC PLASTIC
1245 W. Fullerton,
Chicago, IL 60614
(312) 243-2500

CENTERWOOD CABINETS
3700 Centerwood Rd.,
New Brighton, MN 55112
(612) 786-2094

CRAFTIC, INC.
2701 N. Pulaski,
Chicago, IL 60639
(312) 235-3307

DIMENSION WORKS
3917 W. Touhy,
Lincolnwood, IL 61049
(312) 676-3200

DUNCAN, VICTOR
200 E. Ontario,
Chicago, IL 60611
(312) 321-9406

FILM CORPS
3101 Hennepin Ave.,
Minneapolis, MN 55408
(612) 827-6996

FULHAM, TOM

932 W. Washington,
Chicago, IL 60607
(312) 829-1500, (312) 827-2715

GRAND STAGE LIGHTING
CO.
630 W. Lake,
Chicago, IL 60606
(312) 332-5611

NIELSON, GLEN
2910 N. 73rd Rd.,
Elmwood, IL 61529
(312) 453-6910

ROMAN MARBLE CO.
120 W. Kinzie,
Chicago, IL 60610
(312) 337-2217

THOMAS, ROBERT
932 W. Washington,
Chicago, IL 60607
(312) 829-1500, (312) 827-2715

WHITE HOUSE STUDIOS
229 Ward Pkwy.,
Kansas City, MO 64114
(816) 931-3608

Southwest

AUSTIN SCENIC DESIGN
GROUP, INC.
501 N. Interstate Hwy. 35,
Austin, TX 78702
(512) 478-8593

DALLAS STAGE SCENERY CO.
INC.
2804 Live Oak St.,
Dallas, TX 75204
(214) 821-0002

FREEMAN DESIGN & DISPLAY
CO.
2233 Irving Blvd.,
Dallas, TX 75207
(214) 638-8800

GRAFICA: A TOTAL DESIGN
CO.
3110 Fairmont,
Dallas, TX 75201
(214) 741-3810

KAY HOWARD DESIGN
3809-D Manchaca,
Austin, TX 78704
(512) 441-3883

BILL REED DECORATIONS
333 First Ave.,
Dallas, TX 55226
(214) 823-3154

TEXAS SCENIC CO., INC.
P.O. Box 28297,
San Antonio, TX 78228
(512) 684-0091

West

A-A SPECIAL EFFECTS
7021 Havenhurst,
Van Nuys, CA 91406
(213) 782-6558

ACT DESIGN & EXECUTION
14833 Valley Vista St.,
Sherman Oaks, CA 91403
(213) 788-4219

AMERICAN SCENERY
18555 Eddy St.,
Northridge, CA 91324
(213) 886-1585

BACKING
10201 W. Pico Blvd.,
Los Angeles, CA 90064
(213) 277-0522

BARONIAN
MANUFACTURING CO.
1865 Farm Bureau Rd.,
Concord, CA 94519
(415) 671-7199

BUTTER, SAMANTHA
8341 Sunset Blvd.,
Los Angeles, CA 90069
(213) 650-5118

CARTHAY SET SERVICES
6311 Romaine,
Hollywood, CA 90038
(213) 469-5618

CARTHAY STUDIO
5907 W. Pico,
Los Angeles, CA 90035
(213) 938-2101

CBS SPECIAL EFFECTS
7800 Beverly Blvd.,
Los Angeles, CA 90036
(213) 852-2345

CINEMA SCENIC SERVICES
5907 W. Pico,
Los Angeles, CA 90035
(213) 469-3240

CRUISE & CO.
1438 N. Gower,
Hollywood, CA 90028
(213) 466-4061, (213) 462-4214

DISCO SIGHT & SOUND FLOOR
CO.
14669 Aetna St.,
Van Nuys, CA 91411
(213) 780-5840

ERECTER SET INC.
1150 S. La Brea,
Hollywood, CA 90019
(213) 938-4762

FAMILY OF SUN
 PRODUCTIONS
710 Heliotrope Dr.,
Los Angeles, CA 90029
(213) 665-9452

GET SET INC.
650 N. Bronson,
Hollywood, CA 90004
(213) 461-4041

GOTHAM STUDIOS
5823 Santa Monica Blvd.,
Hollywood, CA 90038
(213) 461-1817

R. L. GROSH & SONS SCENIC
 STUDIO
4144 Sunset Blvd.,
Los Angeles, CA 90029
(213) 662-1134

HOLLYWOOD SCENERY
665 Eleanor Ave.,
Hollywood, CA 90038
(213) 463-2123

HOLLYWOOD STAGE
6650 Santa Monica Blvd.,
Los Angeles, CA 90038
(213) 466-4393

KROFFT ENTERTAINMENT,
 INC.
7200 Vineland Ave.,
Sun Valley, CA 91532
(213) 875-3250

LOMBARDI ENT., INC.
752 N. Cahuenga Blvd.,
Hollywood, CA 90038
(213) 466-3361

MAD MOUNTAIN DESIGN
5240 E. Highline Pl.,
Denver, CO 80222
(303) 757-3924

MOLE-RICHARDSON CO.
937 N. Sycamore Ave.,
Hollywood, CA 90038
(213) 851-0111

PACIFIC STUDIOS
8315 Melrose Ave.,
Los Angeles, CA 90069
(213) 653-3093

PRODUCERS STUDIO
650 N. Bronson Ave.,
Los Angeles, CA 90004
(213) 466-3111

RJ SET SERVICE INC.
6006 Eleanor Ave.,

Hollywood, CA 90038
(213) 467-2127

SCENIC SERVICES
1237 N. Vine St.,
Los Angeles, CA 90038
(213) 465-6411

SERRURIER & ASSOC.
61 W. Mountain St.,
Pasadena, CA 91103
(213) 681-3711

SEWARD STAGES
6605 Eleanor St.,
Hollywood, CA 90038
(213) 466-8559

SHAFTON INC.
5500 Cleon Ave.,
North Hollywood, CA 91601
(213) 985-5025

SHOW TIME SCENERY
1777 N. Main,
Los Angeles, CA 90031
(213) 227-4101

SPECIAL EFFECTS
 UNLIMITED
N. Cahuenga Blvd.,
Hollywood, CA 90038
(213) 466-3361

STAGE RIGHT
Box 2265,
Canyon County, CA 91351
(805) 251-4342

SUPERSTAGE
5724 Santa Monica Blvd.,
Los Angeles, CA 90038
(213) 464-0296

TRANSPARENT PRODUCTS
3410 La Cienega Blvd.,
Los Angeles, CA 90016
(213) 938-3821

TRIANGLE SCENERY
1215 Bates Ave.,
Los Angeles, CA 90029
(213) 662-8129

VIP SCENERY
71 E. Palm Ave.,
Burbank, CA 91502
(213) 845-7949

ZOETROPE STUDIOS
1040 N. Las Palmas Ave.,
Los Angeles, CA 90038
(213) 469-9011

PROPS

New York City

AAA/AMERICAN FLAG
 DECORATING CO.
12 W. 37th St.,
New York, NY 10018
(212) 279-4644

ABSTRACTA STRUCTURES
 INC.
38 W. 39th St.,
New York, NY 10018
(212) 944-2244

ADIRONDACK DIRECT
219 E. 42nd St.,
New York, NY 10017
(212) 687-8555

ADLER, KURT
1107 Broadway,
New York, NY 10010
(212) 924-0900

ALICE'S ANTIQUES
552 Columbus Ave.,
New York, NY 10024
(212) 874-3400

ALPHA-PAVIA BOOKBINDING
 CO. INC.
55 W. 21st St.,
New York, NY 10010
(212) 929-5430

ARCHER SURGICAL SUPPLIES
 INC.
217 E. 23rd St.,
New York, NY 10011
(212) 689-3480

ARGOSY BOOKSTORE
116 E. 59th St.,
New York, NY 10022
(212) 753-4455

ARTISTIC NEON BY GASPER
76-19 60th Ln.,
Glendale, NY 11378
(212) 821-1550

ARTS & CRAFTERS
175 Tech Pl.,
Brooklyn, NY 11201
(212) 875-8151

ASSOCIATED THEATRICAL
 DESIGNER
220 W. 71st St.,
New York, NY 10023
(212) 362-2648

AUSTIN DISPLAY
139 W. 19th St.,
New York, NY 10011
(212) 924-6261

BIL BAIRD'S MARIONETTES
41 Union Sq.,
New York, NY 10003
(212) 989-9840

ERICKSON, HARRISON
95 Fifth Ave.,
New York, NY 10003
(212) 929-5700

BREITROSE, MARK
524 W. 23rd St.,
New York, NY 10011
(212) 242-7825

BROOKLYN MODEL WORKS
INC.
60 Washington Ave.,
Brooklyn, NY 11205
(212) 834-1944

BROWSERS WELCOME
380 Columbus Ave.,
New York, NY 10024
(212) 724-0688

CARROLL MUSICAL
INSTRUMENT SERVICE
351 W. 41st St.,
New York, NY 10036
(212) 868-4120

CHESS SETS
320 W. 86th St.,
New York, NY 10024
(212) 873-5990

CHURCHILL FURNITURE
RENTAL INC.
1421 Third Ave.,
New York, NY 10028
(212) 535-3400

CLOCK HUTT, LTD.
1050 Second Ave.,
New York, NY 10022
(212) 759-2395

CLOVE LAKE STABLES INC.
1025 Clove Rd.,
Staten Island, NY 10301
(212) 448-1414

CONTINENTAL FELT
22 W. 15th St.,
New York, NY 10011
(212) 929-5262

CRYSTAL CLEAR IMPORTING
CO.
220 Fifth Ave.,
New York, NY 10001
(212) 683-6272

CYCLE SERVICE CENTER INC.
74 Ave. of the Americas
New York, NY 10013
(212) 925-5900

DOHERTY STUDIOS
252 W. 46th St.,
New York, NY 10036
(212) 840-6219

ECLECTIC PROPERTIES INC.

204 W. 84th St.,
New York, NY 10024
(212) 799-8963

ENCORE STUDIO
410 W. 47th St.,
New York, NY 10036
(212) 246-5237

FHM FOOD ARTS INC.
79 W. 12th St.,
New York, NY 10011
(212) 691-5853

FLORENCO FOLIAGE
SYSTEMS INC.
30–28 Starr Ave.,
Long Island City, NY 11101
(212) 729-6600

FLOSSO-HORNMANN MAGIC
304 W. 34th St.,
New York, NY 10001
(212) 279-6079

THE FOCARINO STUDIO
156 E. 23rd St.,
New York, NY 10010
(212) 533-9872

FURS, VALERIE
150 W. 30th St.,
New York, NY 10001
(212) 947-2020

THE GAZEBO
660 Madison Ave.,
New York, NY 10021
(212) 832-7077

GILBERT, DARLENE
321 W. 24th St.,
New York, NY 10011
(212) 989-5765

OFFICE INTERIORS, INC.
574 Fifth Ave.
New York, NY 10036
(212) 719-5150

GORDON NOVELTY CO.
933 Broadway,
New York, NY 10010
(212) 254-8616

GOSSARD & ASSOCS. INC.
801 E. 134th St.,
New York, NY 10014
(212) 665-9194

GOTHIC COLOR CO. INC.
727 Washington St.,
New York, NY 10006
(212) 929-7493

GUCCIONE
6 W. 37th St.,
New York, NY 10018
(212) 279-3602

JOHN HARRA WOOD &
SUPPLY CO.
511 W. 25th St.,
New York, NY 10001
(212) 741-0290

HARRISON/ERICKSON
95 Fifth Ave.,
New York, NY 10003
(212) 929-5700

IRVING'S FOOD CENTER
867 Ninth Ave.,
New York, NY 10019
(212) 586-5041

JEAN'S SILVERSMITH
16 W. 45th St.,
New York, NY 10036
(212) 697-0367

JEFFERS, KATHY
106 E. 19th St.,
New York, NY 10003
(212) 475-1756

ROBERT JOYCE STUDIO LTD.
321 W. 44th St., #404,
New York, NY 10036
(212) 586-5041

KAPLAN, HOWARD
35 E. 10th St.,
New York, NY 10003
(212) 674-1000

KARPEN, BEN
212 E. 51st St.,
New York, NY 10022
(212) 755-3450

H. KAUFMAN & SONS
139–41 E. 24th St.,
New York, NY 10010
(212) 684-6060

KELLY, BOB
155 W. 46th St.,
New York, NY 10036
(212) 245-2237

KEMPLER, GEORGE J.
160 Fifth Ave.,
New York, NY 10010
(212) 989-1180

KENMORE FURNITURE CO.
INC.
156 E. 33rd St.,
New York, NY 10016
(212) 683-1888

MANHATTAN MODEL SHOP
40 Great Jones St.,
New York, NY 10012
(212) 473-6312

MANNY'S MUSICAL
INSTRUMENTS
156 W. 48th St.,

New York, NY 10036
(212) 757-0576

MANWARING STUDIO
232 Atlantic Ave.,
New York, NY 11201
(212) 855-2796

MASON'S TENNIS MART
911 Seventh Ave.,
New York, NY 10019
(212) 757-5374

MATTY'S STUDIO SALES
543 W. 35th St.,
New York, NY 10001
(212) 757-6246

MAYHEW
509 Park Ave.,
New York, NY 10022
(212) 759-8120

MENDEZ, RAYMOND A.
220 W. 98th St., #12B,
New York, NY 10025
(212) 864-4689

MESSMORE & DAMON INC.
530 W. 28th St.,
New York, NY 10001
(212) 594-8070

METRO SCENERY STUDIO
 INC.
215–31 99th Ave.,
Queens Village, NY 11429
(212) 464-6328

JIMMY MEYER & CO.
428 W. 44th St.,
New York, NY 10036
(212) 246-5769

MIRANDA DESIGNS
745 President St.,
Brooklyn, NY 11215
(212) 857-9839

MARC MODELL ASSOCIATES
430 W. 54th St.,
New York, NY 10019
(212) 541-9676

MODERN MILTEX CORP.
280 E. 134th St.,
New York, NY 10037
(212) 585-6000

MOVIE CARS
825 Madison Ave.,
New York, NY 10021
(212) 288-6000

NEWELL ART GALLERIES
 INC.
425 E. 53rd St.,
New York, NY 10022
(212) 758-1970

NOSTALGIA ALLEY

ANTIQUES
380 Second Ave.,
New York, NY 10010
(212) 988-3949

NOVEL PINBALL CO.
594 Tenth Ave.,
New York, NY 10036
(212) 736-3868

THE PLACE FOR ANTIQUES
993 Second Ave.,
New York, NY 10022
(212) 475-6596

PLANT SPECIALISTS INC.
524 W. 34th St.,
New York, NY 10001
(212) 279-1500

PLASTIC DESIGN CENTER
535 Hudson St.,
New York, NY 10014
(212) 989-6138

PLEXABILITY LTD.
200 Lexington Ave.,
New York, NY 10016
(212) 679-7826

POKO PUPPETS, INC.
12 Everitt St.,
Brooklyn, NY 11201
(212) 522-0225

PORTER-RAYVID
19 Second Ave.,
New York, NY 10003
(212) 677-9502

PORTOBELLO ROAD
 ANTIQUES LTD.
370 Columbus Ave.,
New York, NY 10024
(212) 724-2300

THE PROP HOUSE INC.
76 Ninth Ave.,
New York, NY 10011
(212) 691-9099

RAY BEAUTY SUPPLY CO.
 INC.
721 Eighth Ave.,
New York, NY 10019
(212) 732-3555

RIDGE, JOHN RUSSELL
531 Hudson St.,
New York, NY 10014
(212) 929-3410

WILLIAM ROGERS—PAINT
 BACKDROPS
26 Bowery,
New York, NY 10013
(212) 732-3555

SIMON'S DIRECTORY OF
 THEATRICAL MATERIALS

1501 Broadway,
New York, NY 10036
(212) 354-1840

SMITH & WATSON
305 E. 63rd St.,
New York, NY 10021
(212) 355-5615

SOLCO PLUMBING SUPPLIES &
 BATHTUBS
209 W. 18th St.,
New York, NY 10011
(212) 243-2659

SPECIAL EFFECTS
40 W. 39th St.,
New York, NY 10018
(212) 869-8636

STATE SUPPLY EQUIPMENT
 CO. INC.
68 Thomas St.,
New York, NY 10013
(212) 233-0474

STUYVESANT BICYCLE & TOY
349 W. 14th St.,
New York, NY 10014
(212) 254-5200

THEATER TECHNOLOGY
 INC.
37 W. 20th St.,
New York, NY 10011
(212) 929-5380

THOR ENTERPRISES
61 Sullivan St.,
New York, NY 10012
(212) 925-8349

THREE-DIMENSIONAL
 MODELS
40 Great Jones St.,
New York, NY 10012
(212) 473-6312

TIMES SQUARE THEATRICAL
 & STUDIO
318 W. 47th St.,
New York, NY 10036
(212) 245-4155

TOY BALLOON CORP.
204 E. 38th St.,
New York, NY 10016
(212) 682-3803

UNCLE SAM'S UMBRELLA
161 W. 57th St.,
New York, NY 10019
(212) 582-1976

DAVID WEISS IMPORTERS
 INC.
969 Third Ave.,
New York, NY 10022
(212) 755-1492

WEST SIDE EXCHANGE FOR

FURNITURE & ANTIQUES
441 Columbus Ave.,
New York, NY 10024
(212) 874-9347

WHOLE ART INC.
114 W. 27th St.,
New York, NY 10001
(212) 255-6229

HARRY WINSTON, INC.
718 Fifth Ave.,
New York, NY 10022
(212) 245-2000

WIZARDWORKS
67 Atlantic Ave.,
New York, NY 11201
(212) 349-5252

YURKIW, MARK
91 Fifth Ave.,
New York, NY 10003
(212) 243-0928

Northeast

ALIZAH CRUISES
22 Pelham Rd.,
New Rochelle, NY 10801
(914) 235-8370

ANTIQUE BICYCLE PROPS
 SERVICE
113 Woodland St.,
Montvale, NJ 07645
(201) 391-8780

ATLAS SCENIC STUDIOS LTD.
46 Brookfield Ave.,
Bridgeport, CT 06610
(203) 334-2130

BAILEY DESIGNS
110 Williams St.,
Malden, MA 02148
(617) 321-4448

BALDWIN, KATHERINE
109 Commonwealth Ave.,
Boston, MA 02116
(617) 267-0508

L.V. BERGMAN & ASSOC.
E. Mountain Rd.,
South Cold Spring, NY 10516
(914) 265-3656

BESTEK THEATRICAL
 PRODUCTIONS
92 Field St.,
West Babylon, NY 11704
(516) 293-9010

BIG APPLE SCENIC STUDIOS
 INC.
502–10 Madison Ave.,

Hoboken, NJ 07030
(516) 293-9010

CADILLAC CONVERTIBLE
 OWNERS
Thiells, NY 10984
(914) 947-1109

TIM DEWART ASSOC.
83 Old Standley St.,
Beverly, MA 01915
(617) 922-9229

GEIGER, ED
12 Church St.,
Middletown, NJ 07748
(201) 671-1707

LAWYERS BOOKSHELF
Box 78,
Bayside, NY 11361
(212) 229-7715

L.I. AUTOMOTIVE MUSEUM
Museum Sq.,
Southampton, NY 11968
(516) 283-1880

DALE MALI & CO.
40 Stevens Pl.,
Lawrence, NY 11559
(516) 239-8782

MASTER & TALENT INC.
1139 Foam Pl.,
Far Rockaway, NY 11691
(516) 239-7719

NEWBERY, THOMAS
Ridge Rd.,
Glen Cove, NY 11542
(516) 759-0880

JACK N. RINDNER ASSOC.
112 Water St.,
Tinton Falls, NJ 07724
(201) 542-3548

CHAS. H. STEWART CO.
6 Clarendon Ave.,
Somerville, MA 02190
(617) 625-2407

THE THEATER MACHINE
20 River Rd.,
Bogota, NJ 07603
(201) 488-5270

THEATER PRODUCTION
 SERVICE INC.
26 S. Highland Ave.,
Ossining, NY 10562
(914) 941-0357

UNGER, CAPT. HOWARD
80 Beach Rd.,
Great Neck, NY 11023
(516) 829-9800

Southeast

ALSTON, ANN
3166 Maple Dr. N.E.,
Atlanta, GA 30305
(404) 237-4040

ARAWAK MARINE
P.O. Box 762,
St. Thomas, VI 00801
(809) 775-1858

BAKER, SHERRY
1823 Indiana Ave.,
Atlanta, GA 30307
(404) 373-6666

BOLQUERIN, PATTI
112 Tomoka Trl.,
Longwood, FL 32750
(305) 862-4746

GAYLE BRUNS & ASSOC.
7810 S.W. 48th Ct.,
Miami, FL 33143
(305) 666-2928

CALHOUN, LARRY EARL
4009 Wisteria Ln. S.W.,
Atlanta, GA 30331
(404) 691-4979

LEE CAROL INC.
2145 N.W. Second Ave.,
Miami, FL 33127
(305) 573-1759

DANIEL, DON
P.O. Box 18881,
Atlanta, GA 30326
(800) 241-7131, (800) 282-2686

DARRACOTT, DAVID
1717 Woodcliff Ct.,
Atlanta, GA 30329
(404) 634-2118

DIAMOND, AMY
7511 W. Venetian St.,
Miramar, FL 33023
(305) 989-9617

DUNWRIGHT PRODUCTIONS
15281 N.E. 21st Ave.,
North Miami Beach, FL 33162
(305) 944-2464

EDWARDS, DONALD H.
1375 Villa Rica Rd.,
Powder Springs, GA 30073
(404) 422-3846

GORDON, M. J.
P.O. Box 88,
Norcross, GA 30091
(404) 493-1171

GUANCI, CHARLIE
1130 Placetas Ave.,
Coral Gables, FL 33146
(305) 667-0608

HALLAS, JEFFREY S.

3113 Briarcliff Wy.,
Atlanta, GA 30345
(305) 938-1457

HARRIS, BETH
834 Heritage Sq.,
Decatur, GA 30033
(404) 321-3301

HARRIS, GEORGE
2875 Mabry Ln. N.E.,
Atlanta, GA 30319
(404) 231-0116

HENDERSON, CHARLES
75 Ponce de Leon at Peachtree,
Atlanta, GA 30308
(404) 892-4317

HEN'S TEETH
1206 Clifton Rd. N.E.,
Atlanta, GA 30307
(404) 378-6076

HUGHES, CHARLES
2734 Tallulah Dr.,
Atlanta, GA 30319
(404) 231-1252

KUPERSMITH, AL
320 N. Highland Ave. N.E.,
Atlanta, GA 30312
(404) 577-5319

MANNING, MAUREEN
1283 Cedar Hts. Dr.,
Atlanta, GA 30338
(404) 296-1520

MARX, MICHELE
6280 S.W. 116th St.,
Miami, FL 33156
(305) 661-8501

McDONALD, STU
6905 N. Coolidge Ave.,
Tampa, FL 33614
(813) 886-3773

MELTON, ERVIN
Heart of Rabun Motel,
Clayton, GA 30525
(404) 782-4565

MILLER, LEE
Route 1, Box 98,
Lumpkin, GA 31815
(912) 838-4959

PERMAR, ANDREW
Route 1, Box 277,
Hull, GA 30646
(404) 546-0241, (404) 542-1731

PIETRO, LAWRENCE J., JR.
3534 Old Chamblee Tucker Rd.
 N.E.,
Atlanta, GA 30340
(404) 939-9636

PONDER, JUDY

952 Rosedale Rd. N.E.,
Atlanta, GA 30306
(404) 872-7700

PLAYER, JOANNE
3403 Orchard St.,
Hapeville, GA 30354
(404) 767-5542

RANGER, JACK
3640 Ridge Rd.,
Smyrna, GA 30080
(404) 434-3640

REEVE, JAMESINE
213 Old Buford Rd.,
Cumming, GA 30130
(404) 887-3258, (404) 237-3337

ROGERS, PEGGY
P.O. Box 1111,
Rome, GA 30162
(404) 232-7928

RUBINSON, GLENNA
P.O. Box 331088,
Miami, FL 33133
(305) 442-1240

SC EDUCATIONAL TV
2712 Millwood Ave.,
Columbia, SC 29205
(803) 758-7284

SEGAL, SAM
1015 N.E. 147th St.,
Miami, FL 33161
(305) 947-2487

SMITH, ROSCOE
15 Baltimore Pl. N.W.,
Atlanta, GA 30308
(404) 252-3540

STRATTON, LEOPOLD
3210 Verdun Dr. N.W.,
Atlanta, GA 30305
(404) 237-3776

SUGAR CREEK STUDIO INC.
16 Young St.,
Atlanta, GA 30341
(404) 522-3270

SUNSHINE SCENIC STUDIOS
1370 4th St.,
Sarasota, FL 33577
(813) 366-8848

Midwest

ACME PROP RENTAL
321 S. Jefferson,
Chicago, IL 60606
(312) 663-0400

ADVANCE THEATRICAL
125 N. Wabash,

Chicago, IL 60603
(312) 772-7150

AMERICAN TROPHIES &
 AWARDS
823 N. Wabash,
Chicago, IL 60605
(312) 939-3452

BAILEY
25 W. Van Buren,
Chicago, IL 60605
(312) 939-2172

BECKER STUDIOS INC.
2824 W. Taylor,
Chicago, IL 60612
(312) 722-4040

BOATER'S WORLD
1534 Indianapolis Blvd.,
Whiting, IN 46394
(219) 374-1558

BOYCE ARMY-NAVY
2456 N. Lincoln,
Chicago, IL 60614
(312) 477-0313

BREGSTONE ASSOC.
440 S. Wabash,
Chicago, IL 60605
(312) 939-5130

BUCKINGHAM BIKE
3332 N. Broadway,
Chicago, IL 60657
(312) 525-9660

CARSON PIRIE SCOTT & CO.
1 S. State St.,
Chicago, IL 60603
(312) 744-2000

CENTURY STUDIO
547 S. Clark,
Chicago, IL 60605
(312) 427-0377

CHANNON CORP.
1343 W. Argyle,
Chicago, IL 60640
(312) 275-4700

CHICAGO HAIR GOODS
428 S. Wabash,
Chicago, IL 60605
(312) 427-8600

CHICAGO SCENIC STUDIOS
 INC.
2217 W. Belmont Ave.,
Chicago, IL 60618
(312) 477-8362

CINDY MAKES THINGS
3028 N. Kenmore,
Chicago, IL 60657
(312) 929-1060

CRATE & BARRELL

1510 N. Wells,
Chicago, IL 60610
(312) 787-4775

CREATIVE AWARDS BY LANE
32 W. Randolph,
Chicago, IL 60601
(312) 787-2317

TIM DEWART ASSOC.
706 W. McNichols Rd.,
Detroit, MI 48203
(313) 863-0197

DUNCAN, VICTOR
200 E. Ontario,
Chicago, IL 60611
(312) 321-9406

THE EMPORIUM
1551 N. Wells,
Chicago, IL 60610
(312) 337-7126

ESSANAY STUDIO STAGE
1345 W. Argyle,
Chicago, IL 60640
(312) 334-9510

MARSHALL FIELD & CO.
111 N. State St.,
Chicago, IL 60603
(312) 781-1000

FIFLES, JOHN
3013 Thayer,
Evanston, IL 60432
(312) 864-5915

FRANKEL ASSOC., INC.
Merchandise Mart Pl.,
Chicago, IL 60654
(312) 527-3099

FURNITURE LEASING
 SERVICE
819 N. Clark,
Chicago, IL 60610
(312) 642-0600

GRONMONGER
446 N. Wells,
Chicago, IL 60610
(312) 467-4622

HARTMAN FURNITURE &
 CARPET CO.
220 W. Kinzie,
Chicago, IL 60610
(312) 664-2800

HATCHER ASSOCIATES
502 N. Wells,
Chicago, IL 60610
(312) 644-3065

HERMAN'S
185 N. Wabash,
Chicago, IL 60601
(312) 372-8026

HOLLYWOOD STAGE
 LIGHTING
5850 N. Broadway,
Chicago, IL 60660
(312) 271-4915

HOUSE OF DRANE
410 N. Ashland Ave.,
Chicago, IL 60622
(312) 829-8686

HOUSE OF RENTAL
4059 Dempster,
Chicago, IL 60648
(312) 677-2010

HOUSE OF WILLIAM
37 S. Wabash,
Chicago, IL 60603
(312) 236-6320

JAY-MAR'S BEAUTY SUPPLY
5532 W. Belmont,
Chicago, IL 60641
(312) 736-7636

JOSEPH'S HAIR GOODS
111 N. Wabash,
Chicago, IL 60602
(312) 236-8646

KAGAN & GAINS
228 S. Wabash,
Chicago, IL 60604
(312) 939-4083

KREMONA MUSIC
6229 N. Broadway,
Chicago, IL 60660
(312) 973-2618

LINCOLN PARK WEST
 STABLES
511 W. Grant Pl.,
Chicago, IL 60614
(312) 871-1999

LIVINGSTON'S
Merchandise Mart Pl.,
Chicago, IL 60654
(312) 337-2661

LYON & HELAY
243 S. Wabash,
Chicago, IL 60604
(312) 922-7900

MAGES, MORRIE
602 N. La Salle,
Chicago, IL 60610
(312) 337-6157

MAYFAIR MARKET
401 N. 3rd St.,
Minneapolis, MN 55401
(612) 338-1802

MERRICK MODELS LTD.
1426 W. Fullerton,
Chicago, IL 60614

(312) 281-7787

MIDWEST STAGE LIGHTING
 CO.
2104 Central,
Evanston, IL 60436
(312) 328-3966

MIDWEST YACHT
10502 S. Longwood,
Chicago, IL 60643
(312) 239-7235

THE MODEL SHOP
415 N. State St.,
Chicago, IL 60610
(312) 822-9663

ROLAND PERLE PERFUME
 SHOP
946 N. Rush,
Chicago, IL 60611
(312) 944-1432

PRODUCTION CENTER
151 Victor Ave.,
Highland Park, MI 48203
(313) 868-6600

DON ROSE GALLERIES
351 N. Wells,
Chicago, IL 60610
(312) 337-4052

RUMMAGE ROUND
435 N. La Salle,
Chicago, IL 60610
(312) 642-8283

SCHWARTZ, F. A. O.
835 N. Michigan,
Chicago, IL 60611
(312) 787-8894

SCRAFF, TOM
1544 N. Sedgwick,
Chicago, IL 60610
(312) 787-2577

SCROUNGERS INC.
401 N. 3rd St.,
Minneapolis, MN 55401
(612) 332-0441

SEDGWICK STUDIO
1728 N. Sedgwick,
Chicago, IL 60614
(312) 642-7216

SHERMAN, SID
226 S. Wabash,
Chicago, IL 60604
(312) 427-1796

STEVE STARR STUDIOS
2654 N. Clark St.,
Chicago, IL 60614
(312) 525-6530

STUDIO 502
502 N. Wells St.,

Chicago, IL 60610
(312) 337-0452

STUDIO SPECIALTIES
409 W. Huron,
Chicago, IL 60610
(312) 337-5131

THEATRICAL SERVICES
180 N. Dearborn,
Chicago, IL 60601
(312) 263-0324

TOYS, HOBBIES & CRAFTS
43 E. Ohio,
Chicago, IL 60611
(312) 467-0670

TOYS 'R' US
3868 N. Lincoln,
Chicago, IL 60613
(312) 248-1500

VILLAGE CYCLE CENTER
1337 N. Wells,
Chicago, IL 60610
(312) 751-2488

GEORGE A. WADDELL &
ASSOC.
831 S. Wabash,
Chicago, IL 60605
(312) 922-6321

WILLIAMS, ROBERT
407 N. Elizabeth,
Chicago, IL 60622
(312) 263-7383

WOODROSE
841 W. Armitage,
Chicago, IL 60614
(312) 929-3020

Southwest

CREATIVE VIDEO
PRODUCTIONS
5933 Bellaire Blvd., ❌110,
Houston, TX 77081
(713) 661-0478

DOERR, DEAN
11321 Greystone,
Oklahoma City, OK 73120
(405) 751-0313

EATS
P.O. Box 52,
Tempe, AZ 85281
(602) 966-7459

MERRICK MODELS LTD.
4302 N. 30th,
Phoenix, AZ 85016
(602) 955-8962

THE STOWER GROUP

5555 W. Lovers Ln.,
Dallas, TX 75209
(214) 352-2166

West

A & A SPECIAL EFFECTS
7021 Hayvenhurst St.,
Van Nuys, CA 91406
(213) 782-6558

ABBE RENTS
600 S. Normandie,
Los Angeles, CA 90005
(213) 384-5292

ALDIK ARTIFICIAL FLOWERS
CO.
7651 Sepulveda Blvd.,
Van Nuys, CA 91405
(213) 988-5970

WALTER ALLEN PLANT
RENTALS
5500 Melrose Ave.,
Hollywood, CA 90038
(213) 469-3621

ALTBAUM, PATTI
244C S. Lasky Dr.,
Beverly Hills, CA 90212
(213) 553-6269

ANTIQUARIAN TRADERS
8483 Melrose Ave.,
Los Angeles, CA 90069
(213) 658-6394

ARNELLE SALES CO. PROP
HOUSE
7926 Beverly Blvd.,
Los Angeles, CA 90048
(213) 930-2900

ASIA PLANT RENTALS
1215 225th St.,
Torrance, CA 90502
(213) 775-1811

BACKINGS c/o TWENTIETH
CENTURY-FOX
10201 W. Pico Blvd.,
Los Angeles, CA 90064
(213) 277-0522

BARONIAN
MANUFACTURING CO.
1865 Farm Bureau Rd.,
Concord, CA 94519
(415) 671-7199

BARRIS KUSTOM IND.
10811 Riverside Dr.,
North Hollywood, CA 91602
(213) 877-2352

BARTON SURREY SERVICES

518 Fairview Ave.,
Arcadia, CA 91006
(213) 447-6693

JOSEPH BASCH GALLERIES
5755 Santa Monica Blvd.,
Hollywood, CA 90038
(213) 463-5116

BEVERLY HILLS FOUNTAIN
CENTER
8574 Santa Monica Blvd.,
Los Angeles, CA 90069
(213) 652-5297

BISCHOFF'S
449 S. San Fernando Blvd.,
Burbank, CA 91502
(213) 843-7561

BRILES WING & HELICOPTER
3011 Airport Ave.,
Santa Monica, CA 90405
(213) 390-3554

MEL BROWN FURNITURE
5804 S. Figueroa St.,
Los Angeles, CA 90003
(213) 778-4444

BUCCANEER CRUISES
Berth 76W-33, Ports O'Call,
San Pedro, CA 90731
(213) 548-1085

THE BURBANK STUDIOS
PROP DEPT.
4000 Warner Blvd.,
Burbank, CA 91505
(213) 843-6000

CADY DISPLAYS
2818 N. 16th St.,
Phoenix, AZ 85006
(602) 265-1701

CINEMA FLOAT
447 N. Newport Blvd.,
Newport Beach, CA 92663
(714) 642-6600

CINEMA MERCANTILE CO.
5857 Santa Monica Blvd.,
Hollywood, CA 90038
(213) 467-1151

CINEMA PROPS CO.
6161 Santa Monica Blvd.,
Hollywood, CA 90038
(213) 464-3191

COLORS OF THE WIND
2900 Main St.,
Santa Monica, CA 93454
(213) 399-8044

CORHAM ARTIFICIAL
FLOWERS
11800 Olympic Blvd.,
Los Angeles, CA 90064

(213) 479-1166

CUSTOM NEON
3804 Beverly Blvd.,
Los Angeles, CA 90004
(213) 386-7940

D'ANDREA GLASS ETCHINGS
3671 Tacoma Ave.,
Los Angeles, CA 90065
(213) 223-7940

**DECORATIVE PAPER
 PRODUCTIONS**
1818 W. 6th St.,
Los Angeles, CA 90057
(213) 484-1080

DEUTSCH INC.
426 S. Robertson Blvd.,
Los Angeles, CA 90048
(213) 273-4949

**DISCO SIGHT & SOUND
 FLOOR CO.**
14669 Aetna St.,
Van Nuys, CA 91411
(213) 780-5840

ELLIS MERCANTILE CO.
169 N. La Brea Ave.,
Los Angeles, CA 90036
(213) 933-7334

FEATHEROCK INC.
2890 Empire,
Burbank, CA 91504
(213) 933-7334

**FIRST STREET FURNITURE
 STORE**
1123 N. Bronson Ave.,
Los Angeles, CA 90038
(213) 462-6306

FLOWER FASHIONS
9960 Santa Monica Blvd.,
Beverly Hills, CA 90212
(213) 272-6063

GAMES UNLTD.
9059 Venice Blvd.,
Los Angeles, CA 90034
(213) 836-8920

GOLDEN BEAR ENT.
P.O. Box 3682,
Glendale, CA 91209
(805) 942-5406

**GOLDEN WEST BILLIARD
 SUPPLY**
6326 Laurel Canyon Blvd.,
North Hollywood, CA 91606
(213) 877-4100

GRAND AMERICAN FARE
2941 Main St.,
Santa Monica, CA 93454
(213) 450-4900

**HALTZMAN OFFICE
 FURNITURE**
1417 S. Figueroa,
Los Angeles, CA 90015
(213) 749-7021

THE HAND PROP ROOM
5700 Venice Blvd.,
Los Angeles, CA 90019
(213) 931-1534

THE HIGH WHEELERS INC.
109 S. Hidalgo,
Alhambra, CA 91801
(213) 576-8648

HOLLYWOOD TOYS
6562 Hollywood Blvd.,
Los Angeles, CA 90028
(213) 465-3119

HOUSE OF PROPS INC.
1117 N. Gower St.,
Hollywood, CA 90038
(213) 463-3166

HUME, ALEX R.
140 N. Victory Blvd.,
Burbank, CA 91502
(213) 849-1614

**INDEPENDENT STUDIO
 SERVICES**
11907 Wicks St.,
Sun Valley, CA 91352
(213) 764-0840

IWASAKI IMAGES
19330 Van Ness Ave.,
Torrance, CA 90504
(213) 533-5986

JACKSON SHRUB SUPPLY
9500 Columbus Ave.,
Sepulveda, CA 91343
(213) 893-6939

RAY M. JOHNSON STUDIO
5555 Sunset Blvd.,
Hollywood, CA 90028
(213) 465-4108

**KROFFT ENTERTAINMENT,
 INC.**
7200 Vineland Ave.,
Sun Valley, CA 91352
(213) 875-3250

LAUGHING CAT DESIGN CO.
723½ N. La Cienega Blvd.,
Los Angeles, CA 90035
(213) 855-8088

LIVING INTERIORS
7273 Santa Monica Blvd.,
Los Angeles, CA 90046
(213) 874-7815

THE MAGAZINE
14350 Millbank,

Sherman Oaks, CA 91423
(213) 990-7124

MALIBU FLORISTS
21337 Pacific Coast Hwy.,
Malibu, CA 90265
(213) 456-2014

MARINA ACTIVITIES
13816 Bora Bora Wy., #140A,
Marina del Rey, CA 90291
(213) 823-4377

**MARINA DEL REY SMALL
 CRAFT HARBOR**
13837 Fiji Wy.,
Marina del Rey, CA 90291
(213) 823-4571

LENNIE MARVIN ENT. LTD.
1105 N. Hollywood Wy.,
Burbank, CA 91505
(213) 841-5882

McDERMOTT, KATE
1114 S. Point View,
Los Angeles, CA 90035
(213) 935-4101

MERCURY ARCHIVES
1574 Crossroads of the World,
Hollywood, CA 90028
(213) 463-8000

MGM STUDIOS PROP DEPT.
10202 W. Washington Blvd.,
Culver City, CA 90230
(213) 836-3000

MODELMAKERS
216 Townsend St.,
San Francisco, CA 94107
(415) 495-5111

**MODERN FURNITURE
 RENTALS**
5418 Sierra Vista Ave.,
Los Angeles, CA 90041
(213) 462-6545

MOSKATELS
733 S. San Julian St.,
Los Angeles, CA 90014
(213) 627-1631

MOTION PICTURE MARINE
616 Venice Blvd.,
Marina del Rey, CA 90291
(213) 822-1100

MUSIC CENTER
5616 Santa Monica Blvd.,
Hollywood, CA 90038
(213) 469-8143

OMEGA STUDIO RENTALS
5757 Santa Monica Blvd.,
Hollywood, CA 90038
(213) 466-8201

PACIFIC PALISADES FLORISTS

15244 Sunset Blvd.,
Pacific Palisades, CA 90272
(213) 454-0337

PARAMOUNT STUDIOS PROP DEPT.
5451 Marathon St.,
Hollywood, CA 90038
(213) 468-5000

THE PLANTATION
1595 E. El Segundo Blvd.,
El Segundo, CA 90245
(213) 322-7877

DON POST STUDIOS
8211 Lankershim Blvd.,
North Hollywood, CA 91605
(213) 768-0811

PROFESSIONAL SCENERY INC.
7311 Radford Ave.,
North Hollywood, CA 91605
(213) 875-1910

PROP CITY
9336 W. Washington,
Culver City, CA 90230
(213) 559-7022

PROP SERVICE WEST
6223 Santa Monica Blvd.,
Hollywood, CA 90038
(213) 461-3371

RENT-A-MINK
6738 Sunset Blvd.,
Hollywood, CA 90028
(213) 467-7879

ROSCHU
6514 Santa Monica Blvd.,
Hollywood, CA 90038
(213) 469-2749

SCALE MODEL CO.
401 W. Florence,
Inglewood, CA 90301
(213) 679-1436

SCHOOL DAYS EQUIPMENT CO.
973 N. Main St.,
Los Angeles, CA 90012
(213) 223-3474

SHAFTON INC.
5500 Cleon Ave.,
North Hollywood, CA 91601
(213) 985-5025

SIERRA RAILROAD COMPANY
3745 E. Colorado Blvd.,
Pasadena, CA 91107
(213) 887-8657

SILVESTRI STUDIOS

1733 W. Cordova St.,
Los Angeles, CA 90007
(213) 735-1481

SNAKES
6100 Laurel Canyon Blvd.,
North Hollywood, CA 91606
(213) 985-7777

SPECIAL EFFECTS UNLIMITED
752 N. Cahuenga Blvd.,
Hollywood, CA 90038
(213) 466-3361

SPELLMAN DESK CO.
6159 Santa Monica Blvd.,
Hollywood, CA 90038
(213) 467-0628

STAR SPORTING GOODS
1645 N. Highland Ave.,
Hollywood, CA 90028
(213) 469-3531

STEMBRIDGE GUN RENTALS
5451 Marathon St.,
Hollywood, CA 90038
(213) 468-5000

STUDIO SPECIALISTS
249 N. Reno St.,
Los Angeles, CA 90026
(213) 480-3101

TRANSPARENT PRODUCTIONS
3410 S. La Cienega Blvd.,
Los Angeles, CA 90016
(213) 938-3821

TRI-TRONEX INC.
2921 W. Alameda Ave.,
Burbank, CA 91505
(213) 849-6115

TROPIZON PLANT RENTALS
1401 Pebble Vale,
Monterey Park, CA 91754
(213) 269-2010

VAL SURF
4807 Whitsett,
North Hollywood, CA 91607
(213) 769-6977

WIZARDS INC.
18624 Parthenia, Bldgs. 3 & 4,
Northridge, CA 91324
(213) 368-8974

WOOLF, BILLY
1112 N. Beachwood St.,
Hollywood, CA 90038
(213) 469-5335

PHOTO CREDITS
AND ACKNOWLEDGMENTS

Page

x: Courtesy of the author
Photographer: Weegee

xi: Courtesy of the author
Photographer: Deborah Turbeville
Client: *Vogue*
Art Director: Rochelle Udell

xii: Courtesy of Columbia
Broadcasting System
Photographer: Paul Strand
Client: CBS
Art Director: William Golden

xiii: Courtesy of Welch Foods, Inc.
Photographer: Edward Steichen
Agency: J. Walter Thompson
Client: Welch Foods

2: Courtesy of Columbia Broadcasting
System
Photographer: Ben Rose
Client: CBS
Art Director: William Golden

5: Courtesy of Columbia Broadcasting
System
Photographer: Erich Kastan
Client: CBS
Art Director: William Golden

6: Courtesy of Richard A. Klein,
© 1979 REMCOM, Inc.
Creators: Jim Weller and Pete
Coutroulis
Client: Richard A. Klein

11: Courtesy of Annie Leibovitz
Photographer: Annie Leibovitz
Client: *Rolling Stone*
Art Director: Bea Feitler

13: Courtesy of Peter Beard
Photographer: Peter Beard
Client: New York *Times*
Art Director: Ruth Ansel

15: Courtesy of Volkswagen of America
 Photographer: New York *Daily
 News* photo
 Agency: Doyle Dane Bernbach
 Client: Volkswagen of America

18: Courtesy of Cornell University
 Photographer: Henry Wolf
 Client: Cornell University Landscape
 Architecture Program
 Designer: Dru DeSantis

19: Courtesy of *Avenue* magazine
 Photographer: Ernst Haas
 Client: *Avenue*
 Art Director: Bob Ciano

22: Copyright © 1980 by David Melhado
 Photographer: David Melhado
 Client: Worcester (Mass.) *News*

23: Courtesy of Danny Korem
 Photographer: Dave Edmonson
 Agency: Richards Design Group,
 Dallas
 Art Director: Gary Gibson
 Client: Danny Korem

24: Courtesy of Richard L. Shaefer and
 Paul Zalon, © 1980 Popshots, Inc.
 Designed and photographed by
 Richard L. Shaefer and Paul Zalon

44–48: Portfolio Photographs by Rob
 Erdman, Courtesy of Rob Erdman

55: Courtesy of the author
 Photographer: Deborah Turbeville

57: Courtesy of Larry Keenan, Jr.
 Photography © 1977 by Larry
 Keenan, Jr.
 Agency: Michael Manwaring Design

72: Courtesy of Ohrbach's
 Photographer: Tony Petrucelli
 Agency: Doyle Dane Bernbach
 Art Director: Bob Gage
 Client: Ohrbach's
 Subject: Man

72: Courtesy of Ohrbach's
 Agency: Doyle Dane Bernbach
 Art Director: Bob Gage
 Client: Orhbach's
 Subject: Cat

72: Courtesy of Cluett,
 Peabody & Co., Inc.
 Photographer: Horn/Griner
 Agency: Young & Rubicam
 Designer: Roger Mader
 Client: Sanforized

73: Courtesy of Scali McCabe Sloves
 Photographer: Alan Dolgins
 Agency: Scali McCabe Sloves
 Client: Perdue Farms

74: Courtesy of the Olivetti Corporation
 Photographer: Carl Fischer
 Agency: Lois Holland Callaway
 Client: Olivetti

74: Courtesy of the Cotton Guild
 Photographer: Ben Somoroff
 Agency: Douglas D. Simon
 Client: Cotton Guild

76: Courtesy of Brenton Banks
 Photographer: Kent Severson
 Agency: Martin/Williams
 Client: Brenton Banks

76: Courtesy of Polaroid Corp.
 Photographer: Howard Zieff
 Agency: Doyle Dane Bernbach
 Client: Polaroid

76: Courtesy of Columbia Broadcasting
 System, © 1977 by CBS Inc.
 Photographer: Ladner-Blake
 Client: Epic Records

79: Courtesy of West End Brewing Co.
 Photographer: Howard Zieff
 Agency: Doyle Dane Bernbach
 Client: West End Brewing Co.

82: Courtesy of Bert Stern
 Photographer: Bert Stern

84: Courtesy of Van Cleef & Arpels
Photographer: Irwin Blumenfeld
Agency: Doland International
Client: Van Cleef & Arpels

84: Courtesy of Harry Winston, Inc.,
and Paccione Photography, Inc.
Photographer: Onofrio Paccione
Client: Harry Winston, Inc.
Art Director: Ronald Winston

85: Courtesy of Ford Motor Company
Photographer: Underwood & Under-
wood
Agency: N. W. Ayer & Son
Client: Lincoln Motor Company

85: Courtesy of Volkswagen of America
Photographer: Manuel Gonzalez
Agency: Doyle Dane Bernbach
Client: Volkswagen of America

87: Courtesy of Happy Legs/Jazzie Inc.
Photographer: Hal Davis
Agency: Dancer Fitzgerald Sample
Client: Happy Legs/Jazzie

87: Courtesy of Echo Scarfs, Inc.
Photographer: Saul Leiter
Agency: Peter Rogers Associates
Client: Echo Scarfs

90: Courtesy of Louis Sherry, Inc.
Photographer: Baron de Meyer
Agency: Winston & Sullivan, Inc.
Client: Louis Sherry

90: Photographer: Herbert Matter
Agency: McCann-Erikson

92: Courtesy of Julius Garfinckel & Co.
Photographer: Toni Frisell
Agency: Sterling Advertising
Client: Garfinckel's

92: Courtesy of the Estate of Margaret
Bourke-White and the Beck En-
graving Co.
Photographer: Margaret Bourke-
White
Client: Beck Engraving

93: Courtesy of N. W. Ayer Inc.
Photographer: Toni Petrucelli
Agency: N. W. Ayer Inc.
Client: United States Army

95: Courtesy of Columbia Broadcasting
System
Photographer: Arnold Newman
Client: CBS
Art Director: William Golden

96: Courtesy of *Geo* magazine
Photographer: H. J. Anders
Client: *Geo*

96: Copyright © 1972 by *Newsweek*
Magazine
Photographer: Alen MacWeeney
Client: *Newsweek*

98: Courtesy of Lightolier, Inc.
Photographer: Ben Rose
Agency: Sudler & Hennessey
Client: Lightolier

98: Courtesy of N. W. Ayer Inc.
Photographer: William Shewell Ellis
Agency: N. W. Ayer Inc.
Client: Oak Flooring Bureau

100: Courtesy of Boeing Aircraft
Photographer: International News
Photo
Agency: N. W. Ayer & Son, Inc.
Art Director: Paul Darrow
Client: Boeing

103: Courtesy of the New York Dress
Institute
Photographer: Berenice Abbott
Agency: Abbott Kimball
Client: New York Dress Institute

104: Courtesy of The Andrew Jergens Co.
Photographer: Edward Steichen
Agency: J. Walter Thompson
Client: Jergens Lotion

105: Courtesy of the Penn Central Corp.
Photographer: Lewis Hine
Client: Pennsylvania Railroad

106: Courtesy of Cannon Mills, Inc.
 Photographer: Herbert Matter
 Agency: N. W. Ayer & Son, Inc.
 Art Director: Paul Darrow
 Client: Cannon Mills

106: Courtesy of E. I. du Pont de Nemours
 & Co.
 Photographer: George Platt Lynes
 Agency: Batten Barton Durstine &
 Osborn
 Art Director: A. Klein
 Client: du Pont

108: Courtesy of Nautical Quarterly, Inc.
 Photographer: Alan Weitz
 Client: *Nautical Quarterly*

114: Courtesy of BMW of North America
 Photographer: Rudolf Tesa
 Agency: Wilson Haight & Welch
 Client: BMW of North America

116: Courtesy of the Boston Museum of
 Fine Arts
 Photographer: Phil Porcella
 Agency: Humphrey Browning Mac-
 dougall
 Client: Boston Museum of Fine Arts

118: Copyright © 1978 Columbia Pictures
 Industries, Inc., "Barney Miller," a
 Four D Production, distributed by
 Columbia Pictures Television
 Photographer: Ralph Nelson
 Agency: Dellafemina, Travisano &
 Partners of Los Angeles
 Client: Columbia Pictures

120: Copyright © 1979, Kentucky Arts
 Commission. Poster/catalog for an
 exhibition of contemporary paint-
 ings by Kentucky artists.
 Photographer: Warren Lynch
 Agency: Images, Julius Friedman
 Client: Kentucky Arts Commission

120: Courtesy of the New York Shakes-
 peare Festival
 Photographer: Jean-Marie Guyaux
 Agency: Case & McGrath, Inc.
 Client: New York Shakespeare Festi-
 val

120: Courtesy of Pioneer High Fidelity
 Photographer: Phil Marco
 Agency: Scali McCabe Sloves
 Client: Pioneer

121: Courtesy of the Coastal Plains
 Regional Commission
 Photographer: Eric Meola
 Art Director: Preuit Holland
 Client: Coastal Plains Regional Com-
 mission

122: Courtesy of Kraft, Inc.
 Photographer: Phil Marco
 Agency: N. W. Ayer & Son
 Client: Kraft

122: Courtesy of Columbia Broadcasting
 System, © 1978 CBS, Inc.
 Photographer: Buddy Endress
 Designers: John Berg and Paula Scher
 Client: CBS Records

123: Courtesy of American Tourister, Inc.
 Photographer: Larry Robbins
 Agency: Doyle Dane Bernbach
 Client: American Tourister

124: Courtesy of Ciba-Geigy Corp.
 Photographer: Jay Maisel
 Agency: William Douglas McAdams
 Designers: Herman McCray, James
 Fogelman
 Client: Ciba-Geigy

125: Courtesy of the Brooklyn Museum
 Art School
 Photographer: Arnold Beckerman
 Client: Brooklyn Museum Art School

127: Courtesy of Bert Stern
 Photographer: Bert Stern
 Client: Smirnoff Vodka

128: Courtesy of Air Jamaica
 Photographer: Walter Kaprielian
 Agency: Ketchum MacLeod & Grove
 Client: Air Jamaica

128: Courtesy of Wrangler, Inc.
 Photographer: James Houghton
 Agency: Altman Stoller Weiss
 Client: Wrangler

129: Courtesy of The Andrew Jergens
 Co.
 Photographer: Hoyningen-Huene
 Agency: Lennen & Mitchell
 Art Director: Louis Menna
 Client: Jergens Lotion

129: Courtesy of The Andrew Jergens
 Co.
 Photographer: Edward Steichen
 Agency: J. Walter Thompson
 Client: Jergens Lotion

130: Courtesy of Hoffritz for Cutlery
 Photographer: Jerrold Schatzberg
 Agency: Trahy/Caldwell
 Client: Hoffritz

131: Courtesy of Volkswagen of America
 Photographer: David Langley
 Agency: Doyle Dane Bernbach
 Client: Volkswagen

132: Courtesy of Oscar de la Renta Mens-
 wear
 Photographer: Hal Davis
 Agency: Anesh Viseltear Hershber-
 ger
 Client: Louis Goldsmith, Inc.

134: Courtesy of Olin Corp.
 Photographer: Mike O'Neill
 Agency: Van Leeuwen & Partners,
 Inc.
 Client: Olin

135: Courtesy of Volkswagen of America
 Photographer: Harold Kreiger
 Agency: Doyle Dane Bernbach
 Client: Volkswagen of America

136: Courtesy of Bahamas Ministry of
 Tourism
 Photographer: Hiro
 Agency: McCann-Erickson

137: Courtesy of Columbia Broadcasting
 System
 Photographer: CBS Photos
 Client: CBS Television Stations
 Art Director: Lou Dorfsman

139: Courtesy of Cluett, Peabody & Co.,
 Inc.
 Photographer: Arthur Beck
 Agency: Cook and Shanosky As-
 sociates, Inc.
 Client: Cluett, Peabody

140: Courtesy of the Estate of Margaret
 Bourke-White and N. W. Ayer Inc.
 Photographer: Margaret Bourke-
 White
 Client: N. W. Ayer & Son

141: Courtesy of the Coca-Cola Co.
 Photographer: Arington Hendley
 Agency: McCann-Erickson
 Client: Coca-Cola

143: Courtesy of The Procter & Gamble
 Co.
 Photographer: Phil Marco
 Agency: Benton & Bowles
 Client: Procter & Gamble

145: Courtesy of Columbia Broadcasting
 System, © 1977 CBS Inc.
 Photographer: Don Hunstein
 Client: CBS Records
 Subject: Ramsey Lewis album.

145: Courtesy of Columbia Broadcasting
 System, © 1977 CBS Inc.
 Photographer: Lawrence Robbins
 Client: Epic Records
 Subject: Babies ad

145: Courtesy of Craig Braun
 Photographer: Andy Warhol
 Client: Rolling Stones Records
 Art Director/Designer: Craig Braun